AUTOCRITIQUE

AUTOCRITIQUE

ESSAYS ON ART AND ANTI-ART

1963–1987

BARBARA ROSE

WEIDENFELD & NICOLSON

NEW YORK

Published by Weidenfeld & Nicolson, New York
A Division of Wheatland Corporation
10 East 53rd Street
New York, NY 10022

Published in Canada by General Publishing Company, Ltd.

Library of Congress Cataloging-in-Publication Data

Rose, Barbara.
 Autocritique : essays on art and anti-art, 1963–1987 / Barbara
Rose. 1st ed.
 p. cm.
 ISBN 1-555-84076-0
 1. Art, American—Themes, motives. 2. Art, Modern—20th century—
United States—Themes, motives. I. Title.
N6512.R635 1988
709'.73—dc19 87-22490
 CIP

Manufactured in the United States of America

Designed by Irving Perkins Associates

First Edition

10 9 8 7 6 5 4 3 2 1

IN MEMORY OF MY CRITICS
BEN ROSE
TERRY DE ANTONIO
THOMAS B. HESS
HOLLIS FRAMPTON
ARTHUR A. COHEN

ACKNOWLEDGMENTS

These essays were written over a period of twenty-five years. Without my editors John Herman and Barbara Berson, who read through thousands of pages, I could not have found a focus for so much material of such disparate subject matter and style. Others I have to thank are Michael Fried, who first encouraged me to write criticism, and Dr. Milton Horowitz and Rachel Stella, who convinced me to finish what I had begun. I am grateful to Michael Stella for seeing the world clearly and insisting I do so as well.

I remain deeply indebted to my professors, Julius Held and Meyer Schapiro, for teaching me that the work of art must be judged first in terms of its formal quality, but that its significance cannot be detached from the historical, economic, and psychological context within which it was created.

Artist friends with whom I have had a continuing fruitful dialogue include above all, Avigdor Arikha, as well as Bernhard Leitner, Alexander Liberman, Georges Noel, Patrick Ireland, Richard Hennessy, Mark Schlesinger, Anna Bialabroda, William Ridenhour, Beverly Pepper, and Mark di Suvero. My colleagues, William C. Agee, Robert Littman, Walter Hopps, Lana Jokel, Gladys Fabre, Margit Rowell, Barbara Novak, Diane Kelder, Susi Bloch, Allen Rosenbaum, and Daniel Berger have been stimulating and loyal friends.

As my editors, Phil Leider at *Artforum* and later William Phillips at the *Partisan Review* pushed me to do my best. I have an enduring debt to Annette Michelson for her brilliance and exigent candor. My assistant Paula Hunt worked in all phases of preparing this manuscript. Without Andrew Wylie's support and encouragement, I could not have under-

taken this project. Paul Manes helped me to look both backward and forward.

Finally, my thanks to Jasper Johns for being my friend throughout these years, for making work challenging enough to keep me thinking, for proving self-criticism is not only possible but essential, and for teaching me that no is also an answer.

CONTENTS

x

CONTENTS

AUTOCRITIQUE

I never wanted to be an art critic. For years I practiced the piano, hoping to become a concert musician like my mother's cousins. My first act of criticism was to stop playing the piano; my second was to quit painting. I have always believed the arts deserved a more discerning audience rather than more mediocre talents competing for attention. I believed art was difficult, demanding, and rewarding, and that its appreciation required study and effort. So at Smith College, I started with the Egyptians, gradually working my way up through the ages to impressionism. Later I studied art history in France, Spain, and Germany. I never studied modern art, American art, or journalism.

After spending a year in Spain on a Fulbright scholarship, I wrote my first critical reviews for the Spanish magazine *Goya*, because I realized that Franco's censorship was so effective that Spanish artists did not even have access to reproductions of contemporary art. When in 1962 I returned to the United States to have my first child, Michael Fried persuaded me to submit an article on pop art as Neo-Dada that I had started working on in Berlin. I sent it to James Fitzsimmons, the late editor of *Art International*, and he subsequently asked me to write a monthly "New York Letter." Michael Fried was already writing regularly from New York, and Annette Michelson was doing a column from Paris. The moment was very exciting: Clement Greenberg had just published his essays on *Art and Culture*, and a group of brilliant young artists, including Frank Stella, to whom I was married at the time, were creating anti-expressionist styles that captured the imagination of the new dealers and collectors bored with the European look of abstract expressionism and anxious to assert an autonomous American cultural identity.

As I look back at my criticism of the sixties, I realize how naive and provincial my outlook was. Blind enthusiasm about the art of one's generation is probably inevitable because the artists' visions correspond with one's own world view. Only after the battles have been won or lost can one have a clearer conception of what the fight was about, who survived, and why. I like to think I championed the best artists working at the time. In retrospect, I see my early embrace of pop and minimal art from a certain critical distance. Both represented an ironic conceptual and critical challenge to the brooding romanticism of abstract expressionism, with its emphasis on individual Ego. The New York School remained tied to the art of Europe, but its critical apologists and partisans argued otherwise, demanding the birth of a brave, fresh, innocent American art free of the decadence of postwar Europe. As I reread artists' statements as well as my own projections about American art, I realized that certain dreams and delusions die slowly. The New York School proclaimed its world hegemony as Europe rose from its ashes, but not, as French critic Serge Guibault would have us believe, in an orchestrated attempt to "steal the idea of modern art." The impulse was rather the recurrent millennial fantasy that a youthful, robust, and morally superior America would save aging Europe from its world-weary decrepitude.

"Manifest destiny" became an aesthetic as well as a political imperative after World War II. The banner of an art with roots in native ground was taken up by the most powerful critics who boosted the New York School, Thomas B. Hess, Harold Rosenberg, and Clement Greenberg, although the first trumpet was probably blown by Barnett Newman in his celebrated essay, "The Sublime Is Now," in 1947. "Here in America," he wrote, "some of us, free from the weight of European culture, are finding the answer, by completely denying that art has any concern with the problem of beauty and where to find it." Interestingly, Jackson Pollock never denied the direct link between his work and that of the old masters he copied for twenty years. In one of his rare interviews, he said he was most interested in two European artists who had never visited the United States, Picasso and Miró. (Pollock never traveled to Europe, but he did meet Miró in New York in 1947, the year he began his celebrated "drip" or poured paintings.)

Rosenberg, who worked for the Advertising Council, was good at inventing snappy titles like "action painting." As editor of *ARTnews*, a magazine with no relationship to the flashy monthly published under that name today, Hess ran a propaganda vehicle for launching the New York School internationally. In that crazy rabbit warren of offices, I

served my apprenticeship as assistant to the surrealist film critic Parker Tyler. Hundreds of reviews were assigned every month. They were written mostly by unemployed poets, who were paid $3 a line. We kept using the same color plates because we could not afford to make new ones. I don't remember the word "advertiser" being mentioned. No one expected the magazine to make a profit.

All the younger writers I knew were graduate students in art history who wanted to put art criticism on a firmer, more professional footing. We did not esteem Rosenberg's writing, but we were uniformly impressed by Clement Greenberg. His 1961 article "How Art Writing Earns Its Bad Name" exposed shoddy jargon and gave one a sense that there was an alternative to sloganizing. *Art and Culture,* his collection of essays published that same year, was similarly inspiring. It soon became evident, however, that Greenberg saw in pop and minimal art a threat to the continuity of mainstream high culture. Younger artists, it appeared, had taken too literally his idea that "American-type painting," as he termed it, was superior.

In retrospect, pop art looks conventional, intelligent, solid in its understanding of Léger and Stuart Davis, and firmly grounded in fine art despite its presumed anti-elitism, a fake identity the populist ethos demanded. Outside of Rauschenberg and Johns, who are more accurately seen as members of the second generation of the New York School, two pop artists stand apart. Oldenburg's soft stitched-cloth works represented a genuine technical innovation in sculpture. And Andy Warhol was a homegrown Duchamp who resurrected the Duchampian stance of anti-art with sustained proletarian vigor. Samson-like, Warhol was determined to bring down the temple of art, if necessary, to gain entry to the pantheon of the immortals. The cleverest of strategists, Warhol won his major victory by convincing the public that art should be easy, dumb, and effortless. This struck at the core of high culture, which maintains that modernism is difficult.

Behind the aesthetics of the most radical pop and minimal artists was a Dadaist wish to change the rules of the art game so that more people could play. There is something intrinsically American about this populist drive. A good case could be made that anti-art Dada was born in volatile New York in 1915, where Picabia and Duchamp were making headlines with their entertaining high jinks, and not in stolid Zurich in 1916 at the Café Voltaire. Dada was perfectly suited to the American temperament because of the recurrent American challenge to the concept of modernism, which is seen as elitist and undemocratic.

In the violence of their rejection of expressive humanistic content and their questioning of whether such content could be communicated, pop and minimal artists shared a fundamentally Dadaist critical attitude antagonistic to the achievements of high art. Their downgrading of talent was essential to this leveling. For all its exalted philosophical and psychological rhetoric, minimal art requires only ideas, not talent, since it is clearly commercially fabricated. Indeed, "not made by human hands" could stand as the motto of American art in the sixties. Automatic techniques in painting paralleled the use of industrial modules in minimal art. The lack of surface texture and the rejection of both tactility and modeling in the name of a spurious "opticality" became trademarks of color-field painting as well as of pop and minimal art.

Unwittingly, I initiated the vogue for minimal art in the article "ABC Art" written for *Art in America*. This shocked me, since both the concept and the title of the article had been ideas of Jean Lipman, then editor of *Art in America*. When the term "minimal art" became synonymous with a kind of pared-down literalist abstraction based on gestalt principles of perception, no one was as surprised as I at the sudden popularity of the new "movement."

However, it was Donald Judd who made the definitive assault on European aesthetics in his much-quoted 1965 article "Specific Objects." He called for an art that would reify the illusionistic qualities of painting into their literal, material equivalents. This, he claimed, would get rid of unreal illusionism, the last miserable vestige of European art. I had met Judd in a graduate seminar on Venetian renaissance painting at Columbia, and was impressed by his intelligence. The ghost of John Dewey was still hovering around Columbia, and Judd was profoundly influenced by pragmatist theory, as was I. For if there is any method in my criticism, it is the pragmatic assumption that function determines meaning. Before trying to evaluate a work of new art in terms of *a priori* categories, I asked myself how the artist intends it to function. Is the work trying to instruct, disorient, mock, stupefy, or shock the audience, and if so, why?

Like Robert Morris, Judd was a Midwesterner, born in Missouri. Both pursued graduate studies in New York, not in studio art, but in art history. By the same token, Oldenburg, the son of a Swedish diplomat, was a Yale graduate, and Stella a Princeton alumnus. Well equipped for polemics, they shared a sense of irony that is probably the appropriate response to the American scene.

Both Greenberg and Judd were authoritarian personalities who made

convincing cases for their respective interpretations of the "modernist reduction." Between Greenberg's cries for aesthetic purity achieved through the reduction of each art form to its essence (in the case of painting, its visible material qualities and two-dimensional flatness) and Judd's call to jettison what was left of the old-world illusion of a space that was not real, or color that was applied rather than intrinsic, American art was headed toward an inevitable cul-de-sac in its rush toward aesthetic purity and autonomy from the European tradition.

Judd attacked Greenberg's criteria for judging art qualitatively, insisting it was unimportant whether art was good or bad because it needed only to be "interesting." In his later essays, Greenberg took to invoking Kant, falling back on the argument of good versus bad "taste" as determining the criteria for quality. One should have been able to anticipate the reaction: on one hand, artists intentionally made things that were boring, hence *uninteresting;* others, bent on offending good taste, started making deliberately "bad" art. This in turn was lauded as the latest radical innovation by curators who created careers by spotting new trends.

Around 1970, I became too unhappy about writing art criticism to do it much longer. It was clear to me that Greenbergian color-field painting was based on the false premise that the canvas cloth could be treated like the porous watercolor page, absorbing color into it so that no illusion of actual space could be interpreted from this wedding of image with support. However, enlarged watercolors made with water-soluble acrylic paint on canvas ultimately lost the substance, depth, and intensity of oil painting. In the cases of Klee and Miró, whose paintings on burlap and rough textured supports prefigured this development, both support and pigment retain their tactile, painterly qualities. These qualities largely disappear in the purely "optical" style of stained painting. The title of Greenberg's essay launching stained color-field abstraction, "Post-Painterly Painting," is an oxymoron. Greenberg's real problem, however, was finding artists exceptional enough to bear the mantle of greatness he wished to bestow. Outside of Frankenthaler, who retained a European sense of scale and detail, and Friedel Dzubas, who continued priming his canvases and using brushes and oil paint during the heyday of staining, spraying, and sponging plastic pigments into raw canvas, Greenberg's various saviors of high art had no dynamic or durable conception.

On the other hand, I did not see artists I grew up with creating

anything but ambiguous objects, easily confused with furniture. All things considered, I had to admit I was not writing about a great moment in world art. And something must be wrong if my words could be used for purposes I had not intended. For example, Eugene Schwartz wrote a booklet titled "Advice to a Young Art Collector." In it, he instructed novice speculators to keep a scorecard on the rising value of their investments by starring artists mentioned favorably by various critics, of which I was not delighted to find I was one. Once it was clear that my opinions were being used as a way of touting an artist, the similarity between the art world and a racetrack or gambling casino was only too clear. I was not anxious to print my value judgments, and instead started writing letters to artists' friends that were private critiques, devoting my published essays more and more to problematic issues.

During the early seventies, I still believed in the idea of an avant-garde that went against the grain of bourgeois society rather than confirming its most philistine tastes. Mainly through my friendships with Robert Rauschenberg and Billy Klüver, I became involved with Experiments in Art and Technology, an idealistic group devoted to demonstrating that technology was a means, not an end, and that it could be used for a variety of purposes. I am not sure this is true any longer. These days I tend to see the mass media as a kind of autonomous demiurge that behaves in ways difficult to calculate.

When post-minimal and conceptual artists decided that painting was dead, I did not believe them. For them, nothing in painting or sculpture has been more advanced than what Pollock achieved in his drip paintings. They fundamentally misunderstood his concerns. Once again, the result was reification. As far as these avant-garde artists were concerned, the traditional manipulations of formal elements like line, shape, color, plane, space, etc., were simply recombinations of known quantities or qualities. Certain of Pollock's discoveries, having to do with the nature of visual perception, the physical impact of materials, the incorporation of random elements, and the emphasis on *process* (in Pollock's case, dripping) as an identifiable agent of form creation, could be extended "beyond painting." Pollock's technique is the antithesis of the *a priori* forms imposed by artists influenced exclusively in the manipulation of the known and fixed formal elements. The argument was that it is pointless to invent a new shape, since all shapes *act* the same way, and the imagination can predict the outcome if it cares to multiply the possibilities.

The greatness and originality of Pollock's drip paintings stopped several generations of American artists dead in their tracks when confronted with canvas. The idea that no more radical technical solution to picture-making could be arrived at sent younger artists reeling away from the art of painting into areas where their work might look powerful and original, such as literal objects, earthworks, minimal art, media, and performance art.

Nevertheless, sincere, sometimes desperate younger artists attempted to build on what Pollock left as a heritage, rightfully denying it could be anything as pallid and easily assimilated as color-field painting. Another group picked up the Duchampian thread of anti-art. But Duchamp, like two other sixties culture heroes, Herbert Marcuse and Norman O. Brown, produced his own autocritique, reversing his position at the end of his life. He completed his oeuvre with a complex work that can never be moved from its site in the Philadelphia Museum, cannot be reproduced and can be seen by only one person at a time, who is literally barred from approaching the work by a wooden door which permits viewing only when one presses up against the peepholes. The antithesis of the transparent *Large Glass, Etant Donnés* totally denies the viewer's right to participate in the "creative act," and reasserts the principle of aesthetic distance. Similarly, in his last book, Herbert Marcuse defines the "aesthetic dimension" as the last refuge of independence and creative freedom.

One would be blind not to see that high art is on the defensive, trying to stand firm against the increasingly aggressive onslaughts of mass culture. For we can no longer talk about the innocence of pop culture, which first captured artists with its vitality. Art has now been converted into the instrument of lesser goals than enlightenment or aesthetic experience. Because of the instant diffusion of information, artists are aware of these uses. Some seek to collaborate with the ultimate victory of anti-cultural values. The transformation I have witnessed in over twenty-five years of looking at art is not a superficial change in the forms art will assume. Criticism can eventually assimilate formal change, even technical change of any kind. The real change now is in the function of art, and the role of the artist in society.

Art critics have never had an easy time of it. They have been ridiculed by artists from Rembrandt to Daumier to Johns and Kienholz. Today, however, they have so little authority or status that they are, with few

exceptions, thoroughly irrelevant. What power they might have had has been usurped by dealers, who have cultivated a rap that convinces a gullible public that *they* are the true critics. Mr. Schwartz, the collector who caused me to question the role of my own work, and his wife, Barbara, a well-known decorator, have become the arbiters of taste followed by herds of those less "in the know." Obviously they have profited from their art investments, so they *must* be experts. Other powerful collectors have informed me that they do not need criticism, because they know what they like and can afford to promote it. Thus, the eclipse of aesthetic distance, initiated by the demand that art become as literal and real as any object in the world, has been coupled with the disappearance of the critical dimension. In this vicious circle, art is indistinguishable from any other commodity, impervious to the authority of reasoned or knowledgeable judgment.

As art becomes entertainment, fashion, public relations, and investment banking, the role of the critic has diminished into affectlessness. In the din, it is hard to hear a single voice. What bothers me most, however, are the fundamentally fallacious principles on which current American art is based, and which alienate me from its current manifestations. The taste of what the late playwright Charles Ludlum so accurately identified as the "bourgeois avant-grade" embraces as its own the latest manifestation of Dada, always waiting in the wings to take over in any moment of bad faith, such as the present. For the practitioners of "appropriation" art and "neo-geo," the point is to demonstrate that the new patrons can no longer distinguish, not between good and bad art, but between art and not art or anti-art. Some find this a diversion that is both fun and profitable, having your cake and eating it too, as Andy Warhol was fond of saying. But art based on reproduction and second-hand sources can be nothing other than second-rate.

The literalist reification of aesthetic concepts means the disappearance of the aesthetic dimension. If American art exists independently from European culture, it loses contact with its own sources and any historical continuity.

This book deals mainly with what I now view as the historical decline of American art since abstract expressionism. It chronicles my changing role from enthusiastic cheerleader of the art of my generation to critic of its (and of necessity my own) excesses and limitations. I believe it is foolish to presume we can reclaim what has been lost through naive innocence, blind ignorance, and arrogant chauvinism, until there is a

general realization that in the future as well as the past we must measure our culture against the European standard in a necessary act of self-criticism.

<div align="right">

Barbara Rose
Camerata di Todi
Perugia, Italy, 1987

</div>

I

AMERICA AS PARADISE

AMERICA AS PARADISE

Writing to Ferdinand and Isabella during his third voyage to America in 1498, Columbus reported he believed he had found that fabled terrestrial paradise lost to man since biblical days. By this time he had come to the conclusion that the world was not flat but pear-shaped like a woman's breast; in this case, the source of the four rivers of Eden would be located at a spot roughly corresponding to the nipple. Columbus himself did not dare enter the sacred garden, but he was confident he had located nothing less than paradise on earth.

Given the historical context within which America was discovered, Columbus was compelled to interpret his voyages as a religious mission. For only a millenarian interpretation of the identity of the new world was grand enough to serve as counterpropaganda against the thundering of the old-world reformist preachers already beginning to predict a coming apocalypse. From the moment of its discovery, the innocence and promise of America were linked conceptually with the exhaustion and corruption of Europe. In Mircea Eliade's words, America was "born under the sign of eschatology." Thus it was inevitable that millennial prophecies and fantasies of redemption should provide the content of the original imagery chosen to represent the unknown hemisphere to the west.

Beginning with Columbus, successive generations of writers, painters, philosophers, and theologians on both sides of the Atlantic imagined America as the fulfillment of the biblical prophecy of an earthly paradise, where regenerate humanity would be born again into a state of unperturbed innocence, a recreation of the happy infancy man enjoyed as part of unconscious nature, before he had tasted the forbidden fruit of knowledge. Such comforting millennial fantasies did not fade easily; they had and continue to have vast repercussions for American civilization

By the nineteenth century, collective fantasies of a new Eden focused themselves on the idea of the American wilderness as a vast, if not infinite, virginal landscape, undefiled by man's presence and the destructiveness of his acts, glorified by the supernatural powers of nature displaying awesome light-and-color spectacles and forms grander than anything man or his art had ever created. Unlike idyllic Claudian scenes from which their Arcadian formula was derived, these American landscapes did not give relatively epic scale to nature by peopling hills and valleys with tiny *staffage* figures; they were as unpopulated as the primeval American wilderness they depicted.

In 1977, paintings of the natural wonders of the new world, which Americans had a great investment in believing would supplant the man-made marvels of antiquity, were the subject of the Museum of Modern Art exhibition "The Natural Paradise." The exhibition marked a considerable departure from the formalist, anti-American bias for which MOMA has been known since it was founded in 1929 to promote the cause of modern art, which, in the opinion of its founders, was mainly made in Paris.

The presence of so much minor and *retardataire* art can be written off to some extent by arguing that the exhibition had essentially an iconographic focus. Nevertheless, one suspects that MOMA is guilty of concluding that if it is too confusing to look forward, it is just as well to look back and rehabilitate mediocre painters. For if nothing radically "new" appears to be surfacing, then "new" names can just as well be dredged up from the dead past. The presence of really inferior painting at the Museum of Modern Art is just one more indication of the massive cultural confusion of recent years.

MOMA's superficial treatment of such a crucial issue in the history of American art seems a reflection of the general consensus, only now changing, that the history of American art is a subject not worthy of the kind of attention we might give to classical, Renaissance, or modern French art. Every time an opportunity to make a specific connection based on indisputable documentary evidence was available, that opportunity was ignored. For example, to establish Jackson Pollock's enduring debt to Albert Pinkham Ryder, one would only have had to see one of Pollock's early oil studies of the thirties juxtaposed with a Ryder seascape to recognize the origin of the turbulent swirling motifs that remain a constant of Pollock's work. Examples of other oversights: the influence of the slashing verticals in Jonas Lie's 1913 painting *The Conquerors: Culebra Cut*—according to Thomas B. Hess "one of the paintings

Newman remembered seeing as a boy in his many visits to the Metropolitan Museum"—on the structure of Barnett Newman's earliest "zip" abstractions. Both the Jonas Lie painting in question and a Newman were in the show, but no connection between them was made in the exhibition or in the catalogue.

"The Natural Paradise" undoubtedly intended to reverse the emphasis on the purely formal element in art, but the irony is that the impact of formalism on both art history and art criticism has been so decisive that MOMA's case for a continuity of metaphysical content in American painting was sometimes sabotaged by the attempt to base connections on nonexistent or obscure formal analogies. For example, in his catalogue essay "The Primal American Scene," Robert Rosenblum dwells on the influence of Augustus Vincent Tack, a painter active in the twenties and thirties collected mainly by Duncan Phillips, on the art of the abstract expressionist Clyfford Still. Comparing the works in reproductions or in slides, one might imagine a resemblance between Tack's pale peaked mountains and waves, stylized and flattened in the manner of the Japanism popular in the art schools of his day, with Still's intensely colored, jagged, restless abstract forms. Still and Tack, of course, are not hung side by side in the exhibition; such a juxtaposition would devastate any argument based on analogies of structure, facture, surface, or color. No documents can be found linking the two artists, because indeed any similarity is strictly coincidental. Tack was essentially a decorator working in an Orientalizing style derived from the Viennese Sezession, whereas Still is a modernist innovator who synthesized impressionist and surrealist sources into sweeping personal images.

Still's great walls of impasto, although nominally abstract, however, have suggested to many viewers dark crevices and caverns, lightning bolts and other natural forms and phenomena familiar as typical themes of nineteenth-century American painting. Such allusive correspondence between abstract expressionist works and earlier American painting reveals that "The Natural Paradise" is not a show about landscape at all; it is, for the most and best part, an exhibition of religious paintings by Protestant artists forbidden to paint the face of God, who found a metaphor for the Creator in impersonal images of nature at the moment of Creation as a timeless, prehistoric wilderness or desert lit by an unearthly light. Later, this supernatural glow was translated by Jewish abstract painters like Gottlieb, Newman, and Rothko into fields of color painted so transparently that light emanated from within the painting for the same reason that it radiated from the backgrounds of works of

nineteenth-century metaphysical landscape painters. The use of light as a metaphor for divine illumination is among the indisputable connections between the luminists and the abstract expressionists.

There is enough information available to document the mystical sources of the imagery of Newman, Pollock, Gorky, Rothko, et al. Yet no such concrete discussion takes place in the catalogue of "The Natural Paradise." Fortunately, a useful section of texts collected by Barbara Novak relates nineteenth-century American aesthetics to the concepts of philosophers like Emerson and Thoreau, whose Transcendental ideas regarding a pantheistic nature religion had and continue to have such a profound influence on American thought and culture. In her seminal book *Nineteenth Century American Painting*, Novak first situated the Luminist School of metaphysical landscape painting within the general context of Transcendentalist thought.

The American alternative to impressionism, luminism was a *retardataire*, naturalistic style of landscape painting that deliberately rejected French art. American artists regarded impressionism as a scientific, secular attitude toward landscape, incompatible with the Transcendentalist idea of nature as a metaphysical force of mysterious origin. Evidence of the American hostility toward modernism is documented in *The Machine in the Garden*, Leo Marx's study of the struggle between the pastoral ideal of agricultural America and the progressive demands of capitalist expansion through industrialization. Of particular interest in an analysis of antiprogressive, antimodernist attitudes in America is his suggestion that the resistance to industrialization was based on the fear of giving up the fantasy of the earthly paradise, a fantasy central to American popular religions. One suspects further investigation will reveal that the profoundly reactionary flavor of American popular religions affected American art to a far greater degree than has been acknowledged.

One of the peculiarities of abstract expressionism as a modern style is that like earlier American landscape painters, the abstract expressionists also rejected the industrial age, deliberately turning their backs on the geometric machine imagery which Europe identified as *the* modern theme. As French as some of its techniques are, abstract expressionism, or at least a lot of it, is still related to earlier American art both in its peculiar conception of history as antediluvian natural history and in its hostility to the European modernist ideal of an art for art's sake.

In any discussion of the presence of a transcendental or metaphysical element in abstract expressionism, Barnett Newman is certainly a key personality, since he so often spoke for his colleagues. In December

1948, a few months before he painted *Horizon Light*—a work not included in "The Natural Paradise" that resembles an abstraction of a luminist landscape—Newman published an article in *The Tiger's Eye*, titled "The Sublime Is Now." This essay is the specific document linking abstract expressionist aesthetics to earlier conceptions of the sublime as a transcendental category. That relationship has been most fully examined by Robert Rosenblum in *Modern Painting and the Northern Romantic Tradition*.

In the essay, Newman denounces the "failure of European art to achieve the sublime" as the result of a "blind desire to exist inside the reality of sensation," reiterating the luminists' original critique of impressionist empiricism. Clearly impressionism did not express faith in nature as the manifestation of a divine presence. Based on scientific observation, impressionism reflected a modernist consciousness of nature dependent not on mystical illumination but on physical laws; therefore impressionism was not acceptable to the American luminists, who were in many respects aesthetic fundamentalists. Similarly, for Newman, modern European art was to be rejected because it was not based on faith. Predicting the postwar rebirth of art in America, where the artist was free from "the obsolete props of an outmoded and antiquated legend," Newman proposed an exalted program for his contemporaries: "I believe," he wrote, "that here in America, some of us, free from the weights of European culture, are finding the answer, by completely denying that art has any concern with the problem of beauty and where to find it. . . . We are reasserting man's natural desire for the exalted, for a concern with our relationship to the absolute emotions."

In Newman's high-flown rhetoric, once again we find American innocence and youth contrasted with European corruption and fatigue. We are reminded of the scene engraved by the Dutch printmaker known as Stradanus around 1600 depicting America as a virginal young woman, trailing a few discreet turkey feathers, and surrounded by nude picnicking noble savages. She rises from her hammock to greet navigator Vespucci, bowed under by the weight of his voluminous civilized garb. The notion that culture was European whereas nature was American implied that the important history of America was natural history, not art history. This anticultural idea had been part of the American artistic consciousness since the Colonial period. When Charles Wilson Peale painted his self-portrait, he showed himself proudly inviting the public into the museum he had established in Philadelphia. A European artist like David Teniers would have painted himself surrounded by the glory of classical art. Peale pulls back a curtain to reveal a collection of stuffed

birds and animals—for his museum was essentially a museum of natural history.

For generations, the lack of an indigenous art history was experienced as a terrible handicap by American painters. That nature was so often depicted as wilderness gave American landscape paintings a millenarian, religious dimension in their references to paradise before the Fall. In the same sense, the barren, deserted, unpeopled landscapes of Hartley, Dove, and O'Keeffe also look archaic, if not distinctly prehistoric. By the time the abstract expressionists began casting about for universal symbols, they were reinforced in their desire to seek primordial, timeless themes by such mystical precedents.

Because history was made in Europe, many American artists, including the abstract expressionists as well as contemporary artists involved with earthworks and archaeological art, have wished to escape art history, to exist outside its framework. In this context, the insistence of modernism on a historical consciousness became just one more reason that modernism so frequently found and continues to find resistance in America.

Returning to Barnett Newman's remarks concerning the sublime, we find other peculiarly American prejudices against an art for art's sake. In *Prophetic Pictures,* Nathaniel Hawthorne indicated the basis, deeply embedded in Puritan thought—and as it turned out for Jewish painters like Newman, Rothko, and Gottlieb, as deeply embedded in Old Testament iconoclasm—of the American antagonism to the purely aesthetic. "Some deemed it an offense against the Mosaic law, and even a presumptuous mockery of the Creator," Hawthorne wrote, "to bring into existence such lively images of his creatures."

In the recurrent rejection of the category of the aesthetic as trivial and void of higher meaning, there is a consistency connecting the disparate chapters in American art that may explain even the virulence of the conceptualists' attack against art for art's sake as meaningless decoration. There is a good argument to be made that the New York School painters were essentially religious painters who found many correspondences between the natural religion of Transcendentalism, the concept of the sublime as a transcendental category, and transcendental ideas in Eastern religions. To see the New York School as merely the lineal descendant and legitimate heir of a mainstream tradition of French art is to miss a great deal of its complexity and meaning. Abstract expressionism flowered in New York not merely because Hitler made Europe unsafe, but also because a tradition of metaphysical painting which could provide a profound content for great art was already well established in

America. Any attempt to ascribe the achievement of abstract expression-ism to a formal revolution misses the essence of its significance as a challenge, not only to the mechanically inspired geometry of cubism, but also to the empiricist, materialist basis of the content of cubism as art made for its own rather than for God's sake.

GEOMETRY, AMERICAN-STYLE

Minority visions are always curious historical phenomena in America, even in art. American popular taste is traditionally happiest with illustrational, bright-colored images. Meticulous photographic realism looks as if the artist worked hard. This reassures the public. Modern abstraction, on the other hand, presupposes a sensitivity to formal values usually unavailable to the common man. Hostility regarding modernism early in the century reached a peak of philistinism sometime in the thirties when even the so-called highbrow critics turned against abstraction with a vengeance. "Ellis Island art" was one epithet for abstract art. Modernism was seen as a foreign conspiracy to undermine the basically sensible tastes of the American people.

The social and political upheavals of the thirties caused many to forget that Americans were among the first abstract painters anywhere in the world. Georgia O'Keeffe, Arthur Dove, Max Weber, Abraham Walkowitz, Marsden Hartley, and a number of other exceptional artists painted entirely abstract work before America entered World War I. Neglect discouraged many abstract artists. Patrick Henry Bruce destroyed most of his work before committing suicide in New York in 1936, ironically the year the Museum of Modern Art put on its celebrated exhibition "Cubism and Abstract Art." The exclusion of Americans from this show was demoralizing. Yet a small group decided to fight back against the indifference of museums and galleries and exhibit together. Calling themselves the American Abstract Artists, they organized their first show in April 1937. It drew crowds so large that the *New York Times* had to admit, "In view of the fact that the official spokesmen for art have consistently preached against abstract art as 'un-American,' the results of this inquiry show that the American public is far more interested, and would like to see more of it, than any one had hitherto suspected."

10

With tenacity, talent, and farsightedness, a small band of pioneer abstractionists maintained that the world of abstract forms was as "real" as the nostalgic evocations of Kansas cornfields and black farmhands dancing the hoedown. (It is heartening to realize that some of our strongest contemporary abstractionists are black, particularly considering the condescending manner in which blacks were presented in American Scene painting.)

Today the cornball realism beloved by the vocal majority of the thirties looks strictly from the sticks, while the much-despised elitist abstraction has a freshness and vitality that the passage of time and the success of future generations of abstractionists have not diminished. Time, however, has put these works into perspective. We see them today as the opposite of what they appeared to be when they were painted. As opposed to being "un-American," native geometric abstraction has a quality so distinctly American that only the most naive could confuse it with European purism. Geometry, in the hands of American painters, never turned out to be the reflection of some Neoplatonic absolute; it was always an extremely personal and subjective form of expression. Few American geometric painters aspired to some ideal order. Rather, they were involved in the expression of the tempo of urban life and the dynamism of its tensions.

American geometry, in comparison with European purist styles, with their commitment to predictable and familiar forms, is eccentric and expressionist. Jagged planes lock together, not in any classical harmony, but in asymmetric uneasy union. The modernization of classicism and purism is so inimical to the American temperament that even painters working within the strict discipline of geometric abstraction—the classical style of modern art—produced restless, tense, highly activated works. Even those closest to Mondrian, who moved to New York in 1940, gave an American inflection to their works. The paintings of Charles Biederman, Ilya Bolotowsky, and Burgoyne Diller are sophisticated because they took Mondrian's researches into the nature of pure nonobjective form as a point of departure, and consequently had a firmer foundation on which to build. Yet all three are very much American painters.

Geometric abstraction was an international style. Its survival in an isolationist, nationalistic epoch like the thirties in America was something of a miracle. The American cubists' forms and space are different from those of their contemporaries in Europe. The forms, for example, tend to be larger and simpler in Diller's works, the spatial experience far more extensive in Biederman's elegant abstractions, the lines bolder in Bolotowsky's compositions than they might be in similar European

works. When in the fifties "hard-edge" painters like Ellsworth Kelly and Al Held began to use geometric shapes opposed to the open contours of "action painting," their view of geometry was also as personal expression, not ideal order. Indeed, one could argue that the Neoplatonic idealist tradition is antithetical to the basic American demand for individualistic self-expression.

SYNCHROMISM: A TALE OF THE TWO GERTRUDES

During the first decade of this century, the course of American art was decisively altered by the tastes and life-styles of two wealthy women named Gertrude. One Gertrude was a German-Jewish merchant's daughter. She studied philosophy with William James at Harvard and escaped the narrow philistinism of a puritanical milieu by settling in Paris with her brother Leo in an apartment at 27 Rue de Fleurus. Here she introduced young American artists to her friends Matisse, Picasso, et al., whose works she collected. Gertrude Stein was a dumpy lesbian bluestocking who invented a classic prose style that aestheticized the American vernacular into a streamlined literary vehicle. She was a great artist in her own right; it does not surprise us that she sought the company of other great artists. Her religion and sexual preference marked her as an outsider. But early in the century, modern art was very much the affair of disaffected, marginal outsiders.

The other Gertrude was the gorgeous darling of WASP society. Although her great-grandfather was railroad tycoon Commodore Cornelius Vanderbilt and her husband was multimillionaire Henry Payne Whitney, she, too, dreamed the dream of art. While Gertrude Stein held court in her Paris salon, Gertrude Whitney made her MacDougal Street studio the center of activity for the young rebels who first exhibited as The Eight and became known as the Ashcan School because of the seaminess of their subject matter. Mrs. Whitney was an accomplished academic sculptor, but as an upper-class society matron, her main relationship to art had to be that of a bohemian Village dilettante who supported and encouraged artists. Socially and culturally, Mrs. Whitney was a socialite insider. As an insider, a blueblood rather than a bluestock-

ing, she bought tame insider's American art that was in many respects a continuation of a long-standing tradition of popular, illustrational narrative genre.

Gertrude Stein and Gertrude Vanderbilt Whitney were both artists who collected the art of their friends. Their personalities and life-styles indelibly marked the history of American art. Stein's taste was the most advanced taste of her time: her home was a gallery of masterpieces by Cézanne, Picasso, Matisse, Braque, Gris—the School of Paris giants whose works would be the focus of the collection opened to the public in 1929 as the Museum of Modern Art. This is not to say that Stein's taste determined the canon established by MOMA. Katherine Dreier and the Arensbergs, other Jewish collectors initiated by Duchamp into the mysteries of modernism, influenced Alfred Barr directly, as did Duchamp himself. However, Stein's preference for French art to the work of the young Americans who flocked to 27 Rue de Fleurus continued to be MOMA's preference.

It was in the "ambience of Cézannism," as William Rubin has described the last years of Cézanne's life and those just after his death in 1905, when he attracted a new public of young artists, that Americans like Morgan Russell, Stanton MacDonald-Wright, and Patrick Henry Bruce, who left the United States in search of the new, first encountered modern art. To be understood correctly, their early attempts at modern styles should be seen within the actual Parisian context in which they were made—especially in the context of the living room of the Steins, where they received their first introduction to art that was alien to the American tradition of academic landscape or illustrational genre. That the comprehensive "Paris–New York" show was finally held in 1977 in Paris instead of New York is explicable on the basis of the historical biases of the founding fathers (and mothers) of the Museum of Modern Art. They rejected Americans to the point of not buying New York School art when it was available at reasonable prices, whereas the Whitney policy was originally an ingrained prejudice against the foreignness of the modern styles, even in the hands of an American artist.

Not, of course, that Mrs. Whitney did not sometimes support an American in Paris in her bountiful generosity. Even if she bought her art in New York, she bought her dresses in Paris. When she was there, she would not fail to visit the Latin Quarter haunts that set the pace for Greenwich Village bohemia. According to one newspaper account, her largess during one of these Parisian jaunts was so great that "artists who borrowed tobacco for a pipe are now buying cigars." One of the lucky painters who received a stipend from Mrs. Whitney was Morgan Russell.

This sum permitted him to live and work in Paris. Russell was both precocious and ambitious. He borrowed a Cézanne still life from Leo Stein and copied it. As one of Matisse's American students, he imitated Matisse's painting style. By 1912 he was making sketches for abstract paintings in his notebooks. In 1913 he had two shows, one in Munich in June and the other in Paris in November, together with a fellow American in Paris, Stanton MacDonald-Wright. Their initial essays at abstract painting of 1913–14 are mainly remarkable in their attempt to combine cubism with color.

To call attention to their work in a period popping with "isms," Russell and Wright called themselves Synchromists, a term Russell claims to have invented by replacing the "phone," meaning "sound," in "symphony" with "chrome," meaning "color." Russell continued to be obsessed with the idea of making literal analogies between color chords and tonal harmonies in music and color combinations in art.

He was hardly alone in this preoccupation. The analogy between music and painting led both Kandinsky and Kupka into abstraction. Much of this discussion relating music and painting popular in Paris in the first decade of this century is traceable to the pseudoscientific theories of Charles Henry, the friend of the symbolist writers and artists who formulated an aesthetic equating color, light, and geometry with mystical visions. Although Synchromism was not a movement or a theory, it has begun to be thought of as such because of the convenience a handle offers. Synchromism has been treated as a genuine theory of color painting based on scientific treatises because Russell and MacDonald-Wright sought to legitimize their crackpot eclecticism, which owed a large—if unacknowledged—debt to Charles Henry, by invoking more conventional authorities.

A real assessment of Synchromism, or even for that matter of such rudimentary theories of color as actually circulated among American painters, remains to be made. However, once a litany is established, it is repeated ad infinitum. The idea that Robert Delaunay was the *chef d'école* of orphic cubism was deliberately propagandized by Apollinaire, who as critic for *Montjoie!, Commoedia,* and *Soirées de Paris* monopolized the French art press on the eve of World War I. In reality, the paintings of the Americans in Paris reflect the primary influence of Cézanne and Matisse far more than they do that of the Delaunays, who seem to have developed from the same sources at the same time as the Americans. As Kupka scholar Meda Mladek has pointed out, Apollinaire was deeply indebted to the Delaunays, both financially and emotionally at this moment. In return for their hospitality and support when Marie

Laurencin left him, he proclaimed Robert Delaunay the leader of a new movement, "Orphic" cubism.

We know that Patrick Henry Bruce and Arthur B. Frost saw the Delaunays socially until the couple moved to Portugal at the outbreak of World War I. However, examining the visual evidence, we find that Frost and Frost alone among the artists associated with Synchromism actually painted like the Delaunays. The problem with Bruce is far more complex, since Bruce destroyed much of his work. What remains reveals Bruce evolving independently of Delaunay in the "ambience of Cézannism" as a serious and original synthetic cubist painter. Patrick Henry Bruce is unquestionably the single early American modernist who fully understood the principles of cubism from a structural point of view. Nothing we know of the man (he also destroyed his papers) suggests he was ever interested in any of the theosophical, mystical, or symbolist ideas equating sound with color that intrigued the two "Synchromists" and their circle. He was, like Cézanne and Matisse, who were obviously his mentors and inspiration, a strict rationalist who never painted cosmic themes. That his extraordinarily original and sophisticated cubist compositions should end up as footnotes to the Delaunays is the final injustice to the work of an artist so misunderstood in his time that his art was only appreciated decades after he stopped painting out of desperation.

Like Russell, Bruce's essential debt, at the time Apollinaire was acting as barker for the Delaunays, was not to them but to Picabia. Bruce soon evolved a mature synthetic cubist style from the *Compositions* he sent back to the United States in 1916. Moreover, he was the only artist among the so-called "Synchromists" who remained an abstract cubist painter. Russell and MacDonald-Wright, egged on by MacDonald-Wright's brilliant brother, art critic Willard Huntington Wright, attached cosmic significance to their art. Looking at the early abstractions of Russell and MacDonald-Wright, we are struck with their affinity, not with the flat planes of Delaunay's concentric circles, but with the modulated color and intersecting arcs of Puteaux cubism.

Russell suffered, as did most of his contemporaries, from constant financial insecurity. In his correspondence with the French art critic Jean Gabriel Lemoine (in the Archives of American Art), he complains that the dealers are only interested in representational art, which leads one to suspect that his return to representation in the twenties was directly related to market demands. Russell's relationship with Gertrude Vanderbilt Whitney is also documented in a series of letters written to her. He informed her regularly of his progress and gave her work. However, he was nervous about her financial aid, which in fact she ultimately

withdrew. In a letter to Andrew Dasburg of September 10, 1911 (Collection Benjamin Garber), Russell thanks Dasburg for sending a check and comments, "I don't know how much longer Mme. is going to hold out and am beginning to think about many matters—am going to see her shortly and will be fixed on that subject." It would appear he was referring to Mrs. Whitney and her support. The collapse of Synchromism after the 1916 Forum Exhibition in New York proved that America was not yet ready for abstract art. Since the spurious movement was really a publicity gimmick, it was not a great loss.

PHOTOGRAPHY IN AMERICA

Alfred Stieglitz founded the Photo-Secession group in New York to prove that photography was not, in his words, "the handmaiden of art [but] a distinctive medium of individual expression." The Whitney Museum, in a historic turnabout from its previous policy of ignoring photographic images of the American scene in favor of third-rate paintings of the same themes, is finally admitting Stieglitz was right. Unfortunately, "Photography in America," a survey of American camera work from 1841 to the present, is a banal and pedestrian approach to perhaps our most exciting and promising contemporary medium. Installed with the imagination and taste of a suburban shoe-store display, the exhibition includes an academic representation of everything already published, catalogued, and officially canonized as "Art." Not a risk is taken, not a discovery made, not an illuminating juxtaposition explored.

Despite its dreary predictability, uninspired selection, and inadequate lighting, the exhibition was packed with throngs of students, amateurs, housewives, stockbrokers, and just ordinary folks of every conceivable color and age—a crowd so heterogeneous that the Whitney resembled a thirties pageant of America. They pressed themselves against each other and nuzzled the photographs, peering at every detail, commenting, chatting, joking, criticizing in a manner so animated and engaged one had to conclude that photography is not only art, it is specifically the art of the people.

The popularity of photography has paralleled the gradual replacement of humanistic abstraction with humanitarian realities. Television, political activism, boredom with intellectual art devoid of feeling and ideas and forms devoid of content, have contributed to this resurgence of interest in content and representation. Photography has always occupied some of the most talented, sensitive, and ambitious American artists

18

from Thomas Eakins to Alfred Stieglitz to Charles Sheeler and Man Ray. Far from being a new American art, photography has been a major force in shaping American taste. Permitting the reconciliation of abstract formal values with objective, concrete reality, photography might well be the art form best suited to the pragmatic American mind. A product of both man and the machine, photography has in its powers the capacity to reconcile technology and humanism: the machine records nature, but the human mind selects and gives quality to the image. Through selection, the eye recomposes reality, dignifying the barren, the pathetic, and the tawdry in the act of recording it. In a photograph, America the Banal can become America the Beautiful, in formal terms at least.

In the catalogue introduction, master photographer Minor White, seven of whose photographic poems are represented in the exhibition, makes a strong and convincing case for the transcendental strain in American photography—from the poetic, mystical, and visionary images pioneered by Stieglitz in the cloud photographs that he titled "equivalences" to equate them with emotional states, to the mysterious evocative photographs of Harry Callahan, Paul Caponigro, and Duane Michals, among others. White concludes his argument for innovation in subject matter and content rather than in technique by claiming that most of what is done today in photography is not art. "The percentage of quality images that reaches display on walls or in books is dropping— as is the quality of those images." This is a provocative negative assessment of photography today, but it is arguably correct.

The number of photographic images produced is growing at an unbelievable rate. Unlike the tools of the painter or sculptor, cameras and film are equally available to all who can afford them, and given their relative cheapness, most people in America can. Moreover, the talent and skill required to make a painting or sculpture, which are at least partially genetically determined, are unnecessary to the reproduction of an image photographically. Whether or not this potential democratization of the means to art, which becomes accessible to Everyman through photography, has actually led to a diminution of quality in photography is not a question that is usually asked, although it is probably the essential issue.

As in every democratizing process, from open admission to TV programming, the ratio of quality to quantity diminishes. This does not mean that there is less quality; on the contrary, it means there may be more quality because there is simply more of everything. But quality inevitably loses out to quantity—either because it goes unrecognized and sinks invisibly into the general morass of mediocrity, or because the

mediocre is officially supported and passed off as high art. This is where standards are lowered, not in the increased production of anything.

The history of photography now exists, and critical evaluation has separated the masters from the monkeys. But contemporary photographic criticism is neither so developed, selective, nor ambitious as contemporary art criticism; the categories of quality or authority regarding recent work are virtually nonexistent. Younger photographers are probably not the geniuses of their generation. Their images are often sentimentalized, sensationalistic, technically brilliant reruns of conceptions initiated by the pioneers in the medium. Eccentric views, distortions, complex printing, and developing substitute for a new vision. It is the destiny of any art that after a certain point, a condition of diminishing returns sets in. This certainly seems to be true of painting today, an old art compared with the youth of photography and film, and it may be beginning to be true of photography itself.

FILTHY PICTURES

It is surprising that Sir Kenneth Clark, in his *The Nude: A Study in Ideal Form,* confines his discussion of the most obvious category to which the nude belongs, the erotic, to a few remarks in the opening chapter, in which he differentiates the naked from the nude. Pausing only to dispute the Victorian notion that the nude as a subject should not arouse erotic desire in the viewer, he contends instead that "no nude, however abstract, should fail to arouse in the spectator some vestige of erotic feeling, even though it be only the faintest shadow—and if it does not do so, it is bad art and false morals."

Today, although the taste for (and production of) perverse erotic art seems to be growing, this art is interesting mainly in the way it reflects contemporary attitudes toward the body as they are expressed in art, rather than as art of any great quality.

Because the recent flurry of excitement about the Austrian expressionists, Gustav Klimt and his disciple Egon Schiele, strikes me as linked in a curious way with the taste for the new erotic art, I want to begin by defining how their works are examples of a perverse eroticism. By perverse, I ought to point out here, I mean that which is used in a way other than the manner in which it was intended to be used. In this context, I mean specifically the nude which evokes not sexual desire but antisexual responses of repugnance or distaste. I mean also, as I intend to illustrate, flesh rendered as a material other than flesh, and the treatment of the body as an inanimate, inorganic object among objects.

To return to Klimt and Schiele: my first reaction was to dismiss most of the work, especially the figure studies, as a superficial echo of the moving expressionism of Munch and the first generation of Germans. But, succumbing to their curious fascination, I began to wonder why Schiele's flayed, distorted figures and Klimt's tortured, crammed surfaces

should prove so provocative, and why after several decades of relative obscurity the Austrians should suddenly be enjoying a vogue. The works, certainly, make no great formal or expressive point. On the contrary, they suffer from the same *horror vacui* as Art Nouveau ornament, to which their tangled, febrile arabesques are related. In Klimt, the multiplicity of small, irregular forms remains a patchwork of fragments that never coheres into any decisive unity. In Schiele's more linear style, the sameness of line and its crabbed, involuted character are as much a sign of an obsessional content as they are of a limited and unvariegated sense of form. But these pictures raise interesting questions, both about expression and about the decorative in art. Why, for example, does Klimt appear superficial when compared to Munch or Klee, and Schiele unambitious when set beside Beckmann?

As expressionists, Klimt and Schiele fail to engage the emotions because they perversely use the explosive rhetoric and thematic material of expression toward the end of an ornamental style. Distortions of the human figure are what mark them as expressionists, rather than the ability of their canvases to evoke an emotional reaction. Not the heartstrings, but the fingertips react. The perfumed garden, the exquisite *frisson* that raises gooseflesh, the exacerbated aestheticism we associate with the *fin de siècle* sensibility of decadent literature and Art Nouveau is still essentially the content of the Viennese works.

Our newfound use for these works seems to me part of that taste defined as "camp" for art that is coy, overdeveloped, elegant, and refined to the point of parodying fashionable elegance and refinement, which is literally, as well as figuratively, superficial. This taste for the *recherché* has led us to appreciate the delights of late mannerism, the Pre-Raphaelites, the Art Nouveau decorators, and, now, the Viennese expressionists. Perverse or "camp" taste, undeniably one of the dominant modes of contemporary sensibility, finds something especially delectable in these styles, which have in common that they are largely concerned with the erotic in its more dessicated and exotic forms of expression. Not surprisingly, perverse eroticism has come to be the content of a certain part of our own art. What is remarkable about this art is not that it is being made—there has always been underground erotic art, even in the most repressed societies—but that, as part of the sexual revolution permitting the distribution of banned books, the screening of banned movies, and the use of banned words, it is now being exhibited.

A good deal of this perverse eroticism has found its way into a new style in figure painting, related to pop art. This new figurative style is quite unlike the figure painting of the past decade, which was more often

than not only a variant of abstract expressionism. Some valuable artists continue to be committed to this late expressionist style, and even de Kooning's most recent pictures have been figurative, but the "return to the figure" trumpeted a few years back has hardly been a mass migration.

The success of pop art appears, on the other hand, to have stimulated a revival of interest in the figure. Mostly these figures are nudes, and their erotic content is quite explicit. Given the social context of more liberal attitudes toward sexuality and its treatment in art, such a development might have been expected. Nor is it surprising that not only non-Western erotica but contemporary Western erotica is beginning to be seen in both museums and galleries. Yet it still comes as something of a shock to get announcements of group shows that consist of photographs of the participants in the raw, smilingly joined in the happy camaraderie of the pages of *Teenage Nudist.* The popularity of nude activity being what it is (nude dances, nude movies, nude announcements, etc.), one begins to have the idea that if you haven't seen your friends without their clothes they aren't really your friends.

I would like very much to agree that this is, as the jukebox would have it, the Garden of Eden, that Paradise Regained looked forward to by Norman O. Brown in *Life Against Death,* wherein the spirit and the flesh are reunited in a post-Freudian Golden Age. But something about the new erotic art, despite its "innocent" frankness, strikes me as, at bottom, essentially perverse. The odd ways bodies are coupled or the unpleasant quality flesh takes on makes one suspect that we have exchanged original sin for another set of difficulties. For ours is not a Mediterranean culture, and the ghost of John Calvin dies hard.

In contrast with Manet, there is something peculiarly artificial about the harsh light that casts patterned shadows in the new nudes, and something unpleasantly unnatural in the quality of the flesh. As a texture, flesh is not differentiated in any way from the inanimate objects.

Philip Pearlstein, Jack Beal, and Mel Ramos, among others, do not differentiate the texture of flesh from other textures. This creates a disquieting equation between the organic and the inorganic. Figures stare out at the spectator with a bland, expressionless impersonality, which is quite the contrary of the intense rapport Manet's figures establish with the viewer.

Philip Pearlstein's *Two Nudes on Tan Drape* differs widely from Courbet's *The Sleepers,* another painting of two women asleep. In the Courbet, the details, the crystal-and-satin setting of the bedroom, are clearly established; Pearlstein's figures, however, are transferred to an anonymous, nondescript setting. Pearlstein seems to work, if not from

photographs, then under the inspiration of them. His figures, too, have a strange super-plasticity, which he exaggerates to even more grotesque proportions by playing with *tour de force* effects such as rapid foreshortening and oblique vantage points. The nudes seem made, not of flesh, but of some bony, calcified material. Frozen in attitudes of trancelike isolation, his figures are aggressively powerful in their grotesque plasticity, but ultimately helpless in their torpor.

Jack Beal's *The Roof* also recalls Manet's *Déjeuner,* containing recognizable faces who stare out at the viewer. Beal shares with Pearlstein the wish to give to flesh the same anonymous, uniform treatment he gives other textures, assigning to the body the status of an object among other equally undifferentiated objects.

Not directly related to precedents in older art, but suggesting an amusing if trivial analogy with Goya's clothed and nude *Majas,* is Alex Katz's life-sized painted wood cutout *Maxine,* which is seen clothed from the front and nude from behind. But the genuinely erotic content of Goya's *Majas* stands in sharp contrast with this oddly neutral, unsensuous treatment of the body. Perhaps the point being made is that dressed or naked the body has the same allure or lack of it—clearly not Goya's point. Beyond this, a fetishistic obsession with genitalia seems to go beyond the merely frank, in Tom Wesselmann's *The Great American Nude* as in some of Schiele's drawings. Wesselmann again reduces the human figure to an objectlike status by failing to differentiate between the appliquéd texture of the leopard-skin couch and the appliquéd pubic hair of the nude reclining on it. Aping Manet's *Olympia,* the figure in *The Great American Nude* wears a velvet band around her neck; otherwise, she has no features save mouth, nipples, and sex. As opposed to Matisse's luxuriating odalisques, she becomes the rather repulsive symbol of a commercialized sexuality. That this is the idea is emphasized by the presence of a half-clad girl in a girdle who runs through a field seen through a window in the background.

As a sexual object, Wesselmann's nude is perverse because she is intentionally unappealing, for his is a critical view of commercialized sex. Belonging equally to the manufactured eroticism of the pin-up and the calendar girl is Mel Ramos's *Peek-a-boo Blonde;* as a sex symbol the figure is as coy and absurd as that in Ingres's simpering *La Source.* Ramos also uses rich paint texture; the pigment is buttered on as it is in Wayne Thiebaud's pastries. Again, the setting is anonymous, and this time the girl is behind a keyhole, an insinuation that the spectator is more voyeur than viewer. The creaminess of the pigment does not in any

way enhance the appeal of this blond cutie, who stands as a caricature of Movieland sexuality; it simply adds to our impression that the flesh is somehow disagreeable.

By considering these new ways artists are treating the nude, I have been trying to make the point that erotic art is not necessarily sensual; it can deny as easily as affirm the body. And although the denial or distortion of the body in former times may be construed as the elevation of spirit over matter, when it appears in a context that should normally be considered erotic, it becomes merely perverse. The schematization of the body and the denial of its corporeality in medieval art or its etherealization and dematerialization into ghostly flickers in El Greco constitutes a negation of the body in favor of the spirit. By contrast, its schematization into a two-dimensional surface pattern or its distortion and attenuation into something gnarled and deformed, but equally incorporeal, as in Klimt or Schiele, is a strange abuse of the flesh. To see Schiele's nudes as sensual, as Michael Levey has in a recent essay, is absurdly kinky. The context is erotic, but flesh is painted like a cold, anonymous surface to deny its warmth, texture, and corporeality. This is perverse. Thoughts turn not to the bedroom but to the mortuary. The fascination with the morbid—quite overt in Klimt's imagery—which critics have found common both to later mannerist art and in *fin de siècle* romanticism, is the antithesis of the true erotic style of Rubens or Renoir.

Although many parallels may be found with *fin de siècle* and Viennese Sezession art, the perverse eroticism in contemporary art is of a radically different order. Rather than projecting fantasies for a sexually deprived Victorian society, it mirrors the collective fantasies of a sexually obsessed American society. The fantasy element in current art is undeniable, but the fantasy mirrored is the realized and externalized one which reflects an environment so erotically charged that sexuality seems to invest the commonest objects from automobiles to vacuum cleaners. Pop art and the new "cold" erotic art reflect the world where giant mouths and breasts stare down from billboards and movie screens, where housewives rush to buy Mr. Clean because "he's mean" and secretaries in topless bathing suits suffer more from exhibitionism than from hysterical repression. The fantasies projected by repressed sexuality are no longer the issue. The problem is the acceptance of a collective erotic fantasy as reality in the absence of any critical apparatus with which to interpret it as perverse fantasy. If what one means by reality is the external world, the objects and environment around us, then the new erotic art is a clear reflection of it. That it is unpleasant and that it tends to be perverse says

as much about the nature of our reality as Rubens's fleshy goddesses and Raphael's ample, soft Madonnas tell us about attitudes toward sexuality in less ambivalent cultures. Confusions about the nature of eroticism, sexuality, perversion, pornography, and obscenity may be an inevitable stage in the evolution of a less puritanical attitude toward the body. That the art being produced in the wake of this confusion is taking on peculiar forms is hardly surprising.

VENUS ENVY

■

In 1972, Prof. Linda Nochlin caused a sensation at a meeting of the College Art Association: she exposed the obvious fact that nineteenth-century erotic art was created by men for men, and suggested a facetious female analogy. First she showed a slide of a popular French illustration of a woman, nude except for stockings, boots, and choker, resting her breasts on a tray of apples; then she projected a photograph of a bearded young man, nude except for sweat socks and loafers, holding a tray of bananas under his penis. Instead of the invitation *Achetez des pommes*—Buy some apples—inscribed under the maiden, the man advertised, "Buy some bananas."

A decade ago, Professor Nochlin's comparison would have been unthinkable at an assembly of art historians. Even more unthinkable, however, would be the idea that women might begin producing their own erotic art, aimed at eliciting a response in a female audience. Today, women are among the most prolific producers of erotica, suggesting that if there was a revolution in the sixties, it was not political but sexual. Perhaps sexual issues appear to dominate the women's movement at this moment because erotic arguments do not fundamentally challenge the social structure as political disputes do.

By equating sexual liberation with radicalism, the women's movement is following a direction other initially revolutionary forces have taken to survive in our time. The most obvious example of the displacement of revolutionary political aims to more acceptable targets is the history of modern art itself. When the goal of social and political revolution seemed unobtainable, the ideology of modernism rephrased itself so as to locate "revolution" exclusively within the boundaries of art itself. "Radical" became the most flattering adjective one could apply to art,

and aesthetic experiments were validated on the basis of how "revolutionary" they were.

Now something similar is happening with sex, which, like art, has become a pursuit for its own sake. Within the general context of feminism, the women's movement has been one of the most energetic exponents of an altered concept of female sexuality. Publications, university courses, and women's cooperative galleries stress the importance of women in art. In meetings, rap sessions, and symposia, women examine the question of whether or not there are such things as feminine sensibility and a subject matter that can be described as female. They cite Georgia O'Keeffe's voluptuous flowers and Louise Nevelson's sculptures of dark, mysterious interiors as early examples of female imagery; and they are searching out the names of the daughters, nieces, and students of famous painters whose works in the past often were attributed to the men they worked with.

Such a reexamination of the forgotten chapters of history is analogous to the quest among blacks for their essence in a universal *négritude.* Indeed, the parallel between women and blacks was one of the fundamental premises of the women's movement. As Gunnar Myrdal wrote in 1944, women, like blacks, had high social visibility because they were different in "physical appearance, dress and patterns of behavior." Most men "have accepted as self-evident, until recently, the doctrine that women had inferior endowments in most of those respects which carry prestige, power, and advantages in society."

Inferior status has stimulated both groups to assertions of pride in their "difference." Black art frequently serves as propaganda for the important idea that "black is beautiful," essential in creating not only an ideology of equality, but a psychology built on the confidence that black is as good as white. To dignify female "difference," what should feminist art glorify?

The answer is obvious. Feminist art bears no slogans proclaiming "power to the pubis," but essentially that is what it is about. Much feminist art labeled "erotic" because it depicts or alludes to genital images is nothing of the sort. It is designed to arouse women, but not sexually. Hannah Wilke's soft latex hanging pieces, Deborah Remington's precise abstractions, Miriam Schapiro's ring-centered *Ox,* Rosemary Mayer's cloth constructions, Judy Chicago's yoni-lifesavers are all vaginal or womb images. They worshipfully allude to female genitalia as icons—as strong, clean, well-made, and whole as the masculine totems to which we are accustomed. Although there are many categories of women's erotic art, the most novel are those that glorify vaginas. This

category of women's art is profoundly radical because it attacks the basis of male supremacy from the point of view of depth psychology. At issue is the horror of women's genitals as mysterious, hidden, unknown, and therefore threatening. This fear is chronicled by H. R. Hayes in *The Dangerous Sex*, a fascinating compilation of age-old prejudices against women as unclean Pandoras with evil boxes, agents of the devil sent to seduce and trap men.

By depicting female genitals, women artists attack the fundamental premise of male supremacy: that a penis, because it is visible, is superior. This is an overt assault on the Freudian doctrine of penis envy, which posits that all little girls must feel that they are missing something. The images in art of non-menacing and obviously complete vaginas are linked in their efforts to convince women that they are not missing anything. Realizing that "equality" depends on more than equal rights and equal salaries, women are exalting images of their own bodies. Their erotic art is, in effect, propaganda for sexual equality based on discrediting the idea of penis envy. Equality on these grounds is far more humane than the alienating prospect of women treating men as sex objects as in Sylvia Sleigh's group portrait of male art critics in the buff.

Unfortunately, turning the tables is not the road to equality; nor will male brothels solve anyone's problems. But there is the prospect that healthy self-respect may diminish the debilitating inferiority complex the second sex finally shows signs of transcending.

THE AUCTION IS THE ACTION

■

In the early seventies, a student of mine unforgettably named Alexis Rafael Krasilovsky made a film called *The End of the Art World.* She had real cows wandering through an Andy Warhol cow painting exhibition. Weathermen planted bombs in Henry Geldzahler's office while Geldzahler blithely pontificated on the glory of high art, and a number of famous artists—groggy, drunk, hysterical—behaved foolishly. Never mind that it was a setup edited and doctored with undergraduate guile; its effect was a convincing statement that, whatever initial goals or ideals the art world might have had, by now its inhabitants were bloated with their own power and success. Forget beauty and truth, she was saying, it's all ego and baloney.

Actually she was premature about when the art world collapsed. In fact, it ended on the night of October 18, 1973, at Sotheby Parke-Bernet; and it ended not with a whimper, but with a bid. The auction was that of the collection of taxi baron Robert Scull. Including many of the most celebrated names in American art, it was a collection made as notorious as its owners through a calculated campaign of press agentry and PR worthy of the building of a movie star's career. Bought for a song, it was sold to the tune of $2.2 million.

The auction, which drew crowds that jammed Madison Avenue, was an ideal illustration of the current relationship between art and society in America. One could only liken the frenzy and pitched excitement of the crowd to that of spectators at some great sporting event. People did not bid on paintings so much as they rooted for them. Cheers accompanied the record-setting prices: $180,000 for a Willem de Kooning; $155,000 for Barnett Newman's *White Fire* (sold sight unseen from the catalogue); $240,000 for Jasper Johns's *Double White Map,* originally

30

bought by Scull for $10,500 and sold to Ben Heller. Heller, in turn, had
just realized an unprecedented profit on the sale of Pollock's *Blue Poles*
to the Canberra Museum for a cool $2 million.

The real excitement obviously was generated not by art—you don't
go to an auction to see art—but by the visible action of instant profit,
the real Main Event, as far as Americans of all interests and persuasions
are concerned. Whispered queries—"How much did he buy that
for?"—went through the room every time the gavel fell. When the Cy
Twombly painting, originally purchased for $750, went for $40,000,
Mrs. Scull leaned over to her husband and said, "Remember when I
bought that for your birthday?" She elbowed him. "That was *some*
birthday present!" The combination of curiosity, simple identification
with the fruits of greed, fantasy (why didn't *I* buy that Johns *Target?*),
and boredom probably accounted for the mob of Beautiful People,
gate-crashers, and just your ordinary garden-variety voyeur, who stood
ten deep, perhaps to tell their grandchildren that they were there on that
great come-and-get-it day. Not, of course, that there were any bargains.
The only bargains were the prices Scull originally paid, such as $1,000
for Larry Poons's *Enforcer,* sold for $25,000; $450 for a Lucas Samaras,
sold for $20,000; $3,500 for Warhol's *Flowers,* sold for $135,000.

The fascination with such excess profit-taking is understandable in
terms of the corporate mentality that now dominates the art world. The
shakiness of the stock market, the fluctuations of currency rates, and
inflation all lead to a situation in which fine art objects, because they are
unique and rare, come to be a major medium of international exchange,
the trading beads of the global village. That is why auction sales now
attract people who once haunted Las Vegas and Monte Carlo: they are
legalized gambling with cultural pretensions.

The corporate mind is interested in profit, and nowhere are the profits
so immense, or realizable in so short a time, as in the art market. As a
matter of fact, Scull *was* a kind of genius. Not necessarily even a financial
genius, but a genius of timing and promotion. The Sculls were their own
pop creations, "living sculpture" if you like. The Sculls learned every-
thing they know from Andy Warhol. They learned, for example, how
to turn themselves into objects through packaging, media exposure, and
sheer, unadulterated *chutzpa.* The Sculls transformed their banal, nou-
veau-riche personas into personalities by not being afraid to flaunt being
all that was considered lowbrow, déclassé, grasping, and publicity-seek-
ing. They made a virtue out of being vulgar, loud, and overdressed. They
were, in short, shameless; and it was their shamelessness that finally got

them the spotlight they ached for, that instant of recognition that lends identity to the humblest Puerto Rican graffiti artist whose scrawl proclaims in the anonymous void: I am I.

The sale was a circus, with those artists dumb enough to attend as a little freak show in a rear room. The artists were given only standing-room tickets, while the collectors and Beautiful People sat. That was as it should be. It expressed the actual relationship of the artist to the public in such a unique moment of truth. In a supreme, masochistic gesture of compliance and passivity, the artists who attended could see *themselves* put up on the block, sold to the highest bidder.

Meanwhile, the audience was full of hooting, giggling, gossiping fans, who knowingly nudged as Lee Radziwill appeared on the arm of Philip Johnson. "Look," collector-lawyer Lee Eastman, who arranged the sale, said, beaming, "there's Dick Bellamy, the man who made all this possible." Enter the shadowy figure who had directed the Green Gallery, which Scull at one time secretly financed. Bellamy probably made as much over the years from sales to Scull as one of Scull's cabbies earned in a similar decade. Scull got rich on art the same way our government and corporate types get rich: with inside information. His shrewdest move was backing Bellamy at a time when there still was an art world with starving artists. The humblest servant the Muses ever had, Bellamy arranged special deals for Scull, like five pieces by Mark di Suvero for $5,000, the least of which was sold in the auction for $20,000.*

The reason the Scull auction was the end of the art world is that no one can pretend naiveté any longer. Artists know their patrons; they know their values; and if they persist in socializing with them, entertaining them, and being party to a promotional enterprise designed to inflate prices to realize greater profits for the "patron," they deserve to be treated as clowns and entertainers, geese that lay golden eggs to be taken to market and sold to the highest bidder.

*One of these works, *Prison Dream*, was then sold at auction in 1987 for $239,000. Going, going, and still going.

DIANE ARBUS: THE AMERICAN SCENE AS THE AMERICAN NIGHTMARE

■

The strangeness of Diane Arbus's subject matter—freaks, transvestites, nudists, or perfectly "normal" people whose gestures, poses, or expressions suggest bizarre inner dramas—has a special appeal for contemporary sensibility. The sixties spawned a generation happy to call themselves "freaks" to distinguish their outward weirdness from the gray conformity of the "straights." Arbus's unique insight was to see the freakiness beneath the polite social surface of any ordinary upper-middle-class couple from suburbia, as well as within the hearts of lower-middle-class families inhabiting dreary city tenements. The fascination of these photographs lies in the duality of Arbus's attitudes toward her subjects: they are exposed as vulnerable and human, but at the same time her understanding sensitivity savagely rips away their social masks.

This mixture of gentle compassion and surgical curiosity regarding the deepest recesses and best-kept secrets of the psyche marks Arbus as one of the most profound and original American artists of the sixties. But the demonstrable quality of her work and her seminal influence on a younger generation of photographers do not fully explain the current fascination with her work. Alive, she was just as great and just as influential; dead, she is a cult figure, a legend, another of the beautiful, brilliant women in some way crushed by the conflict between aspirations for creativity and freedom on the one hand, and traditional female role conditioning on the other. She becomes, like the poet Sylvia Plath and the artist Eva Hesse, as well as the greatest symbol of the female drama of all, Marilyn Monroe, a martyr to the "feminine mystique."

I find the morbid curiosity regarding the lives and dramatic deaths

of these women very revealing of current attitudes on the part of both men and women toward the idea of female creativity. None of these women would have been the subject of the same attention had they lived. Brigitte Bardot's appetite for life is uninteresting when compared with Marilyn Monroe's death wish. Sylvia Plath's poetry would have been as good and Eva Hesse's sculpture as significant had they lived to the age of Marianne Moore or Georgia O'Keeffe; but they would not have become symbols to a whole generation of unfulfilled women.

In the late nineteenth century the figure of the dashing young man too sensitive to endure the vicissitudes of politics or art dominated literature. Caught in an extreme situation, the romantic hero took the only possible poetic way out. Now the people in extreme situations are women, and their suicides are not literary but real. Many psychoanalytic and sociological explanations could be imagined for this phenomenon; all would be as unverifiable as my feeling that survival and success are predicated on the capacity to be inhuman and brutal—and that women support this brutality less well than men. There are many women, of course, who can adjust to society's demands for insensitivity (just look the other way, and you won't see it), but Diane Arbus was not one of them. In fact, she may have seen too much to bear.

The text of her own words, published in the monograph of her photographs (Aperture Monograph, available in paperback through MOMA), suggests that she identified so closely with her subjects that ultimately she merged with them, feeling their experience and their pain. One day I observed Diane Arbus working. She was a small, fragile woman who looked much younger than she was. Perhaps symbolic of her sense of herself as an explorer, she was wearing a safari suit before it was fashionable to be a guerrilla girl. She came to our house early in the morning; by the time she left in the evening, I didn't notice her anymore. She was able to insinuate herself into the situation until she became as unobtrusive as the furniture. She writes that she was aware that people liked her, and she was right. I did like her. One felt free to be open with her because she was sympathetic, unthreatening, and seemed very open about herself. I suppose she was that way with all the people she photographed, from the painted transvestites and feathered drag queens to the suburban sunbathers joylessly tanning themselves on their manicured lawn.

It would be easy to presume from the photographs that she always saw a grim world full of small-time heartbreak and quiet desperation. But she

took other pictures, too, of smiling introverts, caught in a rare moment of expansive joy. What is consistent in her work is not an obsession with freaks or a desire to turn everybody into a freak, but an attraction for the abnormal, the eccentric, the perverse. Arbus deals in extreme situations, paradoxically presented in the most prosaic terms with that most "factual" instrument, the camera. Her subjects are posed, static, peculiarly formal. Overtly, there is no drama. Yet each photograph tells a story; it is the compressed history of a whole life we may reconstruct from the plenitude of detail she includes.

Because she was a true artist, Arbus's work developed. Her mature style, which evolved to its most crystallized form at the time of her suicide in the summer of 1971 (she was forty-eight), emphasized natural light and sharp focus, the fundamentals of documentary photography, to heighten psychological effects. Some critics have taken her words regarding an apparent lack of concern with composition to mean that the formal quality of her work is relatively unimportant. But form is essential in her work because of the manner in which it serves the ends of content. For the most part, her subjects are seen head-on. They face the camera with a frontal directness that deliberately evokes a sense of personal confrontation. The intimacy of these confrontations is a distinguishing feature of Arbus's work. It was her extraordinary achievement to put the viewer in her own place.

From her words, we infer that she was a modest woman who stressed her luck in encountering the felicitous accident. Yet the relationship between accident and choice is most complex in modern art; and intentionality may be a function of the intelligence rather than the rational decisions of conscious mind. Only through intuition, however, is the unexpected ever seized, the spontaneous explored, or the poetic grasped. No one has commented on the poetic element in Arbus's vision, perhaps because hers is a severe, pessimistic poetry. There are no compromises either with her medium or with her subject matter.

As subjects, freaks are familiar in films like the 1932 Tod Browning classic *Freaks,* which must have influenced Arbus, as well as in Fellini's treatment of marginal, deformed creatures. To have understood that *human nature itself has been deformed,* to have seen that the most banal subject has its layers of personal kinkiness and traumatic alienation, is an aesthetic discovery of the first order. That a woman came to this understanding is not coincidental at this point in history, when the art and literature as well as the lives of women reflect the extremity of their current existential situation. Diane Arbus had more guts, took more real

risks, and had a greater spirit of adventure than any other photographer of her generation. It is altogether possible that the emergent creativity of women, as it challenges the whole human pecking order, will produce others with her spirit who will experience her freedom without her conflict.

ANDY WARHOL'S ALUMINUM FOIL: THE MIRROR OF OUR TIME

Can a boy from a poor Czech mining family in Pennsylvania find happiness in life as the wealthy and fabulous queen of the New York art and fashion world? Apparently so, if the boy's name is Andrew Warhola, alias Andy Warhol, alias—as of the opening of his retrospective at the Whitney Museum, when he legally changed his name—John Doe.

As usual, Andy's timing is flawless. His chalky puckish mask has been plastered over so many newspapers, scandal sheets, art reviews, and fashion magazines, beamed through so many TV sets, projected on so many movie screens, reproduced on so many posters and announcements, that he can afford to change his name to John Doe and still be recognized as Andy Warhol on any street corner in the Western world. His genius for manipulating the media is only part of the reason Andy is probably the most famous artist in the twentieth century. He has created an image of himself, packaged himself, and marketed himself with the expertise of an army of press agents and PR men. The idea that Andy Warhol ever needed advice on this score is ridiculous, the rumor that he had someone overseeing his publicity absurd. Madison Avenue needs Andy Warhol, not vice versa. Andy Warhol creates fashion, and others follow him. Merging life and art more closely than any Dadaist or surrealist could imagine, Andy is the *Zeitgeist* incarnate. The images he leaves will be the permanent record of America in the sixties: mechanical, vulgar, violent, commercial, deadly.

Dreaming the American dream, Andy not only creates but lives the American myths. He is the poor immigrant, Horatio Alger, who struggles to the top; he is Norma Jean Baker, whose apotheosis as Marilyn Monroe requires the human sacrifice of self-destruction; he is shot like

the Kennedys, nearly assassinated by a crazed women's lib fanatic who storms his transvestite seraglio and puts a bullet through him. In his studio, which he calls the Factory, he mass-produces shoddy cheap goods to sell to the highest bidder. He is so alienated from himself that he requires others to answer questions for him and sends doubles in silver Andy Warhol wigs to replace him at social gatherings and lecture tours.

He finds his true medium in the movies, turning his camera mercilessly on the flotsam of the jet set who surround him. He lives as if his life were a movie and his individual acts the episodes in a giant cinematic epic of America the grotesque, swollen, and middle-aged, still pretending to be America the young and the beautiful. Here are some flashbacks from that movie:

A young art student from Carnegie Tech arrives in New York and begins to develop a kinky style of shoe illustration that brings him jobs and a fancy social life in the fashion world. But he aspires to the greater prestige of the world of high culture. More than that, he really loves art. He haunts the gallery openings, and uses the money earned in advertising to fill his closets with paintings, sculpture, and collages by "real" artists like Rauschenberg, Johns, Stella, Serra, etc.

He lives quietly in a brownstone with his mother, a religious Czech woman to whom he is devoted. He continues to attend Mass on Sunday, and he has a box at the opera. He gives presents, including many of his own works, to his friends. He knows how to impress through exaggeration. He arrives at the house of an artist, who opens the door to find Andy hidden behind a six-foot panda bear he has brought as a present for the artist's new baby. He is not a simple person.

He meets Henry Geldzahler, curator about town, and begins to be seen in his company at every notable party from Park Avenue to the Lower East Side. He dresses outrageously: black tie and tuxedo jacket over black Levi's, usually splattered with a few telltale spots of paint to identify the wearer as an artist. He goes to parties at Philip Johnson's glass house; he is seen with Jean Shrimpton and Twiggy, Cecil Beaton and the Beatles. He is mad for celebrities, and haunts the places they are likely to be.

He moves to a new studio and paints the walls, the toilets, the ceiling, the furniture, a tinselly silver. He papers the pipes with aluminum foil, and has parties where people like dance critic Jill Johnston hang from the silver pipes. Soon everything is silver, including the metallic backgrounds of his silk-screen paintings of disasters. He paints silver electric chairs, silver race riots, silver Elvis Presleys pointing silver guns (presum-

ably loaded with silver bullets). He persuades heiress Edie Sedgwick and
poet Gerard Malanga to dye their hair silver.

The Factory becomes a kind of super discotheque where the worlds
of art and fashion meet. There is a constant flow of young, beautiful,
deranged creatures with glazed eyes, gyrating to records amplified to
earsplitting loudness. Their lithe, skimpily clad bodies are showered with
brilliant moving patterns of light reflected from the giant mirrored globe
suspended from the ceiling. Poets and painters, models and millionaires
twist, jerk, frug, shuffle, and boogaloo. A rock group called the Velvet
Underground, after the title of a study in sadomasochistic practices, is
installed in residence. Every night is Mardi Gras, Halloween, or Walpur-
gisnacht, depending on your point of view. The Factory is Bertolt
Brecht's decadent *Mahagonny*—the "City of Nets" located in the state
of *anomie*—where flesh, whiskey, drugs, action are all available for the
asking.

In the Factory, there is a kind of monstrous obscene abundance, as
if the cream were being spilled off the top of American affluence and
channeled into its silver funnel. Elegantly bored debutantes, spaced-out
teenage refugees from suburbia, brilliant psychotic dropouts—them-
selves the excess baggage of a society of waste—pop pills, hold each
other's sweaty palms, and massage each other's silky skins while Andy
films, tapes, and preserves for posterity every idle spontaneous word and
gesture. The camera is always running in the Factory. Like a ubiquitous
Peeping Tom, it records all of life's ordinary processes: eating, sleeping,
talking, even lovemaking.

There is something for everyone in the Factory. The voyeurs can
watch the exhibitionists perform, the actor-artists can amuse the vicari-
ous livers. There are parties every night, and all day, too. They begin to
make headlines in the fashion press; the smartest names in New York
compete for Andy's attention. They know that Andy can make them
somebody, the way he made himself somebody. He understands the
machinery of myth-making. He can multiply their images so many times
that he can make them believe they exist. He can make their images
move in film, and create the illusion they are alive. Like a fairy god-
mother, Andy can transform the drossest nouveau-riche dolly into a
silver Cinderella with a wave of his magic camera. The film image *is* real:
it removes the most anonymous insurance executive from the mass of
men and singles him out for public attention. If there is no immortality
anymore, at least there is momentary fame. "In the future everyone will
be famous for fifteen minutes," Andy says.

Sometimes, unfortunately, Andy does not have the time to effect a total transformation, and an unsuspecting Liza Doolittle forgets the players without a scorecard. One night there is a party with "pop" food, hot dogs and beer, pop music, with plastic guests in "pop" vinyl clothes, given by a pop collector and his social-climbing wife. His wife is dying to meet Norman Mailer. She asks the Pinkertons checking the guest list, which includes all the celebrities of the art and fashion worlds, to advise her when he arrives. Ray Johnson, a pale bald underground artist who mails his art to friends, is not famous enough to be invited; but he announces he is Norman Mailer when asked his name. While he rides the elevator to the Factory, the guards call upstairs to announce Mailer's arrival. The elevator door opens, and a balding cherubic Ray Johnson emerges to be embraced by his hostess, who gurgles, "Normie, I'm so glad you could come."

Andy is surrounded by his transvestite harem and the boy star of Fellini's *Satyricon*. A friend asks him how he has been feeling. He opens his coat to the doubting Thomas and points to his chest. "Here," he says, "want to feel my wound?"

At the opening of the 1970 Metropolitan Museum's exhibition of New York painting and sculpture, Andy, dressed in dinner jacket and Levi's (a symbolic combination of his proletarian origins and current top social standing), remains outside the door watching the other art celebrities. Does he still feel the outsider—the poor boy from the provinces, the intruder in the citadel of culture from the world of commercial art? A week later, at the Whitney, he is flanked by Superstars, old and new, dressed in bizarre thrift-shop drag and enough wigs to prove that the decadence of a society can be measured by how many people are wearing other people's hair. Surrounded by the press and the gaping public, the witness at his own canonization, he is the most important art object on view. For to talk of Warhol's art without talking of his life is to miss the point of his endeavor to make them literally identical. In all matters, including the art–life dialogue, he has taken the most extreme position. While not so difficult to occupy, the extreme position takes a genius to find these days. But Andy does it again, turning the Whitney into a boutique covered with wallpaper of grazing cows—the stock subject of popular academic middle-class genre painting. The museum has been a boutique for a long time, and people have been treating paintings like wallpaper even longer, but Andy spells it out with his usual cruel clarity. Stripping our cultural illusions from us, he reveals the hypocritical reality beneath the surface pretensions.

II

ART OF THE SIXTIES

POP IN PERSPECTIVE

THE PRESENTATION OF THE DADA WORK IS ALWAYS FULL OF TASTE, THE
PAINTINGS REVEAL CHARMING COLOURS, ALL VERY FASHIONABLE, THE
BOOKS AND MAGAZINES ARE ALWAYS DELIGHTFULLY MADE UP AND
RATHER RECALL THE CATALOGUES OF PERFUME MANUFACTURERS.
THERE IS NOTHING IN THE OUTWARD ASPECT OF THESE PRODUCTIONS
TO OFFEND ANYONE AT ALL; ALL IS CORRECTNESS, GOOD FORM, DELI-
CATE SHADING, ETC.

> —Albert Gleizes, *The Dada
> Case* (1920)

BUT AS DIVERTING AS POP ART IS, I HAPPEN NOT TO FIND IT REALLY
CHALLENGING. NOR DOES IT REALLY CHALLENGE TASTE ON MORE THAN
A SUPERFICIAL LEVEL. SO FAR . . . IT AMOUNTS TO A NEW EPISODE IN
THE HISTORY OF TASTE, BUT NOT TO AN AUTHENTICALLY NEW EPISODE
IN THE EVOLUTION OF CONTEMPORARY ART.

> —Clement Greenberg, Intro-
> duction to the exhibition cata-
> logue "Post-Painterly Abstrac-
> tion" (1964)

In New York, in the month of November (1962), Andy Warhol had
party hats in *McCall's* magazine, shoe illustrations in *Good Housekeep-
ing,* and an exhibition of silk-screen paintings of flowers at the Leo
Castelli Gallery. What does this mean, if anything? The meaning at-
tributed to such a flagrant dismissal of the traditional boundary between
fine and commercial art differs according to the position from which it
is considered. From the Academy, which sees everywhere the annihila-

tion of humanistic values by the instruments of mass culture, it looks like the end of the Renaissance distinction between fine and applied art, the end of the tradition of the artist as the gentleman scholar—the divinely inspired practitioner of a liberal art—and his lapse once again into the anonymous ranks of the craftsman. Yet, despite the distrust with which academic circles view pop art, their attitude is distinctly ambiguous. For example, the number of symposia, papers, seminars, etc., dealing with pop art produced in the last two years might well equal the total campus discussion of all twentieth-century art.

In academic circles, pop art evokes the morbid curiosity that the prurient businessman feels toward the prostitute he patronizes: revulsion mixed with fascination. Art historians, never happy with abstract art, can now decry the new barbarism while invoking iconography, social history, and *Geistesgeschichte.* Relieved of the burden of grappling with the problem of developing a terminology for discussing abstract art, professors can once more relax into the familiar disciplines of motif-tracing, analogy-making, and sociopsychological studies of "the relationship of the artist to society." Pop art lends itself to illustrating how the modern artist continues to fail his society, accepting its values instead of trying to reform them.

Originally, "Pop art" was the term invented by English critic Lawrence Alloway to describe what some young English painters were doing, but I am using it to talk about American pop art, which for various reasons ultimately attracted more international attention. (English pop had a good deal in common with American art; much more, obviously, than it has to do with Continental pop art or "new realism.")

It is easy to understand why pop art can be seen as lowbrow art. It is compromised on all scores by the caliber of its supporters. To aggravate matters, discussions of pop art descend quickly to the lowest possible level, serving to discredit it that much more. Worst of all is the ghastly if unforeseeable irony that the public really *does* love it: they look at it, talk about it, enjoy it as they never have abstract painting. All this tends to make the high-minded justifiably suspicious. Moreover, pop art is open to serious questioning, on the one hand because it is compromised by its relationship to commercial art, and on the other because of its link to the commodity market through the publicity apparatus that supports it. Even on the level on which motives are no longer questioned, there is still resistance not only to the debased imagery but to the introduction of commercial techniques into fine art.

No one thought to condemn Toulouse-Lautrec for making posters or Magritte for designing wallpaper, but critics (Hilton Kramer in particu-

lar) are constantly bringing it up that many of the pop artists worked as commercial artists—forgetting of course that de Kooning earned a living as a sign painter. For many sophisticated viewers, the use of commercial techniques such as photoengraving dots, billboard paint-handling, stencils, and silk screens, which lend a mechanical, reproducible, not-hand-made look to the work, is even more objectionable than the unpleasant imagery. Like the painting and sculpture of young artists such as Poons, Williams, Judd, Flavin, Morris, et al., the work looks easy to execute; it looks, in fact, as if anyone could do it. And if art can be mass-produced or made by anyone (anyone human, that is; the monkey's hands aren't steady enough), then the artist as an individual no longer counts. He counts less, in fact, than the medieval craftsman, since he may not even make the work by hand, entrusting its execution either to others or to mechanical means.

Each criticism of pop art has some validity. There is something wrong with the society that produces pop art, though not necessarily with the artists who make it. More responsible, certainly, for our inverted values than any artist is the museum director who advertises prices of masterpieces in order to roll up statistics of the "culture boom," or the critic who encourages hostility to art by impugning the motives of artists, or the collector who plays the art market as he plays the stock market. Then, of course, the content of pop art, all too frequently a kind of regressive infantilism, is often objectionable. But so is the sadomasochistic content of much religious art, not to mention the morally unappetizing content of a lot of surrealism, but that does not make such works any less art.

The problem, obviously, is to put pop art back into perspective. So far no critic, no matter how aggressive or offended, has gone so far as to call it kitsch. And of course pop art is not kitsch; its pictorial conventions and roots are the same as those of abstract art. Nor is it commercial art made by commercial artists. Stylistically, the work is linked with that of contemporary abstract artists. Like them, pop artists work on a flat surface, usually with closed, two-dimensional shapes having legible contours. Often they use the same "nasty," brash commercial colors and resistant surfaces found in the work of such young abstractionists as Poons, Williams, Bannard, and Stella.

Linking the pop artists again to the abstract artists of their generation is the bland impersonality, the aloofness, the disavowal of emotion or "message," and the amount of playing with vulgarity and bad taste that tends to characterize the art of many young artists, both pop and abstract. Why this is so is another question. Partially, it is because the new

sensibility that animates this generation wants to maximize resistance and tension. As the pretty, another category of the easy, is distrusted as decorative, the good and the difficult become synonymous. Impact and immediacy of response are goals. Without elaborating on what is essentially a complicated problem, one may merely remark that although the effect of the communications media was felt to a degree before, these young artists have been hit in a more direct way, perhaps to the extent that their perceptions are altered. Certainly experience with movies and art books has changed ways of seeing. Young artists confront a different world, offering different temptations and rewards, not to mention different stimuli, from those that older artists faced. A gap which seems broader than that ordinarily separating generations separates these young artists from both first- and second-generation abstract expressionists in whose footsteps they follow. But the irony is that this art is being made for the same elite public for which abstract expressionism was made, and its abstract formal qualities remain as remote and unassimilable as ever (if not more so).

The work of younger artists today evolves stylistically from the style of the New York School, but the content of the new art is not the same as that of abstract expressionism, which for all its detachment from representation still had about it the warmth and glow of life. The new art, in contrast, is cold and calculated. The countless statements made by the pop artists to the effect that they are uninterested in or against taste, feeling, and personal expression and are content to celebrate the faceless banality of contemporary America do not sit well with those who see civilization in terms of the individualistic values that have obtained since the Renaissance. Enough of this nonsense has gained currency to suggest that it is about time to call the cards on both sides. For their part, the pop artists are misrepresenting themselves. These are a group of educated spectators of mass culture, not glazed participants in its rituals, despite the extent to which they allow themselves to be exploited as part of the personality packaging that goes into contemporary myth-making. Pop art is not the naive art of the unlettered, and no amount of bubbly affirmation can hide the irony and at times the desperation behind what was at least originally its statement.

Some pop artists have already given up "pop" imagery for more neutral subjects like flowers and landscapes. This tends to remove the sting of the topical, although the continued use of commercial techniques serves to maintain a brash vulgar look. This ironic, perverse, hostile art, based on the same pictorial conventions as contemporary

abstract art, which remains an elite art, has, however, found for itself a mass public.

If the pop artists are guilty of indulging in a masquerade in order to veil the subversive nature of their statement, then their detractors are allowing a fruitless nostalgia for the functional relationship of the artist to a healthy society to fog their vision. As it stands, the role of the artist in the evolving technological mass society is unhealthy. We find it difficult to come to terms with the ambiguous art of our youngest artists, which has as its end both the destruction of old values and the construction of new ones. Artists are questioning the meaning, role, and function of art in the mass society that at this moment is taking shape; this questioning, which presupposes a speculative detachment, does not make their art less valid. On the contrary, it testifies to its authenticity.

We may get beyond questioning the validity of pop as art, but we are still left with the problem of how good it is. I have no doubt about how relevant its content is to the contemporary situation. Clearly, the only objection of any substance is Clement Greenberg's: that it is formally inadequate. But is it? Isn't it equally conceivable that rather than being subjected to the same criteria for evaluation as abstract art, pop art is found wanting by Greenberg and those who uncritically accept his position because it is not being subjected to those same criteria?

I wonder if, on the one hand, Lichtenstein's compositions are so inadequate or unoriginal and if, conversely, some of the abstract painters Greenberg included in the exhibition of post-painterly abstraction he organized recently in Los Angeles are not ultimately more inadequate, even if more palatable. In the catalogue introduction to this show, Greenberg makes the point that it should have been obvious that abstract expressionism was very much art, rooted in the history of art, as soon as distinctions in quality could be made. Yet these are precisely the distinctions in quality that Greenberg refuses to make with regard to pop art, preferring to dismiss it wholesale.

In large part, the grounds on which pop art has been attacked are spurious: it is not commercial art made by commercial artists, but art that accepts the implications and conventions of abstract art. Andy Warhol's flower paintings could not have been made without the precedent of Pollock and Gottlieb. Neither is it sell-out art made by artificially created personalities to legitimize the values of the commodity culture that makes them rich. Rather it is the hold-out art of a generation of artists who have seen flag-wavers collapse both left and right. That it has been widely accepted and sometimes put to strange use is rarely the fault of the artists.

Pop art is not only art, most of the time it is not even bad art, judged by the same standards with which one judges abstract art. If the level of formal invention is not great, it is scarcely worse than that of most of the abstract art shown today, nor is the content more vacuous. And sometimes, it is distinctly better. To assign pop art categorically to the history of taste as Greenberg does is to miss this point. And to ignore the messages artists such as Oldenburg and Rosenquist are sending, although they may be essentially literary or social, is to overlook a set of interpretations of contemporary reality that may be more penetrating than those being made available by our literature and sociology today.

It would be absurd to maintain that pop art is going to add much to the history of forms. To an extent, it belongs to that same current of exacerbated aestheticism in which everything, no matter how appalling, becomes art that began with the *fin de siècle* retreat into the self. And pop, which seems so public, is but another kind of retreat into the self, perhaps of a deeper sort. The wish to maintain the inviolability of the person, who has a grinning made-up double to answer questions and entertain, certainly accounts for some of the curious inversions pop art has brought about.

ROY LICHTENSTEIN: REPRODUCTION AS REPRESENTATION

Roy Lichtenstein's series of relief prints based on the theme of *Entabla-tures*—friezes of architectural ornament—represents both his most technically complex and his most sophisticated graphic works to date. It is the culmination of a long involvement with the relationship be-tween representational and abstract art—both as an iconographical theme and as a formal problem to be solved in terms of a new definition of the very concept of style. Conceived and executed over a two-year period of experimentation in collaboration with Ken Tyler of Tyler Graphics, the eleven *Entablatures* combine traditional fine art tech-niques of printmaking with innovative processes borrowed from ad-vanced industrial technology to create a new form of collaged paper relief that utilized graphic means, normally associated with flat, two-dimensional images, to raise and depress surfaces through embossing and debossing. The result is that the element of literal bas-relief that orna-ment itself possesses is graphically conveyed. This irony is as typical of Lichtenstein as the play between the literal object and the art object; it is typical of most of the important art developed in the sixties.

Pop art first looked like a homogeneous style because all the artists associated with the movement chose subjects from the popular culture. However, it soon became clear that there was a retrograde element tying some pop artists irrevocably to cubist design. Some of the important art of the sixties was representational, some was abstract. This obscured the connection between "pop" artists like Lichtenstein, who were also work-ing in post-cubist styles based on hard-edge single images perceivable only as integral gestalts, and the advanced abstract art of the sixties. Leo

Published by Tyler Graphics, 1977

Steinberg prophetically guessed at the time that the issue of representation was a red herring cleverly contrived to obscure the formal qualities of pop—to keep it resistant to formal interpretation even as it attracted literary, sociological, and iconographical analysis. Lichtenstein appears thoroughly bored by the latter. His gradual phasing out of popular images was replaced by a new iconography that could be equally seen as apparent desecration of the masterpieces of modern art. This shock absorbed, Lichtenstein turned to increasingly neutral subjects such as landscapes and brushstrokes, and finally to intrinsically "abstract" motifs derived from pure design elements such as architectural ornament.

Lichtenstein's early pop paintings, based on ads, labels, and, above all, cartoons, were startling. They were innocuous enough in subject matter—a rotisserie, a golf ball, a cat, a diamond ring, a ball of twine. However, they were extremely upsetting to viewers and critics accustomed to the conventions that have governed representational art since the Renaissance. They appeared, in some novel, mysterious, and, as far as some were concerned, unspeakably horrifying fashion, to represent recognizable images, while simultaneously totally flouting the conventions, particularly those regarding the fundamental relationship between positive figure and negative ground, on which the very concept of representational art depended.

As a young art historian working part-time at Leo Castelli's gallery, I was among those aghast when Ivan Karp brought the first Lichtenstein paintings up to the gallery one day in 1961. It took me some time to understand why these paintings were so strange, as they seemed at the same time very much part of the history of art since cubism, descending directly from the cubist realism of Léger and Stuart Davis. I did not realize immediately that Lichtenstein's paintings were so peculiarly powerful and unsettling because they were not pictures of things but pictures of pictures. In other words, they were representations derived explicitly from images already printed. When I realized this, however, I understood that Lichtenstein had arrived at new conclusions about how the concept of representation had been altered as the result of the invention of *mechanical* techniques for reproducing images. This alteration, beginning with photography and ending with the latest means of multiplying and duplicating images made possible by an ever-expanding technology, is described by Walter Benjamin in "The Work of Art in the Age of Mechanical Reproduction." In this visionary study, Benjamin first wrote about the transformations in the status of the art object as a unique work brought about by the possibility of mechanical reproduction.

That the work of art is created within a context of multiple reproduc-

tions available to a mass public was raised to a level of conscious aware-
ness only twenty-five years later by the generation of pop artists; none,
however, made this new insight so central to his art as Roy Lichtenstein.
Given his particular sensitivity to the fact that the unique work of art
was in danger of, as Benjamin put it, losing its "aura" by drowning in
a flood of mass-produced reproductions, it was perhaps surprising that
Lichtenstein perversely chose the most vulgar, easily and cheaply repro-
duced form of mass-communicated imagery—comic strips—as the basis
for a new style of representational art that had more in common with
the remoteness and detachment from reality of abstract art than it did
with any previous form of realism.

For some, pop art, and especially Lichtenstein's tough and resistant
version of it, was a dreadful disappointment. Here was a representational
style that ironically and pointedly was not realistic, not "humanistic" in
any recognizable sense, even though human figures were depicted, be-
cause they, too, were represented in the cartoon clichés of scenes from
love and war comics—two special-interest genres of American popular
culture no child of the forties or fifties escaped experiencing as part of
America's dreadful sentimental education in the varieties of inauthen-
ticity. Parodying the false sentiment huckstered by the popular culture
to the naive masses, Lichtenstein painted "hot" scenes of clinching
couples and combat drama with the same cold, impersonal detachment
with which he depicted the consumer goods which that same innocent
public was brainwashed into buying.

The lowest common denominator of these images was the extreme
simplification of line, shape, and color to which images were subjected
in order to be reformulated as abstract signs in the new popular hiero-
glyphics, hybrid condensations of verbal and visual images, developed by
the mass media for instant communication. Although Lichtenstein con-
tinued to use the thick black outlines of the graphic cartoon style to
depict images, he stopped parodying false sentiment with false represen-
tation. Beginning in 1962 with *Mme. Cézanne,* a painting based on a
textbook diagram of Cézanne's celebrated portrait of his wife, Licht-
enstein started to eliminate the comic-strip images that combined word
and picture, replacing them with purely visual themes taken from the
history of art. First Cézanne, then other giants of modern art were
selected to be translated into representations of reproductions that were
ironically to be experienced as unique new works created by Lichten-
stein. Perhaps the maddest of these homage paintings is *Non-Objective
Painting No. 1,* based on a work by Mondrian, which manages to be a
representation of an abstract painting.

The practice of quoting or paraphrasing earlier works, generally derived from widely circulated prints done after paintings by well-known masters like Raphael and Dürer, is familiar to art historians, although it was not to critics looking at Lichtenstein's work who were untrained in art history. While journalistic critics condemned it, art historian Robert Rosenblum, for example, was quick to praise Lichtenstein's painting for what it was: not popular or commercial, but fine art solidly grounded within an art-historical tradition that used techniques for simplifying and stylizing forms first explored by popular imagery, because it was free of academic conventions that eventually brought naturalism to the brink of *trompe l'oeil* verisimilitude. The invention of photography brought an end to the further development of naturalistic art, which survived mainly in the popular diorama, and finally as backgrounds for stuffed animals in natural history.

That the rise of photography and the decline of realism coincided is a fundamental assumption by now; however, the relationship between these obviously connected phenomena and new theories regarding formal and stylistic evolution has not yet been noted as evidence of an altered consciousness regarding the history of art as an evolutionary stylistic development that could be mapped, diagrammed, and ultimately abstracted in the same manner that representation itself was gradually being transformed into a system of abstract forms and symbols. For the invention of photography was as potentially lethal to the concepts of individual style as it was to an artist's unique ability to represent reality. Because the camera is a machine, style becomes a function not of the artist's manual expression, but of his choice and technical treatment of his subject. Technique has become so central to personal innovation as it has recently because images recorded by machines can only be altered—i.e., rendered subjective and expressive—through the manipulation of technique.

That the means of the technical production of images determines the range of expression available to a culture was one of the critical insights of Alois Riegl. His revolutionary theory of stylistic evolution, *Stilfragen*, was an analysis of the history of ornament as a prime indicator of transformations in style that could be traced even in so-called "dark ages" when only minor art was produced. The focus on *ornament* as the fundamental abstraction of period style prevalent in Victorian treatises such as Owen Jones's *Grammar of Ornament* as well as in the studies of Germanic scholars such as Riegl and Semper must be seen in the context of the Industrial Revolution, as it challenged fundamental ideas

regarding craft, now increasingly taken over by machines as the province of representation was being gradually usurped by photography.

In an ironic commentary on abstraction, Lichtenstein turned in the seventies to the very books on ornament that initially disengaged style from questions of representation, and allied style more closely with technique. Thus he illustrates how processes of mechanical reproduction are now altering our conception of style—both historical and individual—as photography and later reproduction processes initially altered conceptions of representation.

The grammars of ornament that inspired Lichtenstein's two series of friezelike horizontal paintings done in 1971 and 1975 as well as the related *Entablature* prints are like the comic strip: reductive, symbolic, and diagrammatic images closer to the world of abstract signs than to representational imagery. Like comic strips, ornament books reduce all the images they represent to a common denominator. Ornament diagrams, although not necessarily derived from reproduction, are schematized, standardized, and stylized in conformity with the considerations of mechanical drawing. Thus they are another means to transcend style by reducing the ornamental expressions of a variety of cultures to the single common denominator of geometric standardization, which is also the basis of design prototypes of industrial production. In a formal sense, ornament books are the equivalent of the emotional leveling of the cartoon style and the leveling of signification implicit in the reproduction of images. In a system of signs defined by its capacity to equalize images by subjugating them to common processes of reproduction, a painting of a reproduced Mondrian "means" the same thing as a painting of a deodorant ad.

In a theory of style based on the isolation of ornament, illustrated with abstract designs reduced to equivalency through mechanical drawing, style is subsumed by a collective cultural expression. This mechanical expression is further leveled in a series of equations of style types conveyed by ornaments, derived from nature originally, but ultimately destined to conform more and more closely—for reasons that continue to ask for examination—to the mechanical geometry inevitably imposed by the requirements of the machinery of industrial production.

Industrialism disrupted our notion of style as much as reproduction altered our conception of representation. Further examining the alteration of artistic concepts in a mechanical age, Lichtenstein reformulates the representation of nature in the horizontal bands of abstract ornament that parody the conventional divisions of landscape by ground and

horizon lines. Seascapes are specifically recalled in the delicately scalloped motifs of *Entablatures IV* and *VI.* The whole series may be seen as the mechanical reformulation of the romantic tradition of landscape and seascape, an antinaturalism as appropriately satirical of our technological environment as the antihumanism of the cartoon style was of the traditional heroic subjects of love and war, deprived of affect by mass media, degraded to meaninglessness through repetitious reproduction.

In the subject of ornament—the original form of abstraction—Lichtenstein has found another means as potent as the comic strip for expressing, through mockery and irony, the contradictions of our time. In the series of "temples" painted in 1964, Lichtenstein began thinking of the meaning of antiquity in a contemporary mass society that identified "Parthenon" as a Greek restaurant. Refining the concept to focus on the remnants of classical ornament that confer the pedigree of Athens on our hardly Athenian democracy, he prints the Latin word JUSTITIA in *Entablature X* and *Xa,* in mockery of the lapidary inscriptions engraved on the buildings that housed a government which brought the republic Watergate. Ancient law becomes as reduced in meaning as the endlessly reprinted woodcut copy of Gilbert Stuart's portrait of George Washington, the basis for Lichtenstein's first "portrait" based on a famous reproduction. In the *Entablature* prints, Lichtenstein continues his ironic commentary on the American scene, but he is gradually shifting his art away from comic-strip imagery in the direction of disguised abstraction.

ABC ART

I AM CURIOUS TO KNOW WHAT WOULD HAPPEN IF ART WERE SUDDENLY
SEEN FOR WHAT IT IS, NAMELY, EXACT INFORMATION OF HOW TO REAR-
RANGE ONE'S PSYCHE IN ORDER TO ANTICIPATE THE NEXT BLOW FROM
OUR OWN EXTENDED FACULTIES. . . . AT ANY RATE, IN EXPERIMENTAL
ART, MEN ARE GIVEN THE EXACT SPECIFICATIONS OF COMING VIOLENCE
TO THEIR OWN PSYCHES FROM THEIR OWN COUNTERIRRITANT OR TECH-
NOLOGY. . . . BUT THE COUNTERIRRITANT USUALLY PROVES A GREATER
PLAGUE THAN THE INITIAL IRRITANT, LIKE A DRUG HABIT.

—Marshall McLuhan, *Under-
standing Media*, 1964

HOW DO YOU LIKE WHAT YOU HAVE. THIS IS A QUESTION THAT ANYBODY
CAN ASK ANYBODY. ASK IT.

—Gertrude Stein, *Lectures in
America*, 1935

On the eve of the First World War, two artists, one in Moscow, the
other in Paris, made decisions that radically altered the course of art
history. Today we are feeling the impact of their decisions in an art
whose blank, neutral, mechanical impersonality contrasts so violently
with the romantic, biographical abstract expressionist style which
preceded it that spectators are chilled by its apparent lack of feeling or
content. Critics, attempting to describe this new sensibility, call it Cool
Art or Idiot Art or Know-Nothing Nihilism.

That a new sensibility has announced itself is clear, although just what
it consists of is not. This is what I hope to establish here. But before
taking up specific examples of the new art, not only in painting and

sculpture, but in other arts as well, I would like briefly to trace its genealogy.

In 1913, Kasimir Malevich, placing a black square on a white ground that he identified as the "void," created the first suprematist composition. A year later, Marcel Duchamp exhibited as an original work of art a standard metal bottle rack, which he called a "ready-made." For half a century, these two works marked the limits of visual art. Now, however, it appears that a new generation of artists, who seem not so much inspired as impressed by Malevich and Duchamp (to the extent that they venerate them), are examining in a new context the implications of their radical decisions. Often the results are a curious synthesis of the two men's work. That such a synthesis should be not only possible but likely is clear in retrospect. For although superficially Malevich and Duchamp may appear to represent the polarities of twentieth-century art—that is, on one hand, the search for the transcendent, universal, absolute, and on the other, the blanket denial of the existence of absolute values—the two have more in common than one might suppose at first.

To begin with, both men were precocious geniuses who appreciated the revolutionary element in postimpressionist art, particularly Cézanne's, and both were urban modernists who rejected the possibility of turning back to a naive primitivism in disgusted reaction to the excesses of civilization. Alike, too, was their immediate adoption and equally rapid disenchantment with the mainstream modern style, cubism. Turning away from figurative art, by 1911 both were doing cubist paintings, although the provincial Malevich's were less advanced and "analytic" than Duchamp's; by 1913 both had exhausted cubism's possibilities as far as their art was concerned. Moreover, both were unwilling to resolve some of the ambiguities and contradictions inherent in analytic cubism in terms of the more ordered and logical framework of synthetic cubism, the next mainstream style.

The inevitability of a logical evolution toward a reductive art was obvious to them already. For Malevich, the poetic Slav, this realization forced a turning inward toward an inspirational mysticism, whereas for Duchamp, the rational Frenchman, it meant a fatigue so enervating that finally the wish to paint at all was killed. The yearnings of Malevich's Slavic soul and the deductions of Duchamp's rationalist mind led both men ultimately to reject and exclude from their work many of the most cherished premises of Western art in favor of an art stripped to its bare, irreducible minimum.

It is important to keep in mind that both Duchamp's and Malevich's decisions were renunciations—on Duchamp's part, of the notion of the

uniqueness of the art object and its differentiation from common objects, and on Malevich's part, a renunciation of the notion that art must be complex. That the art of our youngest artists resembles theirs in its severe, reduced simplicity, or in its frequent kinship to the world of things, must be taken as some sort of validation of their prophetic reactions.

MORE IS LESS

The concept of "minimal art," which is surely applicable to the empty, repetitious, uninflected art of many young painters, sculptors, dancers, and composers working now, was discussed as an aesthetic problem by Richard Wollheim (*Arts*, January 1965). It is Professor Wollheim's contention that the art content of such works as Duchamp's found objects (that is, the "unassisted ready-mades" to which nothing is done) or Ad Reinhardt's nearly invisible "black" paintings is intentionally low, and that resistance to this kind of art comes mainly from the spectator's sense that the artist has not worked hard enough or put enough effort into his art. But, as Professor Wollheim points out, a decision can represent work. Considering as "minimal art" either art made from common objects that are not unique but mass-produced or art that is not much differentiated from ordinary things, he says that Western artists have aided us to focus on specific objects by setting them apart as the "unique possessors of certain general characteristics." Although they are increasingly being abandoned, working it a lot, making it hard to do, and differentiating it as much as possible from the world of common objects formerly were ways of ensuring the uniqueness and identity of an art object.

Poet and critic John Ashbery has asked if art can be excellent if anybody can do it. He concludes that "what matters is the artist's will to discover rather than the manual skills he may share with hundreds of other artists. Anybody could have discovered America, but only Columbus *did*." Such a downgrading of talent, facility, virtuosity, and technique, with its concomitant elevation of conceptual power, coincides precisely with the attitude of the artists I am discussing.

Some of the artists, such as Darby Bannard, Larry Zox, Robert Huot, Lyman Kipp, Richard Tuttle, Jan Evans, Ronald Bladen, and Anne Truitt, obviously are closer to Malevich than they are to Duchamp, whereas others, such as Richard Artschwager and Andy Warhol, are clearly the reverse. The dancers and composers are all, to a greater or

lesser degree, indebted to John Cage, who is himself an admirer of Duchamp. Several of the artists—Robert Morris, Donald Judd, Carl Andre, and Dan Flavin—occupy to my eye some kind of intermediate position. One of the issues these artists are attacking is the applicability of generalizations to specific cases. In fact, they are opposed to the very notion that the general and the universal are related. Thus, I want to reserve exceptions to all of the following remarks about their work: in other words, *some of the things I will say apply only in some cases and not in others.*

Though Duchamp and Malevich jumped the gun, so to speak, the avenue toward what Clement Greenberg has called the "modernist reduction," that is, toward an art that is focused on its essence, was traveled at a steadier pace by others. Michael Fried (in the catalogue for "Three American Painters," Fogg Art Museum, 1965) points out that there is "a superficial similarity between modernist painting and Dada in one important respect: namely that just as modernist painting has enabled one to see a blank canvas, a sequence of random spatters, or a length of colored fabric as a picture, Dada and Neo-Dada have equipped one to treat virtually any object as a work of art." The result is that "there is an apparent expansion of the realm of the *artistic* corresponding— ironically, as it were—to the expansion of the pictorial achieved by modernist painting." I quote this formulation because it demonstrates not only how Yves Klein's monochrome blue paintings are art, but because it ought finally to make clear the difference in the manner and kind of reductions and simplifications he effected from those made by Kenneth Noland and Jules Olitski, thus dispelling permanently any notions that Noland's art and Olitski's art are in any way, either in spirit or in intention, linked to the Dada outlook.

Although the work of the painters I am discussing is more blatant, less lyrical, and more resistant—in terms of surface, at any rate, insofar as the canvas is not stained or is left with unpainted areas—it has something important in common with that of Noland, Olitski, and others who work with simple shapes and large color areas. Like their paintings, this work is critical of abstract expressionist paint-handling and rejects the brushed record of gesture and drawing along with loose painterliness. Similarly, the sculpture I am talking about appears critical of open, welded sculpture.

That the artist is critic not only of his own work but of art in general and specifically of art of the immediate past is one of the basic tenets of formalist criticism, the context in which Michael Fried and Clement

Greenberg have considered reductive tendencies in modern art. But in this strict sense, to be critical means to be critical only of the formal premises of a style, in this case abstract expressionism. Such an explanation of a critical reaction in the purely formal terms of color, composition, scale, format, and execution seems to me adequate to explain the evolution of Noland's and Olitski's work, but it does not fully suffice to describe the reaction of the younger people I am considering, just as an explanation of the rise of neoclassicism which considered only that the forms of the rococo were worn out would hardly give one much of a basis for understanding the complexity of David's style.

It seems clear that the group of young artists I am speaking of were reacting to more than merely formal chaos when they opted not to fulfill Ad Reinhardt's prescription for "divine madness" in "third-generation abstract expressionists." In another light, one might as easily construe the new, reserved impersonality and self-effacing anonymity as a reaction against the self-indulgence of an unbridled subjectivity, as much as one might see it in terms of a formal reaction to the excesses of painterliness. One has the sense that the question of whether or not an emotional state can be communicated (particularly in an abstract work), or worse still, to what degree it can be simulated or staged, must have struck some serious-minded young artists as disturbing. That the spontaneous splashes and drips could be manufactured was demonstrated by Robert Rauschenberg in his identical action paintings *Factum I* and *Factum II*. It was almost as if, toward the *Götterdämmerung* of the late fifties, the trumpets blared with such an apocalyptic and Wagnerian intensity that each moment was a crisis and each "act" a climax. Obviously, such a crisis climate could hardly be sustained; just to be able to hear it at all again, the volume had to be turned down, and the pitch, if not the instrument, changed.

Choreographer Merce Cunningham, whose work has been of the utmost importance to young choreographers, may have been the first to put this reaction into words (in an article in *trans/formation*, No. 1, 1952): "Now I can't see that crisis any longer means a climax, unless we are willing to grant that every breath of wind has a climax (which I am), but then that obliterates climax, being a surfeit of such. And since our lives, both by nature and by the newspapers, are so full of crisis that one is no longer aware of it, then it is clear that life goes on regardless, and further that each thing can be and is separate from each and every other, viz: the continuity of the newspaper headlines. Climax is for those who are swept by New Year's Eve." In a dance

called *Crises*, Cunningham eliminated any fixed focus or climax in much the way the young artists I am discussing here have banished them from their works as well. Thus Cunningham's activity, too, must be considered as having helped to shape the new sensibility of the post–abstract-expressionist generation.

It goes without saying that sensibility is not transformed overnight. At this point I want to talk about sensibility rather than style, because the artists I'm discussing, who are all roughly just under or just over thirty, are more related in terms of a common sensibility than in terms of a common style. Also, their attitudes, interests, experiences, and stance are much like those of their contemporaries, the pop artists, although stylistically the work is not very similar.

This shift toward a new sensibility came in the late fifties, a time of convulsive transition not only for the art world, but for society at large as well. In these years, for some reasons I've touched on, many young artists found action painting unconvincing. Instead they turned to the static emptiness of Barnett Newman's eloquent chromatic abstractions or to the sharp visual punning of Jasper Johns's objectlike flags and targets.

Obviously, the new sensibility that preferred Newman and Johns to Willem de Kooning or his epigoni was going to produce art that was different, not only in form but in content as well, from the art that it spurned, because it rejected not only the premises but the emotional content of abstract expressionism.

The problem of the subversive content of these works is complicated, though it has to be approached, even if only to define why it is peculiar or corrosive. Often, because they appear to belong to the category of ordinary objects rather than art objects, these works look altogether devoid of art content. This, as it has been pointed out in criticism of the so-called contentless novels of Alain Robbe-Grillet, is quite impossible for a work of art to achieve. The simple denial of content can in itself constitute the content of such a work. That these young artists attempt to suppress or withdraw content from their works is undeniable. That they wish to make art that is as bland, neutral, and as redundant as possible also seems clear. The content, then, if we are to take the work at face value, should be nothing more than the total of the series of assertions that it is this or that shape and takes up so much space and is painted such a color and made of such a material. Statements from the artists involved are frequently couched in these equally factual, matter-of-fact descriptive terms; the work is described but not interpre-

ted and statements with regard to content or meaning or intention are prominent only by their omission.

For the spectator, this is often all very bewildering. In the face of so much nothing, he or she is still experiencing something, and usually a rather unhappy something at that. I have often thought one had a sense of loss looking at these big, empty things, so anxious to cloak their art identity that they were masquerading as objects. Perhaps what one senses is that as opposed to the florid baroque fullness of the *Angst*-ridden older generation, the hollow barrenness of the void has a certain poignant, if strangled, expressiveness.

For the present, however, I prefer to confine myself mostly to describing the new sensibility rather than attempting to interpret an art that, by the terms of its own definition, resists interpretation. However, that there *is* a collective new sensibility among the young by now is self-evident. Looking around for examples, I was struck by the number of coincidences I discovered. For example, I found five painters who quite independently arrived at the identical composition of a large white or light-colored rectangle in a colored border. True, in some ways these were recapitulations of Malevich's *Black Square on White* (or to get closer to home, of Ellsworth Kelly's 1952 pair of a white square on black and black square on white); but there was an element in each example that finally frustrated a purist reading. In some cases (Ralph Humphrey's, for example) a Magritte-like sense of space behind a window-frame was what came across; other times there seemed to be a play on picture (blank) and frame (colored), though again, it was nearly impossible to pin down a specific image or sensation, except for the reaction that they weren't quite what they seemed to be. In the same way, three of the sculptors I'm considering (Carl Andre, Robert Morris, and Dan Flavin) have all used standard units interchangeably. Again, the reference is back to the Russians—particularly to Rodchenko in Andre's case—but still, another element has insinuated itself, preventing any real equations with constructivist sculpture.

Rather than guess at intentions or look for meanings I prefer to try to surround the new sensibility, not to pinpoint it. As T. E. Hulme put it, the point is to keep from discussing the new art with a vocabulary derived from the old position. Though my end is simply the isolation of the old-fashioned *Zeitgeist*, I want to go about it impressionistically rather than methodically. I will take up notions now in the air that strike me as relevant to the work. As often as possible I will quote directly from texts that I feel have helped to shape the new sensibility.

MEANING IN THE VISUAL ARTS

LET US, THEN, TRY TO DEFINE THE DISTINCTION BETWEEN SUBJECT
MATTER OR MEANING ON THE ONE HAND, AND FORM ON THE OTHER.
WHEN AN ACQUAINTANCE GREETS ME ON THE STREET BY REMOVING
HIS HAT, WHAT I SEE FROM A FORMAL POINT OF VIEW IS NOTHING BUT
THE CHANGE OF CERTAIN DETAILS WITHIN A CONFIGURATION THAT
FORMS PART OF THE GENERAL PATTERN OF COLOR, LINES AND VOLUMES
WHICH CONSTITUTES MY WORLD OF VISION. WHEN I IDENTIFY, AS I
AUTOMATICALLY DO, THIS AS AN EVENT (HAT-REMOVING), I HAVE AL-
READY OVERSTEPPED THE LIMITS OF PURELY FORMAL PERCEPTION AND
ENTERED A FIRST SPHERE OF SUBJECT MATTER OR MEANING . . . WE
SHALL CALL . . . THE FACTUAL MEANING.

—Erwin Panofsky, *Studies in
Iconology,* 1939

The above text and some of the subsequent passages in which Professor
Panofsky further differentiates among levels of meaning in art was read
by Robert Morris in a work (I hesitate to call it a dance, although it was
presented in a dance concert at the Surplus Theatre in New York) titled
21.3. Morris is the most overtly didactic of all the artists I am consider-
ing; his dances, or more precisely his events, seem to represent a running
commentary on his sculpture as well as a running criticism of art inter-
pretation. At the Surplus Theatre concert he stood before a lectern and
mouthed the Panofsky text, which was broadcast from a tape simultane-
ously. From time to time he interrupted himself to pour water from a
pitcher into a glass. Each time he poured water, the tape, timed to
coincide with his action, produced the sound of water gurgling.

Until recently, in his glass-and-lead pieces, Morris was fairly explicit
about putting subject matter (mostly Duchampesque speculations on
process and sex or illustrations of Cartesian dualism) into his art. But
now that he is making only bloated plywood constructions, which serve
mostly to destroy the contour and space of a room by butting off the floor
onto the wall, floating from the ceiling, or appearing as pointless obsta-
cles to circulation, he seems to be concentrating on meaning. This
victory for modernism has coincided with his retirement from the per-
forming arts in order to concentrate on his role as theoretician. That he
chose the passage from Panofsky, which deals with slight changes of
detail and the difference between factual and expressive meaning, is
significant for the purpose of isolating the kind of matters that preoccupy

many of these artists. For the painters and sculptors whom I am discussing here are aware not only of the cycle of styles but of levels of meaning, of influences, of movements, and of critical judgments. If the art they make is vacant or vacuous, it is intentionally so. In other words, the apparent simplicity of these artists' work was arrived at through a series of complicated, highly informed decisions, each involving the elimination of whatever was felt to be nonessential.

ART FOR AD'S SAKE

NOWHERE IN WORLD ART HAS IT BEEN CLEARER THAN IN ASIA THAT ANYTHING IRRATIONAL, MOMENTARY, SPONTANEOUS, UNCONSCIOUS, PRIMITIVE, EXPRESSIONISTIC, ACCIDENTAL, OR INFORMAL, CANNOT BE CALLED SERIOUS ART. ONLY BLANKNESS, COMPLETE AWARENESS, DISINTERESTEDNESS; THE "ARTIST AS ARTIST" ONLY, OF ONE AND RATIONAL MIND, "VACANT AND SPIRITUAL, EMPTY AND MARVELOUS," IN SYMMETRIES AND REGULARITIES ONLY; THE CHANGELESS "HUMAN CONTENT," THE TIMELESS "SUPREME PRINCIPLE," THE AGELESS "UNIVERSAL FORMULA" OF ART, NOTHING ELSE. . . .

THE FORMS OF ART ARE ALWAYS PREFORMED AND PREMEDITATED. THE CREATIVE PROCESS IS ALWAYS AN ACADEMIC ROUTINE AND SACRED PROCEDURE. EVERYTHING IS PRESCRIBED AND PROSCRIBED. ONLY IN THIS WAY IS THERE NO GRASPING OR CLINGING TO ANYTHING. ONLY A STANDARD FORM CAN BE IMAGELESS, ONLY A STEREOTYPED IMAGE CAN BE FORMLESS, ONLY A FORMULAIZED ART CAN BE FORMULALESS.

> —Ad Reinhardt, "Timeless in Asia," *ARTnews,* January 1960

FINE ART CAN ONLY BE DEFINED AS EXCLUSIVE, NEGATIVE, ABSOLUTE, AND TIMELESS.

> —Ad Reinhardt, "Twelve Rules for a New Academy," *ARTnews,* May 1957

No one, in the mid-fifties, seemed less likely to spawn artistic progeny and admirers than Ad Reinhardt. As abstract painter since the thirties, and a voluble propagandist for abstract art, Reinhardt was always one of the liveliest spirits in the art world, though from time to time he would be chided as the heretical black monk of abstract expressionism, or the

legendary Mr. Pure, who finally created an art so pure it consisted of injecting a clear fluid into foam rubber. His dicta, as arcane as they may have sounded when first handed down from the scriptorium, have become nearly canonical for the young artists. Suddenly, his wry irony, aloofness, independence, and ideas about the proper use and role of art, which he has stubbornly held to be noncommercial and nonutilitarian, are precisely the qualities the young admire. It is hard to say how much Reinhardt's constant theorizing, dogmatizing, and propagandizing actually helped to change the climate and to shift the focus from an overtly romantic style to a covertly romantic style.

Of course, Reinhardt's "purity" is a relative matter, too. The loftiness is ultimately only part of the statement; and as he made of impersonality one of the most easily recognized styles in New York, so the new blandness is likely to result in similarly easy identification, despite all the use of standard units and programmatic suppression of individuality. In some way, it might be interesting to compare Reinhardt with the younger artists. To begin with, in Reinhardt's case, there is no doubt that his is classic art (with mystical overtones, perhaps), and there is no doubt that it is abstract, or more precisely that it is abstract painting. Both the concepts of a classical style, toward which an art based on geometry would naturally tend, and that of a genuinely abstract style, are called into question frequently by the ambiguous art of the younger artists. First of all, many use a quirky asymmetry and deliberately bizarre scale to subvert any purist or classical interpretations, whereas others tend to make both paintings and sculptures look so much like plaques or boxes that there is always the possibility that they will be mistaken for something other than art. Their leaving open this possibility is, I think, frequently deliberate.

A ROSE IS A ROSE IS A ROSE: REPETITION AS RHYTHMIC STRUCTURING

. . . THE KIND OF INVENTION THAT IS NECESSARY TO MAKE A GENERAL SCHEME IS LIMITED IN EVERYBODY'S EXPERIENCE, EVERY TIME ONE OF THE HUNDREDS OF TIMES A NEWSPAPER MAN MAKES FUN OF MY WRITING AND OF MY REPETITION HE ALWAYS HAS THE SAME THEME, THAT IS, IF YOU LIKE, REPETITION, THAT IS IF YOU LIKE THE REPEATING THAT IS THE SAME THING, BUT ONCE STARTED EXPRESSING THIS THING, EXPRESSING ANY THING THERE CAN BE NO REPETITION BECAUSE THE ESSENCE OF THAT EXPRESSION IS INSISTENCE, AND IF YOU INSIST YOU MUST

EACH TIME USE EMPHASIS AND IF YOU USE EMPHASIS IT IS NOT POSSIBLE WHILE ANYBODY IS ALIVE THAT THEY SHOULD USE EXACTLY THE SAME EMPHASIS.

—Gertrude Stein, "Portraits and Repetition," in *Lectures in America,* 1935

FORM CEASES TO BE AN ORDERING IN TIME LIKE ABA AND REDUCES TO A SINGLE, BRIEF IMAGE, AN INSTANTANEOUS WHOLE BOTH FIXED AND MOVING. SATIE'S FORM CAN BE EXTENDED ONLY BY REITERATION OR "ENDURANCE." SATIE FREQUENTLY SCRUTINIZES A VERY SIMPLE MUSICAL OBJECT; A SHORT UNCHANGING OSTINATO ACCOMPANIMENT PLUS A FRAGMENTARY MELODY. OUT OF THIS SAMENESS COMES SUBTLE VARIETY.

—Roger Shattuck, *The Banquet Years,* 1955

In painting, the repetition of a single motif (such as Larry Poons's dots or Gene Davis's stripes) over a surface usually means an involvement with Jackson Pollock's allover paintings. In sculpture, the repetition of standard units may derive partly from practical considerations. But in the case of Judd's, Morris's, Andre's, and Flavin's pieces it seems to have more to do with setting up a measured, rhythmic beat in the work. Judd's latest sculptures, for example, are wall reliefs made of a transverse metal rod from which are suspended, at even intervals, identical bar or box units. For some artists—for example, the West Coast painter Billy Al Bengston, who puts sergeant's stripes in all his paintings—a repeated motif may take on the character of a personal insignia. Morris's four identical mirrored boxes, which were so elusive that they appeared literally transparent, and his recent L-shape plywood pieces were demonstrations of both variability and interchangeability in the use of standard units. To find variety in repetition where only the nuance alters seems more and more to interest artists, perhaps in reaction to the increasing uniformity of the environment and repetitiveness of a circumscribed experience. Andy Warhol's Brillo boxes, silk-screen paintings of the same image repeated countless times, and films in which people or things hardly move are illustrations of the kind of life situations many ordinary people will face or face already. In their insistence on repetition both Satie and Gertrude Stein have influenced the young dancers who perform at the Judson Memorial Church Dance Theater in New York.

Yvonne Rainer, the most gifted choreographer of the group (which formed as a result of a course in dance composition taught by the composer Robert Dunn at Merce Cunningham's New York dance studio) has said that repetition was her first idea of form:

"I remember thinking that dance was at a disadvantage in relation to sculpture in that the spectator could spend as much time as he required to examine a sculpture, walk around it, and so forth—but a dance movement—because it happened in time—vanished as soon as it was executed. So in a solo called *The Bells* (performed at the Living Theater in 1961) I repeated the same seven movements for eight minutes. It was not exact repetition, as the sequence of the movements kept changing. They also underwent changes through being repeated in different parts of the space and faced in different directions—in a sense allowing the spectator to 'walk around it.' "

For these dancers, and for composers like La Monte Young (who conceives of time as an endless continuum in which the performance of his *Dream Music* is a single, continuous experience interrupted by intervals during which it is not being performed), durations of time much longer than those we are accustomed to are acceptable. Thus, for example, an ordinary movement like walking across a stage may be performed in slow motion, and concerts of *Dream Music* have lasted several days, just as Andy Warhol's first film, *Sleep,* was an eight-hour-long movie of a man sleeping. Again, Satie is at least a partial source. It is not surprising that the only performance of his piano piece *Vexations,* in which the same fragment is ritualistically repeated 840 times, took place two years ago in New York. The performance lasted eighteen hours and forty minutes and required the participation in shifts of a dozen or so pianists, of whom John Cage was one. Shattuck's statement that "Satie seems to combine experiment and inertia" seems applicable to a certain amount of avant-garde activity of the moment.

ART AS A DEMONSTRATION: THE FACTUAL, THE CONCRETE, THE SELF-EVIDENT

BUT WHAT DOES IT MEAN TO SAY THAT WE CANNOT DEFINE (THAT IS, DESCRIBE) THESE ELEMENTS, BUT ONLY NAME THEM? THIS MIGHT MEAN, FOR INSTANCE, THAT WHEN IN A LIMITING CASE A COMPLEX CONSISTS OF ONLY ONE SQUARE, ITS DESCRIPTION IS SIMPLY THE NAME OF THE COLORED SQUARE.

THERE ARE, OF COURSE, WHAT CAN BE CALLED "CHARACTERISTIC

EXPERIENCES" OF POINTING TO (E.G.) THE SHAPE. FOR EXAMPLE, FOL-
LOWING THE OUTLINE WITH ONE'S FINGER OR WITH ONE'S EYES AS ONE
POINTS. —BUT THIS DOES NOT HAPPEN IN ALL CASES IN WHICH I "MEAN
THE SHAPE," AND NO MORE DOES ANY OTHER ONE CHARACTERISTIC
PROCESS OCCUR IN ALL THESE CASES.

—Ludwig Wittgenstein, *Philo-
sophical Investigations,* 1953

If Jasper Johns's notebooks seem a parody of Wittgenstein, then Judd's
and Morris's sculptures often look like illustrations of that philosopher's
propositions. Both sculptors use elementary, geometrical forms that de-
pend for their art quality on some sort of presence or concrete thereness,
which in turn often seems no more than a literal and emphatic assertion
of their existence. There is no wish to transcend the physical for either
the metaphysical or the metaphoric. The thing thus is presumably not
supposed to "mean" other than what it is; that is, it is not supposed to
be suggestive of anything other than itself. Morris's early plywood pieces
are all of elementary structures: a door, a windowframe, a platform. He
even did a wheel, the most rudimentary structure of all. In a dance he
made called *Site,* he mimed what were obviously basic concepts about
structure. Dressed as a construction worker, he manipulated flat plywood
sheets ("planes," one assumes) until finally he pulled the last one away
to reveal behind it a nude girl posed as Manet's *Olympia.* As I've
intimated, Morris's dances seem to function more as *explications du
texte* of his sculptures than as independent dances or theatrical events.
Even their deliberately enigmatic tone is like his sculpture, although he
denies that they are related. Rauschenberg, too, has done dances that,
not surprisingly, are like three-dimensional, moving equivalents of his
combine constructions and are equally littered with objects. But his
dance trio called *Pelican* for two men on rollerskates and a girl in toe
shoes has that degree of surprise which characterizes his best paintings.

ART AS CONCRETE OBJECT

NOW THE WORLD IS NEITHER MEANINGFUL NOR ABSURD. IT SIMPLY IS.
IN PLACE OF THIS UNIVERSE OF "MEANINGS" (PSYCHOLOGICAL, SOCIAL,
FUNCTIONAL), ONE SHOULD TRY TO CONSTRUCT A MORE SOLID, MORE
IMMEDIATE WORLD. SO THAT FIRST OF ALL IT WILL BE THROUGH THEIR
PRESENCE THAT OBJECTS AND GESTURES WILL IMPOSE THEMSELVES, AND
SO THAT THIS PRESENCE CONTINUES THEREAFTER TO DOMINATE, BE-

YOND ANY THEORY OF EXPLICATION THAT MIGHT ATTEMPT TO ENCLOSE THEM IN ANY SORT OF A SENTIMENTAL, SOCIOLOGICAL, FREUDIAN, METAPHYSICAL, OR ANY OTHER SYSTEM OF REFERENCE.

—Alain Robbe-Grillet, "Une voi pour le roman futur," 1956, from *Pour un nouveau roman*

Curiously, it is perhaps in the theory of the French objective novel that one most closely approaches the attitude of many of the artists I've been talking about. I am convinced that this is sheer coincidence, since I have no reason to believe there has been any specific point of contact. This is quite the contrary to their knowledge of Wittgenstein, whom I know a number of them have read. But nonetheless the rejection of the personal, the subjective, the tragic, and the narrative in favor of the world of things seems remarkable, even if or even because it is coincidental.

But neither in the new novels nor in the new art is the repudiation of content convincing. The elimination of the narrative element in dance (or at least its suppression to an absolute minimum) has been one of Merce Cunningham's most extraordinary achievements, and in this the best of the young choreographers have followed his lead. Although now, having made dance more abstract than it has ever been, they all (including Cummingham in *Story*) appear to be reintroducing the narrative element precisely in the form of objects, which they carry, pass around, manipulate, and so forth.

ART AS FACT, DOCUMENT, OR CATALOGUE

RESEARCHERS MEASURED HEARTBEAT, RESPIRATION, AND OTHER INTIMATE BODY RESPONSES DURING EVERY STAGE OF THE SEXUAL EXCITATION CYCLE. IN ADDITION, MOTION-PICTURE CAMERAS CAPTURED ON COLOR FILM NOT ONLY SURFACE REACTIONS (DOWN TO THE MOST FLEETING CHANGE OF SKIN COLOR) BUT INTERNAL REACTIONS, THROUGH A TECHNIQUE OF MEDICAL PHOTOGRAPHY.

—Newspaper ad for *The Sexually Responsive Woman*

I could have picked any number of statistical quotations about the population explosion, or the number of college graduates in Wilming-

ton, Delaware, but the above quotation illustrates better how we can now treat all matters statistically, factually, scientifically, and objectively. One could bring up in this context not only the flood of art with sexual themes and explicit images, but Warhol's *Kiss* and *Couch* movies as well. Morris's *I* box, in which he exposes himself behind an L-shaped flesh-colored door, or his nude dance might also be brought up here. Mainly the point is that what we are seeing everywhere is the inversion of the personal and the public. What was once private (nudity, sex) is now public, and what was once the public face of art at least (emotions, opinions, intentions) is now private. And as the catalogue, of things again mainly, has become part of poetry and literature, so the document is part of art. As an example I might use Lucas Samaras's documentation of his years in a tiny, cell-like bedroom in West New York, New Jersey, transplanted in its entirety to the Green Gallery, or George Segal's quite literal plaster replicas of real people in familiar situations. In a similar inversion, whereas the unusual and the exotic used to interest artists, now they tend to seek out the banal, the common, and the everyday. This seems a consequence of the attitude that among young artists today, nothing is more suspect than "artiness," self-consciousness, or posturing. Not only do painters paint common objects, and sculptors enshrine them, but poets seek the ordinary word. Carl Andre has said that in his poetry he avoids obscene language because it calls attention to itself too much, and because it is not yet sufficiently common. Along these same lines, one of the most interesting things the young dancers are doing is incorporating nondance movements into their work.

BLACK HUMOR, IRONY, AND THE *MEMENTO MORI*

I COULD DIE TODAY, IF I WISHED, MERELY BY MAKING A LITTLE EFFORT,
IF I COULD WISH, IF I COULD MAKE AN EFFORT.

—Samuel Beckett, *Malone Dies*

IL N'Y A PAS DE SOLUTION PARCE QU'IL N'Y A PAS DE PROBLÈME.

—Marcel Duchamp

It is part of the irony of the works I'm discussing—and irony plays a large part in them—that they blatantly assert their unsalability and function-lessness. Some, like Artschwager's pseudofurniture or Warhol's Brillo boxes, are not too unwieldy to be sold, but since they approximate real

objects with actual uses, they begin to raise questions about the utility of art, and its ambiguous role in our culture. On the one hand, art as a form of free expression is seen as a weapon in the Cold War, yet on the other there appears no hope for any organic role for art in the life of the country. The artists, scarcely unaware of the provisional nature of their status, are responding in innumerable peculiar ways, some of which I've mentioned. Now, besides making difficult, hostile, awkward, and oversize art, an increasing number of artists seem involved in making art too large to fit into existing museums. There is no conceivable use in our society as it exists for such work, although it may endure as a monumental *j'accuse* in the case of any future rapprochement. Thus, part of what the new art is about is a subversion of the existing value structure through simple erosion. Usually these acts of subversion are personal rather than social, since it seems to be the person rather than the society that is in danger of extinction at this point.

Using irony as a means, the artists are calling bluffs right and left. For example, when Yvonne Rainer, using dramatic speeches in her dances as she has been, says one thing while she is doing another, she is making a statement about how people behave as well as performing a dance. In fact, the use of taped narratives that either do not correspond with or contradict the action is becoming more frequent among the dancers. The morbidity of the text Rainer chose as "musical accompaniment" for *Parts of Some Sextets,* with its endless deaths and illnesses and poxes and plagues (it was the diary of an eighteenth-century New England minister), provided an ironic contrast to the banality of the dance action, which consisted in part of transporting, one by one, a stack of mattresses from one place to another. Such a setting up of equations between totally dissimilar phenomena (death and play, for example) can be seen in a number of cases. Dan Flavin describes several commemorative sculptures he made this way: *"Icon IV. The Pure Land* is entirely white. The surmounting light is 'daylight' that has a slight blue tint. I built the structure in 1962, finishing it late in the fall. I believe that the conception dates from the previous year. *The Pure Land* is dedicated to my twin brother, David, who died October 8, 1962. The face of the structure is forty-five inches square. It was made of a prefabricated acrylic plastic sheeting that John Anderson cut to size for me." The factual tone does not alter when he describes (in a lecture given in Columbus, Ohio) his marriage: "After I left *Juan Gris in Paris* unfinished in 1960, there was a pause of many months when I made no work. During this period I married Sonja Severdija, who happens to be a strong carpenter."

Or consider Carl Andre's solution for war: "Let them eat what they

kill." Andy Warhol, whose morbid interest in death scenes has led him to paint innumerable Marilyn Monroes, electric chairs, and car crashes, claims that "when you see a gruesome picture over and over again, it doesn't really have any effect." Dan Flavin, in a journal entry of August 18, 1962, makes it clear that sentimental notions of immortality are to be ignored as motivations: "I can take the ordinary lamp out of use and into a magic that touches ancient mysteries. And yet it is still a lamp that burns to death like any other of its kind. In time the whole electrical system will pass into inactive history. My lamps will no longer be operative; but it must be remembered that they once gave light."

As a final example, I cite Robert Morris's project for his own mausoleum. It is to consist of a sealed aluminum tube three miles long, inside which he wishes to be put, housed in an iron coffin suspended from pulleys. Every three months, the position of the coffin is to be changed by an attendant who will move along the outside of the tube holding a magnet. On a gravel walk leading to the entrance are swooning maidens, carved in marble in the style of Canova. This opposition, of the sentimental to the ice-cold, is similar to the effect he produced in a dance in which two nude figures inch solemnly across the stage on a track to the accompaniment of a particularly lush aria from *Simon Boccanegra*.

THE INFINITE: NEGATION AND VOID

I HAVE BROKEN THE BLUE BOUNDARY OF COLOR LIMITS, COME OUT INTO THE WHITE, BESIDE ME COMRADE-PILOTS SWIM IN THIS INFINITY. I HAVE ESTABLISHED THE SEMAPHORE OF SUPREMATISM. I HAVE BEATEN THE LINING OF THE COLORED SKY, TORN IT AWAY AND IN THE SACK THAT FORMED ITSELF, I HAVE PUT COLOR AND KNOTTED IT. SWIM! THE FREE WHITE SEA, INFINITY, LIES BEFORE YOU.

—Kasimir Malevich, *Suprematism*, 1919

The art I have been talking about is obviously a negative art of denial and renunciation. Such protracted asceticism is normally the activity of contemplatives or mystics. Speaking of the state of blankness and stagnation preceding illumination, usually known (after St. John of the Cross) as the mystic's Dark Night, Evelyn Underhill says that the Dark Night is an example of the operation of the law of reaction from stress. It is a period of fatigue and lassitude following a period of sustained mystical

activity. How better to describe the inertia most of these works convey, or their sense of passivity, which seems nonetheless resistant rather than yielding. Like the mystic, in their work these artists deny the ego and the individual personality, seeking to evoke, it would seem, that semihypnotic state of blank consciousness, of meaningless tranquillity and anonymity that both Eastern monks and yogis and Western mystics, such as Meister Eckhart and Miguel de Molinos, sought. The equilibrium of a passionless nirvana or the negative perfection of the mystical silence of quietism requires precisely the kind of detachment, renunciation, and annihilation of ego and personality we have been observing. Certain specific correlations may be pointed out to substantiate such allusions. The "continuum" of La Monte Young's *Dream Music* is analogous in its endlessness to the *maya* of Hindu cosmology; titles of many of Flavin's works are explicitly religious (*William of Ockham, Via Crucis*). In fact, Flavin calls his works "icons," and it is not surprising to learn that he left a Catholic seminary on the verge of being ordained.

Of course, it is not novel to have mystical abstract art. Mondrian was certainly as much a mystic as Malevich. But it does seem unusual in America, where our art has always been so level-headed and purposeful. That all this new art is so low-key, and so often concerned with little more than nuances of differentiation and executed in the *pianissimo* we associate with, for example, Morton Feldman's music, makes it rather out of step with the screeching, blaring, spangled carnival of American life. But if pop art is the reflection of our environment, perhaps the art I have been describing is its antidote, even if it is a hard one to swallow. In its oversized, awkward, uncompromising, sometimes brutal directness, and in its refusal to participate, either as entertainment or as whimsical, ingratiating commodity (being simply too big or too graceless or too empty or too boring to appeal), this new art is surely hard to assimilate with ease. And it is almost as hard to talk about as it is to have around. Of the art that is being made now, it is clearly the most ambivalent and the most elusive. For the moment one has made a statement, or more hopeless still, attempted a generality, the precise opposite then appears to be true, sometimes simultaneously with the original thought one had. Roger Shattuck says of Satie's music, "The simplest pieces, some of the humoristic works, and children's pieces built out of a handful of notes and rhythms are the most enigmatic for this very reason: they have no beginning middle and end. They exist simultaneously." So with the multiple levels of an art not so simple as it looks.

COLOR-FIELD PAINTING: THE WASHINGTON SCHOOL

■

By this time, the early history of the Washington School is a matter of undisputed record. Important events include the founding of the Institute of Contemporary Art in 1947, the year Morris Louis moved to Washington, D.C. and Leon Berkowitz became the director of the Washington Workshop Center. Directed by Robert Richman, the Institute of Contemporary Art filled a function somewhat like that of the Artists Club in New York by sponsoring lectures, talks, and readings. Hayter, Gabo, and Albers as well as other avant-garde figures were invited to speak there. Studio classes, some taught by Kenneth Noland after his arrival in Washington in 1949, were held at the ICA as well. Classes and exhibitions were also conducted at the Washington Workshop Center, where Jacob Kainen, Morris Louis, and later Kenneth Noland taught. As informal meeting places, the ICA and the Workshop were the hub of the small circle of serious modern artists active in Washington.

Information reached Washington painters through reproduction, but there were also firsthand contacts with New York art and New York artists. Jack Tworkov, for example, taught at The American University in the early fifties, and de Kooning also lectured there. The art department of The American University was an active center. Later Catholic University, where Kenneth Noland taught and arranged exhibitions, became important. Clement Greenberg had met Noland at Black Mountain College; he was in Washington often to visit relatives.

Greenberg obviously played an important role in informing Washington artists regarding developments in New York. But Greenberg's view

of the New York School was highly partial. He was best known at the time as the friend and champion of Jackson Pollock, whose work he had praised for the first time in a celebrated review published in 1951. Because Greenberg acted as a filter, so to speak, for New York art, Washington artists were spared the confusion of the Tenth Street phase of action painting. They were introduced directly to Pollock and Frankenthaler through Greenberg.

The major difference between Greenberg's activities in and out of Washington is that in the various former colonies of the British Empire where he subsequently spread his doctrine, the results have been meager and basically decorative. In Washington, on the other hand, through fortuitous coincidence, Greenberg came into contact with an inspired group of artists capable of development.

ORIGINS OF THE STAIN TECHNIQUE

In the spring of 1953, Noland and Louis made their historic pilgrimage to New York to see Helen Frankenthaler's *Mountains and Sea,* the first color painting utilizing the stain technique. That same year, a de Kooning exhibition was held at the Washington Workshop—the brochure contained a brief preface by Greenberg—and Adelyn Breeskin held a major exhibit of the leading abstract expressionists at the Baltimore Museum. Because of this exposure to New York art, by 1954 Washington artists had enough of an idea of the look of abstract expressionism to imitate Gorky, de Kooning, and Kline. Only Louis, however, was at this point sufficiently daring or mature to attempt to follow Pollock's example. Several black-and-white works such as the 1951 *Charred Journal* paintings document Louis's early interest in Pollock. Because he had obviously already been thinking about Pollock, Louis was readier to understand how Frankenthaler was using the method she adapted from Pollock's 1951 paintings, using Duco enamel dripped and poured into raw canvas to create a new technique for sinking color directly into unprimed cotton duck.

Inspired by Frankenthaler's technique, Louis painted his first series of veils in 1954. These visionary works come closer to the exceptional unity of Pollock's drip paintings than any other paintings made since. By spilling and pouring paint, Louis was able to create for the first and last time since Pollock an image as "automatic" in execution and as indissolubly whole in appearance as Pollock's interwoven meshes of dripped paint. Louis's innovative process of applying paint allowed him to efface

manual gesture entirely. This in turn annulled the separation between painting and drawing still linking Frankenthaler to Gorky, Kandinsky, and Miró, and consequently to earlier art in which painting and drawing were separable elements. In their capacity to synthesize the traditionally antithetical elements of painting, *desegno* and *colore*, Louis's veils were the most "advanced" painting of their time.

Louis initially conceived the veils while Pollock himself was still alive and struggling to find another fresh synthesis yet more radical and more absolute than that of the drip paintings. In many respects, Louis's veils solve the problem Pollock himself could not resolve: that is, how to create an image even more compressed, immediately communicable, and wholistic than that of the drip paintings. In these revolutionary works, Pollock had already synthesized painting and drawing, eliminating the shape-defining function of line as closed contour, with his swelling painterly line.

By folding the canvas vertically, apparently draping it over a trough, and pouring paint down into the folded channels, Louis coalesced the process of creating an image with its resultant structure. He also found a unique way of referring the image to its frame through this process. Not all the early veils, however, relate image to frame so explicitly. It appears that only some were made by pleating and folding the canvas; others seem worked more freely. We understand the importance of the structural element in those early veils in which paint was poured into vertical channels when we examine Louis's second series of veils done in 1958, which are in many ways a critical revision of the initial veils. In these, the flow of paint in vertical patterns parallel with the side edges of the frame is consistently emphasized, ensuring the visual coupling of image with frame.

Thus Louis's 1958 veils are refinements of the original 1954 veils, the best of which, in terms of unity and coherence, are those that explicitly stress image-frame relationships by emphasizing vertical flow. By contrast, the series of paintings related to the veils known as "florals," done in 1959 as a kind of coda to the 1958 veils, in which color is allowed to spread laterally, are weaker works because they lack the explicit relational structure of the veils.

In Washington the groundwork had already been prepared for the development of a color art. Noland was already especially sensitive to color, having studied at Black Mountain College, where he was exposed to Albers's theory of the interaction of adjacent colors, a modernized Bauhaus version of neoimpressionist color theory based on the writing of Eugene Chevreul.

Frankenthaler was, to quote Louis, "the bridge between Pollock and what was possible." For his part, Louis was able to arrive at what one must term a new definition of painting, so complete was his revision of cubist canons. This revision was begun by Pollock and Frankenthaler, but Louis took their concepts one step further by revising the role of drawing. Pollock, and Frankenthaler following his lead, drew in paint, thus synthesizing the two classical antipodes of art. But their drawing remained the record of a manual gesture. Louis removed the hand of the artist entirely in his pouring and spilling, and gained a greater degree of abstractness through impersonality. In the veils Louis arrived at a technical process—contingent mainly on the way paint dried—by means of which the *detail of drawing* was still present without any evidence of manual gesture. This enabled him to preserve the function of drawing without separating it from color or creating conventionally contoured shapes.

The presence of detail created through a *mechanical* rather than a *manual* process was made possible by staining successive layers of paint into paint (probably while underneath layers were still wet). The result of this process was that paint dried irregularly, so that a smoky residue often appears to lie on the surface of the veils. These delicate smoky paint residues form patterns unlike drawn shapes in that they lack sharp linear contour. Nevertheless, soft edges bleeding into canvas or into painted surface create elegant detail by lying against each other, thus subsuming the *function* of drawing.

THE WASHINGTON CONTEXT

While Louis was painting his first series of veils in 1954, Gene Davis was also looking at Klee and Dubuffet, whose work he had seen in exhibitions at the Kootz Gallery in New York. Noland, too, was experimenting in several styles; and some early works were strongly influenced by Paul Klee.

Noland was not the only Washington painter to look closely at Klee. Klee played the role in Washington that Kandinsky played in New York, which made for crucial differences in approach and emphasis. As opposed to Kandinsky's expressionist romanticism, Klee's experiments with surface and texture, his early use of banding, central images, and geometric motifs, provided important precedents for the kind of technique and imagery eventually developed in Washington. Klee was accessible in

Washington as Kandinsky was accessible in New York because of the taste of a local collector. As Solomon Guggenheim had assembled a great collection of Kandinsky's works in his New York museum, so Duncan Phillips put together a remarkable collection of Klee's works. No one who has ever lived in Washington (this writer included) can ever forget the impact of the Klee room at the Phillips Gallery. There are paintings in that room such as *Arab Song*, a whimsical figure painted directly into burlap, as Washington painters would later stain their images directly into raw canvas. In *Arab Song* Klee emphasizes the coarse weave and texture of the burlap ground as a piece of cloth, as they would call attention to the identity of the canvas as fabric. Klee's subtle, unusual color sequences often included muted pastels and a range far beyond that of the colors of the spectrum used by Kandinsky in his expressionist works.

Klee was not the only important painter Washington artists could see in depth at the Phillips Gallery. Because of Duncan Phillips's taste for impressionist and impressionist-derived paintings, the Phillips Collection is strong in examples of color art. Consequently the memories of Washington artists were impressed with the light-filled images of a colorist like Bonnard, and of painters like the neoimpressionist Monticelli, whose uniform surfaces of identical *machiaioli* were an early example of the allover distribution of stippled color, in terms, however, of a figurative style. (Monticelli could also be seen at the Corcoran, which had a room full of his works on exhibit in the fifties.)

The Phillips Gallery is also particularly rich in watercolors by the Americans Dove and Marin, whose works may have helped to develop the taste for thin transparent paint and the watercolor-like technique of staining adopted by the Washington painters. Thus in constructing the context of the Washington School, one must count the Phillips Collection as the other decisive factor, along with Greenberg's influence, in orienting Washington painters toward color painting and away from any cubist-derived style. Possibly the Washington School developed as other provincial schools did not because Greenberg was there often over a period of years, rather than just to give a lecture, and because the Phillips Gallery, like the Museum of Modern Art in New York, provided examples of a tradition artists could study. That the Modern is predominantly a collection of classical cubist and constructivist painting whereas the Phillips is rich in color painting, decorative art, and the painting of Paul Klee must be taken into consideration in any historical study of the Washington School.

BEYOND ABSTRACT EXPRESSIONISM

Distance from the New York art market gave Washington painters freedom and the time to develop gradually while experimenting with new techniques and images that did not necessarily have to be salable. But despite the physical remove of Washington artists from the New York scene, the psychological pull of action painting—the modish vanguard style throughout the fifties—remained strong. Not surprisingly, all experimented with forms of gestural abstraction. For the most part, these efforts are not memorable, with the possible exception of a few canvases painted in the mid-fifties by Gene Davis in imitation of Kline's bold structuring of the paths of gesture. In these works, which mark his first use of banding, David regularized Kline's brushstrokes, lining them up parallel to the framing edge to reiterate, as did Newman's stripes, the vertical support.

Louis's action paintings, now mostly destroyed, were executed between the first and second series of veils, that is, between 1955 and 1957. In these works, Louis apparently regressed to a pictorial illusionism based on color contrast reminiscent of Hofmann's "push-pull" principle of the optical illusion involving the advancement and recession of color lanes. Abandoning the stain technique for the moment, presumably in pursuit of greater color intensity, Louis failed to reconcile color with flatness in a convincing manner. In these works, planes of color laid over one another—as the veils had been superimposed—created a series of receding planes because of their opacity at odds with Louis's desire to transcend cubist illusionism.

Louis was mercilessly critical of his own work and destroyed most of the paintings. Two of the few examples still extant are an untitled abstraction of 1956 in the Corcoran Melzac Collection and another work of the same year in the Detroit Art Institute. These painterly works appear to be experiments in gaining luminosity through color saturation as an alternative to the muted receding tones of the veils. Louis was finally able to achieve the brilliance and purity of hue he desired in the "unfurls." He could do this, however, only by separating colors out from one another, contrasting them with the dazzling whiteness of the raw canvas, which made them appear that much brighter. The relative transparency of the veils, on the other hand, created a very different kind of illusion. This illusion was related to the use of light in the "unfurls" in that it gave the impression of a light source within the canvas, that is, of light coming from behind and filtering through the image. This

use of light links Louis with the whole tradition of luminist landscape painting from Claude Lorraine to Turner, in which a light source within the painting floods the foreground. Indeed the very structure of the unfurls, with their diagonal rivulets of color framing an open center, recalls the structure of Claude's classical landscapes in which architectural monuments frame a light-filled open center.

It was Noland who first realized that opaque, fully saturated colors had to be separated from one another so as not to create cubist overlapping. Possibly Louis's unfurls which overlap are not as successful as those which do not simply because they are not as uncompromising in this respect. With the stain technique, Noland was able to create an entirely different spatial experience from that of Albers, although he continued to utilize Albers's principle of the interaction of adjacent colors. But Albers's space, like Hofmann's color space, remained essentially cubist because it depended on the advancement and recession of planes from the surface. Although Noland creates space through optical color contrast, his space never recalls cubism because the technique of staining, visibly uniting figure with ground, frees him from the illusion of receding and advancing planes.

By 1958, Louis's style and imagery had crystallized. This was not true of the younger painters working in Washington. Louis's veils were extremely powerful and original images. With the veils and to some extent the unfurls rests Louis's claim to originality as a colorist. Examining the color of the later stripe paintings we find it is dominated by the conventional primary and secondary colors and variations of them. The grayed twilight pastels of the early veils and the bronzed autumnal tones of the later veils are, however, another matter. Here the technique of pouring color into color enabled Louis to create an unusual optical mixture *within* the canvas itself through subsequent pourings. As a result of this process, bright residues of earlier stainings seep around and through the smoky transparent surface "veils."

As long as Louis continued working this way, his color was original. As soon as he began following Noland's example and setting colors adjacent to one another, however, he lost a lot of his originality as a colorist. In the unfurls, the image of a vast expanse of reserved canvas flanked by curtains of brilliant color was sufficiently dramatic to carry the paintings. When Louis moved on to the stripes, however, he became involved in a neutral image lacking inherent drama. Without the interest created through highly charged imagery, the stripes in themselves must rely exclusively on the power of Louis's color to engage and arrest. Often his color is simply not unusual or surprising enough in these late works

to carry the full burden of pictorial expression placed on them. Thus the most exciting of Louis's stripes are usually the most irregular in structure and asymmetrical in placement because they are not entirely static images.

Imagery was crucial to the expressive content of Louis's work, but technique permitted his final breakthrough. Louis worked as Pollock and Frankenthaler worked—that is, on a canvas roll that was cropped and stretched after the painting was finished. Louis's cropping, however, was quite different from Pollock's and even from Frankenthaler's. Pollock cut the canvas close to the image, obviously with the dimensions of the stretcher in mind as he painted, perhaps the reason his drip paintings are closer to the easel-painting tradition and to analytic cubist concerns than are the paintings of Frankenthaler, Louis, and the color painters who followed them. Frankenthaler was willing to allow her images to break the frame; she "cropped" as Degas had cropped his images, in imitation of the camera eye. Louis, on the other hand, placed his images in the center of areas of unpainted canvas, taking full advantage of the ability of the bare canvas to suggest limitless space. However, except in his very last stripes, which float freely in space, Louis anchors his images to at least one edge of the canvas, usually the bottom, emphasizing a sense of gravity in the directional flow of paint.

Noland's paintings, as well, owe many of their striking features to the way he made them. The circular image must have originated in some part from the act of walking around his works. Because one understands he marked the center by reaching with his arms from the periphery, these works have an implicit sense of human scale Noland loses in his later banded paintings. Stretching after the fact had other advantages too. In the chevron paintings that superseded the circular motifs, Noland was able to orient the image with regard to the frame by stretching the diagonal chevrons to bisect the corners, calling attention to the angle formed by the bars of the support.

Another difference in the effect of paintings done off as opposed to on the stretcher is the kind of surface tension created. In stain painting, surface tension is not necessarily bought at the price of a hard resistant surface limiting illusionism to a literal minimum. On the contrary, the emphasis on the softness of the cloth and transparency of paint creates a surface that appears to open itself to visual penetration, rather than to close itself off in a literalist definition of flatness. This is an important distinction between Washington color painting and the works of Kelly, Stella, Youngerman, Bannard, etc., who work on prestretched canvases.

Twelve years younger than Louis, Noland was understandably influenced by the older man's more mature works. Noland came later than Louis to staining and to a structure based on image-frame relationship. Noland's so-called tip or pinwheel paintings of 1959 appear directly related to Louis's unfurls, both in the way they are painted, i.e., through pouring, and in their spreading flamelike image. In a sense they appear the reverse of the unfurls; whereas Louis leaves the center bare, framing it with banks of color flowing outward to the canvas edge, Noland centers the image, leaving the periphery bare. Noland's chevrons also recall Louis's unfurls in the manner they are stretched to acknowledge the framing edge of being anchored to its corners. Similarly, Noland's adoption of the stripe motif beginning in 1968 recalls Louis's earlier use of such a motif.

Having followed Louis's example in adopting the stain technique as a means for creating a special class of color illusions compatible with flatness, the major question for Washington artists was how to find an adequate way to structure a pictorial statement. Allover painting was not really suitable to an intense color experience, which may be one reason Pollock never developed as a color painter. Allover painting involving stippling or calligraphy of the kind Noland, Mehring, and Downing were doing in the fifties could not yield as direct and intense a color experience as, for example, Newman's large field of a single color, because the allover inevitably involves optical mixture, not optical purity. Alone among Washington painters, Louis found a way of circumventing this problem.

In comparison with the wholeness and singleness of image Louis was able to create in the veils, the other Washington painters appeared to be still embroidering the surface with their drawing, dots, patches, and calligraphic patterns.

Arriving at a structure capable of presenting color in the most direct and unencumbered way possible was not easy, if cubist shapes were to be avoided. Pollock's and Louis's respective techniques of dripping and pouring precluded the creation of conventional figure-ground discontinuities. The simplest solution, and the one everyone in Washington outside of Louis took initially, was to find some variation of Pollock's alloverness. But the atomization of color and its consequent diminution in intensity gave rise to other problems. The allover style carried to a literalist extreme can only produce wallpaper, not art. Without the surface variations employed by Pollock in the drip paintings (varied consistency, thick pigment, reflective paint, foreign materials), the all-

over style has a hard time distinguishing itself as painting from repeated design motifs. Louis's veils were sufficiently irregular, and in the best sufficiently explicit in their awareness of the frame.

There was, however, an important source for such symmetrical, centered imagery in currency in the late fifties. Painted in 1955, Jasper Johns's targets were exhibited in 1957 at the Jewish Museum and in his first one-man show at the Castelli Gallery in 1958. It is doubtful if anyone in Washington saw these shows, although like painters all over America, Washington artists took notice of the target by Johns which appeared on the cover of *ARTnews* in January 1958. The cover had as profound an effect on artistic thinking in Washington as it did everywhere else it was seen. The radicality of Johns's preconceived image, especially in the context of action-painting improvisation, was that it provided an avenue of escape from the looseness and lack of structure that led to the demise of abstract expressionism. Although Johns remained a painterly painter, other artists, inspired by his example of a preconceived emblematic structure, rejected the painterliness of abstract expressionism in favor of the style Greenberg has called "post-painterly abstraction."

Greenberg's implicit claim that post-painterly abstraction is the style of advanced art in the sixties is justifiable on the basis that it is a more complex synthesis—one which includes the lessons of Pollock—than other styles of color painting. "Op art," for example, continues to depend on cubist figure-ground relationships already superseded by Pollock. Similarly, color painting that leans exclusively on Matisse's late cutouts without incorporating the lessons of the mature Monet regarding a dispersal of pictorial focus and a virtual obliteration of edge as drawing through an atomization of color is not as advanced as painting that takes Monet and Pollock into consideration.

Judging by such criteria, the work done in Washington while New York artists blindly imitated de Kooning formed the basis for the post-cubist abstraction of the sixties. Washington must be regarded as the initial stage of the explosion of color painting that characterizes American painting of the last decade.

III

ON PAINTING

MONDRIAN BOOGIES IN NEW YORK

By the time Piet Mondrian arrived in New York in 1940, his work was appreciated, his essays studied, and his style closely imitated within the small circle of New York abstract painters. Mondrian's actual presence in midtown Manhattan had two additional consequences: it reinforced the current of American geometric abstraction, a branch of the original European circle-and-square and abstraction-creation groups seeking to establish geometric abstraction as an international style; it was also a tremendous boost to the flagging morale of avant-garde American artists generally, even those who rejected Mondrian's own closed, hard-edged style and strict dogmatic canons regarding the exclusive use of the right angle and the primary colors. In the forties, American artists were at the bottom of their psychological depression. They felt alone, rejected by society, useless in the war effort. Yet here was Mondrian, an obviously great master who waited until the age of seventy to have his first and only one-man show in New York in 1942 at the Valentine-Dudensing Gallery. The emerging American avant-garde saw the show if only because there was so little to see. For the occasion, Mondrian wrote a text published by the gallery titled "Toward a True Vision of Reality." Mondrian's preoccupation with art's *reality*—in a philosophical as opposed to a representational sense—was, we shall see, his central contribution to the formulation of the aesthetic of the New York School. That this contribution was not attributed to Mondrian specifically, but found its way into New York thought partially through a gradual osmosis of cubist thought, may be explained by the frank distaste of New York artists for Mondrian's style. Even if Mondrian's personality was upheld as an example of heroic perseverance in the face of philistine hostility, Mondrian's purist classical art was largely rejected as the contrary of the

spontaneous, free expression sought by abstract expressionists in New York.

In the forties, Mondrian's works might not have been as fashionable as Max Ernst's or Matta's latest experiments in automatism, but nonetheless they were extremely visible. By the time Mondrian died of pneumonia in 1944, his work was included in all the major collections of modern art in America: Peggy Guggenheim's "Art of This Century" (for the catalogue of which Mondrian wrote an important preface on abstract art); A. E. Gallatin's Gallery of Living Art; the Museum of Modern Art; and the Société Anonyme. The Guggenheim Museum, then the Museum of Non-Objective Art, also exhibited Mondrian's paintings during the forties.

Mondrian's influence was central to the development of postwar American art even if within the "action" painters' milieu his style was anathema. This has not been sufficiently acknowledged because of the altogether erroneous assumption, again indoctrinated into critics by artists involved in their own myth-making, that to acknowledge a source is to deny one's originality. Certainly we have reached the point now when we must investigate the historical sources of recent work and question the idea that "innovation" confers any degree of quality. It is an urgent critical problem to dissociate the concept of historical innovation from that of qualitative durability.

The time has certainly come to close the phase of chauvinistic criticism that accompanied the emergence of the new American painting. It is appropriate to begin with an honest appraisal of the contribution of Mondrian.

Mondrian's influence may be divided into three distinct phases. The initial phase took place during the early forties, when he displaced Jean Hélion to become the major theoretical influence on the group of painters who formed the American Abstract Artist, to which he nominally belonged (although apparently he attended only one meeting). Most AAA artists were indebted to Mondrian's theories of geometric form and relational composition. Some clearly imitated Mondrian's image. Among this group were Ilya Bolotowsky, Michael Loewe, and Mondrian's close friends Harry Holtzman, Charmion von Wiegand, and Fritz Glarner. Other American abstractionists, such as Burgoyne Diller and Nassos Daphnis, referred to aspects of Mondrian's neoplasticism, such as the restrictive use of color and exclusively geometric form, but were able to evolve a more original image. Diller, especially in his late paintings and sculptures, developed into an artist of considerable significance and originality.

After Mondrian's death, his influence did not wane. If anything, he became more prominent in the minds of American artists, who began to define themselves not in imitation of Mondrian's image, but in opposition to his highly codified purist aesthetics, which centered on the issue of *relationships*. We shall see how this obsession culminated in a post-cubist style.

In 1945, a year after Mondrian's death, there was a major retrospective of his work at the Museum of Modern Art with a catalogue by James Johnson Sweeney. Mondrian's own essays were published by George Witteborn as part of the Documents of Modern Art series (edited by Robert Motherwell and Ad Reinhardt), and he came to the attention of a mass public in an article in *Life* magazine, which presented him as a symbol of asceticism, integrity, and artistic independence.

Consequently, in the late forties, the second phase of his influence, Mondrian was on everyone's mind. Entering the larger awareness of artists beyond his own circle, Mondrian began to be seen by the New York School as the quintessential late-cubist geometric painter. Hence he was the Enemy. As consciousness of his work and theories grew, this negative reaction ironically became more intense; fewer ambitious artists were content merely to imitate Mondrian's style. More consciously than earlier art, and perhaps because of the Marxist training of its leading spokesmen (e.g., Harold Rosenberg, Clement Greenberg), New York School art has defined itself in terms of a dialectic. Since the forties, Mondrian has consistently represented one pole of that dialectic, while the other pole has changed through time. At first it was Mondrian vs. Picasso: pure geometric abstraction vs. figurative expressionist cubism. Then in the late forties, as Pollock developed a new form of composition based on the allover texture and lack of hierarchical distinctions of late impressionism, Mondrian's architectonic analytical cubist works, the plus-and-minus paintings, which also influenced Pollock, came into new historical focus. Philip Guston's first abstract works, their crosshatched painterly marks huddled in the center of the field, are also certainly indebted to Mondrian's *Ocean and Pier* paintings.

In the late forties and early fifties, structural elements drawn from Mondrian's mature grid paintings were fused with the transparent atmospheric painting of Matisse and the "allover" style of late impressionism in a synthesis that determined the future of American painting. The formulation of this synthesis may be traced as it evolved in Mark Rothko's and Ad Reinhardt's work of the late forties. In Rothko's works of 1947–49, we see the amorphous surrealizing blots of paint gradually coalescing into structured rectangles reminiscent of Mondrian's planes

of color, at least with regard to their frontality and explicit relationship to the framing edge, which they echo. During the same period, Ad Reinhardt's paintings, which had been abstract since the thirties, began to resemble, in their floating rectangles silhouetted against a field, Mondrian's *Compositions with Color Planes* of 1917, which represent Mondrian's initial introduction of flat color planes as yet unbounded by the tight linear corset of the black lines of the grid.

A crucial issue of New York painting in the late forties was the need to find a structural principle that would provide coherence, spatially and compositionally, for the spontaneous, automatic gestures of painterly brushstrokes lacking closed contours. More often than not, this structure was adapted from Mondrian's grid. If we take *Little Spanish Prison*, a painting that stands out as a brilliant anomaly in Robert Motherwell's early career, it is hard to find sources other than Mondrian for the strictness with which vertical bands, parallel to the framing edge, are contrasted with the single horizontal opening. Inspired by a literary image of vertical prison bars with a viewer's slot behind which the prisoner was metaphorically caged, the image is hard to imagine without the precedent of Mondrian and his theories, with which both Motherwell and Reinhardt were familiar in their capacity as the editors of the Documents of Modern Art.

The awareness of Mondrian by the New York School is less obvious than it might be. But abstract expressionism had a stake in obscuring its European origins. Emphasis has been put on the origins of abstract expressionism in the rejection of the closed forms of synthetic cubism, including Mondrian's hard edges, geometric forms, and clearly located flat color planes. This is correct. But it should be added that the importance of having Mondrian as foe, as a highly concrete and visible presence to react against, was crucial for the emergence of any structural principle in the works not only of Guston, but also of Rothko, Motherwell, Reinhardt, Tomlin, and Gottlieb, whose pictographs reflect Mondrian's grids once removed as seen through the eyes of Torres-Garcia. Even Franz Kline's bold black-and-white paintings, especially those with rectangles occupying the center of the field, were influenced by Mondrian's flatness, as well as by his use of black and white as colors and planes, and not simply as graphic elements. Hofmann's paintings of abutted colored rectangles of the sixties appear to belong to the third wave of Mondrian's influence in America, which began in the sixties.

Hofmann's late paintings, however, remain both clearly *relational* and clearly *asymmetrical*, the two principles Mondrian insisted upon with greatest emphasis. The task for American painters of the fifties, on the

other hand, if they wished to incorporate anything from Mondrian without becoming merely epigones of his style, was to refute these two elements as the basis for pictorial design. This task fell mainly to Barnett Newman. Although Newman attended lectures and exhibitions, and was known as one of the best-read and most articulate members of the New York School, he did not exhibit any work executed prior to 1946. By that time Mondrian had died. We may assume Newman spent this time thinking, since he was consistently on the art scene, and that a lot of this thinking was devoted to Mondrian. Among Newman's first works are two paintings whose titles refer to a hostility toward geometric abstraction: *The Death of Euclid*, and *The Euclidean Abyss*. These early abstractions by Newman represent an attempt to find a structuring principle which would definitively supersede Mondrian's theory of relationships as the basis of pictorial design. If we substitute Mondrian's name for Euclid's as the symbol of geometric order, we can see Newman's struggle against the principles of relational composition, so didactically asserted by Mondrian, as a heroic undertaking. Einstein, however, probably found it easier to finish off Euclid than Newman did to write off Mondrian. Because of his contact with a milieu of architects, Mondrian had built his theories around a crucial discovery regarding the social role of easel painting in the twentieth century. Defining the problem, he found its solution as well.

When the expressive function of art began to dominate even secular art in the nineteenth century, a certain crucial dilemma was posed: how to relate the easel painting organically to its architectural context. Attempts were made by painters like Puvis de Chavannes and Whistler to create decorative ensembles that placed painting in a harmonious relationship with architecture. But basically the problem became insoluble once paintings were no longer commissioned by either architect, designer, or patron for a specific setting.

Because of his contact with the architectural theory that formed so great a part of the ethic and aesthetic of de Stijl, Mondrian was acutely aware of the significance of the social and architectural context. He believed in the union of the three plastic arts within a collective universal style based on the timeless constant of geometry, a common denominator of form that could be traced back to the most ancient civilizations. For the present, however, Mondrian acknowledged the equivocal status of easel painting with regard to its architectural context. Still he continued to hope for the disappearance of painting within a universal architecture. Recently his sketches for a room, whose purpose of subsuming painting and sculpture within architecture was not unlike Lissitsky's

reason for creating the Proun room, was realized in Formica—a material Mondrian could not have known but might have liked—by the Pace Gallery in a questionable but interesting experiment. In this room, Mondrian's geometric forms were embedded directly in the walls, as opposed to hanging them in the normal relationship of the raised surface of the easel picture separated by its frame from any architectural context.

The failure of the International Style to emerge as *the* architectural style of the twentieth century, a uniform, generalizable modular system based on pure geometry, capable of infinitely variable combinations, had special repercussions for Mondrian's vision of painting. Beginning in works of the twenties, he focused on the actual physical properties of his frame, emphasizing its boundaries by raising the canvas from a background as if to assert its further autonomy and absolute independence from any architectural context. Ad Reinhardt's paintings, although negations of Mondrian's opaque resistant surfaces, were defined in opposition to Mondrian. But one of their peculiar qualities is the recession of the painting behind its frame. This was an inversion of Mondrian's denial of the importance of any context beyond that established by the painting itself, now armored from incursions or the necessity to relate to the surrounding wall on which it hangs.

The continuing *agon* between painting and architecture set up by the aggressively sculptural forms of Frank Lloyd Wright's design for the Guggenheim Museum has proved that individualism indeed won out over any impulse toward the collective. Seeing Mondrian's paintings hanging in a building so at odds with his own principles of design proves that the assumptions of the de Stijl and constructivist architects were false. An international modern style compatible with the aims of socialized society was an unrealizable utopian ideal. The modern world tends toward disorder, not order. A rational economic system capable of integrating humanistic cultural impulses has been the dream of generations of modern artists. The realization that no such marriage between an international architectural style based on rational principles of design and a rational socialist economy was forthcoming forced Mondrian to acknowledge that there continued to be an irrevocable separation of painting and sculpture from any architectural or social context. Thus the new emphasis on the frame we discern in Mondrian's mature style. Extending the forms around the lip of the support, and framing the canvas in such a manner as to "raise" it from the wall surface, is a sign of this acknowledgment, a signal that modernist painting, intentionally or not, was doomed to autonomy and self-reference. An even greater emphasis had to be placed on the frame itself as the only context to

which the elements contained within the pictorial field could refer themselves. The frame became, by default, the architectural context by means of which painting declared its independence from architecture. The extent to which image–frame relationships are stressed in Mondrian's neoplastic paintings, which abandon the earlier oval format completely, is the degree to which the *frame itself* becomes the missing context for painting. This is especially true of the "lozenge" paintings, which confront the rectangularity of the room by counterposing a diagonal, in the framing edge though not within the pictured right angles within the painted field, against the straight angles of wall, floor, and ceiling.

Mondrian assumed that architecture would continue to stress the right angle and that rooms would be boxes as paintings were rectangles. That Mondrian had actually conceived of a room as a total visual environment is in itself significant; it represents yet a further admission that he had abandoned any real hope of a fusion of the arts, unless that fusion was imposed by the painter himself within an architectural context of his own design, regardless of any social function.

In this light, Mondrian's insistence on the central importance of *relationships* within his work can be seen as the acknowledgment that this was the only sense in which the painter had any power to determine the context for his images: part-to-part, part-to-whole, and image-to-frame relationships necessarily became the core of his work. The intervals between planes and lines were an essential element in the balance of these relationships. This was a tight and logical system to break. Of the painters of the New York School who sought to find a different system of structure, Barnett Newman was the most radical, because he was the first to challenge the issue of relationships. In the sixties it became fashionable to speak of Newman's works as "nonrelational" because he did not depict forms against a background or relate them to one another in the manner of familiar cubist "rhyming," of which Mondrian's repeated rectangles were merely a severer form. The term "nonrelational" is a misnomer. Although Newman jettisoned Mondrian's system of balancing out *internal* relationships within the field, by simply dividing the field with a band or bands, he did so to give an even greater emphasis to the dominant relationship of the painted image to its framing edge. Newman's bands or stripes or "zips," as he sometimes called them, are explicitly parallel to the framing edge, the better to insist more forcibly on the importance of the frame as the only context painting had to acknowledge. Newman did not use Mondrian's rectangles, grids, or primary colors, but Mondrian's attitude toward the num-

ber of elements and colors painting might reduce itself to, while remaining a complex experience, surely encouraged Still and Rothko, as well as Newman, to experiment with severely reductive formats.

It is doubtful Newman could have forged so powerful a style without a strong opponent like Mondrian to define himself against. In a lengthy theoretical article, "The Plasmic Image" (quoted by T. B. Hess in his monograph on Newman), whose very title refers to Mondrian's "plasticism," Newman discussed Mondrian's 1945 Museum of Modern Art exhibition:

> There has been a great to-do lately over Mondrian's genius. In his fantastic purism, his point of view is the matrix of the abstract esthetic. His concept, like that of his colleagues, is however founded on bad philosophy and on a faulty logic.

The essence of Newman's argument against Mondrian's neoplasticism, which reduced the world to "the horizon table-line of the earth" and "the vertical lines of things that stand and grow on it," was that it was still Platonic. It continued to picture a world, no matter how abstracted, that existed outside the painting. Newman, on the other hand, spoke of the goal of his work and that of his New York contemporaries as being concerned with "a new type of abstract thought," directly embodied in pure form, as opposed to being abstracted from nature.

Newman's attack on Mondrian is the finale of the idea of the independent *reality* of the work of art, as an object in the world, and not merely the reflection, depiction, or representation, of other objects in the world. This change in the status of the art object, from a reflection of things in the natural world to a thing in itself, a fundamental assumption of modernism first focused on as a philosophical problem by the cubists, was developed even further by Mondrian.

Newman might have written off Mondrian on paper, but he continued his dialogue with the master in his work. Drawing on Mondrian's discovery of the ability of image–frame relationships to free painting from the need of any context other than its own boundaries, Newman began to enlarge his painted fields, in which he had eliminated internal part-to-part relationships. The enlargement of the painting to mural size, the fact that it became larger than the field of vision, created a new relationship of view to work, and acted to further defy any context to impinge on the autonomy and totality of the pictorial experience. The viewer's relationship to such work was necessarily more immediate than to paintings he could stand outside of and calculate the relationships of

part to part within the painting, instead of concentrating on his own primary relationship to a field of color.

No doubt Newman won the bout with Mondrian, although it went on, silently, throughout his life. Among the last paintings by Newman is a series of four titled *Who's Afraid of Red, Yellow and Blue?* Finally, assured of his own conquest of the problems posed by Mondrian's paintings, he was free to use Mondrian's own palette, and Newman could publicly declare the challenge to Mondrian always implicit in his paintings. The bands in these late paintings no longer divide a field but frame it. They are moved to the framing edges themselves. The painting "frames" itself, dividing itself from any context, which reiterates Mondrian's insistence on the independence of painting from context.

It is not coincidental that the magazine published to publicize abstract expressionism was called *It Is.* Mondrian's assertion on the literalness of the properties of the painting, including his insistence on flatness as a defining property of painting as an object in the world, was subsumed within the aesthetic of abstract expressionism without open acknowledgment of its source. Indeed, there was no member of the New York School who was not touched by Mondrian. The locked-in forms of Still, the divided color fields of Newman, the rectangles of Rothko, the planar stress of Motherwell and Kline are indebted to Mondrian's radical compression of pictorial space. Even the widespread use of black and white in New York painting around 1950 is more closely linked to Mondrian's dramatic juxtaposition of the two than to the chiaroscuro tradition. In the sixties, Al Held's bold geometric solids viewed as transparent diagrams would once again recall paintings by Mondrian that confined themselves exclusively to heavy black lines against a white ground.

Of all the first-generation New York School artists, however, Ad Reinhardt remained closest to Mondrian in terms of image as well as aesthetic. That he studied Mondrian's theoretical writings closely is evident when reading Reinhardt's own texts on art. Indeed, some are direct, if unconscious, parodies of Mondrian's writings. Reinhardt's auto-interview in *ARTnews,* for example, refers to Mondrian's well-known 1920 text "Natural Reality and Abstract Reality," an essay in dialogue form in which Mondrian interviewed himself. The obsession with purity and reductiveness is likewise parallel with Mondrian's thinking, although Reinhardt's extremism is yet more absolute than Mondrian's, for he too dispensed with the relational aspect of composition. But Reinhardt can in no way be considered, like Mondrian's initial

admirers, in any way an imitator of his style. He subverted the clarity
of geometric forms by darkening his palette to black so that no shapes
or hard linear boundaries could be seen any longer. As Newman and
Rothko had done, Reinhardt chose a symmetrical image, defying Mon-
drian's demand that "dynamic equilibrium" was the basis of good paint-
ing. Mondrian defined the laws so that the New York painters could defy
them; but Reinhardt liked to lay down the law as much as the old Dutch
master.

The Americans who reacted against Mondrian did so in a typically
American fashion, whereas Mondrian remained a European no matter
how much he liked Broadway, Harlem, boogie-woogie, and the jitterbug.
In a formal as well as a psychological sense, the issue of relationships is
crucial. American nonrelational painting that developed in opposition to
Mondrian may be taken as a metaphor for the isolation of the American
artist, an open acknowledgment of a lack, not only of an architectural,
but of a social or historical context for their work. The American artist
is forced into large scale, not only by the scale around him of natural and
urban landscape structures—which his work must challenge to look
ambitious—but also because to communicate with an equally culturally
deracinated viewer, he *must* draw him into an intimate relationship with
the work, into a private world where no collective thought is possible.
The lack of utopian theorizing among American artists is evidence of the
understanding of a pluralistic society as permanently incoherent, and of
the artist as permanently isolated in that society. Mondrian's rectangles,
as they say in thousands of group therapy sessions, "relate" to each other.
American society, because of its history and composition, provides psy-
chological blocks against social relationships familiar to Europeans. The
vastness of the American landscape, at one time an impediment to
communication, also creates a different sense of the relationships of
natural formations to each other and of the human body to the land-
scape. This is reflected in the ethos behind recent large-scale "nonrela-
tional" American art.

Like Duchamp, Mondrian touched a sympathetic chord in American
taste and character. Both were appreciated here more than in Europe
because they strengthened existing indigenous American tendencies and
attitudes. Mondrian's point of contact was with an entirely different
thread of American thought than Duchamp's pragmatic pessimism
reached. It was the mystical and the transcendental current in American
thought that was highly compatible with Mondrian's thinking. This is
one of the most important connections not only between Mondrian and
Reinhardt, who insisted that the function of painting be as an object of

contemplation, but also between Mondrian and recent mystical painters like Agnes Martin and Alfred Jensen, who used Mondrian's own grids as points of departure.

Duchamp finally replicated reality literally instead of imitating nature. Mondrian found another form of literalism—one that permitted painting to survive, however. Creating the most literally flat as well as the most literally frontal paintings produced until the abstract art of the sixties, Mondrian diminished illusionism and focused on surface to such a degree that only monochrome paintings like Frank Stella's and Ellsworth Kelly's could look flatter. Pop artists no less than hard-edge painters demonstrated their awareness of Mondrian's continuing importance. Both Andy Warhol and Roy Lichtenstein, for example, painted works we may consider homages to Mondrian. More important, however, was their acceptance of Mondrian's literal flatness and, in Lichtenstein's case, of the use of bold black lines and primary colors. Warhol's black and white dance diagram is a witty reference to Mondrian's original black and white *Foxtrot.*

Jasper Johns found the representational equivalent of Mondrian's flatness, and thus reunited the two varieties of "realism"—literalism and objectivity—that were the most complete American synthesis possible of modernist and native attitudes. Johns's identification of literal with depicted flatness in his flags fuses together a tradition of literalism already existing in nineteenth-century American *trompe l'oeil* painting, such as Haberle's painting of a clock in the shape of a clock, with Mondrian's insistence on the literal properties of painting as a flat surface.

A 1952 painting of a Paris window by Ellsworth Kelly like Johns's flag marked these two currents of literal "realism" with representation. Its connection with Mondrian's black and white paintings seems too visually obvious to ignore. Ellsworth Kelly's 1951 sketch for a mural of square colored panels similarly recalls Mondrian's earlier checkerboard paintings. The grid pattern initially regularized by Kelly has by this time become a familiar device for structuring areas of color.

Mondrian's importance for New York painting can be summed up as: 1) his insistence on literal flatness of forms *interlocking* on the plane of the surface; 2) his reduction of the elements of painting to two or three colors and black and white, concomitant with his reduction of the number and variety of forms; 3) his stress on the intimate symbiotic relationship between image and frame, resulting in a situation in which the frame itself became the actual missing or lost architectural context for painting.

That Mondrian used the horizontal format usually scorned by Parisians, who preferred the vertical format evocative of the human figure, is not as crucial as the degree to which he dispersed energy *away from the center toward the edges,* coming closer to filling the *whole* of the field than Braque or Picasso. Their respective attitudes toward the field are as different as the sources of their styles. Braque and Picasso came out of Cézanne. Mondrian evolved out of impressionism, with its allover dispersal of focus. Mondrian's initial impressionist experience permitted him to arrive at his mature style in which the entire canvas is subdivided into areas by lines and planes. This attitude toward the painting as a single field to be filled to the edges rather than as a ground to be marked more densely in the center is another of Mondrian's major contributions to New York painting. It was an essential link between postwar American painting and impressionism, the pre-cubist style from which postcubist color abstraction has drawn its most significant inspiration.

When Mondrian arrived in New York, he came to a place ready to benefit from his art, one congenial to its spirit. Mondrian's puritanically ascetic technique—his call for the precedence of idea over execution—struck a familiar response in America, where sensuousness of surface was highly suspect and a native style called precisionism was our answer to cubism. Mondrian's dedication to craft and simplicity were virtues of earlier American art like that of the Shakers. It is time to forget Mondrian once represented a threat, and to claim him as one of our own—a signal figure in the history of the New York School.

THE LATE PAINTINGS OF
GEORGIA O'KEEFFE

■

Because she kept pace with current developments, while at the same time evolving her imagery from her own work, the relationship of Georgia O'Keeffe's paintings of the sixties to her earlier works is complicated. In certain respects the late paintings appear merely to elaborate her traditional themes: the grandeur and vastness of the American landscape, the simple geometry of the patio, the enigma of a single isolated object like a stone, a flower, or a bone examined at close hand. In other respects, however, the later work is quite different. Instead of the patio door recessed into a wall that is explicitly the side of a building of the forties and fifties we have, in a painting of her celebrated Abiquiu courtyard, an open abstract field punctuated by rectangular dashlike markings. Whereas the patio is depicted in past versions of the theme as bounded by a finite architectural context, the 1960 *Patio with Red Door* is distinguished by its lack of confining boundaries. It is quite evidently a fragment of a larger field—an endless blank whiteness infinitely extendable beyond the framing edge. Into this ambiguous ground—ambiguous in the sense that it suggests both the flatness of a wall as well as the incalculable space within a dazzling white cloud—is inserted the familiar rectangle of the patio door. But the use of aerial perspective, in the fading of the red to pink from bottom to top, suggests that behind the door there is a view into an infinite distance.

The *Patio with Red Door* is a poetic reformulation of the concrete theme of the courtyard with undeniably metaphysical overtones. The rectangular door opens now not to a domestic interior but to the distant vista suggestive of a pure and limitless beyond. The insistent concreteness of O'Keeffe's earlier paintings of skyscrapers, barns, and domestic

buildings has been exchanged for a glimpse into the mysteries of a world beyond the one we know so well. The patio now is no longer anchored firmly to the ground, but floats, like the saints ascending to heaven in religious altarpieces, above the horizon. Within an abstract context, O'Keeffe is able to evoke the strange otherworldliness of a mystical experience. Even were her content not so deep, *Patio with Red Door* would be a significant painting sheerly on the grounds of its formal brilliance. Further refining and paring down an already highly selective vocabulary of form, O'Keeffe relieves the ascetic symmetry of this composition by value gradations. Thus the gradual reddening of the landscape strip at the bottom of the picture is picked up in reverse contrapunto in the graded red to pink of the patio door and the various roseate tints of the stitchlike row of irregular rectangles that carry the eye across the top of the canvas.

In earlier paintings, too, O'Keeffe's profoundly mystical content was equally manifest. For example, in the highly original *Shelton with Sun Spots,* one of the skyscraper paintings of her New York period, she painted the hotel where she and Stieglitz lived illuminated by an unnatural brilliance reminiscent of the efflorescence of light surrounding traditional interpretations of the theme of the Transfiguration. But in *Patio with Red Door,* O'Keeffe introduces the theme of the infinite, which would be dominant in her paintings of the sixties.

In addition to new themes in her recent paintings, we may remark several other novel elements in O'Keeffe's work of the 1960s such as *Red Past View,* the several versions of *Sky Above White Clouds I, Above Clouds Again,* and the series of cloud paintings culminating in the extraordinary 1965 cloud mural. They include the following: the lack of external referents to orient the viewer geographically, and the use of a paler, whiter, more translucent palette, giving the impression that light is suffused from within rather than focused on forms from a source outside the painting. The absence of cast shadows in these works, together with the close-valued luminous white tints that predominate, contribute to the sense of an incandescent luminosity, of a radiance from within. The generally pastel range, however, suggests a fragility that softens the forcefulness of their simple, bold design. Edges too are softened through O'Keeffe's avoidance of sharp angles or hard linear contours.

Because we confront an unbounded field lacking the conventional visual cues for bodily orientation, we do not picture ourselves in relation to these paintings as looking at something; rather we are forced to project ourselves imaginatively rather than intellectually, as in the case of care-

fully constructed Renaissance perspective view into the painting space. Thus, in a curious way, and as always in her own way, O'Keeffe, in her recent works, has joined an important direction in the evolution of modern painting. In the past she has painted birds in flight, picturing their motion as they sweep across the sky. Now she gives us views of the clouds and sky that are in fact what the bird sees when flying, so that the floating sensation and the motion become transferred to the viewer's own body. The greater immediacy gained by placing the sensation of movement within the viewer's own body has a great deal in common with certain advances made by Monet in his late water-lily paintings. In these paintings the absence of a horizon line forces us to perceive the view as if we were floating along the lily pads. When Pollock, who studied Monet's paintings closely, spoke of being "in" his paintings, he referred also to this sensation of a physical projection of the body into the painting space.

I do not know how we can account for the presence of this kind of imagery, which has no precedent in earlier art, except perhaps to conclude it may have something to do with the experience of flying. In other paintings of the theme of the road or the river seen from an air view, O'Keeffe paints other subjects that refer to flying. Such air views are unique to twentieth-century art. Perhaps the first artist to become conscious of the new perceptions induced through the experience of flying was Malevich, who published photographs of aerial views in *Suprematism*, revealing the manner in which his own compositions had been abstracted from such views.

Malevich's aerial abstractions differ from O'Keeffe's cloud scenes, however, in the sense that we have mentioned: Malevich's remain a bird's-eye view, whereas O'Keeffe paints what we might see if we were floating among the clouds ourselves. Perhaps the most original of these views is that depicted in the poetic series *Sky Above Clouds II*, which culminates in O'Keeffe's largest work, the immense 8-by-24-foot mural executed in 1965. Here a double image is unexpectedly insinuated through the introduction of a horizon line above the clouds, suggesting that the blue sky might be the blue sea flowing away toward a distant horizon. The rhythmic movement of the oblong cloud forms fading from view also suggests the rocking motion of the sea and supports the metaphor. The use of exaggerated and rapid diminution of scale pulls our eye rapidly toward a distant horizon, creating the impression that the patch of the air or water we see lies at an angle to our vision. Yet the fact that the cloud patches themselves are parallel to the picture plane reasserts the flatness of the plane. Once again, one is reminded of certain of

Malevich's interests. He spoke, for example, of "the sensation of fading away," a pure sensation involved with the idea of infinity, because of its negation of measurable distances between foreground and background.

In O'Keeffe's work, the relationship between foreground and background has always been somewhat peculiar and unconventional because she characteristically excludes the middle ground. Because of her use of close-up views together with rapid reduction in the size of cloud units, she creates the feeling that the eye zooms in quickly from foreground to background. The spatial sense created is not that of Old Master paintings—partially because of the strange absence of middle ground, and partially because of the frontality of the cloud shapes. In addition, the toughness of the paint surface establishes a resistance to visual penetration, almost as strong as that created by painters who deliberately build up painterly crusts to establish a surface plane.

In her earlier paintings, O'Keeffe usually clearly established the background plane. In the paintings of the sixties, however, this is not the case. On the contrary, the "sensation of fading away" is carried to an extreme, the better to convey the impression of a view into infinity. O'Keeffe's images have always had a resolutely stable quality; but in her most recent paintings, the predominance of the horizontal axis establishes a mood of tranquil serenity that projects an even greater resolution than even the architectonic severity of the earlier works.

In the past, O'Keeffe has frequently reworked a theme to refine it. The cloud paintings represent a particularly significant group of works because they constitute a closed series. The progress from the first, relatively naturalistic and freely painted version to the final severe, hieratic mural not only documents a gradual process of refinement, but gives us important clues to O'Keeffe's current preoccupations.

In the intermediate second and third phases of the cloud series, overlapping in the foreground and reduction in scale of elements meant to be perceived as more distant give the impression that what we view is gradually receding from us. There is, moreover, a strange sensation of movement attached to this perception, for the smaller clouds in the distance seem to be fading from view at a constant rate. This sensation of movement is achieved by the rhythmic quality imposed on the diminution of intervals in the size of the clouds. The reduction in size of cloud forms from foreground to background is not haphazard.

In the final cloud mural, we can no longer think of ourselves as occupying a point in front of the painting from which we view clouds receding. The flattened clouds are nearly equal in shape and size; and

we could only perceive them this way if we walked out of an airplane into the infinite blue sky she paints.

Movement in O'Keeffe's work throughout her career is rhythmic. One of those modernists inspired by analogies between music and abstract painting, O'Keeffe has been extremely successful in creating a sense of rhythmic flow. She also relies on other musical elements, such as repetition and interval. Earlier I spoke of the gentle sense of motion in the cloud paintings. In paintings like the 1932 *Landscape Nature Forms*, which was painted in the Gaspé, O'Keeffe creates this sense of a rolling or swelling motion through the use of rhythmic swirling and spiral patterns. In later works like *Red Patio*, this sense of movement may be felt as the rapid speed of the highway, whose markings are recalled by the staccato row of rectangular patches that carry the eye rapidly across the canvas in that painting.

During her student days with Arthur Dow, O'Keeffe had learned the importance of interval, that is, the space between forms. Even before she came to Dow, however, she had a highly developed interest in Japanese art, with its emphasis on economy of means, simple forms, bold patterning, and appreciation of negative areas around forms.

Indeed this inborn affinity for both the forms and spirit of Japanese art defined O'Keeffe immediately as a natural modernist. Her earliest drawings and watercolors are amazingly contemporary, as various authors have noted. They are so not from any determined effort on O'Keeffe's part to be up-to-date, but because they are an expression of a spirit that simply appears to have been born modern. For this reason, there is a consistency and a unity throughout O'Keeffe's career that is rare in the art of a painter who has continued to grow and evolve as much as she has. Compare, for example, the sophisticated reductiveness of the celebrated 1916 drawing of blue lines (shown in O'Keeffe's first show at 291) with the 1959 charcoal *Drawing No. 10*, which was the point of departure for the series of paintings based on aerial views of roads and rivers. A comparison of the two images is instructive in terms of comparing the frontality of the former with the oblique tilt of the image in the latter. There are many differences, of course, but there is the same sure control together with the originality and freshness of an artist unafraid to transcribe her experience simply—albeit with a maximum sophistication— and directly. Similarly, the early watercolor *Starlight Night* is morphologically related to the recent cloud paintings.

These paintings, in the strength of their imagery and the character that this strength implies, are the work of an artist who has managed to

achieve a rare balance between the extremes of the American tempera-
ment. Avoiding the literalist excesses of a photographic realism and also
the banality of sentimental genre, she nevertheless ties her work con-
cretely to a world of perceived reality. Moderating between the subjec-
tive and the objective, the abstract and the concrete, the humble and
the epic, the real and the ideal, O'Keeffe is among America's true
classicists. For in her later work there is no extreme or excess, no violence
and no brutal impact. The mood of her work is contemplative; its
intention is to provide a spiritual discipline, not only for the viewer, but
for the painter who conceives her art in this way, creating a firm order
through will and expressing a moral integrity through craft.

Writing of O'Keeffe in 1936, Marsden Hartley spoke of her approach-
ing "the borderline between finity and infinity" and of her quest "to
inscribe the arc of concrete sensation and experience." He saw her as
a mystic, correctly locating her within the context of a mysticism firmly
grounded in the direct experience of the here and now, a mysticism that
insists on the sanctity and importance of the commonest flower or stone.
One thinks of certain analogies with such mystics as Meister Eckhart
and Saint Teresa as well as the Zen masters who valued the humble and
insisted on the holiness of the commonplace. Because of this content,
O'Keeffe's paintings have far more in common with the still lifes of
Sanchez-Cotán or Zurbaran than they do with the paintings of the
precisionists who were her contemporaries.

For too many American artists, the finiteness of appearances has been
the totality of experience. This is not so for O'Keeffe, who transforms
what she sees into something finer, more poetic and perfect, than reality,
thereby escaping the literalist materialism that has seemed the limit of
the American imagination.

It is almost too easy to see O'Keeffe as the prototype for the struggles
of today's women for freedom. Yet it is inspiring to trace the evolution
of her imagery from violence and conflagration to the images of floods
and deluge in the works of the early thirties through the struggle with
mortality that the *memento mori* themes of the late thirties and forties
suggest, to these beautiful new works which convey a profound spiritual
resolution. In a 1923 review by Henry McBride I was amused to find a
description of O'Keeffe; he called her "a sort of modern Margaret Fuller,
sneered at by Nathaniel Hawthorne for too great a tolerance of sin and
finally prayed to by all the super-respectable women of the country for
receipts that would keep them from the madhouse." Today O'Keeffe's
modernity is perhaps even more evident, and the lessons of her discipline
even more to be appreciated.

DECOYS AND DOUBLES: JASPER
JOHNS AND THE MODERNIST MIND

███

If we consider the career of Jasper Johns, we find the artist periodically
assessing, tallying, and reviewing his past. This tendency to retrospective
résumé strikes us as unique in contemporary art, which is frequently
characterized by deliberate discontinuity and perpetual flight from the
past, both from the tradition of art history and from the artist's own
earlier works. In Johns's case, continuity is preserved with artistic tradi-
tion and the painter's own history through constant references to the
works of earlier masters, specifically Leonardo, Cézanne, and Duchamp
(and now lately Picasso), as well as through an overlapping of themes
within the artist's own oeuvre. This thematic overlapping lends an
unusual sense of one work flowing seamlessly into another. We may
characterize this seamless quality evoked by the connection of sequences
of works as the expression of a *continuous* consciousness. Constantly
reflecting upon its own history—a mental world of related perceptions,
memories, and images shuttling back and forth across time—Johns's
aggregate picture of a continuous consciousness uninterrupted in its
analytic self-reverie has its closest analogue in Proust's *Remembrance of
Things Past,* which sets as its goal the externalization, in a work of art,
of overlapping and interweaving themes and leitmotifs: that is, the
representation of the totality of consciousness.

Johns's commitment to the exposé of the whole content of conscious-
ness is necessarily bound to the perpetuation of the continuity of mem-
ory. In this sense, his involvement with a connected sequence of works
is necessarily opposed to the notion of serial imagery as it is explored by
many of his contemporaries. Although recent art is crowded with works
in series, such self-contained series are discontinuous with other series

by the same artist; there is no pretense that they are the product of a continuous consciousness. On the contrary, it is obvious that they are conceived as related units for the specific purpose of a planned exhibition. As exhibition ensembles, they convey, implicitly if not explicitly, a connotation of the environmental. Respecting the limitations of easel painting, especially with regard to its separation of the contents of the work from any external context (although in works like *Evian* and *Studio,* shapes break the rectangular frame), Johns makes no effort to affect the context of the work or its reception, either through theatrical effect or aspirations toward the environmental. *Field Painting,* for example, is Johns's rebuttal to the intent of color-field painting to create an encompassing environmental experience that inevitably must compromise the definition of easel painting as an object distinct from and other than the viewer's own space. *Field Painting* and Johns's works in general are clearly bounded objects not continuous with an amorphous visual field. They require an act of concentrated and conscious *focusing,* as opposed to the generalized sensation of warm luminosity created by the environmental glow of color-field painting.

In Johns's attitude toward both serial imagery and color-field sensation, we find the element of negation primary. Indeed, it is this element of negation—an intractable commitment to going against the grain instead of with the traffic—that identifies Johns as a radical conservative intent on preserving, with exceptional clarity in the midst of aesthetic and moral confusion, the dialectical ethos of modernism. Johns's modernism is implicit in his fidelity to the central modernist themes: reflexiveness, autonomy, and self-sufficiency of the work of art, aesthetic distancing, and unresolved complexity leading to a condition of permanent doubt. The content of Johns's art is posited above all on the act of self-criticism. The importance of the critical attitude to the survival of the modernist spirit is self-evident: in the age of doubt, when conviction and authenticity present themselves as problematic, the act of autocriticism plays the cathartic role that the auto-da-fé played for the age of faith. The difference is that the secular attitude demands that the inquisitor no longer be external to the inquiry: Baudelaire's interlocutor is identical with the "hypocritical reader"—the poet's own double.

In the future, we shall have more to say about the central importance of both the critical and the autocritical examination to Johns; and we shall study as well the crucial role the theme of the *Doppelgänger*—the double, the alternate—plays in Johns's iconography. For the moment, let us return to the impulse behind Johns's negativity: his need to create

doubles or mirrors of an initial thesis. If not for his compulsion to negate, acknowledged by the artist in the painting of the word *No*, Johns would have been, probably more easily than his many contemporaries who became pop stars, absorbed into mass culture as a familiar celebrity. As it stands, his early works brought a fame that did not mean understanding. That initial fame continues to surround the works made since 1960, which did not capture the mass imagination, with a charisma that seems entirely detached from Johns's evolving preoccupation with philosophy and increasingly introverted, reclusive personality. The early flags, targets, numbers, etc., were fundamentally resistant to interpretation, but because they were based on familiar graphic emblems and signs that were easily and powerfully reproduced, Johns became an overnight sensation. The cause of his notoriety was dual: in the context of the fifties, Johns's negation of both the *abstract* and the *expressionist* aspects of the New York School was a shocking challenge to accepted dogma within the art world; at the same time, in the world of media and mass culture, their simplicity, familiarity, and reproducibility attracted the attention of a large public never before provoked into response by the remote images of an abstract art alien to commonplace experience.

Given the enthusiastic reception of these works, one would have expected a steady stream of cleverly punning object-paintings to flow from the artist's studio. However, the spirit of contradiction was too strong in Johns to find comfort in easy success. Since the audience, both informed and uninformed, was eager to swallow these images without questioning, he was forced to criticize himself. Instead of producing quantities of the popular subjects, in 1959 he changed both his technique and his repertoire of images: he replaced legible, familiar subjects with ambiguous motifs, often combining words and images in dissociative conjunction, and renounced the regular, measured impressionist stroke for less obviously controlled nervous jets, bursts, and flares of color reminiscent, although through mockery rather than through imitation, of the painterliness of expressionism.

Irony has been lightly used by lesser artists; for Johns, mockery and irony are not superficial jokes, but methods to bracket his reminiscences and revivals to indicate that their context has been altered by consciousness. Irony establishes that his duplication or repetition of preexisting techniques, images, and styles are *not* identical with their sources, from which they are irrevocably alienated by awareness. Irony serves to distance the viewer; it causes second thoughts. Irony is not a tool of superficial ridicule for Johns, but an essential means to emphasize his

awareness that history repeats itself: his understanding that repetition is a rule rather than an exception in history, both as autobiography and as an abstract record of human events.

PLUS ÇA CHANGE

Even before he began using the concept that context alters meaning as a specific iconographical theme, Johns intuitively grasped the possible application of this insight to the problem of differentiating conscious repetition from naive repetition. Had *Jubilee, False Start,* et al., been painted some years earlier, they would have appeared as a variation of abstract expressionism. Such an interpretation, however, would have been based on superficial stylistic similarities. On close inspection, Johns's gestural painterly style, initiated in 1959 after the success of the flags and targets, remained until 1963 a style of disciplined control. In contradistinction to action painting, Johns's painterliness was never permitted purely spontaneous emotional expression. Although later color bursts are large and more irregular and modulated than the flat, regular, parallel brushstrokes of the initial flags, targets, and numbers, they are still carefully controlled, roughly equivalent in area and jagged outlines and vaguely analogous, like the pieces of a jigsaw puzzle deliberately designed to interlock. Beginning in the works produced in 1959, collisions of color are hardly accidents either; randomness and chance are employed as illustrations or pictures of these ideas rather than as technical processes Johns is pursuing as ends in themselves.

By the time Johns paints *Device Circle* in 1959, a critical revision of the circular target motif, structure—that is, the clear structure based on closed contour—has dissolved itself into the mere suggestion of containment. Inside and outside bleed into one another. The discontinuity between figure and ground—the fundamental basis for depicted representation—was neatly dispensed with in the rectangular *Flag* by identifying the whole image with the whole field. Now it is reformulated by picturing foreground and background as seeping into one another by means of osmosis through the porous broken contour of the circle. Centered within the centered circle is the "device" which traced the circle. This allusion to the process by means of which the work was created held great significance for Johns, as well as for those "process" artists who chose this single aspect of Johns's reflexiveness as the basis for an entire body of work. In *Device Circle,* the central image of the circle is embedded in a painterly context so thoroughly that it resembles

a camouflaged object that is distinct from but nevertheless apparently contiguous with its surroundings.

Although Johns's paintings of 1959–63 appear different in technique, medium (he had begun using oil paint), and subject from those which preceded them, we can see that certain themes are constantly being reexamined. Despite the brushiness and superficially abstract look of paintings like *Device Circle,* these works continue to picture images or words that are specific and nameable. They maintain connections between language and pictorial representation announced in the earlier works. Johns's apparent conversion to the painterliness of "action painting" in 1959 caused many to feel that he was going backward in relationship to "advanced" taste. For just at the moment that a new generation of artists was using his impersonal anti-illusionistic painting-objects as a point of departure for styles that went far beyond Johns in detaching the artist's subjective sentiment and personal mark from the work, Johns was becoming increasingly insistent on the hard-painted uniqueness of his images. Originally, he had generated his structured, conceptual style in opposition to the unbridled looseness of abstract expressionism; now he found himself in equal opposition to the mechanical and automatic techniques, the hard-edge graphic images, and the factory mentality characteristic of the art world of the sixties, which took the industrial assembly line as its model of productivity. Declining to supply paintings in relation to demand, Johns made his first sculpture in 1958 and his first print in 1960. These experiences in new media expanded his technical capacity. Slowly, ideas generated by the processes of casting and transferring images from one surface to another began to find their way into paintings like *Diver,* which bears the imprints of the artist's hands, and *Watchman,* which incorporates the cast of a human leg.

THE VARIETIES OF REPRESENTATION

Aside from the experiences of casting and reprinting during the period 1959–64, two crucial intellectual encounters also changed Johns's thinking, inspiring the first of his periodic summae of all that he had undergone, both personally and artistically, until that moment. In 1960, Johns reviewed *The Green Box,* the first complete English translation of Marcel Duchamp's notes for the preparation of *The Large Glass (La Mariée Mis à Nue par Ces Célibataires, Même).* Stimulated by Duchamp, Johns began keeping detailed sketchbook notes of diagrams and plans for future works which grew increasingly complex, as new ideas were added

over a period of time. Shortly thereafter, he began a careful study of the works of the linguistic philosopher Ludwig Wittgenstein, whose *Philosophical Investigations* had become Johns's *livre de chevet.* The *Green Box* inspired Johns to further analyze the relationship between representation and reality; *Philosophical Investigations* provided the conceptual constructs, as well as the specific iconography for doing so. Together the two works formed the basis for Johns's largest, most ambitious painting to date, the hallucinatory *According to What*—a horizontal canvas in four panels that presents a jumbled index of the varieties of representation. In emulation of Duchamp's proposal to "strain the laws of physics," Johns proposes in this work to strain the laws of logic, to accomplish the presumably impossible feat of expressing abstract concepts in visual images. That this infinitely complex work, examining a range of relationships—between words and images, the real and the illusory, the literal and the depicted, a concept and its negation—was produced at the height of the simplification of ideas concerning pictorial design to "non-relational" formats is another instance of Johns's consistent inability or unwillingness to adapt to the dominant direction of the moment. Within the context in which it was created, *According to What* represented his rejection of both the naive simplification of nascent minimalism and the simplifications of a narrow art criticism that ignored all significance except the significance of form.

According to What has been correctly construed as an homage to Duchamp, whose profile appears silhouetted on the hinged canvas in the lower left corner of the painting. However, it is also much more. There is no question that Johns derived the notion of an encyclopedia of representation from *Tu m'*, Duchamp's last painting. There are similarities with Duchamp's public resignation from the art of paintings; Johns's response forty-six years later was an affirmation of the continuing significance of paintings as a carrier of meaning. Both *Tu m'* and *According to What* are ambiguously titled, permitting multiple interpretations of their subject; both incorporate elements taken from their respective maker's earlier works; and, perhaps most significantly, both are attempts at a taxonomy of representation.

Sifting out individual elements from their reciprocal interplay with each other within the respective works, we find that the following categories of representation occur in both paintings:

1. Literal Objects: A real bolt passes through the painted color samples, and real safety pins mend an illusionistic tear in *Tu m'*. A real hanger is bent back to cast a painted shadow and Duchamp's profile is traced

on a real canvas in *According to What*. A real bottle brush hangs from *Tu m'*; a real wire attached to a real spoon casts a real shadow in *According to What*.

2. The Shadows of Objects: In addition to the shadow of an elongated and distended corkscrew—presumably outside the work in the viewer's space—that spreads horizontally across *Tu m'*, the shadow of the coat hanger and the bicycle wheel ready-mades have been projected onto the canvas, traced in pencil and filled in. In *According to What* a real chair, sawed in half, casts a real shadow that is painted over by Johns, so that it appears as illusory chiaroscuro.

3. Depicted Images: In *Tu m'*, both the color chart and pointing finger (painted not by Duchamp but by an anonymous sign painter) are conventionally depicted; in *According to What* letters and the colored circles that have been interpreted as traffic lights are depicted images, although both are accompanied by literal equivalents.

4. Reflected Objects: In *Tu m'*, the Three Standard Shoppages are shown in outline in the lower left of the canvas; at the right they are represented again, but this time in perspectival studies, as if seen from a point of view other than the frontal. In *According to What* literal three-dimensional letters made of metal and painted over are mirrored on the surface of the canvas by their depicted two-dimensional doubles.

To Duchamp's inventory of the types of representation, Johns adds two more possibilities: *reproduction* and *replication*. The jagged white swathe of newsprint that pulls together the right half of *According to What* and balances the vertical "traffic lights," although reminiscent of the pieces of newspaper collaged by Johns onto his encaustic paintings, is created by silk-screening the image of newsprint letters onto the painted canvas. A three-dimensional cast of a human leg, reversed so the inside of the hollow cast is visible, taken from life directly, is essentially a replica of a leg, as the cast bronze ale cans were replicas, identical in shape and size to the originals. Although both reproduction and replication are hinted at in Duchamp's ready-mades and his *boite-en-valise*, these types of representations have a history in Johns's own development.

One of Johns's earliest-known works contains the plaster cast of a human head that became the prototype for the casts included in the twin target paintings, one with casts of a face cut off at eye level, the other with casts of anatomical fragments. Although the initial *Flashlight* sculpture of 1958 was merely a found object embedded in plaster, suc-

ceeding sculptures were replicas of the objects they represented. They gave the impression of three-dimensional solidity. *The Critic Sees* of 1961 combined human and man-made forms (mouths and glasses in this case). These casts, however, as well as those of the 1960 sculpture, appear solid because they are taken directly from the objects duplicated. In 1964, however, in the painting *Watchman*, executed during a trip to Japan, the cast of the leg involved an extra step: from the hollow plaster cast molded from the body, a hollow wax cast (which permits the inside to be seen when reversed) was made. The wax was tinted flesh color, with the ironic result that a negative representation of the original, which involved more distance from the original than the plaster casts themselves, resembled the original leg more closely than the casts taken directly from objects. Once more, the laws of logic are strained.

THIS IS NOT A PIPE

With the introduction of cast replicas into the works, side by side with literal, depicted, and reproduced images, a full range of representational functions is displayed. That they are logically contradictory is certainly intentional on Johns's part. Since no single focus can arrive at a consistent hypothesis that would account for the conflicting realities represented in *According to What*, we are forced to adopt a shifting point of view: a variable focus that identifies definitions as relative as opposed to absolute. The totality of reality is apprehensible only if each system of representation is recognized as an independent system ruling out confusing comparisons of unlikenesses.

We may follow the evolution of Johns's anatomy of representation in its various stages. Initially, he appears inspired by Magritte's investigations into the nature of illusion, specifically by the contradiction implied in the celebrated painting of a pipe labeled *Ceci n'est pas une pipe.* It was probably Magritte's painting of a torso isolated from any context, titled *La Représentation*, that led Johns to conceive of a painting that would dispose of figure–ground discontinuities that underlay illusionistic representation. Closer to Johns, and undoubtedly a source as essential if not more so than Magritte, however, are native American sources. Johns's initial response to illusionism as a "lie" to be exposed as such is characteristically American. This response derives not from symbolist or cubist aesthetics but from fundamental American attitudes toward illusion as a trick and a deception, both delightful and dangerous. Most significant in this connection is the school of *trompe l'oeil* illusionism

that flowered in the United States around 1900, from which Johns takes a surprising number of themes. These deceptions, based on the illusionistic still lifes of easel-shaped paintings and hunting trophies or letter racks that were a popular amusement beginning in the seventeenth century in Europe, continue to be a favored form of American art. According to Alfred Frankenstein, the leading authority on the subject, "Our pleasure in *trompe l'oeil* arises from the realization that our *oeil* has been *tromped.*"

Frankenstein defines the rules of this kind of illusionism as follows: the subject must involve as little depth as possible so that the eye stops at the picture plane, which gives the illusion that objects depicted on this surface protrude into the spectator's space. He explains that *trompe l'oeil* is confined almost exclusively to still life because the eye will only be fully deceived if the object is the same size as that which it represents. It is not coincidental that all of Johns's subjects are actual size and that the initial emblems were chosen for their flatness. If we compare Johns's *Flag* with Haberle's *Clock*, painted roughly half a century earlier, we see that precedents for the painting-object exist within the American tradition itself. In Peto's *Lincoln and the Pfleger Stretcher*, we recognize the origin of Johns's reversed stretcher as well as the reproduced self-portrait appearing on a plate in *Souvenir*. (The portrait of Lincoln was recognizable to Peto's public as a popular engraving, i.e., a reproduction of J. C. Buttree after a photograph by Mathew Brady.) Johns's hanging cups, hangers, and brooms recall Harnett's closet still lifes of music instruments hung from cupboard doors; the accumulation of memorabilia in Peto's *Old Reminiscences* with its folded letter rack reminds one of the diagonal folds of Johns's *Disappearance*, its carved traces prefigure Johns's imprints of objects on canvases. Hinged drawers with suggestions of something hidden behind the picture surface abound in such paintings and have many analogues with Johns's theme of the intimation that behind the canvas is concealed another appearance. Johns's *Good Time Charley* pays homage to Peto's *The Cup We All Race 4*, and Johns's stenciled titles and signature at the bottom of many paintings are clearly reminiscent of Peto's *Office Board for John F. Peto*.

With these native sources in view, Johns's early paintings do not appear so weirdly unprecedented. In fact, they reveal Johns initially, despite extraordinary painterly and conceptual gifts, as essentially a provincial painter, whose ideas regarding illusion were determined largely by limited experience with local sources. The impact of Duchamp and Wittgenstein on such a mind was to bring its potential for abstraction into line with the requirements of modernist aesthetics, which had long

since identified illusionism as only one category of the infinitely more complex problem of representation. When, as a result of his experience with printmaking, as well as a growing acknowledgment of the social context in which works of art are created and experienced, Johns became aware of how reproductive media altered contemporary concepts regarding representation, a new crisis was provoked. It was resolved only a decade after Johns first introduced reproduction into *According to What*, in the sequence of paintings and prints involved with the theme of the *Decoy*: the double deception.

ELLSWORTH KELLY: AN AMERICAN IN PARIS

THE SOUL ITSELF IS SO SIMPLE THAT IT CANNOT HAVE MORE THAN ONE
IDEA AT A TIME OF ANYTHING. . . . A PERSON CANNOT BE MORE THAN
SINGLE IN ATTENTION. . . .

—Meister Eckhart

Surveying Ellsworth Kelly's career, one is struck by the consistency and
single-mindedness of his vision. In its strict adherence to a series of
fundamental tenets the artist postulated early in his life, Kelly's stylistic
evolution differs from the norm in postwar American painting. Never
prey to the leading cultural myths of our time, he embraced neither the
myth of total freedom nor the myth of protean man, who changes guises
at will.

Like his resistant surfaces, Kelly is stubborn. His flexibility as an artist
has not been in adapting to every new wave, but rather in his capacity
to constantly reformulate and reassert his own way of seeing. Kelly's art
is intentionally not limitless: bounded by specific and inviolable conven-
tions of decorum, it is often surprising in the range of expression evoked
within a set of limitations self-imposed at an early date.

Against the protean ambitions of postmodernism to smash all bounda-
ries, Kelly has maintained his commitment to an ideal of rigor, integrity,
and discipline that lends his work a moral authority over and above its
aesthetic dimension. The work has evolved in a number of directions in
the thirty years Kelly has been an abstract artist, often in unpredictable
ways, but there is always a recognizable core that remains unchanged.
His contemporaries may have come to view modernism as a shopping

center from which to select the elements of eclectic and shifting styles. Abstraction for Kelly remains a way of seeing things in the world in a clearer, more perfectly ordered and coherent form. Never an *a priori* Platonic system for Kelly, abstraction represented for him a means of subjecting experience to self-control, of converting the Real into the Beautiful. Focusing and concentrating vision on shapes so large they cannot be ignored, so sharp in outline they cannot be misunderstood, and so abstract that they cannot be interpreted with literary associations, Kelly defines his art not as an external decorative object, but as an internalized heuristic exercise—a means to refine and clarify the perception of "reality" in general, not only in art.

In its heuristic and exemplary functions as ethical model, Kelly's work diverges significantly from the role of art for art's sake that dominates formalist aesthetics. Despite its moral tone, however, his work preaches no specific doctrine or ism. A sensual dimension to his edges, shapes, and colors contradicts the Puritan inhibition or a lack of self-revelation in either his generalized forms or his impersonal paint application. The lucidity, straightforwardness, craft, and precision of Kelly's style are among the strongest qualities we associate with the American character. The deliberate lack of illusion in his work is an analogue for the ingenuousness Europeans perceive in Americans. However, his obvious affinities with the clean, impersonal, hard-edge style of earlier American artists like the precisionists, who based their cubist realism on photographs of architecture (as Kelly later used such photographs for inspiration), hardly categorize Kelly as a typically American artist. The fascination and durability of his work derives not from its apparent analytic simplicity, but from its sophisticated, synthetic complexity.

Kelly's style is actually an amalgam and synthesis of qualities of European, as well as Oriental and primitive art. It incorporates elements of Dada and cubo-constructivism in an individual style, and the large scale of the New York School. Significantly, Kelly spent his formative years not in New York, but in Paris, where a synchronic concept of world art history as simultaneously available to the contemporary artist gained currency in André Malraux's "museum without walls" of art-book reproductions, and Henri Focillon's interpretation of the "life of forms" as potentially autonomous of specific historical contexts. Both Focillon and Malraux supported the claims of modern artists that forms congenial to the modern spirit were available in other cultures. This same idea influenced Kelly's earliest abstract works, cut-out reliefs whose elongated shapes relate directly to decorated paddles of primitive tribes.

In a 1949 photo of Kelly in his Parisian hotel room, such a paddle

hangs on the wall. The potential availability of many sources of inspiration continues to enlarge Kelly's vocabulary of images. For example, in his recent work, the "bow-tie" shape of the polished banner stones of the North American Indians he collects and studies are reflected in the converging mirror-image parallelograms of the enormous spreading *Dark Grey Panel,* 1977. As a young art student in Paris, Kelly was a tireless museumgoer. In addition to the encyclopedic collection of the Louvre, he studied Oriental art in the Musée Guimet, medieval art at the Cluny Museum and the Institut Byzantin, and primitive art at the Musée de l'Homme and Musée des Arts Décoratifs. All these sources influenced Kelly's art. Although Kelly first saw Paris briefly as a U.S. soldier in 1944, when he returned to study art in 1948, it was with the intention of investigating modern art at its source.

At the School of the Boston Museum of Fine Arts, he had painted promising nudes and portraits in a realistic style, impressed by the visit of German expressionist Max Beckmann, whose boldly outlined figures influenced several self-portraits. Once in Paris, however, he evolved a more sensitive pastel palette and technique, based on Klee, more in keeping with his own quiet temperament and modest personality. For the first six months in Paris Kelly painted—mainly half-length figures or portraits—in a style decidedly indebted to Picasso's later cubism. Mainly abstractions from the human figure, these were talented works by a young artist who had not yet found himself.

Kelly's adoption of a fully abstract style in 1949 had the abruptness, inspiration, and finality of a religious conversion. It was the result of a specific epiphany experienced by the artist regarding the nature of concrete reality and its specific relationship to the reality of the art object. In Paris, he had begun to draw and photograph architectural details— bridges, roofs, and facades—as well as the fleeting ephemera of reflections on water and shadows on buildings. While visiting the Musée d'Art Moderne (now the Palais de Tokyo) in autumn 1949, Kelly became transfixed by its impressive vertical *style moderne* windows. He found this experience more powerful and more real than the Klees and Picassos in the museum. The tripartite, triptych-like construction of the window was a "found" composition he could translate directly into architectonic painted object. He first made a drawing, and then a relief of wood and canvas based on the window. These had a startling originality and concrete presence. (On a trip back to Paris in the late sixties, he photographed the window as a record of his initial encounter. By now, it was covered with graffiti, as different from Kelly's immaculate construction as one could imagine.)

Kelly's relationship to photography is complicated by the fact that the photographs he has taken which resemble forms he uses postdate the related paintings and reliefs, which evolve from drawings and collages, in which the original object is refined and distilled into a single shape. The process of focusing on a particular detail, however, is a function of the photographer's eye. Degas could not conceive of the close-up image, which became important to later artists, including Kelly, but he composed his paintings by cropping the image, as a photographer might select a view. In a similar fashion, Kelly's shapes seem cropped by the frame, by the camera apertures.

Elizabeth C. Baker has remarked on the relationship between Kelly's photographs of barns and sidewalks to the skewed and twisted rectangles and polygons that appear in his recent work. A 1970 photograph, which records the slow curve of the cropped segment of a great circle, relates to many of the pieces of the seventies. The curve bisecting the corners of an elongated rectangle was a motif Kelly first explored in two small paintings made in 1968 in Bridgehampton, Long Island. The photograph, taken two years later, convinced him to pursue the motif further, and the idea was then elaborated in a series of drawings, collages, and paintings.

It would be simplistic to assume any one-to-one relationship between photographs, drawings and collages, and paintings, particularly since many works are not based on such specific prototypes. Kelly searches in the world for certain kinds of visual experiences he finds pleasing or inspiring; when his vision is confirmed in a detail he sees in architecture or nature, he records that confirmation. The possibility of superimposing a formal order onto reality by flattening and isolating details into shapes through photography—which has the capacity to transform garbage into a formal aesthetic arrangement—was first viewed as potentially useful to painting by artists of the Stieglitz circle like Sheeler, Demuth, and O'Keeffe. Because of their association with the photographers like Strand who also exhibited at 291, they saw that humble objects might be transformed into monumental form through the photographic eye. It is unlikely Kelly knew their work; nevertheless, there are interesting similarities between Sheeler's 1929 photographs of Chartres and the photographs of French architecture Kelly took twenty years later.

Kelly's development is a record of encounters with visual phenomena he felt the urge to seize permanently and fixate in art. His forms are related, at least in their genesis as "found" compositions, to Duchamp's *objets trouvés*. While Kelly was in Paris, Duchamp was mainly in New York; although there is an uncanny correspondence between Duchamp's

Fresh Window, his miniature French window, and Kelly's wood-and-canvas relief of the Musée d'Art Moderne window, Kelly could not have seen Duchamp's work, at the time in Katherine Dreier's private collection. However, he doubtless did come into contact indirectly with Duchamp's thought. Along with the many other Americans, including Robert Rauschenberg, Al Held, Kenneth Noland, Sam Francis, and Kelly's friend Jack Youngerman, choreographer Merce Cunningham and composer John Cage were in Paris briefly in the late forties.

By the spring of 1949, Kelly, looking for a way out of cubist composition, was already experimenting with automatic drawing. He had become disenchanted with the School of Paris style imitating Picasso. Looking at the outlines of shapes of real objects in a disinterested way as a camera might, he isolated forms that already existed. They did not need to be adjusted and composed in the manner of cubist fragmentation of plane and rhyming of one shape with another because they were *a priori* givens. Among the first works based on the simplification of a detail of a fragment of reality was *Toilette,* an abstraction of an old-fashioned Parisian toilet.

Meeting John Cage in Paris confirmed Kelly's selection of objects outside the studio as points of departure, as an alternative to abstracting from the studio setup of the nude or still life. A sheet of photographic contact prints Kelly sent to Cage, who had returned to New York, documents several of his earliest abstractions and painted wood reliefs. Three of the reliefs were directly connected to the Cunningham-Cage aesthetic that invested the ordinary and the chance with special meaning: the *Window, Museum of Modern Art, Paris*; the *Relief with Blue,* 1950—a reference to curtains opening on a theater stage—and the *White Relief,* based on a Japanese *pochoir* similar to the ones that Cage had introduced to Kelly during his Parisian visit the previous year. This piece is particularly significant because of its acceptance of a given (the original stencil of the *pochoir*) rather than an invented form as a point of departure. Thus, Kelly had developed a new way to compose his art, identifying the whole of the image with the whole of the field, and balancing object against image in perfect equilibrium.

When Kelly returned to America in 1954, he found that the progressive painting of the New York School, from Pollock to Newman and Reinhardt, was engaged in the problem of eliminating the detachment of figure from ground, the last vestige of representation present even in cubist abstraction. In Paris, Kelly had made contact with a geometric tradition of hard edges, flat shapes, and local color that were out of vogue in New York, where heavily impastoed, painterly painting was the style

of the moment, as second-generation abstract expressionism emerged in the shadow of the giants of the first generation.

Meeting Arp and seeing his work and the work of his wife, Sophie Taeuber-Arp, whose little-known paintings he found even more striking, confirmed Kelly's interest in the random as a means of creating new shapes that did not conform to any ideal geometric canon. This quality of eccentricity remains central to Kelly's vocabulary of form; it means that anything, including a French toilet, may be the point of departure for paintings, sculpture, or relief. The idea that anything can be useful—a denial of any absolute category of ideal forms that are intrinsically superior, the Platonic basis of purist geometric styles—seems typically American. If we compare the geometric styles of American artists from Frank Lloyd Wright to Kelly and Frank Stella, we find what they have in common is a disregard for conventional geometry, and a pragmatic attitude toward geometry as a structuring or building element that can be freely altered by the artist.

Kelly's first abstractions, executed in Paris between 1949 and 1954, the year he returned to New York, established the groundwork for a post-cubist style that transformed geometric shapes, derived initially from random views of details, into impressive forms that, no matter what their actual size, implied an architectonic monumentality. That Kelly was literally inventing a vocabulary of form, an alphabet of shapes with which to express himself, during the germinal Paris years is testified to by his plan in 1951 to make a book to be called *Line, Form, Color*. The book was never completed. However, he described the project as "an alphabet of pictorial elements without text, which shall aim at establishing a larger scale of painting, a closer contact between the artist and the wall, and a new spirit of art accompanying contemporary architecture." The early connection of Kelly's work to architecture was another reaction to the Parisian postwar scene where Le Corbusier played a leading role. By this time the great architect had given up his purist canvases and was painting solid walls of color that acted as structural elements in his houses, which Kelly visited with interest. As Kelly's style evolved, the flat planes of dense color, although they function independently of any architectural context, express an architectonic content that Le Corbusier hinted at in coloring the walls themselves. But these works, often closer to reliefs than paintings in their literal depth, material, and cut-out shapes, differed radically from what Kelly found in the galleries once he returned to New York, where the reaction against cubism had driven geometric styles underground. In Paris, however, geometric styles had remained in the forefront. Although Mondrian died in New York during

the war, his friend Michel Seuphor, together with Vantongerloo, kept constructivist ideas alive in Paris after the war. Kelly met both in Paris. It is tempting to connect his emergence as an abstract geometric artist to the primary position assumed by international constructivism in Paris after the war. This was largely a result of Seuphor's tireless proselytizing in behalf of nonobjective abstractionism. In April 1949, for example, Seuphor organized the first major historic exhibition of early abstract painting, "Maîtres de l'Art Abstrait," at the Galerie Maeght, where Kelly's work was later shown. The text by Seuphor was the basis of his seminal book *L'Art Abstrait,* a survey of geometric painting first published in 1949.

The connection between Kelly's 1953 oil-on-wood *Black Square* construction and Malevich's original *Black Square* is apparently coincidental, as his link to later neoplastic constructivism is more a matter of superficial coincidence than of specific derivation. Kelly's geometry began as straight-edged and parallel to the frame, but it became progressively irregular, in the same way that his color evolved more in relation to Matisse, who stressed colors as light volumes, than it did to Mondrian's compartmentalized planes of primary colors.

That geometric art had a high place in Paris in the forties while expressionism and surrealism prevailed in New York must surely be taken into account when one studies the genesis of Kelly's style. The Parisian context of his emergence as an abstract artist also accounts perhaps for his interest in photography and architecture, which played a prominent role in postwar Paris they did not have in New York until fairly recently. The war had caused massive cultural disruption. Léger and Le Corbusier, among others, took up where they had left off when Hitler emptied Paris of its artists with their demand that painting serve an architectural function and assert the flatness of the wall. The evolution of Kelly's style in the immediate postwar period in Paris irrevocably stamped the rest of his development. Picasso and Matisse once again dominated the scene, and although Kelly's shyness prevented him from meeting either, he visited a number of School of Paris masters. Two studio visits, however, were to remain indelible early imprints whose vital importance is only fully revealed in his latest series of reliefs of the seventies. Brancusi was still alive when Kelly made the pilgrimage to the Impasse Ronsin; Monet, on the other hand, had been dead twenty-six years when Kelly accompanied a friend to Giverny to see the stacks of late paintings going to ruin in the abandoned studio.

Brancusi and Monet were two of the earliest "serial" artists. Their interpretation of seriality as the search for perfection rather than the idea

of serial painting as a means of mass production informs Kelly's work to this day. Indeed, the spirits of Brancusi and Monet seem more alive than ever in Kelly's works of the seventies. Brancusi's search for the Absolute manifested itself in a series of closely related, often repeated forms executed in different materials. Kelly now may make the same shape relief in canvas and in metal. Brancusi's perfection is echoed in the distilled form and elegance of these remarkable works. As Brancusi's soaring *Bird in Space* and *Endless Column* hint at infinity, the sections of a grand circle of immense circumference, which creates the gradual curve of the edges of Kelly's recent works, imply continuation in an area far beyond what the eye can see. In Kelly's earlier rectangular paintings, full-blown forms push and balloon out to the framing edge in a voluptuous amplitude that strains the confines of the canvas. Some forms, with their ever so slightly curving edges implying vast great circles, create a new dimension of scale that is remarkable even for a master of the monumental like Kelly.

Brancusi is recalled, too, in the totemic character of Kelly's recent sculptures, which surround the viewer in Stonehenge-like configurations, or tower over us in a mysterious silence that calls to mind the awesome presence of the gods of Easter Island or the Olmec heads. Although Brancusi's art was devoted to no specific cult, it fills the viewer with a sense of mystery and infinity. Such qualities are also brought to mind by Kelly's somber, majestic sculptures, reliefs, and paintings of the seventies.

More than ever in Kelly's career, his recent works demand to be seen as an ensemble. As individual pieces, they are still stunning and effective; implacable yet generous presences. Together, they create an ambience of awesome grandeur that is greater than the sum of the parts! They immerse the viewer in pools of silence. The dramatic effect and scale of the reliefs and painting is intensified by creating an energetic tension in the angle of orientation, and by extending the surface of the shape to the degree that it is larger than the visual field. Horizontal fanning shapes suggest the earth's curve; magnanimous, silent fields portend immensity. We are bathed in silence and repose, as the water lilies Monet painted themselves floated serenely in their surroundings. Kelly's recent paintings create a convincing and coherent ambience of sensation, which, for want of better words, may be described as a confrontation with a Presence as abstract and ineffable as the spirit that inhabits the Mayan pyramids or the Great Sphinx of Giza; they immerse the spectator in a similar experience of the immensity beyond imagination by extending shape beyond the field of vision.

Figure–ground relationships are not evoked by the placement of cut-out shapes on the wall. The relationship of a shape to its background is replaced by the focus on the relationship of a shape to the field of vision itself. The introduction of horizontal formats and extended surfaces creates a different visual situation from Kelly's earlier paintings; those paintings divided in such a way as to prevent a shape from detaching itself from the ground, or the spectrum panels, in which the wall functions as ground. Because of their vast expanse, the eye cannot "read" these recent works as the earlier works can be interpreted quickly as wholistic gestalts. To read the whole of a shape at a glance would require sight lines longer than any museum provides. A tension is set up between the urge to know the whole shape immediately and the fact that we can only know it by reading around its perimeter, which takes time. Large scale is not arbitrary but intrinsic to these works. The extensiveness of the surface sets up the psychological tension: a choice between focusing directly ahead on the neutralized area of canvas or metal, where visual incident is reduced to far less than it is outside the work, or peripherally on the edges of the circumference. The duality of focus in the recent large monochromatic works creates a different kind of polarity from the positive–negative, figure–ground choice of reading required by the shapes that interlocked in yin-yang fashion in earlier paintings of two and three colors. Now focus is dual. The yin-yang shapes in earlier paintings set up a visual paradox of an either/or reading. In the recent works, we may read around the edge of a shape, as Kelly draws a plant or flower in outline to capture its shape in two dimensions, or we may focus straight ahead. In this case, we are confronted with a colored blankness that has none of the visual incident of a Newman or Rothko color field.

The idea of the non-color-field or monochrome work appears to have suggested itself also to Kelly during the seminal Paris years. His reaction to Monet's late paintings was to see them as pointing toward monochrome. Shortly after he returned from Giverny, in 1952, he painted an all-green painting, which has never been exhibited, as his interpretation of Monet. Originally *Grey Panel II* (1977) was painted green, which Kelly found unsatisfactory. Repainted a steely gray, it recalls the cold, early-dawn, grayed-out palette of Monet's late *Nymphéas.*

Kelly's recent works are impressive, not attractive. Monastic renunciation, an even greater concentration of the visual focus, is more present than ever. The coldness and neutrality of the gray and the metal surface of the wall reliefs remind us of the gray stone of the Romanesque churches Kelly admired in France. At the same time, there is a new plentitude of form, an absolute assurance of touch and scale. The pleas-

ures of color have been sacrificed to enhance the drama of shape and the grandeur of scale.

They spread across a flat surface rather than receding into depth, but Kelly's perspectives are vast in a way the vistas of Renaissance perspective are vast. In some of the works, there is an indication of an adumbrated perspective, knowingly used to intensify the sense of space *beyond* the boundaries of the work. These works indicate expanding space while hugging the wall like architectural members. This is paradoxical. However, paradox—the ability to entertain two mutually exclusive propositions—is often a quality of great art.

Kelly's recent works have been painted not in the city but in the country, in greater solitude perhaps than the artist has known since his student years in Paris. In many respects, particularly in their renunciation of color and their recollection of Brancusi and Monet, they are reminiscent of those early years of invention and self-definition.

Ellsworth Kelly has large, intensely blue eyes and the fair skin of his Scotch-Irish and German ancestors. His is the coloring of those who are abnormally sensitive to light. It is not surprising that he has made of the act of seeing itself—particularly the relationship between light and shadow, figure and ground, edge as the joining and separation of areas— the central subject of his work. For those who are hypersensitive to visual phenomena, bright light can sometimes be painful in its intensity. Seeing becomes an act of heightened consciousness.

The conditions of light Kelly has worked in have affected his paintings in a remarkable manner. In the pale gray Parisian light, he produced white and pastel paintings. On the Riviera, he painted his first brightly colored works. When he returned to New York, his color became more brilliant as well as more artificial, culminating in the high-key acid palette of the spectrum panels of the late sixties, painted in a dark studio in Manhattan. The move to the country in upstate New York, where he now lives, brought with it a new palette—this time a neutral *grisaille* gamut of shades of gray not found in Kelly's earlier work. This virtual renunciation of color was surprising on the part of an artist known primarily as a colorist. But the capacity to surprise is another mark of the truly original artist.

The gray scale seems suggested to Kelly by his work in aluminum sculpture, the freestanding vertical pieces that initiated the current series of mysterious environmental works. Some of the collage studies for recent paintings were done on postcards from the Caribbean island of St. Martin, where Kelly sometimes vacations. The stark opposition of

black and white were evoked in opposition to the brilliant light and tropical color of the island flowers. (Like Ad Reinhardt, Kelly has an outlet for the wit, whimsy, and nostalgia he leaves out of his immaculately abstract art in collaged postcards he sends to friends.)

Throughout his career, Kelly's color has been, like his geometric shapes, always somewhat altered from the known standards—knocked off-center as it were—by the artist. The oblique relationship of both his color and form to the norms of geometry and to the standard chromatic scale, both conceptually in origin, is another key to the nature of Kelly's nonconformity and originality. Both hue—which is always brought to full and often blinding intensity—and shape in Kelly's work are almost within the range of the familiar. But not quite. His palette and color juxtapositions were muted as well as brought to maximum *eclat*. His personally invented vocabulary of form—the language it has taken him a lifetime to perfect—evoke the ordinary and the familiar. Close inspection reveals that neither shape nor color is part of anything other than the artist's specific experience: his transformation into art of encounters with reality he perceives as peculiarly emotionally charged.

In the painted reliefs of recent years, black is never literally black, but like Ad Reinhardt's infinite varieties of the absence of color, Kelly's black is a mixture of very dark gray arrived at through mixing color into black. The metal reliefs, either milled steel or Cor-Ten (a naturally rusting steel), have their own intrinsic color, which Kelly accepts rather than invents, although he may reject a metal surface that is too "interesting." The mediation between the acceptance of a given reality and the need to transform the given is the resistant streak in Kelly's nature; it is a great part of his strength, which has as its literal analogy the resistant opacity of his surfaces, a protective coat vision cannot penetrate. Because of their surface irregularities, the metal reliefs are ironically more painterly in their textural variegations than the paintings themselves.

Throughout his life, Kelly has repressed any evidence of the action of his own hand. His hard-edge style of flat opaque local color is the opposite of the brushy painterliness of both abstract expressionism and the stained color-field abstraction that issued from it. There is much in Kelly's grand impersonality that reminds one of the American Transcendentalist philosopher Ralph Waldo Emerson, who admired the anonymity of the gothic cathedral because it "was done by us and not done by us." According to Emerson, "The difference between men is in their principle of association. Some men classify objects by color and size and other accidents of appearance; others by intrinsic likeness, or by the

relation of cause and effect. The progress of the intellect is to the clearer vision of pauses, which neglects surface differences."

Emerson might have been writing of Kelly's focused vision that perceives unity in diversity: "Genius," Emerson wrote, "detects through the fly, through the caterpillar, through the grub, through the egg, the constant individual; through countless individuals the fixed species; through many species the genus; through all genera the steadfast type; through all kingdoms of organized life the eternal unity." This is the process of abstraction and generalization by means of which Ellsworth Kelly distills permanent, universal forms from specific visual impressions and fleeting sensations.

PAINTING WITHIN THE TRADITION: THE CAREER OF HELEN FRANKENTHALER

Tracing Helen Frankenthaler's career, one finds that she began as an eclectic modernist, influenced by Gorky, Kandinsky, and Miró, and perhaps peripherally by Klee. Her coming of age as a painter occurred abruptly, when, as a twenty-two-year-old Bennington graduate, she encountered the work of Jackson Pollock. By the time she was twenty-four, she had visited Pollock several times at his home in Springs, Long Island. Quickly she understood that the most radical aspect of Pollock's art was not his highly personal image, but his *technique.*

That Frankenthaler was able to separate technique from image, to use Pollock's method of working on the floor directly into raw, unprimed canvas, put her a giant step ahead of her contemporaries, who had been sidetracked into imitating de Kooning's image. Even in her earliest work Frankenthaler's image is her own: a hazy, transparent wash as diametrically opposed to Pollock's nervous, electrically charged web as one could imagine. When she began staining diluted oil paint into raw duck late in 1952, adapting Pollock's mechanical technique for applying paint without the use of the brush, her image developed as a relaxed atmospheric marine vision of adjacent transparent planes avoiding overlapping. This was a great contrast to Pollock's muscular, densely interwoven, and superimposed skeins and nets.

Originality of image is one of Frankenthaler's great strengths. Even when one first encounters her as a young painter, there is no doubt that the bursting, flowing, expanding, unfolding, and flowering image she creates is hers and hers alone. In Frankenthaler's case, quality depends on the uniqueness of a lyric sensibility and a languorous mood. Franken-

thaler's adoption of Pollock's method of working and technique of paint application was crucial not only to the further development of her own art, but also to color abstraction in general. As early as 1937 John Graham, in his prophetic book on aesthetics (*Systems and Dialectics of Art*), had pointed out that a change in technique necessarily predicated a change in form. Soaking and staining paint directly into the canvas fabric combined with working on the floor from all sides (rather than in one direction against the wall or easel) had many immediate formal repercussions. The exchange of the movements of the hand for an automatic, mechanical, and impersonal technique removed a degree of contrivance that had hampered painting from achieving a desired unity and immediacy of impact.

Working straight down on the floor permitted a new way of composing in which the framing edge was arrived at last rather than first. As a method, it gave greater freedom to diverge from preconceived images. Neither geometric nor conceptual, Frankenthaler's forms are spontaneously generated by the process of their creation. Automatism is understood as a principle of form creation, but it is controlled in such a way as to create legible, coherent patterns or structures related through analogy rather than repetition. However, Frankenthaler's patterns consciously approximate or deviate from each other and from familiar patterns or configurations. This introduces a kind of allusive ambiguity she obviously cultivates. Often there is a good deal of wit in these associations. The title of one of her most exciting works, *Seven Types of Ambiguity*, pays homage to William Empson's study of the varieties of poetic metaphor. Frankenthaler is interested in maximizing all types of ambiguity—spatial, structural, illusive, and allusive—to create as rich and as complex a statement as possible.

Composing by cropping the image, Frankenthaler gained both the freedom to reconsider a composition and to revise in the process of creation without resorting to the compositional juggling at the heart of cubist painting. But the most important advantage gained by using the new technique was the resolution—or at least the staving off—of the double-edged crisis which ultimately compromised the works of so many lesser artists unable to achieve a similar resolution. The nature of this crisis was so deep and pervasive, in fact, that Pollock himself was unable to create an entirely satisfactory new synthesis once he abandoned the drip technique that had initially made the resolution possible. The dual crisis involved (1) the rejection of the tactile, sculptural space of painting from the Renaissance until cubism in favor of the creation of a purely optical space that did not so much as hint at the illusion of a third

dimension, and (2) the avoidance, if not ideally the banishment, of figure–ground or positive-shape-against-negative-background silhouetted arrangements. The drip technique allowed Pollock to reconcile flatness with a purely optical illusionism by freeing line from its traditional role as shape-creating contour. In later works, Pollock further questioned the nature of figure–ground relationships by actually cutting holes out of his webs. In painting on glass, he attempted to render the background neutral by literally suspending the image against a transparent ground.

The invention of staining permitted Frankenthaler to overcome the obstacles just mentioned because it identified figure with ground, thus eliminating any duality between them; at the same time it allowed her to identify drawing with form creation by marrying the two in a manner that caused the painterly to encroach upon and ultimately to subsume the graphic entirely. This was a difficult and complex process, and it did not happen all at once.

Not Pollock's classic drip paintings but the black-and-white figurative works of 1951–52 were Frankenthaler's point of departure in developing the stain technique as well as elaborating an allusive landscape image. In most practical respects, Pollock's Duco enamel heads and figures were the first stain paintings. At any rate, they were the first pictures to take advantage of the viewer's awareness of the actual physical character of the support in identifying the image as part of the ground. The importance of *Mountains and Sea* is that it added light and color to Pollock's discovery. It does not mean much to credit Frankenthaler with the invention of a revolutionary new technique already posited in Pollock's black and white paintings. Her historical importance resides in her deflecting the current of art history in the early fifties, when many of the best painters were painting in black and white, back in the direction of color painting. And she did it without resorting to the highly formal, hieratic images and reductive formats of Rothko and Newman. By marrying the technical freedom of automatism with atmospheric color, she was able to eliminate the airlessness and artificiality of much painting derived from postimpressionist sources. In other words, she was able to redeem the Venetian tradition of an airy, loose painterliness without compromising the principles of modernism.

The emphasis on *liquidity* of pigment is constant in Frankenthaler's work; it focuses on the actual nature of the medium, as the rawness of canvas identifies the true character of the support as fabric. Before Frankenthaler, Marin had attempted to translate a watercolor technique into oil, but he was hampered from fully achieving this goal because he was still priming the canvas, with the result that he was painting on a

hard rather than an absorbent ground in his oils. This was not true in the watercolors themselves, of course, since the paper ground absorbs pigment directly, and his watercolors are fresher than his oils. In staining, however, Frankenthaler allowed the ground to soak up color just as the page absorbed watercolor, enabling her to achieve in oil both a transparency and a luminosity previously available only in watercolor, an intimist medium inimical to a monumental statement.

Yet some of the highest moments in American art had occurred in the landscape watercolors of Homer, O'Keeffe, and Marin, while many of Demuth's finest works are also watercolors. These links to a strong native tradition are worth remarking in relation to Frankenthaler's approach, which in many ways is centrally located within the American tradition. Despite the degree to which it is linked to French precedents, Frankenthaler's attitude toward landscape is not French but American, much more so than, for example, the first-generation abstract expressionists who prided themselves on the radicality of their break with the French tradition. By the fifties the American tradition no longer represented the threat of provincialism, which had been so clearly banished by the abstract expressionists that a younger painter like Frankenthaler could view it with a fresh eye.

To work as she chose to work, allowing the initial mark to stand as final, Frankenthaler had to have a fantastic natural talent as well as an unshakable conviction in the intrinsic worth of her "mark." Given her terms, which exposed the rhetoric of risk-taking to a real test, there were no second chances. If the painting failed in part or at a point along the way, it had to be totally rejected. But if it was realized, the image had the unity of something created all at once; it appeared decisively of a piece, since obviously that was how it was created, speed of execution being of primary importance to Frankenthaler's style. In a film made for NET, Kenneth Noland speaks of the search for the means to make "one-shot" paintings. Frankenthaler's early achievement was based principally on her ability to bring off such "one-shot" images, which convinced the viewer of their immediacy and indivisibility, a wholeness and indissolubility of image really only attained, up to that point, by Pollock. That it was possible to achieve this in a color art was apparently the important message her paintings held for Louis and Noland.

While the fashion was to load the brush and to pile the surface with pigment, Frankenthaler was allowing her diluted, transparent, often pastel washes to sink into the canvas, creating a soft, vulnerable, unified surface that looks stripped-down and naked in comparison with brushy, encrusted action paintings. But in retrospect her paintings also look a lot

less mannered than "action" painting. In the late fifties, however, her work appeared "thin" to a lot of viewers precisely because of these qualities. It took a shift in taste brought about by the recognition of Louis and Noland to allow the quality of Frankenthaler's work to become generally apparent. Her strange, original palette with its grayed and muted mauves, pinks, and blues and its rusted ochers and browns offended taste familiar with conventional color.

One of the most remarkable aspects of Frankenthaler's development is the manner in which she is able to feed off her own work without retracing her steps. When she gets lost—and this invariably happens with regard to format or structure, and never with regard to scale or color, for which she seems to have an infallible eye—she seems able to renew herself by picking up threads of her own work. Particularly crucial in this respect is the 1953 rose-and-blue horizontal painting *Open Wall*, which is prophetic in many respects of recent directions in Frankenthaler's work. *Open Wall* resolves for the first time any remaining conflict between the graphic and the painterly that she had inherited from Gorky and Kandinsky. Line is allowed to spread and bleed into blotlike forms, which because of their ragged irregularity and obvious contiguity with the surface do not stand as closed shapes with relation to the ground. The monumental simplicity of the large forms and their *lento* pulse is played off to great advantage against the sprightly staccato of the bursting and streaming motifs they frame and enclose. As the title indicates, Frankenthaler has arrived at a way of simultaneously holding the surface and opening it up.

Frankenthaler's paintings fall into two categories: one is directly related to Matisse, in terms of decorative deployment of a few clear-cut shapes, such as *The Human Edge* and *Tone Shapes*; the other, represented by *Flood, Adriatic,* and *Cape,* relates back to earlier works in which tonal modulation and variation in saturation and intensity play a large role. The latter group, by far the more powerful, renews the motif of the "submerged" or immersed form. The influence of Matisse's late works on American paintings will eventually be seen as a mixed blessing, with perhaps more drawbacks than advantages. For one thing, it encouraged the isolation of discrete shapes against a background, a convention, as I pointed out earlier, already rejected by advanced painting. Frankenthaler's technique saves her from entirely falling into this trap; on the other hand, there is a brittleness and dryness about *The Human Edge* that works against spontaneity, liveness, and movement. *Tone Shapes,* on the other hand, does not participate in the planar flatness that causes Matisse's late works to be so purely and exclusively decorative. In *Tone*

Shapes, forms are oriented directionally to suggest a very elusive and complex spatial relationship, evoking the conventional landscape divisions of foreground, middle ground, and background, even as it denies them by eliminating horizon lines. The highly original, low-key color, contrasting dark gray, purplish gray, and black, together with the mottling of areas to prevent a depiction of flatness, establishes the superiority of *Tone Shapes* over the majority of paintings of 1966–67.

Frankenthaler's work has moved away from the playful and engaging forms of the fifties—even deliberately away from technical brilliance for its own sake—toward clear simple forms whose irregular boundaries avoid the familiar or the geometric. At the same time, the color has changed from the muted pastels of *Mountains and Sea* to the rusty palette of the late fifties to the intense full range of the mid-sixties, in which colors do not merge but are separated by areas of raw canvas, accentuating their brilliance, to the dark tones of the late sixties. It is as if color, having been light and air for Frankenthaler, is now transformed into gravity. Color is translated into weight: the balance in *Tone Shapes* is not achieved through harmony, but through one's sense that the small black area, the large gray mass, and the purplish boulderlike shape at the top are calibrated in terms of density and value to balance out. In her preoccupation with literal and metaphoric gravity, Frankenthaler leaves the lyric. She is a painter now who builds as much as she sings. Unfortunately, this preoccupation with building, when it is expressed solely as a concern with structure rather than with relative weight and density, can create a rigid format in conflict with her basic impulse toward openness.

Frankenthaler first became concerned with the relationship of the image to the frame in 1964, obviously under the pressure of developments in the works of Noland and Stella, to whom it was the central concern at the time. She managed to combine openness and structure in a series that includes at least two beautifully realized works, *Interior Landscape* and the exotic, brilliant *Small's Paradise.* In these paintings the motif is centered and floats, although it is framed by ragged-edged rectangular hands. The relationship between image and frame becomes more problematic in 1966, when she attempts to anchor the forms of the interior "frame" to the edges. The dilemma is resolved in recent works, in which she is once again able to signal awareness of the frame without being enslaved by its geometric rectangularity.

Flood reaffirms Frankenthaler's mastery of scale, and reintroduces a complex illusionism. And it does this in the context of a fresh palette Frankenthaler developed in the sixties: a high-key brilliant range of hot

oranges and ochers and pinks contrasted with an equally intense range of greens and purples that are only nominally cool. A brilliant *tour de force* of optical effects, a sumptuous orchestration of color so rich it flirts with gorgeousness, *Flood* is everything the art of the sixties has not been: it is spontaneous, extravagant, romantic, voluptuous, and full of air, light, and pure, uninhibited *joie de vivre*. We are back again with Veronese's feasts and Tiepolo's skies. But there is another note, too, a ring of solemnity and grandeur that announces the mature style of a fine painter who has come a long way and is opening another chapter with a style still full of refreshing vitality, but a vitality informed by experience.

SEVENTIES PAINTING

Ten years ago when I started writing art criticism, opinions might differ about what was good and what was bad, but there was still a consensus regarding what constituted "painting," or at least serious painting. That consensus has fairly well dissolved. Critics are reluctant to generalize or to discuss more than the work of an individual artist. Painting today is besieged from many quarters—new media and materials, commercial art, craft techniques, and hybrid forms marrying painting with any number of other arts and even sciences. The situation is further confused by the aspiration of artists to transcend the traditional limits of pictorial art, even while remaining nominally painters. Innovation still seems the way to make one's mark. Yet ground-breaking innovation appears increasingly difficult as abstract art becomes a mature discipline with a history that is more or less understood. Despite the possibility that no new major "breakthrough" may be open to abstract art—that personal variations and individual sensibility may be the future of abstraction—the public continues to respond to a look of newness more than it responds to anything else. The result is a certain desperation to produce, if not a radical art, then at least an obviously "new look," especially among younger painters.

Lacking any specific focus, the heirs of the New York School are experiencing difficulty in isolating relevant questions (let alone finding new answers) germane to painting fifty years after the cubists attacked the function of painting as solely a representational art. Although cubism was not abstract art, it pointed the way to a pure art purged of everything that tied painting to representation. The aim of post-cubist abstraction has been to expunge the vestiges of representation. This process has been gradual. There have been many setbacks, since the urge to regress to more comfortable and familiar modes of realism is always seductive in

insecure times. Today the "call to order" is strong in all areas. In art, it expresses itself in the sudden popularity of the various realist and neorealist styles filling the galleries and museums with updated versions of American scene painting. Most of this work is just provincial, academic painting in a nostalgic vein reminiscent at its best of Edward Hopper. Some of it—the gleaming neon signs, fetishistic motorcycles, and pornographic close-ups of ladies' behinds—is simply commercial art appealing to the lowest level of popular taste.

While these regressive tendencies earn praise, abstract art does not stand still. In fact it seems to have gained a second wind recently. Many painters are slowly evolving painterly, romantic styles in opposition to the strict, cerebral reductivism of the art of the sixties. These new styles, however, continue in the direction of creating an abstract art as purified as possible of any elements that tied cubism to earlier representational art.

Because cubism continued to deploy silhouetted shapes against a background, it remained bound to the conventions of representing figures in a room or landscape. But cubism made no pretense of being independent of representation, no matter how closely it bordered on becoming a purely abstract style. The cubist-derived geometric styles, which called themselves "nonobjective" to hail their divorce from representation, were hardly freer than cubism of the traditional conception of pictorial space as a series of planes parallel to the picture plane. No matter how compressed and flattened space became in cubism and its offshoots, the presence of positive shapes contrasted with a negative area surrounding them necessarily evoked the receding planes of Renaissance illusionism.

This issue was commented on, if not resolved, in pop art, which examined the relationship of representation to reproduction in novel ways. Pop artists felt free to use representation, which abstract art had rejected, because they took their subjects from reproductions. Printed images immediately identify themselves as flat, and as having only one property, that of *surface*. During the sixties, pseudo-representational styles based on reproductive techniques, as well as images derived from reproductions, were used by pop artists.

Lichtenstein's and Warhol's painting is particularly sophisticated because it simultaneously acknowledges that reproduction has usurped the mimetic function of painting, while representing images in the terms familiarly associated with reproduction. The most thorough as well as the most profound examination of the relationship of representation to reproduction, however, is the extensive rumination on the subject that

constitutes the complex iconography of Jasper Johns's paintings, drawings, sculpture, and prints. Continuing to explore, in a linked series of methodical transformations of context, technique and association, the relationship of depiction to representation, of the literal to the illusory, Johns refuses to take the position that any art—even abstract art—has completely rid itself of the vestiges of pictorial representation binding modern art to its past.

Johns is certainly correct that the situation is not so simple as it seems. For the most part, the painting of the New York School that called itself "abstract" was still conceptually wed to traditional means of depicting the figure in space. Johns made a punning reference to this fact in his 1955 *Figure 1,* a painting of the numeral 1 in white embedded in a "field" of white that served as an analogy for landscape. Unlike the human figure, however, the numeral has only a single surface, so that no matter how traditional Johns's impressionist technique, the "figure" 1 remained flat, contiguous with the surface on which it was depicted.

As usual, Johns anticipated things to come. The central problem of the sixties was the establishment of a post-cubist style of abstraction no longer indebted to Renaissance modes of depiction and illusionism. Shaped paintings resolved the problem of foreground-vs.-background relationships by discarding the background altogether, cutting out the image so that the entire canvas field was identical with the whole of the image. Both Frank Stella and Ellsworth Kelly used this means of causing depicted shape to coincide with literal shape. After 1966, however, Stella combined shapes depicted within the canvas together with the literal shape of the eccentric canvas cutout, introducing an unexpected element of illusionism.

Another alternative to creating cubist planes and shapes was popularized by Helen Frankenthaler, Kenneth Noland, and Morris Louis in the technique of staining paint into raw, unprimed canvas. Sinking the image directly into the support, staining identified the figure with its ground so that the spatial illusion created was not related to cubist space but to the more ambiguous atmospheric space of the color-field painting of Rothko and Newman.

The question of what liberated Newman and Rothko from cubism becomes more pressing as their liberation assumes increasing significance for current painting. Now that we have had another chance to see both Matisse and Miró once again in recent retrospectives, the answer becomes clearer. Matisse's high-key color and Miró's conception of space as an indeterminate atmospheric continuum are the obvious sources for the post-cubist style of color abstraction that remains domi-

nant in present-day American art. However, we must remember that Matisse remained a representational artist, no matter how radically he reformulated the canons of representation. Miró, on the other hand—especially in the paintings of the late twenties shown recently at the Guggenheim Museum—could be amazingly free of objective referents. The experience Miró had that Matisse did not was of course surrealism.

Fashionable as it still is in New York to deny that surrealism had other than literary importance, it seems time to admit that surrealism rather than cubism was the key to the emergence of an art whose conception of space and figuration were not bound to traditional models. For surrealist space, at least as it was developed by Miró, is open, expansive, indeterminate, as opposed to the closed, finite, restrictive space of cubism with its layered planes and silhouetted shapes. Surrealist space is as fluid as the thought process involved in the technique of free association that inspired surrealist automatism. Certainly it is no accident that the discovery of the unconscious, as well as man's initial experiences in exploring atmospheric outer space, coincided with the conceptualization of a new kind of pictorial space that is both continuous and unbounded.

Miró's contribution to current painting is inestimable. Part of the distortion and confusion of the present situation is the irony that while New York fashion, smugly complacent in the success of American art abroad, elevates petty novelties, Miró serenely continued to paint pictures that will count as much for our time as they did for the twenties. It has been obvious for some time that Miró's simplification of painting into an empty, open field of subtly modulated color decisively affected New York painting. Today, however, another aspect of Miró's works of the twenties has assumed prominence. For the primary role Miró assigned to drawing as a space-creating inflection as opposed to a shape-enclosing contour (its traditional function) is at this moment a central issue in painting.

Drawing, used as an independent element in opposition to its traditional role of bounding and defining color areas as shapes, first appears in the works of Kandinsky and Klee, who were surely important influences on Miró. But Miró detaches line from color and shape more completely than they. Using line to cut through space, Miró suggests depth without communicating sufficient visual information to complete an illusion of the third dimension. Miró's drawing is unprecedented because of its exclusively space-creating function; for in Kandinsky and Klee's works drawing remains surface markings that do not penetrate deep space. This is truer, of course, for Klee—whose drawing resembles a kind of graphic overlay—than for Kandinsky. In Miró's surrealist

paintings, however, automatic drawing pierces the field, often recalling perspective illusions set at an angle to the picture plane. Converging and backward-curving lines are used by Miró to accentuate spatial ambiguity; they evoke but do not establish references to foreshortening and the sensation of depth created by perspective.

Miró's shifting space differs from the strict formality of the cubist grid, which requires each successive plane to line up, no matter how telescoped their order, with the picture plane. In comparison with cubism, Miró's intercalations of flat shapes, lying on the surface or parallel to the surface, with lines that twist and curve, reaching back into depth, were an extraordinary invention.

Today we see a special emphasis placed on drawing that inflects space rather than depicting shapes in the recent paintings of Helen Frankenthaler, Kenneth Noland, Richard Diebenkorn, Al Held, Jack Tworkov, Robert Motherwell, and Jules Olitski, not to mention their legion of younger imitators. The importance of drawing is particularly dramatic when compared with its absence in the painting of the sixties, a decade during which drawing was virtually abandoned as a hindrance to the impact of a more intense color experience. Because of the desire for immediacy, drawing was prohibited from playing an important role in the sixties, since drawing creates complicated detail that impedes the instantaneous visual perception of an image.

One may assign various interpretations to the goal of instantaneous impact characteristic of American painting in the sixties. Certainly it was a decade in which any kind of delayed gratification—whether in life or in art—appeared anathema. The "now" took such precedence over all other considerations that a statement of presentness became the primary aesthetic objective: Freedom Now, Paradise Now, See It Now—these were the slogans of the sixties. The mood of the seventies is intensely different. The feeling that the future is in our grasp has given way to a new sense of extended time as the general rate of change in all areas has slowed. This reflects itself in expressionist painterly painting as a reaction against the minimal, simplifying reductiveness, crisp, easily legible striped bands, and familiar geometry of the sixties in favor of greater complexity of both image and illusion. Both the new painterliness, which emphasizes detail-creating and negates impact, and the interest in drawing as a way of adding visual incident are characteristic of the reaction against the extremes of flatness and simplification characteristic of the sixties.

As an example of the way painters are using drawing to increase spatial ambiguity, one may cite Robert Motherwell's "Open" series of paint-

ings. In these recent generally monochromatic paintings, Motherwell frequently draws an incomplete rectangular figure within a modulated color field, which suggests infinite space, while the drawing simultaneously asserts flatness because it locates the plane of the surface. In other examples of the "Open" series, the direct calligraphy of Zen brush drawings is recalled, not in the sense of Kline's enlarged ideograms, but as kinds of marks to establish Motherwell's conversion from an "action" or gestural painter to a more contemplative artist whose chromatic-field paintings have greater analogies with Newman and Rothko than with Pollock and de Kooning.

Richard Diebenkorn's return to abstraction after a decade of painting the figure is a welcome addition to the dwindling ranks of mature American artists. His new abstract paintings, among his finest, are no longer compromised by an unresolved conflict between the abstract and the representational. Although Diebenkorn's spatial divisions into separate planes link him more closely to cubism than to color-field painting, his horizontal and vertical lines reiterate the frame in the manner of Motherwell and Noland, and acknowledge the importance of structure in recent abstract art.

Painterliness in the seventies is not conceived as it was in the "action painting" of the fifties, in terms of visible brushstrokes recording animated physical gesture. The static anti-"action" painterliness of the seventies is rather a matter of a general softening of forms and fields, a looser technique, a more variable surface, and a renewed interest in detail. One may trace the turn toward a new painterliness to the success of Helen Frankenthaler's Whitney Museum retrospective in 1969. Her show coincided with a general feeling that the reductiveness of minimal art and the simplified formats of the sixties, with their dry, intellectual logic, had run their course. Frankenthaler's sensibility was never at home with the extremes of bland emptiness and repetition of motifs of the impact painting fashionable in the sixties. Although she eliminated line per se after 1962, she continued to make the edges of her forms so irregular that they subsumed the detail-creating function of drawing. She resisted the general use of symmetrical formats and familiar shapes that could be instantaneously perceived with a stubbornness not altogether appreciated at the time. The 1967 painting titled *The Human Edge* acknowledges her revulsion against "hard-edge" painting, the prevailing cold geometric style achieved through the precision of edges painted with masking tape. Currently drawing has resumed a crucial role in her paintings, which seems natural since she had used line so effectively in the fifties.

Frankenthaler's style seemed an alternative to the severely restrictive structural style of the sixties for many younger artists, who created an instant academy of stain painting, seized upon by museums desperate for a *nouvelle vague,* as "lyrical abstraction." Imitating Frankenthaler's freely spreading forms, improvisational approach, and stain technique, young painters were drawn to her nature imagery as well, which appeared a welcome relief from the emotionally detached, intellectual stringency of the sixties. However, it is obvious that none of Frankenthaler's young followers understood her work because of the speed with which they deserted "lyrical abstraction" once the vogue for Jules Olitski's version of painterliness—which emphasized thick paint as opposed to staining— began to attract the eye of critics and collectors. Although Olitski was staining diluted pigment in the early sixties, by the late sixties he had begun to build up a crust that called attention to surface as a material entity that took priority over any image.

Olitski's move toward emphasizing the literal qualities of surface as a film or crust of paint coincided with another reaction against stained painting that was yet more literal in its interpretation of the importance of surface. The emphasis on surface must be seen as part of the increasing identification of the actual, that is, "real," properties of the materials and techniques involved in painting that has been characterized by the self-awareness augmenting each evolution of modern consciousness. In recent American art, however, literalism has received some extreme formulations. Perhaps the most extreme form of literalism is the idea that it is necessary to reveal, in the interest of total candor, that a painting is really nothing but a piece of cloth. Taking the canvas off the stretcher and draping it around the room, or tacking it directly to the wall, some younger artists like Alan Shields and Richard Tuttle have attempted to extend the premises of stained painting in the direction of an even greater literalism regarding the fact that the support is just cloth and drawing is merely one kind of marking. To this category also belong Robert Ryman's white paintings stapled directly to the wall, Sol Lewitt's marks made directly on the wall, and Sam Gilliam's stained canvases, casually draped and folded to create cloth environments.

The move to take painting off its stretcher in an effort to further deprive it of any capacity to create an illusion of space is very popular. The artist who has attracted the most attention with his sewn and appliquéd painted banners is Alan Shields. In this genre, Shields's craft-oriented paintings, in which drawing becomes a literal sewn line of stitching, fulfill the demands of the counterculture ethos, playing right into the taste for patchwork quilts, primitive and folk tapestries, rugs,

and wall hangings. Unfortunately, none of the craft-derived techniques for pursuing the implications of stain painting in the direction of anti-illusionistic literalism hold their own against a good Navajo rug. This says something about the quality of American Indian art, as well as about the impossibility of producing convincing home craft in an advanced technological society. Innocence, whether real or simulated, in the present context can only end up looking quaint or at best ingratiating.

In the most extreme formulations of literalism, the pragmatic spirit that finds any kind of illusionism an unconscionable fiction triumphs. Paintings and sculpture come dangerously close to becoming confused with ordinary objects in the world. In fact, they come so close that the main problem appears no longer the necessity to distinguish painting from the other arts, but the need to find ways of differentiating painting from other objects in the world.

Jules Olitski's paintings are so compelling because he came up with a very persuasive solution to this problem: he asserted that painting is surface and surface alone. Because painting is the only kind of object that can have surface as its exclusive property, Olitski's emphasis on surface drew artists floundering around for some focus into his orbit. Certainly Olitski's aggressive insistence on surface as a physical, material entity is more sophisticated than removing the support from the stretcher, but the two must be seen as related attempts to redefine painting as a two-dimensional surface.

Currently Olitski is the *chef d'école* of a school of heavily impastoed painting that includes Walter Darby Bannard, Dan Christensen, John Hoyland, Jack Bush, Larry Poons, and John Seery in its growing ranks. In the context of the soft absorbent ground of stained painting, Olitski's move to a hard, encrusted surface looked radical. Moreover, he had succeeded in creating a painterly style not dependent on the gestural brushstrokes of "action painting," but on the idea that impastoed color applied in varying densities was a sufficiently interesting visual experience in itself. This also looked radical.

The look of radicality in Olitski's case proves false, however, if one is aware of the antecedents of such a style. As sorting out the relationship between depicted or drawn shapes to literal or actually shaped canvas became more and more pressing for Stella, Noland, and Kelly, the really extreme move appeared to Olitski to be to banish shapes entirely. And he had precedents for doing so. They were Yves Klein's pancake-thin monochrome blue paintings with their lumpy *matière* crusts, in which surface was emphasized to the exclusion of all else, and Dubuffet's *texturologies* and *météorologies*, small oatmeal-colored paintings that

imitated the real surfaces of walls and pavements while also stressing the physical characteristics of painting as a kind of surface. The use of physical matter, of encrusted pigment as a literal material, was central to postwar French painting when Olitski was studying in Paris in the fifties. In his French & Co. show in 1960, he showed paintings with mottled plaster crusts quite indistinguishable from Parisian *art informel* except by their generally larger size.

By returning to his own roots in Parisian painting, Olitski found a way seemingly to outdistance his colleagues who remained loyal to the stain technique. I say seemingly, because the contradictions that result from an effort to combine the surface emphasis of *informel* painting with monumental scale and grandiose aspirations for a disembodied art of pure color and light are singularly unconvincing.

Although I was very enthusiastic about Olitski's initial stain paintings of the early sixties, I came to have more and more reservations regarding his works as they began increasingly to rely on familiar art-historical formats to sustain their purported radicality. In the last series of paintings in the stain technique, for example, large fields of fluid paint are given awesome scale by the presence of tiny dots of color that cause the fields to appear that much grander in comparison. This was a device to establish heroic scale well known to classical landscape painters like Domenichino and Poussin, who added tiny *staffage* figures to their panoramic views. In nineteenth-century American landscape painting, the discrepancy between minuscule figures and gigantesque landscape become ludicrously contrasted. Americans have a tendency to exaggerate.

Olitski's ambition forces him to return to academic formulae to establish his paintings as pictures, differentiating them from experiences of pure phenomena that painting cannot deliver. As an example of such contrivance one may cite Olitski's use of drawing. For Olitski, drawing functions in two ways: to establish scale in contrast with immense fields of color, and to frame these fields, defining their boundaries so that they may be understood as pictorial statements as opposed to just yard goods. Toward this end he elaborates the edges of the canvas with various kinds of apparently nonchalant marks. Olitski's emphasis on the frame, created by drawing around the edges, is crucial to defining the solid wall of opaque pigment he has built up as a painting, as opposed to just another architectural surface. Moreover, drawing is necessary to define the location of the picture plane, since the tonal modulations present within the field would otherwise create the illusion that the picture plane itself was buckling.

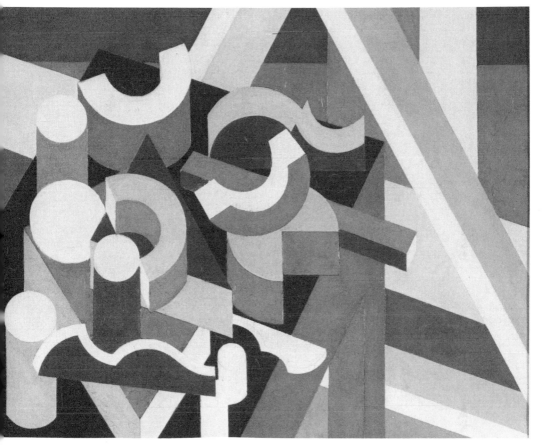

Patrick Henry Bruce: FORMS ON TABLE (1924)
Oil and pencil on canvas, 28³/₄″ × 36¹/₄″

Patrick Henry Bruce was Matisse's outstanding American student. Bruce, however, became an abstract cubist painter, esteemed by Apollinaire, then forgotten until his unique geometric paintings were rediscovered in the sixties. (Addison Gallery of American Art, Phillips Academy, Andover, MA, Gift of Mr. and Mrs. William H. Lane, 1958)

Roy Lichtenstein:
ENTABLATURE (1975)
Oil and magna on canvas,
60″ × 90″

In his series of embossed prints based on the theme of architectural ornament, Roy Lichtenstein used sophisticated technology to comment on the relationship between reproduction and representation, emphasizing that the source of pop art imagery was not a firsthand experience of the world, but the secondhand images of mechanical reproduction. (Leo Castelli)

Donald Judd: UNTITLED (1973)
Copper with bottom insert of aluminum painted cadmium red light, 3′ × 5′ × 5′, with ½-inch-thick upper panels

Donald Judd was the spokesman for "specific objects," structures that combined elements of painting with sculptural volume. An articulate critic, he argued for well-made, abstract art that would make literal qualities that European art had depicted illusionistically, in a new American aesthetic based exclusively on pragmatic principles. (Rudolph Burckhardt for Leo Castelli, with permission of Locksley-Shea Gallery)

Morris Louis: CAPRICORN
(1960–1961)
Acrylic on canvas,
78¼″ × 105¼″

Morris Louis, leader of the Washington Color School, used automatic techniques to create his mysterious veils of color stained directly into raw canvas. Their evocation of natural phenomena gave these works a metaphorical and poetic dimension missing in the work of others who used the new plastic-based water-soluble acrylic paints, which dry as quickly as watercolor. (Courtesy André Emmerich Gallery, New York).

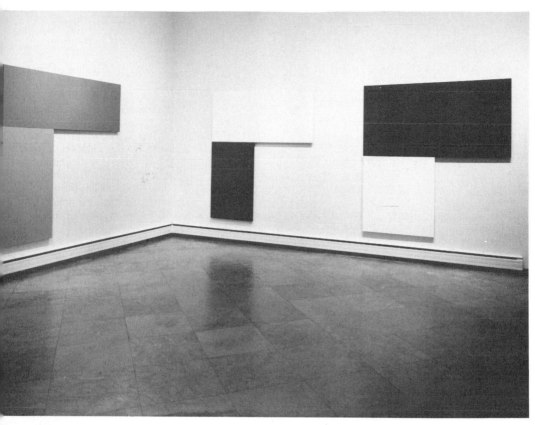

Ellsworth Kelly: CHATHAM SERIES (1972–1973)
Installation view

Continuing his evolution toward increasing purity and monumentality in recent work, Ellsworth Kelly has built on a solid foundation and a personal vision of European constructivism seen through American eyes. (Albright-Knox Art Gallery)

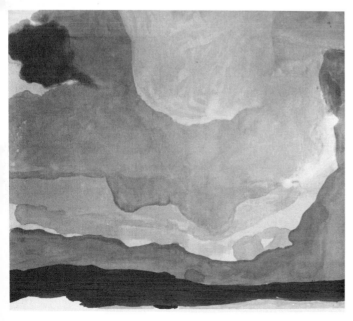

Helen Frankenthaler:
FLOOD (1967)
Acrylic on canvas, 124″ × 140″

A precocious admirer of Jackson Pollock's late paintings, Helen Frankenthaler also learned a great deal about color from Hans Hofmann. Unlike hard-edge and central-image serial abstractionists, she remained faithful to the scale, detail, and internal relationships characteristic of Old Master painting that became unfashionable in the sixties in America. (The Whitney Museum)

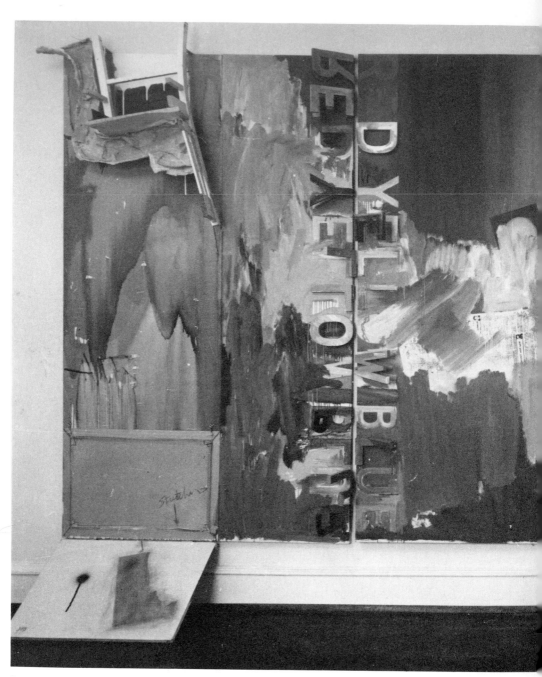

Jasper Johns: ACCORDING TO WHAT (1964)
Oil on canvas with objects, 88″ × 192″

Inspired by Duchamp's philosophical, conceptual attitude toward art, Jasper Johns painted this pendent to Duchamp's last canvas, extending the limits of painting by inventing new categories of representation. (Rudolph Burckhardt for Leo Castelli, S. I. Newhouse collection)

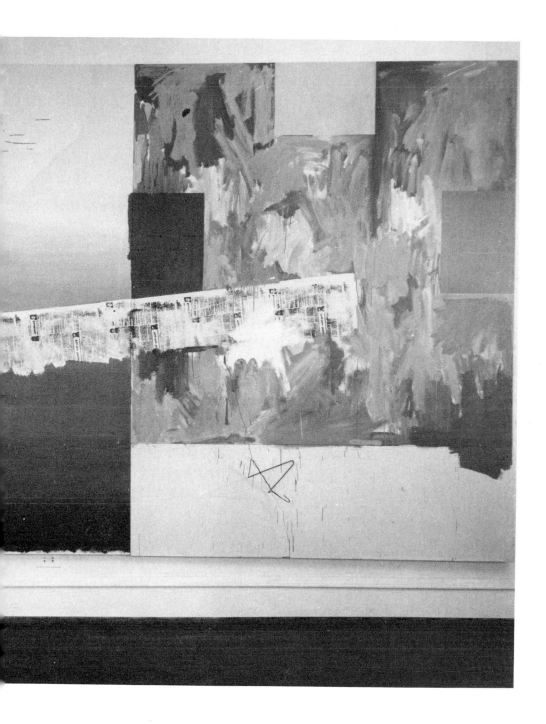

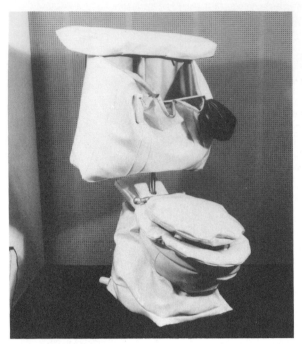

Claes Oldenburg: SOFT TOILET (1966)
Vinyl filled with kapok, painted with
liquitex, wood, chromed metal rack,
50½″ × 32⅝″ × 30⅞″

Claes Oldenburg's soft sculptures of sewn
cloth and vinyl represented a genuine tech-
nical innovation in sculpture. His subjects,
like the soft toilet, were often humorous car-
icatures of American icons. (Leo Castelli)

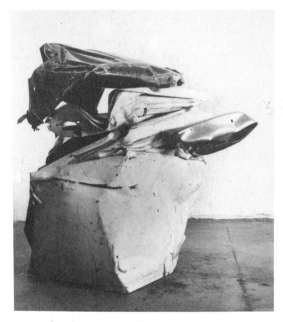

John Chamberlain: BUCKSHUTAM (1963)
Welded auto metal, 45″ × 45″

John Chamberlain's materials—fragments of
wrecked automobiles—gave him the opportunity to
create a colorful painterly sculpture. He deliber-
ately scavenged material from "God's own
junkyard," as one critic referred to America's ubiq-
uitous monuments to wasteful consumption,
transforming cheap found materials into elegant,
expressive, unique works. (Shunk-Kender for Leo
Castelli)

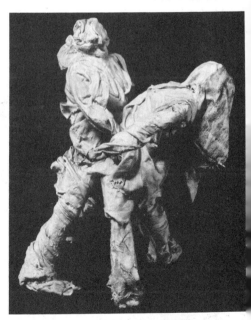

Lucas Samaras: UNTITLED (1959)
Cloth and plaster, 9¼′ × 7½′ × 7½′

Lucas Samaras, like Oldenburg, Dubuffet, and
other artists involved in recreating the world in
their own image, has used his face, body, and
surroundings to redefine the self as both icon and
environment. These early plaster-coated rag dolls
are like homemade toys, self-generated compan-
ions that the isolated, eccentric artist creates to
fill the void of his own solitude. (Photograph
courtesy of the Pace Gallery)

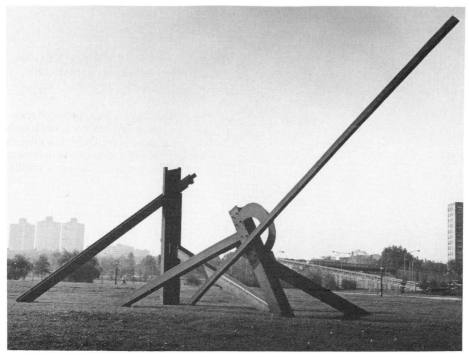

Mark di Suvero: LOVER (1971)
Steel, 21′ 8″ × 27′ 7″

Mark di Suvero began his career as a sculptor assembling junk into three-dimensional transla-
tions of bold abstract expressionist brushwork. After a crippling accident, he began using a
crane to pick up huge pieces of heavy metal. After building a 100-foot peace tower in Los
Angeles, he went into exile in his native Venice and in France for the duration of the Vietnam
war. Back in the United States, he builds monumental kinetic pieces designed to engage the
public in a sense of physical interaction. (Pedro E. Guerrero for Oil and Steel Gallery)

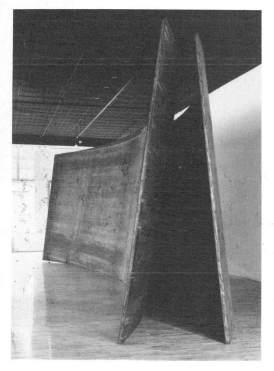

Richard Serra: MY CURVES ARE NOT
MAD (1987)
Cor-Ten steel, two plates,
each 14′ × 44′ 11³/₈″ × 2″

A pioneer of "site specific" sculpture—
works designed for outdoor spaces they are
intended to animate and identify as
unique—Richard Serra has challenged
previous assumptions regarding the role
and form of sculpture without compromis-
ing its essence as a three-dimensional art
requiring an active perception of space as
well as form. (Bill Jacobson Studio for Leo
Castelli)

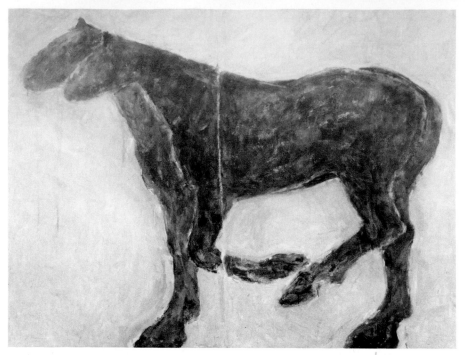

Susan Rothenberg: LAYERING (1975)
Acrylic and tempera, 66½″ × 82½″

Susan Rothenberg is the leading artist associated with New Image painting, a return to representation compatible with the compressed space and frontality of abstract art. Held tightly within the frame, her restricted horses express an existential frustration with artificial boundaries and barriers, like young people who feel confined by the conformity of the regimented hierarchies of posttechnological society. (Sperone Westwater Gallery)

Jackson Pollock: AUTUMN RHYTHM (1950)
Oil on canvas, 105″ × 207″

The unique synthesis of drawing and painting of color and line achieved by Jackson Pollock in his so-called "drip" or poured paintings introduced the concept of applying paint through automatic means to a younger generation of American artists. They are interpreted by many as the ultimate unity painting could aspire to, an achievement so radical and inimitable that it signaled the death of painting after Pollock. (The Metropolitan Museum of Art, George A. Hearn Fund, 1957)

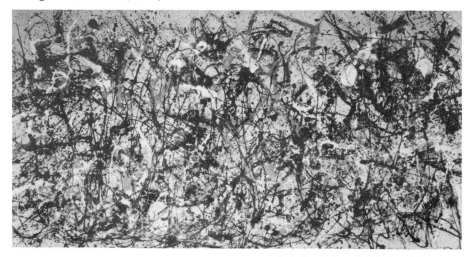

Olitski's most successful attempts to emphasize the frame were those of his spray paintings in which an internal frame, reminiscent of Seurat's halo of pointillist dots around his compositions, were masked off around the perimeter of the canvas. Dissatisfied with this solution, Olitski opted for attempting to establish the rectangle of the canvas as a shape strong enough to act as a container for modulated color. Unfortunately the rectangle is the simplest and hence the weakest gestalt. These paintings had the tendency to decompose visually, having no strong boundaries to frame the billowing clouds of sprayed, shapeless color.

Olitski soon realized there was only one way out of such a dilemma: the use of framing *repoussoir* elements to lend coherence to atmospheric effects. Such *repoussoir* framing devices are common to the paintings of Turner. Undoubtedly Turner, and the whole concept of the sublime that Turner's seascapes epitomize, was a crucial inspiration for Olitski. Turner, like Olitski, was one of the original practitioners of aesthetic brinkmanship. Some of his paintings seem to be asking the same question Olitski now poses: how far can you go in the direction of an art of pure color and light and still make paintings?

The fantasy of immaterial painting is a contradiction in terms. Although it may depict color and light, no painting can actually *be* disembodied color and light. This confusion, however, seems a peculiarly American heresy initiated by the Synchromists, the original American pseudo-visionaries. Like Thomas Wilfred, whose *Lumia Suite,* the light box that still pathetically anticipates color television in the Museum of Modern Art lounge, Olitski is guilty of asking of painting what painting cannot deliver. As Walter Benjamin wrote in 1935: "The history of every form of art comprises critical periods in which art aspires to produce effects that can be achieved only after a drastic modification of the technical *status quo,* that is to say by a new form of art." Surely there is an art of pure light and color, and it is realized in slides, films, and the rapidly developing new art of video, but not in painting.

Despite the emergence of these new forms, there is still a lot of good painting going on today, and it is addressed, like Olitski's art, primarily to a redefinition of the roles of drawing and surface within a fresh approach to the painterly. It does not, however, defy the limits of the pictorial in the pursuit of a spurious radicality that can be redeemed only through academic contrivance.

Olitski is surely addressing the crucial questions. But his answers, I fear, are a good indication of the present state of moral as well as aesthetic confusion. The combination of a purely pyrotechnical display of spectacle for its own sake with an emphasis on paint as literal matter

is a contradiction that could only occur to a consciousness capable of mistaking the hedonistic for the visionary, the material for the mystical. Advanced abstract art today is free of any ties to the representational art of the past, but it is not free of *all* limitations. It must continue to operate within the boundaries of what constitutes a convincing pictorial statement. The issue of limits is as crucial to painting in the seventies as it is to the other areas of thought.

JACKSON POLLOCK AND THE
DEATH OF PAINTING

In autumn 1950, Hans Namuth made two films of Jackson Pollock working. The first, a black-and-white study, is a direct extension of the series of motion photographs of Pollock working indoors. Namuth considered it a "rehearsal" for the second film, a ten-minute color documentary featuring Pollock painting on glass. Pollock's repeated rhythmic steps as he worked his way around the four sides of his canvas were interpreted as a kind of ritual dance. As a result, the word "choreographed" began to be used to describe the compositional mode of Pollock's classic poured paintings.

It has been suggested that the invention of a means to photograph macrocosmic and microcosmic phenomena influenced the creation of Pollock's imagery, which has affinity with both. Certainly visual perception and consequently artistic conception has been modified by experience of film viewing, which, along with flying, has been a principal means of altering man's conception of space in the twentieth century. Pollock anticipated body-in-space sensations, which he projected metaphorically in painting in "galactic" imagery, two decades before Stanley Kubrick was able to achieve related sensations in the film *2001*. An image that implied a field which could be penetrated by vision not grounded to a fixed horizon, but free to move in and out, up and down, in any direction in space, is inconceivable before the invention of the mobile motion picture camera. Through fortuitous coincidence, Namuth hit upon an analogy to Pollock's conceptions of space and composition in his color film of Pollock painting.

Namuth's choice of an angle of vision *below* his subject was not only inspired to accentuate the drama of Pollock's daring. It also further

enhanced the sense of a fully three-dimensional space by effectively rotating the normal plane of vision. Placing himself under a sheet of plate glass on which Pollock was painting, Namuth held the camera in a position to record the loops of liquid paint as they fell. The resulting illusion is that the spectator, seeing through the camera eye, feels that the painting is coming out at or literally on him. The scene of Pollock painting on glass is extraordinarily vivid, an inventive collaboration of artist and filmmaker that is unforgettable to anyone who has seen it. Because of this sequence, the idea that Pollock's images mysteriously projected themselves in front of the picture plane in the space between viewer and canvas became inextricably attached to the meaning of the poured "drip" paintings. Namuth's film also encouraged the perception of Pollock's paintings among that group of literalist artists who had more experience with media images than with original art works. The idea of filming Pollock in this novel fashion, so that the paint would seem to hurtle out into the viewer's space, was, I believe, suggested to Namuth by 3-D movies, which were popular at the time. Indeed, the entire development of art that literally projected into the viewer's environment, although in certain respects a logical evolution of cubist collage into three dimensions, was also conditioned by the experience of 3-D films.

To accommodate Namuth's decision to lie on his back and film from below, rather than from above or from any side, Pollock constructed a wooden scaffold on which he placed a sheet of plate glass. During the course of the filming, Pollock completed a painting, eventually sold to the National Gallery of Ontario as *No. 29, 1950*. The history of this unique work and its relationship to Pollock's oeuvre is of great significance in understanding the crisis that caused Pollock to abandon the poured technique, to return, in the Duco enamel paintings of 1951, to black-and-white representational images. That its existence was owed to a chance encounter between the painter and the photographer and their subsequent interaction is entirely consistent with Pollock's attitudes toward the acceptance of accident as part of the creative process.

The problems raised in the poured paintings regarding the relation of the painted image to the canvas field which supported it made it natural for Pollock to conceive of dripping on glass in 1950. Indeed, it is altogether possible he would have experimented with painting on glass independently of Namuth's film as an extension of his technical experiments. There were several art-historical precedents for expressionist glass paintings in Kandinsky and Hartley and a whole tradition of folk *Hinterglasmalerei*. Whether or not Pollock was aware of any of these prece-

dents, however, is not as relevant to *No. 29, 1950* as the one glass work that every modern artist knew: Duchamp's *Large Glass.*

In *The Large Glass,* Duchamp inverted the assumption fundamental to Western art since the Renaissance that the painting was a window into which the viewer looked to see an illusion of three dimensions located *behind* the picture plane. In *The Large Glass,* the picture plane is transparent, and the image, inlaid in metal in a technique reminiscent of medieval *champlevé,* is literally embedded into the surface. By creating a transparent support, Duchamp eliminated the conventional figure–ground relationships on which representational art is based, sealing the figure "in" the ground, as fully as the image is embedded in the raw canvas in stained color-field painting.

The conception of an absolutely neutral support that could not be interpreted as negative space around a depicted figure was thus already posited by Duchamp in *The Large Glass.* When Dorothy Miller installed *No. 29, 1950* in her Museum of Modern Art exhibition "Fifteen Americans" in 1952 (the first time it was seen publicly), she chose to display it freestanding in the middle of the room, an obvious analogy to the installation of *The Large Glass* in the Philadelphia Museum of Art. Although the idea was Miller's, according to Lee Krasner, Pollock was pleased with the solution and congratulated her on the installation.

In the only serious attempt to deal critically with the issues raised by the poured paintings, Michael Fried, in his introduction to *Three American Painters,* saw the 1949 paintings with areas removed from the web by Pollock, *Cut-Out* and *Out of the Web,* as solutions to achieving figuration without resorting to conventional drawing, within the context of the "optical" allover style of the poured paintings. The relationship of *No. 29, 1950* to the problem of reconciling figuration with pure opticality seems quite clear. *No. 29* is an inversion of *Out of the Web:* what has been "removed" from vision is not the figure but the surrounding field.

In the poured or "drip" technique, Pollock tested the limits of painting. In the paintings with sections cut out and removed to reveal the support, and in the glass painting, in which the ground has been rendered invisible through transparency, he attempted to go beyond the tangled-web image. One reason Pollock's poured paintings provoked a crisis not just for him but for art in general is that in their heroic thrust forward into a post-cubist space and style, they portended an art that went "beyond painting." The idea that literal images were "beyond painting" had haunted artists from Morgan Russell to Moholy-Nagy throughout the twentieth century. Artists who responded directly to

Pollock's challenge, like Ad Reinhardt, who appears to have been propelled into the inner space of his black paintings in answer to the "outer" space of Pollock's imagery, were forced to take extremely radical positions. For his own generation, Pollock was a problem; for the younger generation who matured in the sixties, his achievement was a catastrophe that paralyzed younger artists, except perhaps Frank Stella, whose entire career can be interpreted as an attempt to come to terms with Pollock. But even Stella had to resort to going "beyond painting," projecting forms forward into real space in metal reliefs, to begin to compete with Pollock's drama and energy.

For Pollock, there was no more possibility of renouncing painting, which he had spent his whole life studying and absorbing, than there was of repeating himself. *No. 29, 1950* was an isolated experiment in the use of literal materials—glass, colored mosaic, plaster slabs, beach pebbles, string, and wire mesh along with oil paint—which he never tried again, although apparently he was considering making more paintings on glass. Instead, in 1951, he turned his back on his allover dripping and began to paint in a style reminiscent of his early automatic drawings with their zoomorphic dream images. Freshness and directness were always what Pollock was seeking. The cut-out paintings of 1949, like *Blue Poles*, involve a radical strategy to retrieve an image lost in the welter of superimposed skeins of paint too dense to be read as anything more than crust. In *No. 29*, the painting on glass, he hit on a way of reconciling figuration with opticality by suspending the paint web in a ground that was literally transparent. I believe Pollock made no more glass paintings not only because of the impracticality, but also because the inevitably decorative quality of literal materials ran counter to his impulse to create pictorial space that depicted a world autonomous of any architectural context.

The reappearance of representational images in Pollock's work in 1951 coincided with the artist's urge to draw more specifically psychologically charged imagery. These paintings, like Kline's black-and-white paintings, are blown-up versions of drawings. We may presume Pollock was as influenced by projection—after all, he had been watching projections of himself working in Namuth's films—as Kline was in arriving at this kind of imagery which is basically a blowup of drawings to large scale.

Far more technically sophisticated than Kline, Pollock used his experience with watercolor and gouache to invent a style that had the freshness and immediacy of watercolor and that, moreover, avoided the cubist disjunction between figure and ground, because the figure was absorbed

by the raw canvas, which functioned exactly as the watercolor sheet. The discovery that the background or support could be rendered neutral by allowing paint to sink in and become one with the surface is the basis of stained-color-field painting, as Fried also points out in his further discussion of Louis and Olitski in *Three American Painters.*

The addition of color in Pollock's last works of 1953–56 posed problems regarding how to embed the image so firmly in the surrounding field that it could not be read as spatially projecting or receding from the plane. Until very recently, when Jasper Johns started dissecting them, artists turned away from Pollock's last thickly painted works. Those artists who were looking at Pollock closely were under Greenberg's spell. Greenberg wrote that after 1951 Pollock became "profoundly unsure of himself," giving the impression there was not much to learn from Pollock after 1951—one of the monumental critical errors of the twentieth century.

In saying, however, that Pollock was at the decisive turning point, poised between easel painting and a kind of portable mural, Greenberg was not wrong. For that is precisely what *No. 29, 1950* was. Incorporating the fragments of a mosaic Pollock had worked on when he was on the WPA, *No. 29* expressed Pollock's continuing interest in architectural decoration. In an interview done in 1950 published by Francis V. O'Connor, Pollock described *No. 29* as "something new for me . . . the first thing I've done on glass and I find it very exciting. I think the possibilities of using painting on glass in modern architecture—in modern construction—terrific." (According to Lee Krasner, Pollock first considered installing the glass painting on their porch, setting it into the structure.)

That Pollock was unsure the glass painting was art is clear. It was left out in the field behind the barn during the winter of 1950 while Pollock considered its status. Eventually it was brought inside, and the artist claimed it as part of his oeuvre. In this act of confirming the status of art by claiming, Pollock illustrates a Dada element consistently present in abstract expressionism.

Pollock's treatment of *No. 29* was entirely consistent with his method of working on other paintings, which he often left for a period of time while evaluating them and considering alterations. These periods of self-criticism were related to Cézanne's "doubt." They were the moments in which the artist objectively analyzed what had been formed as part of a working process. There are a number of photographs of Pollock by Namuth showing Pollock performing these painful acts of self-criticism; but these are rarely reproduced. Instead of the man of contempla-

tion—the thinker whose perplexed cogitation Namuth captures in the photograph of Pollock on the grass withdrawn in thought as much as he had been lost in action in the motion photographs—the popular imagination has only the picture of Pollock as the man of action. It is a distorted picture that should be corrected if Pollock is ever to be understood, or his late paintings to become the point of departure for an art as firmly secured within the tradition of painting as Pollock's art was.

IV

ON SCULPTURE

SCULPTURE AND PERCEPTION

For most of the twentieth century, sculpture has been based on nine-teenth-century premises: it has been related to the human body, either literally or allusively, separated from the spectator's space on a pedestal, and distinguished from painting mainly in its demand for an "in-the-round"—i.e., spatial—reading in three dimensions. Cubism changed this. Around 1930, Gonzalez and Picasso turned sculpture into assem-bled collages constructed of open, flat planes as opposed to the earlier monolithic closed mass. The invention of the technique of assembling through welding together separate parts and planes, which created inte-rior "negative" shapes in the space enclosed between them, was the only significant innovation in modern sculpture until the sixties. Assembling sufficed David Smith throughout his life; even his last works, the *Cubi* series, in which he added volume to his form, are essentially assembled from discreet individual and separable parts. They are still meant to be "read" in the manner of nineteenth-century sculpture—as self-con-tained objects to be circulated leisurely around—with the exception of the final "gates": they always refer back to the human figure, if not for their forms, for their general principle of organization.

All ambitious recent sculpture, from Anthony Caro to Robert Morris, Larry Bell, Robert Murray, and Donald Judd, has rejected these prem-ises. Even Caro and Murray, who are the closest to David Smith, in that their work continues to be assembled of flat planes relationally disposed, reject obvious anthropomorphism; they also diverge from Smith in the nature of the relationship set up between object and viewer. This rela-tionship is far more intimate than that traditionally demanded by sculp-ture. The obvious intention of creating greater intimacy between specta-tor and object is to gain for sculpture the immediacy, impact, and power painting has achieved. In Caro's case, the sense of intimacy is cultivated

by splaying out the sculptural members in such a way that to get any satisfactory angle for viewing the work, the spectator must be practically *in* the piece, since as he walks around and views the work sequentially, one of the parts may actually appear to be behind him, enclosing him within the work itself. This is not always true of Caro's work, of course, but it is often true of the best recent large pieces.

Robert Murray's scale is larger than Caro's in terms of vertical extension, but it often covers as much ground horizontally as well, thus requiring the same kind of intimate relationship between viewer and object Caro's work demands. In one of his most successful pieces, *Athabasca,* Murray opposes two enormous fan-shaped shells that appear to embrace the viewer, and into whose space the viewer can actually step. Murray's gradual honing down and simplification of form in his work involves freeing himself from cubist organization; his recent use of multipart forms and modular or quasi-modular ordering is a similar attempt to get beyond a conventional approach to sculpture.

Object sculptors like Morris, Kauffman, Bell, and Judd, who have followed abstract painting in abandoning relational composition for single images, have also renounced open planes for closed—albeit frequently transparent—volumes. They achieve intimacy and immediacy in other ways. Larry Bell, for example, coats glass so that surfaces are either partially or entirely mirrored. Although the sensual or conventional "aesthetic" appeal of color and light yields enjoyment that differentiates Bell's work from the cheap optical tricks using mirrors to "involve" the spectator, it is true that the spectator's consciousness that he is involved in the act of perceiving, since he glimpses reflections of himself and his surroundings, binds viewer to work in a particularly intimate manner.

Originally, much object sculpture was relatively small in scale; its size identified it as something that could be picked up or handled. This knowledge also heightened the degree of intimacy between viewer and object. That so much object sculpture shares shapes and materials with common non-art objects also acts to erode any "psychic distance" the viewer might bring to art. Initial responses to work that looks in some way vaguely familiar ensures that art is not a category so vastly different from the everyday as, for example, Renaissance sculpture was from Renaissance plumbing. Approximating art to the everyday, then, although it may have other complex causes and effects, also intends to establish a feeling of intimacy through a supposed familiarity with the object.

The great distancing factor separating art from reality in older art was illusionism. Originally many object artists, who had been painters,

broke with painting because of its unavoidable illusionism, which appeared to them a falsification and hence a contradiction of reality. Today, the best have found ways of using illusionism to heighten immediacy and directness of experience. Judd's new works, for example, are extended multiunit pieces that, because they are larger than the field of vision, cannot be seen without some type of illusionistic distortion, i.e., perspectival foreshortening, occurring. The crucial difference, however, is that this foreshortening is not depicted, it is actual; it does not depend on the artist's skill in convincing the viewer of a fiction, but on his demand that the viewer be so involved in the work that the distortion occurs within the viewer's eye itself as a product of normal vision seeing the work in question.

Larry Bell's new glass "walls" that eerily distort the space they are in, madly disorienting the spectator, require a similar literal involvement. Both Judd's and Bell's new work sets up, as I have pointed out, a greater intimacy between viewer and observed object. We can trace the development of this growing intimacy in the history of art from Jan van Eyck's wedding portrait of Arnolfini and his wife, in which a mirror reflects two absent witnesses, who obviously stand outside the depicted space, to Velázquez's group portrait *Las Meninas*, in which the king and queen, who seem yet more obviously in the viewer's own place, are reflected, to Manet's *Bar at the Folies Bergères* (in many ways indebted to Velázquez), in which the figures dimly reflected behind the barmaid's head are obviously our own since we stand on the other side of the bar, from behind which the girl stares straight ahead, serving an anonymous customer who must be the spectator. In this sequence, spanning four centuries, the mirror, which stands for the spectator's involvement, symbolically grows larger until in the Manet, it stretches clear across the painting. The demand for greater and greater involvement and immediacy—by which I mean something much more serious than works that ask the viewer to "participate" in some superficial and gimmicky manner—has culminated today in the new object sculpture which makes self-referential involvement, awareness of the act of perception, and immediacy of impact absolute and central, as opposed to relative and peripheral, values.

The unanimous rejection of the base by all sculpture with any pretension to modernity in the sixties can be seen as yet another device for ensuring a more intimate and immediate relationship between object and viewer: for if the object actually stands on the floor as we do, then it is clearly part of our own space. An object raised above us on a pedestal, on the other hand, is isolated from the space inhabited by the body.

Larry Bell, in particular, had difficulty in resolving this problem; only in the recent "walls" has he been able to eliminate the base satisfactorily, even though he had rendered it neutral earlier by making it transparent. That much of the best contemporary work relates itself in one way or another—through reflection, transparency, contact with or orientation toward the environment—throws the locus of aesthetic experience from an empathic projection of emotion into the object to a heightened awareness of one's own relationship to the environment and to the object of perception through an emphasis on the relatedness of the sculptural object to its surroundings

Other notions that had turned stale have been reformulated in the sixties, often toward the end once again of achieving a greater immediacy of response. Thus everything that might stand between viewer and object—metaphor, allusion, evidence of hard work—has been rejected in order to render the object more naked and more accessible to direct apprehension. The actual physical characteristics and qualities of materials, their properties of density, transparency, weight, texture, color, and reflectiveness, are meant to be experienced in their literal, concrete specificity—as themselves, rather than as agents of something else, whether that something else be emotional content, implied allusion, or a general notion of form. For the object sculptor, this has meant turning cubism inside out: where cubism placed color, surface, and material in secondary roles in the service of form, recent sculpture downgrades the essence of cubism—composition and the creation of unusual shapes—to the bottom rung of the ladder. This is done to ensure the primacy of the specific qualities of highly individual materials like Morris's steel mesh, Kauffman's sprayed plastic, Bell's optically coated glass, and Judd's brilliantly enameled aluminum.

The destruction of the cubist aesthetic and the construction of a new aesthetic has been the intention of such sculpture, as have radical aspirations in the sixties. Cubism structured perception into sequential units, and attempted to integrate those sequential moments into a single apprehension, in which these time units would be "simultaneously" integrated. The technique used to achieve this was superimposition. That the various views of an object in space could be superimposed to telescope into a single perception is at the heart of cubist painting and hence cubist construction, which derives directly from it. The new sculpture completely rejects the cubist notion of simultaneity, demanding instead an actually instantaneous perception of a work that can be grasped, conceptually at least, as three-dimensional from any single given point of view. This is achieved through the use of several devices. Instead of

separating out planes and then reassembling them, object sculpture invariably presents form as whole to begin with. Object sculpture is visibly hollow or open from one or more sides or transparent, so that inside or outside are simultaneously visible in the literal sense, as opposed to the metaphorical expression of simultaneity developed by the cubists, who attempted to combine inside and outside by depicting them as partaking of or incorporated into one another.

It becomes clear that the content of the most ambitious sculpture of the sixties is the nature of visual perception. Its only relationship to cubism, outside of a negative one, is that cubism was the first art style to focus so emphatically and decisively on the nature of the perception of the object. Certain concepts from gestalt psychology and phenomenology, either studied or intuitively grasped, play a large role in determining the current understanding of the nature of perception. Robert Morris has articulated many of these concepts in a series of articles on sculpture that have been widely quoted and read. From gestalt psychology comes the emphasis on the object as known in the mind as well as the object as seen by the eye. That is to say, gestalt psychology first pointed out that our immediate perception is made up not only of what is immediately visible, but of all the knowledge we have of the size, shape, and general character of the object. Perhaps the principal reason much object art has confined itself to the most familiar geometric shape, the rectangle, is that we can mentally reconstruct the shape of the rectangle, given a relatively small amount of initial information on the basis of prior knowledge. From wherever we first approach a Judd, a Bell, or a Morris, we can immediately (without necessarily walking around it) understand that we are looking at a certain kind of known three-dimensional shape. Unlike sculpture "in the round" which requires a sequence of acts of looking, we can experience transparent or familiar forms *immediately* as gestalts. It takes us much less time, in other words, to process the information regarding such forms because we either see or can sense them all at once.

From phenomenology, the object sculptor borrows the principle of "sedimentation," which defines the perceptual act as layered and made up of both the experience at hand and memories of past experiences. This is another way of saying that the experience at hand is conditioned or completed by previous knowledge of the nature of the thing perceived. Object sculpture also subscribes to the phenomenological notion that perception is a heuristic, self-referential process and experience. The intention of object sculpture is both to refer the viewer back to the experience of the act of perception and to reverse the traditional process

of viewing sculpture by delivering all of the information usually amassed from a sequence of readings from differing vantage points into the initial encounter from any given point of view. The object is no longer analyzed, dissected into planes, and then reconstituted from these planes; all of the information regarding it is evidenced at once and immediately. This is not to say that one does not enjoy circulating around the work, but merely that no new information can be gained by so doing. `

Comprehending this, one understands that "minimal" art is not minimal in offering less to the eye than traditional sculpture; simply, it offers an entirely new and different set of experiences, in which perception, not emotion, is the focus. In a pluralistic society in which no values or experiences are held in common, this seems an inevitable departure.

BLOWUP: THE PROBLEM OF SCALE
IN SCULPTURE

■

What is striking about the sculpture produced in the first half of the twentieth century is how relatively insignificant it looks in comparison with the achievements of world art. Until very recently (until David Smith's *Cubi* series, to be exact), modern civilization had produced virtually no monumental sculpture to rank with the great sculptural creations of the other high civilizations. Even Matisse's and Picasso's most important works were on the whole conceived as intimate decorations for domestic interiors.

The reason for the dearth of monumental sculpture in the modern period is complex; it has to do with both the traditional function of sculpture and the ambiguous role of the arts in modern society. Unlike painting, which decorated homely pots as well as ritual vessels, tombs, and public halls, earlier sculpture was always primarily a public art, an art of celebration or commemoration. As we know, even the small figures that are all we have left of the sculpture of the pre-Greek Aegean were evidently associated with religious ritual. Painting, on the other hand, although it began as a kind of magical rite, soon assumed an independent life as a pure art of decoration, easily accommodated to the needs and scale of domestic life. But sculpture remained an art of limitation, permanently tied to either religious observances or historical events, like battles or the death of a great personage; by the same token, it was more often than not tied to an architectural complex.

The decline of sculpture in the modern period, although it clearly had other purely stylistic or economic causes as well, is surely related to the decline of general systems of belief. For the most part, the best artists in our century have not been called on or have not seen fit to celebrate

either religious or secular authority. In addition, the avant-garde artist who "commissioned himself" could seldom afford the expense of making a large-scale sculpture. Another problem militating against the creation of monumental modern sculpture was that the materials and techniques of traditional sculpture were in many ways unsuited to the modern aesthetic. A good illustration of the difficulty of translating cubism into a monumental sculptural style is the *Large Horse,* a five-foot-high blowup executed from a smaller version by Raymond Duchamp-Villon shortly after his death in 1914. Exhibited recently in New York at Knoedler's, the *Cheval Majeur* is in every way inferior to its prototype, although it is physically larger. Unfortunately, Duchamp-Villon did not live long enough to solve the problem of how to retrieve the monumentality of past sculpture, but he was acutely aware of it. In 1912, he wrote: "We suffer, or rather sculpture suffers, from museum sickness. . . . It is an absurdity which gradually turns sculptors from their art: they become modelers of bibelots, enlarged to monuments or reduced to clock figures as need be."

Much has happened since Duchamp-Villon wrote these words. In fact, as is obvious from what has already sprung up around us, we are witnessing the development of a new style of architectural sculpture, whose only function, paradoxically, is decoration. The terms on which this development is taking place should be critically examined at this juncture, because aesthetically the creation of these imposing forms, which are beginning to grace the entrances of banks and cultural complexes alike, is not an unmixed blessing. One of the greatest limitations from which these works suffer is precisely what makes the *Large Horse* a lesser work than its smaller model: that is, they are merely enlargements (often gigantic blowups) of forms conceived on a tabletop scale. Some of the worst offenders in this category are Bernhard Luginbuhl's *Sentinel* in front of the Giegy Chemical Corporation in Ardsley, New York, and Norbert Krieke's immense glittering fountain sculpture, which is every bit as vulgar as the facade of the Los Angeles County Museum behind it. On the other hand, Eero Saarinen's graceful 630-foot *Gateway Arch* in St. Louis, Alexander Calder's mammoth stabile for Spoleto, and José de Rivera's sinuous revolving sculpture in Washington, D.C., prove that it *is* possible to execute meaningful architectural sculpture in our time. These works seem to justify their scale, whereas works that are just enlargements strike one as merely inflated. Prominent examples of such blowups are the aggrandized versions of Picasso's modest works being executed for American sites. One of the surprises that hit home hardest in the Museum of Modern Art exhibition of

Picasso's sculpture was the realization of how small his classic works of the twenties and thirties actually are. Installed on pedestals, they were at eye level; had they rested on the floor one would have been even more acutely aware of how they were dwarfed in comparison with the human body—a comparison that all freestanding sculpture is ultimately forced to measure up to.

Our ideal of the monumentality of Picasso's works, in other words, is not dependent on actual scale; in fact, in my case an appreciation of their monumentality was largely a result of never having seen the originals, but of having experienced them as slides or photographs. In this way, the comparison with the human body never came up, so that the epoch-making 1928–29 *Construction in Wire*, although a scant twenty inches high in actuality, was as large as the imagination cared to make it. Conversely, I think the experience of seeing photographs of sculptures must be taken into consideration as part of the change in scale we are currently witnessing. The photograph, as Michelangelo Antonioni was scarcely the first to realize, permits a blowup to any scale, even the most gargantuan. Through the agency of the photograph, the viewer can mentally transform the intimate living-room art of early modern sculpture into the outdoor monuments Duchamp-Villon envisioned. (To understand the pitfalls of such speculation, one need only entertain for a moment the nightmarish vision of a fifty-foot Degas bronze dancer.)

In many ways, Duchamp-Villon's simplified geometric volumes were only a polished, stylized post-Rodin version of what was essentially still the Renaissance approach toward sculpture, despite the artist's attempts to arrive at a machine aesthetic. The first artists to translate the aesthetic advances of cubism into a kind of sculpture that was so radical a departure from the past that it required *a new way of seeing* were Gonzalez and Picasso. After a false, even if powerfully moving, beginning in the 1909 bronze *Woman's Head*, in which he tried unsuccessfully to recreate cubism in three dimensions, Picasso finally realized that genuinely cubist sculpture could not be based on solid volumes, but it would have to be *literally* as open and transparent as cubist paintings gave the illusion of being.

Eventually Picasso, together with Gonzalez, found the solution by conceiving a sculpture that was a kind of standing three-dimensional collage. This new constructed, welded sculpture with its transparencies, flat planes, and discrete silhouettes was a direct extension of painting. When we realize that the first genuinely modern sculptural style came into being in a symbiotic relationship with painting, it should not surprise us to find that current sculpture, which proposes to revise the

canons of cubist sculpture, plays a similar role with regard to recent abstract painting. Based on simple hollow volumes or planes twisted or bent in such a way as to demand an in-the-round reading, work by younger artists such as Murray, Morris, Judd, and Lewitt is, like the cubist sculpture it rejects, largely extrapolated from painting. The clear shapes, single indissoluble images, and allover disposition of elements, as well as the impersonal surfaces, are derived directly from recent American abstract painting, especially that of Barnett Newman.

Above all, the large scale of much current sculpture seems inspired by the "environmental" scale of American painting, although it would be a simplification to claim that the change in scale in sculpture had no other causes. Certainly one of the factors that has contributed to making large scale endemic in new sculpture is the demand on the part of American institutions as diverse as banks, churches, museums, schools, airports, and municipalities for impressive, monumental objects to decorate their premises and enhance their images. But it would surely be naive to see these many new outlets for sculptural decoration as expressive solely of a hunger for beauty on the part of American civilization in general. In fact, it seems clear that many of the weaknesses of current large-scale work reflect the lack of knowledge and conviction of its patrons, who confuse aesthetics with public relations.

Nevertheless, one may presume that there is among sculptors a legitimate aesthetic urge to work on a large scale. As proof one might cite the fact that a number of older American sculptors such as David Smith, Tony Smith, Alexander Liberman, and Herbert Ferber, although working in widely divergent modes, as well as a group of younger artists, were already making large-scale sculpture before there was much if any demand for such work. Of course the situation has been altered somewhat by the increased demand for large-scale works, which has in most instances stimulated not the execution of sculpture of increased quality so much as the creation of works of increased size.

The difficulty is that sheer size—the fact that the work towers over and encompasses or dominates the viewer—gives even inferior work an imposing presence that is enough to impress the less-knowing patrons of the new sculpture. Many of these people—particularly, it would seem, the leading purchasers of monumental sculpture such as schools, corporations, and the rapidly multiplying cultural centers—cannot make any significant discriminations of value because they are unable to separate the impact of scale from that of quality.

Scale is, of course, an important element of all art. But the juxtaposition of small elements with larger elements in painting can serve to

create a sense of impressive scale or infinite distance even in works that are not large. For instance, the change in the relationship of the scale of figures to landscape that marks the creation of the heroic classical landscape of the seventeenth century, and Jules Olitski's recent use of tiny elements punctuating an extended field, are both examples of the creation of a grand manner without resorting to a superhuman scale. The vast historical paintings, the so-called "machines," of the nineteenth century, on the other hand, prove that large scale alone is no assurance of grandeur or significance. In sculpture, the problem of scale is even more acute, since scale is actual. The sculptural object is always seen in relationship to the human body, whose space it shares. It would seem, therefore, that in order to create a monumental sculpture, one would be forced to resort to a scale that was larger than life. And this is precisely the solution many sculptors have accepted. The result has been that forms conceived on a small scale have been inflated into works that are monumental only in the sense that they rival the scale of monuments, without having their expressive content. Indeed, what we are seeing today in many instances is the replacement of content by scale.

The pervasive and, I would argue, pernicious notion of scale as content is undoubtedly the most unfortunate side effect of the present American sculptural explosion. On first considering the new work, I felt bound to try to isolate its good points; but by this time I think we might begin to consider its limitations. When the new work is bad, it is more often than not because its size is not justified by its formal content. Certainly the bathetic Henry Moore lounging like a great melancholy behemoth in the plaza of Lincoln Center is a perfect example of a work executed on an inappropriate scale, although its vacuity is probably a perfect symbol of the committee taste that selected it.

As among the most egregious examples of this new blowup art of bigness for its own sake—of execution on monumental scale of works that were clearly conceived for the coffee table—one ought certainly to note the colossal Nadelman white porcelain ladies that tower over the lobby of the New York State Theater like twin mountains of lacquered meringue glacée. Perhaps if one did not remember the Campidoglio, which Lincoln Center so painfully evokes, one would not be quite so revolted at the travesty of greatnesses it represents. Clearly our civilization is at a point where it is beginning to cast about for public symbols to celebrate its imperial majesty and cultural achievements. We may, consequently, expect more, not fewer, spurious monuments like the Picasso commissioned for the I. M. Pei New York University development in Greenwich Village. Conceived as a folded and painted metal

cutout of a woman's profile originally less than two feet high, this minor effort was blown up to the towering height of over thirty-five feet. What was charming and spontaneous in a flimsy construction can only be tacky and ridiculous on a monumental scale.

Obviously, the blowup of an informal studio piece into a public monument could only happen in a culture so insecure and uninformed about aesthetic values that it is willing to substitute the status of the master's name for the creation of a masterpiece. At this point, we may well ask what a better alternative to the blowup would be for the purposes of contemporary decoration. The problem, as I have tried to point out, is that a work is conceived on one scale and executed on another. If the question is so posed, the answer is obviously to eliminate the state of the maquette so that the sculptor can work directly on the scale of his conception.

LUCAS SAMARAS: THE SELF AS ICON AND ENVIRONMENT

Of the artists who emerged in the sixties and continue to be creative forces today, Lucas Samaras is a peculiarly isolated figure. His involvement with body imagery, autobiography, and photography prefigured many of the concerns of current video, narrative, and body art, but Samaras does not fit conveniently into any of the journalistic classifications contrived to organize the chaotic jumble of styles characteristic of the art of our day. A prickly personality, Samaras has aggressively assaulted classical categories that distinguish high from low, major from minor art, or painting from sculpture, object from environment. Working in the interstices between aesthetic categories, he manages to adulterate everything he touches—which has made his work anathema to formalist critics.

Among the many fixed definitions Samaras most effectively challenged is the conventional idea that "style" is a set of constant formal characteristics evolving in one direction. Perhaps the most succinct definition of style is that offered by Samaras's own teacher, Meyer Schapiro: "By style is meant the constant form—and sometimes the constant elements, qualities, and expressions—in the art of an individual or a group." Traditionally, our conception of style is tied to the ideas of constancy and evolution. These are the concepts Samaras attempts in a highly self-conscious manner to deny and subvert.

It is likely that in addition to Schapiro's essay, which was widely circulated among his students, Samaras was also acquainted with the theories of Henri Focillon and George Kubler, which predicated the possibility that certain stylistic traits were transhistorical, belonging not exclusively to specific periods in history, but more freely available. Other

artists of Samaras's generation trained in art history such as Claes Oldenburg and Robert Morris also realized that once reproduction of world art reached a certain level of popular diffusion in slides and art books, the entire history of art coexisted simultaneously in the present in a form André Malraux described as the "museum without walls."

There is much to criticize in the idea that style is a floating and malleable abstraction, which is fostered by the availability of reproductions. A new concept of style, no longer fixed in historical time, is evolving because of the availability of reproductions. This altered conception of style as fluid and transhistorical is essential to Samaras, among the first artists to make style the content of his art.

The possibility that the artist is now in a position to create mutations of historical styles, to shed artistic identities like a series of masks or costumes, appealed to Samaras. A Greek-born alien who was deeply superstitious, he associated identification with a single style with identification by authorities who might seize or deport him if he remained too visible instead of dodging categorization. Compelled to pursue a protean career, he began to assert his individuality in opposition to general movements at an early date. Zigzagging from representation to abstraction and back, swinging between the linear and the painterly, the simple gestalt and the relational composition, the hand-held object and the enveloping environment, he defied the idea of stylistic consistency. In Samaras's case, stylistic coherence is replaced by the connection of obsessional subject matter. The repetition of a set of images rather than of forms or techniques defines the work as that of a single individual.

The objects Samaras creates are icons for the worship of the artist, whose relics or image are enshrined. They are all equally incarnations of Lucashood, distillations of the artist's experience condensed into an object or an environment so intensely personal that confrontation with it commits the spectator to join the artist in communing with himself. Samaras's works do not follow a pattern or stylistic evolution in the conventional sense, but a work by Samaras is clearly recognizable as such. First of all, there is the Samaras palette: the rainbow of fully saturated spectrum colors, as harsh, intense, and standardized as neon. Then there are the materials—the garish patterns, synthetic fabrics, tasteless prints that, along with the pins, yarn, sequins, and spangles, recall the sweatshop or the sewing room.

Images related to sewing are another of the constant features in Samaras's work: from the early rag dolls that looked like homemade toys to the pin-covered objects to the scissor-cut découpage environments, there is an obsession with cutting and sewing, perhaps because his aunt

was a dressmaker and his father was a furrier whose activities Samaras carefully observed. In his preoccupation with home economics, however, Samaras is hardly alone among the artists of the sixties, whose works so frequently recall hours spent by Mother's side in the nursery or kitchen or sewing room. We need only think of Grooms's and Oldenburg's overgrown stuffed toys, Stella's cookie-cutter-shaped paintings, Olitski's mopped surfaces, Johns's well-baked encaustic icings, or Rauschenberg's and Dine's childhood memorabilia to appreciate the contribution to art history made by a generation of creative American mothers through the medium of their sons.

With Samaras, the homemaking imagery is not secondary, but highly self-conscious. With his cutting and sewing, pinning and tacking, he continued arts and crafts activities long after childhood's end, drawing constantly on memories that one assumes, given Samaras's chosen imagery of piercing and slicing, to be painful. Indeed, physical pain is one of his most unpleasant and consistent images. The autobiographical element, strong in much recent art, owes a lot to Samaras. Among the first to focus on autobiography as iconography, he fixated his attention on film and photography of his own body and face—often distorted beyond recognition.

We may trace the origin of the obsession with the self—the increasingly seamless identification of the artist with his art—to the religious crisis of the late nineteenth century. The moment when the artist had to take full responsibility for creation led to the disappearance of any distance between creator and created. The absence of any external authority threw the artist deeper into his own subjectivity as the unique source of an art that no longer served a purpose higher than itself.

The doctrine of art for art's sake parallels too neatly Nietzsche's proclamation of the death of God to be written off as mere coincidence. The origins of abstract art lie buried in the occult precisely because art replaced religion as the medium of transcendence. This transference of functions, however, had severe psychological repercussions for the artist who was forced into a godlike role, or at least into performing a shamanistic function in a secular civilization. The religious content in Samaras's imagery has direct bearing on the problem of the religious crisis and the role of the artist in secular society.

Raised in the Greek Orthodox Church, Samaras spent his childhood surrounded by the furnishings of the Byzantine ritual—the icons, reliquaries, mosaics, and various liturgical objects associated with the elaborate Eastern rite. As a young man he painted Crucifixions; later as a tourist in Greece, he bought icons. The work that won him a scholarship

was an icon without God: in their most essential form his richly encrusted boxes are reliquaries.

In his work the techniques of Byzantine art reappear in a contemporary form. The sparkling glitter, colored stones, dazzling metallic fabric, and brilliant sequins are cheap imitations of the gold and cut-glass tesserae of mosaics. The strands of yarn are inlaid side by side in slotted patterns, also recalling mosaics. The richness of texture, surface, and embellishment of the boxes and reliefs and the ornate arabesques of the recent Cor-Ten sculptures are rooted in a faraway past, dimly remembered but constantly with the artist. The results are objects of exquisite bad taste on a level with a purple plastic Jesus. They intentionally challenge another important component of classical aesthetics: the notion of good taste. The relationship of "good taste" to an aristocratic class is negated in Samaras's synthetic icons in which Lucite and rhinestone iridescence are a modern analogue for aureoles of saintliness.

Given that in the modern period a negative attitude has been a fruitful point of departure for original art, Samaras's essential sense of himself as an outsider, a marginal alien, was useful in helping him remain free of the period styles of his generation, which at the very least demanded a choice in favor of either representation or abstraction, geometric or painterly styles. These were choices Samaras refused to make. Versatility was both his problem and his strength. He was not only a budding artist, but also a writer and a would-be actor who studied with Stella Adler and finally ended up in the art-world theater of happenings. At the same time he wrote, he painted, drew, and made pastels, objects, and environments. Yet the choice between theater and art remained an open option for some time. Experience in the theater fed both his proclivity toward exhibitionism and his interest in spectacle and environment. As a happenings star, his performances were electrifying; but he often mocked his own physical grace and classical features by impersonating a variety of German expressionist vampires. In his autobiographical film *Self,* made with Kim Levin in 1969, Samaras explored the psychological implications of narcissism long before it became fashionable to exhibit pathology publicly.

His art meanwhile swung wildly back and forth from painterly pastels to hard-edge découpage, from precious objects to public spaces, from intimate pornography to flamboyant spectacle. At the same time, the mockery of art history became increasingly conscious. In the auto-Polaroids that occupied him in the seventies, he sometimes impersonated art-historical images, particularly those of saints, both male and female. The use of photography to produce images further compromised purity

of consistency of style. Style in photography is different from style in the traditional arts because of the generic similarity of mechanically recorded images. Yet even this inherent consistency of photographic imagery was attacked by Samaras's perverse sensibility. Manipulating and distorting the photographic image, he created self-portrait photographs as personal and as intimate as a pastel.

Samaras has been called a surrealist, but his photo transformations extend not surrealist imagery so much as its technical experiments (frottage, grattage, decalcomania). His writing also depends on surrealizing fantasy. His pidgin-English stories and evocative personal memoirs of life in his native Greece mark him as a writer of a highly developed poetic imagination whose images are far more concrete and specific than the surrealist norm. The surrealist element in Samaras is most apparent in his metaphoric objects. However, his is the natural, organic surrealism of a writer like Jerzy Kosinski, who has lived a surrealistic existence, rather than the artificially contrived surrealism of Parisian sophisticates who needed to cultivate nightmares. As a writer, Samaras has the self-conscious precision of those who express themselves in a second language learned late.

Samaras maintains an equal distance from both Western art and high art, deliberately keeping his ties with Byzantine art and a native tradition of village craft and superstitious folklore of preindustrial provincial Greece. Ethnicity has been a topic of general anathema to writers on American art, still struggling to define this "Americanness" of American art. De Kooning's debt to Hals and Hobbema, Graham's involvement with Russian icons, Reinhardt's Lutheran asceticism are rarely commented upon. Only recently have we become aware that a great deal of Gorky's originality was derived from his intense involvement with his Armenian heritage, which Gorky himself tried to obscure. Recently, black and Hispanic artists have become highly conscious of maintaining ties with remote tribal cultures. It is in this context of melting-pot aesthetics that we must evaluate Samaras's opposition to the idea of a historical style that subsumes individuality.

For Samaras, the struggle has always been to maintain his ties with a non-Western preindustrial folk culture dominated by irrational superstition and pre-Freudian totems and taboos, which is static, nonevolutionary, and nonprogressive, if not antiprogressive. Because of his status as a displaced person, Samaras is the modern artist par excellence. His deracination is the point of departure from which his images, his worldview, and his originality evolve. His difficulty is constantly in trying to reconcile his sophistication, both psychological and art-historical, with

an archaic past, a childhood in a backward culture of Byzantine rem-
nants.

As part of his self-defense against the process of assimilation, he
exhibited his tiny bedroom, complete with trash, debris, and unfinished
art works, in the Green Gallery shortly after Oldenburg exhibited his
parody of motel modern, the *Bedroom* furnished with oversized furni-
ture parodying the American obsession with bigness. It is a telling
comparison: Oldenburg's *Bedroom* was three-sided and could be seen
without being entered; Samaras contrived to imprison the viewer within
the cramped quarters of his own claustrophobic experience by closing
the fourth wall. He forced us to accompany him on his own individual
odyssey to reexperience a personal martyrdom, as opposed to a collective
nightmare. Oldenburg's *Bedroom* may be culturally impoverished, but
it reeks of an affluence that remained strange and foreign to Samaras.

Born in a small country, Samaras keeps his scale deliberately small.
Human scale is one of the common denominators of his work in all
media, proving once again that the parameters of Samaras's style exist,
but they are not formal but psychological. Samaras clings to his marginal-
ity as his contemporaries proclaimed their Americanness. His works
remain private, introverted—the record of a subjective experience gener-
alized to the point that it is not merely the illustration of a casebook
neurosis, but a totally recreated worldview.

The relationship of pathology to art today is hardly ever discussed as
such. Alienation, fragmentation, and nihilism loom large in the art of our
day. Specific disorders, particularly of the psychosexual variety, including
voyeurism and exhibitionism, aggravated by the reproductive technology
which encourages the perception of the mechanically duplicated self as
"other," are paramount themes. Samaras deals with narcissism,
sadomasochism, etc.; however, he is an observer and conceivably a critic
rather than a purveyor and salesman of these phenomena. The subject
of his works may be pathological, but Samaras maintains the distanced
stance of irony and implicit self-criticism. He may be the lover and the
loved, the image and the imaginer, but he is also Beauty and the Beast.
Through the advances of high-speed photography, he creates the ulti-
mate Duchampian "vicious circle": the Polaroid of Lucas sodomizing
Lucas. Why then does his art strike us not as masturbatory but moral?

Because he insists on aesthetic transformation—*bête noir* of the liter-
alist sensibility—Samaras creates aesthetic distance, another current
anathema, and therefore makes it impossible to confuse art with life.
The self and its history are Samaras's material, but they are used to
promote neither the artist nor his peculiar fixations and fetishes. The

face and the body are altered through manipulation. Autobiography is generalized to the point where content is general, nonspecific. We are not drawn into the vagaries and particulars of the artist's life. Given the amount of self-exposure Samaras has engaged in, we know little of his private life. The elaborate drawers and enigmatic boxes imply secrets they never divulge, displaying rare discretion in a moment of solipsistic exhibitionism and pathological narcissism.

JOHN CHAMBERLAIN: PAINTERLY SCULPTURE

John Chamberlain's diction reveals a great deal about his character. He expresses himself without intellectual pretense in everyday slang. He is intuitive rather than methodical, revising a thought in the process of communicating it rather than referring to a set of fully formed predetermined referents that might form any kind of *a priori* logical system. Both his basic nature and his means of expression ran counter to the sixties' vogue for terse, unambivalent (presumably factual) statements which disregarded emotional reaction, experiential context, or on-the-spot improvisation. His attitudes, both aesthetic and personal, his life-style, his self-contradictory moves and phrases, are typical of the forties or fifties, rather than of the highly cerebral, buttoned-down and straightened-out sixties, with their preference for the hard line, both in criticism and in art.

In his unwillingness to be pinned down or compartmentalized, his elusiveness and restlessness and his drive to experiment without regard for the success or failure of the results, and his constant experimentation, Chamberlain reveals his affinity with traditional avant-garde values. During the sixties, his art did not suffer, but his career did, precisely because of this streak of obstinacy and nonconformity. His nomadic life-style— the endless crossing and recrossing from coast to coast, the brief stays in New Mexico, the restless compulsion to move on—is reflected in his artistic development.

From an academic viewpoint, there seems no internal logic to Chamberlain's development as there clearly is in the serial and systemic artists of the sixties, with their historicizing penchant for taking the next logical step. His belligerent stance, his subjective means of expression, his anti-

170

intellectual phraseology, his obvious bias toward the improvisational, the raw and the existential "process" of making distinguish Chamberlain from his own generation. They mark him at the same time as very much an abstract expressionist sculptor.

That abstract expressionism was not capable of generating a sculptural style is fairly obvious at this point. Sculpture by the artists of the first generation of the New York School is poor in comparison with the painting—so poor in fact that many collectors were forced to pair the paintings with primitive sculpture to achieve a balance in terms of expressive force. David Smith, the great sculptor of the period, was a cubist assembler until his latest stainless steel, volumetric works. Still indebted to cubism, they shared certain new qualities of post-painterly abstraction such as frontality and geometric clarity. Genuine abstract expressionist sculpture was made later, not by Smith, but by younger artists. Both Mark di Suvero and Chamberlain were able to adapt the thrust–counterthrust struggle for balance, the urban imagery and violent energy of "action painting" toward sculptural ends. Di Suvero's imagery is obviously close to Kline's. Chamberlain claims to have been influenced by Franz Kline (he never denies an affiliation with abstract expressionism), but the work actually derives from de Kooning, in terms of its palette, use of curved and bent planes, chiaroscuro, and linear elements.

Both di Suvero and Chamberlain are painterly sculptors. So were Rodin, Rosso, Degas, and many earlier baroque sculptors of the first rank. Chamberlain arrived at sculpture in the same manner as Picasso and David Smith, but with different results. All three moved from painting into collage, finally freeing collage from the wall, propelling bas-relief into fully independent freestanding sculpture. But cubist collage, the point of departure for both Picasso and Smith, is fundamentally geometric and linear. Chamberlain's collages are sensitive, fragile, open, and painterly. They are a projection of de Kooning's twisted, bent planes and curvilinear motifs, and of his open contours into a third dimension.

Chamberlain speaks frequently of materials. They are of essential importance to his expression. His disavowal of literary connotations in using junk is, I think, both sincere and correct. He used it, as Oldenburg, Kaprow, and Whitman used it, because it was free. Chamberlain worked with junk for the same reason Kline, de Kooning, Pollock, and Stella used Sapolin enamels: he had no money for more expensive materials.

Chamberlain's formation at Black Mountain College, where the Bauhaus course on materials was taught, explains his sensitivity to materials. His own involvement with process, however, as opposed to tidy craft, is an urban New York vision. Scrap metal, paper bags, polyurethane, and

Plexiglas are equally potential media upon which the artist imposes his sensitivity. For a brief period Chamberlain used discards of Donald Judd's steel boxes; he was forced by his inner drive, his tendency to violate and contradict, to compress and deform them. He scarred their manufactured surfaces, crushing them into his own form, which is concerned not with volume per se, but with an exploration of interior spaces, of hollows, darkened crevices, and recessions contrasted with protrusions and angry projections. Recently he has coated his plastic pieces in Larry Bell's optical surfacing machine. The result has not been the glossy mirrored transparent surfaces one associates with Bell, but a curious translucency of variable nuances that is distinctly Chamberlain.

John Chamberlain has influenced many artists. His use of material as literally and concretely real had many repercussions. His spray paintings, begun in 1963, antedated the use of the technique by anyone other than Billy Al Bengston. Unlike his sculpture, these paintings are related to sixties preoccupations and emblematic images, frontality, flatness, and nonpainterly surfaces and techniques. They are much underestimated.

Chamberlain continues to believe that art is a way of life, not a small business. (He is a rotten businessman. When he went into furniture with his disintegrating foam couches, the interior decorators fled.) Because work comes out of a personal need to express vulnerability, it is always convincing. To my knowledge Judd and I were the only writers with anything good to say about John Chamberlain in the sixties. A new climate of opinion may revive attitudes formed by that time's frame of mind. My own opinion remains unchanged.

Gonzalez and David Smith, although they broke with traditional techniques to pick their materials off the junk heap, remain acceptable to people who see in a Chamberlain only the remains of a car wreck. For this, the Museum of Modern Art must be held mainly accountable. How much damage the placard next to Chamberlain's large relief *Essex*, once on permanent exhibition there, has done to the real understanding of his art is inestimable. According to the MOMA: "Excepting the American woman, nothing interests the eye of an American more than the automobile, or seems so important to him as an object of aesthetic appreciation. Like men, automobiles die." Further, it is declared that Chamberlain has "taken parts of wrecked bodies and reassembled them in forms related to cubism, but in materials which are peculiarly rich in associations." It is precisely these rich associations, conjured up in the public mind by such a description, that make it virtually impossible for most people to view Chamberlain's work as abstract sculpture rather than as social commentary. To reinforce its message, the museum iso-

lated *Essex* in a small gallery with Cesar's crushed *Yellow Buick* and Jason Seley's immaculately burnished bumpers—the point being apparently that all three represent the afterlife of automobiles. This is like putting Picasso's goat and Rauschenberg's goat in the same room because they are both goats. If there is no dharma that causes cars to become sculpture after they "die," this is slander by analogy. It should be pointed out, however, that it is slightly less unfair to Cesar, who merely compressed what remained of John Rewald's Buick into a compact rectangle, thus (again according to the Museum) "transforming a beloved vehicle into its own tombstone." Indeed, *Yellow Buick* may be nothing more than Rewald's car's cenotaph, but *Essex* is a fully realized, articulate, sophisticated piece of sculpture, having in its present state no associations with cars, car wrecks, or junk yards. (If, for instance, Chamberlain wished to comment on the hazards of urban civilization, why then did he not allude—as Cesar does in giving the license plate a prominent place—to the real life of automobiles?) No, finally we must conclude that Chamberlain uses the scrap metal in an abstract, anonymous manner, with the intention of transcending its ordinary connotations. That these abused and worthless materials are transformed into works of art is his triumph.

The mass public sees in a Chamberlain only a car wreck. The elite public has other objections: the pieces are dirty, the paint is scratched and chipped, the edges are rough and jagged. Even more unfortunate from some points of view, Chamberlain's pieces are usually big; the scope as well as the vision is heroic. Thus a taste that can forgive the junkyard origins of Stankiewicz's polite, bijoulike constructions or Seley's manicured assemblages is still having trouble coming to terms with Chamberlain's unapologetic Cyclopean ruggedness.

I have sought to show what Chamberlain's work is not. Now it remains to say what it is. First it is one of the fullest attempts in our time to deal with all that sculpture can do, to redeem for it the third dimension, traditionally that which differentiates the plastic from the pictorial. Even in his reliefs, Chamberlain makes irresistible demands on the surrounding space, violating, cutting through, breaking, embracing or rejecting the external ambience with powerful masses and sharp, undulating curves. Besides this willingness to come to terms with the third dimension—the ability, seemingly on the verge of disappearance as sculpture increasingly accepts the conventions of pictorial space, to make true sculpture in the round—Chamberlain is exceptional in his extraordinary use of color in sculpture. He does not cede to the temptations of pictorial space, although he uses color in a painterly way. So far, this has

been "found color" that he has merely cut up and combined to suit his compositional requirements. Now he is beginning to experiment with commercial enamels, which offer totally new possibilities for controlling the finish.

It is said that Chamberlain employs color as a painter. By and large this is true. Certainly he composes as a painter, constantly trying out and revising solutions until the correct one is found. As we have remarked, analogies between Chamberlain's work and abstract expressionist painting (which have been used to argue that Chamberlain's work is *retardataire*) may be found: explosive energy, aggressive forms that drive or streak by, and emotional expressiveness are common to both. In fact, it appears that Chamberlain has accepted the aesthetic premises of the New York School, at a point when much of their original relevance for painting has been lost. Yet this is scarcely unusual. The history of art abounds with examples of styles whose characteristics are defined in painting before they find sculptural expression. As outstanding examples of sculptors who carried painterly preoccupations over into the sphere of the three-dimensional, one may cite Bernini and Rodin. Because painting lends itself more easily to experimentation and hence to innovation, it would be surprising to find the reverse true.

Chamberlain is concerned with relationships, not gestalts. Often, these relationships are exceedingly complex, for Chamberlain will combine a massive hulk with a jagged sheet of metal that curves and winds about it, allowing us to see behind, around, and through from a variety of angles. Such overlappings and sequences of planes are indeed essentially cubistic. Chamberlain's most recent freestanding pieces, however, escape such definition because they are involved with volume and mass.

No mere formal analysis can hope to do Chamberlain justice. What separates his work from much of what is done today is its expressive content, which Chamberlain seeks continually to enlarge and expand. In trying to create works of a full-blown—again one must use the term "baroque"—sensibility, his ambition exceeds that of most contemporary sculptors. The special charge of his works resides largely in the tension born of contradiction. The gentle patience with which a rosette is worked in *Wildroot* contradicts the crude force with which other parts of the same piece are jammed and banged together. Or, in another instance, the delicacy of a fragile, intricate flourish may be paired off against the brute thrust of a massive wing. A fine baby blue may be set against an angry corroded orange; an elaborate arabesque may find its counterpoint in a rigid, blunt rod.

Chamberlain's sculptures ask to be explored. The caverns, tunnels,

hollows, and gorges need to be looked up into or through in order that we may experience the interior vistas they open up. Yet, paradoxically, his materials discourage such a tactile exploration. We rightly sense danger. A curious situation: we are invited to explore by the arrangement of forms and simultaneously repelled by the barbarous state of the materials. To many this calls forth a frustration they cannot qualify. So, too, other ambivalences may be catalogued. Within a single work, such as *Coo Wha Zee,* for example, there may be forms that both accept and reject, beckoning outward and recoiling back into themselves at the same time. These strange mixtures, of tenderness and violence, of elegance and brutality, of patience and recklessness, evoke a complex response that for me is part of the unique beauty of a Chamberlain. The nature of Chamberlain's material—usually thin-gauge metal sheets—contradicts also the effects of bulk and mass he achieves with it. The look of gravity or solidity is illusory; behind the rigid, tensile surface is the hollow. Interior space is enclosed as well as exterior space is broken. This enables Chamberlain to surprise by the unexpected flexibility of material we presume to be intractable. What we feel is that some superhuman pressure must have caused a section to collapse and finally give way, creased as though by a blow: the fierceness of a thrust may be so great as to give a continuing physical sense of the energy that has been the agent of its vehement *repoussoir.* The enormousness of the force required is suddenly overwhelming: what titan made such a work?

To restore to sculpture the largeness of scope that has seemed recently deficient is Chamberlain's ambitious goal. And if it is possible any longer for sculpture to have an expressive as well as a formal content, then it is John Chamberlain, who, uniting the fragile with the massive, the poignant with the brutal, and the gentle with the violent, seeks at the moment its fullest realization.

ON MARK DI SUVERO: SCULPTURE OUTSIDE WALLS

I. ARTIST IN EXILE

The name on the passport is Mark Shawn di Suvero, but his real name is Marco Polo di Suvero. He invented the Shawn after his family moved to California when he was eight years old because it seemed the kind of a name an American boy should have. Born in Shanghai, he is the second son of the commander of the only Italian submarine in the Far East. In 1941, the family emigrated to California because of increasing anti-Semitism, from which they were not immune even though the di Suvero family lived in Venice since the fourteenth century, when they fled the Portuguese inquisition.

During the Vietnam War, di Suvero exiled himself to Europe in protest. The six steel works executed by the American sculptor in the factories of Chalon-sur-Saône during 1972–73 and exhibited in public outdoor areas of Chalon in 1973–74 constituted a unique event in the history of modern sculpture. In many respects the fulfillment of the aspirations of generations of avant-garde artists who desired to escape the confining context of the museum, they reclaim their function as public symbols within a social context. Special circumstances prevailed in the Burgundian shipbuilding town of Chalon to make possible di Suvero's realization of these monumental, Herculean sculptures. The belief in di Suvero's vision on the part of Marcel Evrard, director of the museum in the neighboring city of Le Creusot, as well as the enthusiasm and support of the staff of the Maison de la Culture in Chalon, together with the generosity of local industry, the participation of local workers, and

the interest of the people of Chalon—all were necessary to the fruition of this unusual cooperative venture.

Di Suvero's creation of a major body of sculpture involving the participation of diverse segments of local populations in Chalon-sur-Saône is being studied by other communities as a test of whether monumental public sculpture, which compromises neither the ideals of the artist nor those of the community, can be made within the context of an industrial democratic society. If a solution to the problems which blocked not only the further development of di Suvero's own art but also that of any modern sculpture aspiring to speak to the totality of a community can be demonstrated to have worked in one place, then Chalon may serve as a model for future projects of a similar nature.

Di Suvero's art requires the viewer to alter the conception of what constitutes a work of art. Presumably this modification of consciousness will in turn lead to the questioning of other accepted modes of thought and received ideas so ingrained by the culture that they are seldom challenged. The opening up of the spectator to new ideas is surely one of di Suvero's main objectives in making so strong, assertive, and in some respects unpalatable a statement. A clue to his intention is the title of the large sculpture exhibited in front of the Maison de la Culture in Chalon. If *La Petite Clé (The Little Key)* is to be used to unlock *something,* perhaps we may assume that what it is meant to unlock is the viewer's consciousness, opening the mind to unfamiliar concepts.

The difficulty of di Suvero's work for the ordinary spectator is that it is not meant to "beautify" the existing industrial environment to make it more acceptable. On the contrary, the reason di Suvero uses the materials of industry itself to create his works is to force the viewer into a direct, intimate encounter with the contemporary environment. Because of his insistence that his works are a series of confrontations with reality rather than a means of escape from the brutality and problems of industrial society, they were particularly appropriate, as well as particularly difficult to appreciate in a factory town like Chalon, whose worker population is intimately familiar with the materials and techniques of industry. Indeed, the greatest test for di Suvero's work is whether it can be acceptable to a factory worker. These enormous steel constructions, welded and cut with the same torches the worker himself uses, hoisted with industrial cranes, bolted together like the scaffolding of modern buildings, rusted like scrap metal, familiar in material and technique, yet unfamiliar and surprising in their forms—can this be art in the eyes of a factory worker?

Many distinguished American and European critics, of course, have answered in the affirmative. Yet the individual viewer must arrive at the conclusion that these works are art, at the how and why they are art, out of his own process of *self-education*; if not, he is merely accepting, perhaps begrudgingly, the judgment of authorities. This is precisely the passive acceptance di Suvero abhors. He spent many months in Chalon, discussing his work and attempting to communicate his meaning with those who came to be involved with it. This process of education, of the artist integrating himself into a community, was essential to the success of the Chalon experiment. The problem, however, is that art for di Suvero is a symbolic structure with a multitude of ambiguous and complex meanings; consequently it is impossible to fully translate his forms into words. Though we are becoming a more visual culture, we are still ignorant of the meaning of the language of visual forms. Obviously we need a gradual process of mass education to learn to understand the language of vision; and this, it seems to me, is an important part of the process that was initiated in Chalon-sur-Saône.

During the Middle Ages, a common language united society. This language was the belief in the values, functions, and structures of the Christian church as an institutional order that took precedence over any individual experience. Modern society, while losing contact with traditional values, has not yet reconstructed a general value system equally intelligible to all men. For this reason, modern art remains a secret language, comprehensible only to the initiated. Di Suvero has always set himself against the hermeticism of the esoteric. His wish to create public sculpture for public places represents, on the contrary, an attempt to communicate with *all* segments of society, not just the elite who visit museums. The title "Sculpture in Liberty" chosen by the Maison de la Culture for the di Suvero exhibition was appropriate. The museum by definition is a confining context. It limits not only the scale the artist can work on, but also the nature of the relationship between viewer and art object. Indeed, there are many reasons to believe, as some theoreticians have suggested, that the museum is a place for alienated leisure, just as the factory and the office are places for alienated work. In the museum, activity is structured; emotional-aesthetic responses are adjusted to a preconceived scale of response. But to come upon one of di Suvero's towering structures in the open air, to have vistas of a piece like *Ave* from across the Saône River, to be able to see from multiple vantage points of a much greater variety than any possible in a museum situation, is the novel experience of seeing sculpture in accessible open space.

Sculpture free from the restraint of confining museum walls thus becomes a metaphor for human liberty of thought and action. That the works are made with industrial materials and techniques is an essential part of their meaning. Di Suvero deliberately uses technology, not as an end in itself, but as a *means* of realizing his own will as a lesson to society. His aim is to demonstrate that if the artist can dominate technology and direct it to serve his own ends rather than vice versa, then humanity in general can control its great and dangerous technological apparatus, and rationally determine the goals for which it will be used. The triumph of the constructive, creative imagination of man over the destructive forces of the technology man has created—this is central to di Suvero's message.

Di Suvero clearly means his work to be a moral example. His feats of engineering, his ability to bend steel to take his form, are meant to demonstrate that man is not condemned to impotence, any more than sculpture is condemned to please established taste, or accommodate itself to existing categories.

Coming to Chalon, working in the precarious conditions available, meant for di Suvero taking considerable risks, since he was not directly paid for his work, nor was he ever sure of its outcome or eventual disposition. But risk-taking has been part of di Suvero's life; apparently he feels keenly alive only in extreme situations, or situations of risk.

It is not surprising that an artist as dedicated to independence as di Suvero should begin his career assembling found objects picked up off the streets of New York, fragments discovered in the decaying market area where he lived in the late fifties and early sixties, and where he still maintains a squalid loft. Ladders, barrels, charred planks, and beams from a burned factory are held together by ropes, rusty nails, and chains in di Suvero's early works. These sprawling, exuberant pieces were, compared with the lucid, focused steel works produced by di Suvero in Europe in the seventies, relatively undisciplined, informal, and crude. Because di Suvero is, despite the external chaos he has often created, an extremely coherent personality whose goals and values have not altered, these early works possess many of the essential characteristics of di Suvero's mature style. Already present in the group of works exhibited at the Green Gallery in 1960 (di Suvero's only one-man gallery show in New York) were the open-form system of cantilevered balances, jutting diagonals, suggestion of strain and tension implicit in thrust–counter-thrust movements, and dynamic, restless elements that stretched out, reached into, and grabbed space, still characteristic of recent works as well.

These early assembled wood constructions used the same junk materials and assemblage techniques as the sculpture of Richard Stankiewicz, Jean Follett, John Chamberlain, and Robert Rauschenberg. Di Suvero's work differed from theirs mainly in its architectural use of linear elements to span and extend into space, which was embraced, penetrated, or otherwise activated by di Suvero's outward angled beams, pipes, and cables, which proclaim a full three-dimensionality unknown to constructed sculpture descended from cubist collage.

It was not by accident that di Suvero chose the materials and techniques of assemblage as a point of departure. The meaning of assemblage is more complex than the exclusively formal interpretations supplied by historians of modern art. More than a translation of the cutting and pasting technique of cubist collage into three dimensions initiated by Picasso, assemblage was the means by which sculpture freed itself from the demands of official patronage. Assemblage permitted sculpture to become a form of personal, subjective expression as opposed to the celebration of an official event, a state function, an ideological message, or the status of a given patron. Because assemblage requires no expensive materials like marble and bronze or difficult processes like casting or carving, it liberated the sculptor from economic dependence on patrons, a matter of great significance because the sculptor, even more than the painter, is the victim of the economic system within which he works, due to the greater expense of making sculpture. Since the invention of assemblage as a technique, the sculptor has at least been able to operate at the level of *bricolage,* making his art out of the waste products of our industrial civilization. Appropriating the used and worn detritus collected from city streets before the garbage trucks arrive, the sculptor could follow his own subjective values and personal inclinations in assembling these bits of found junk. This is the way di Suvero began.

Di Suvero did not remain a *bricoleur,* however. The diversity of materials, and the obviously contrived balances that were not truly expressive of actual stress or real structural needs characteristic of assemblage, detracted from the unity of di Suvero's work. We cannot know what direction his work might have taken were it not for a decisive, nearly fatal accident that occurred shortly before his Green Gallery exhibition in 1960. Delivering some lumber that was too big to fit inside an elevator, di Suvero mounted the elevator cab with the lumber—an example of his predilection for situations either psychologically or physically dangerous. The elevator never stopped, and di Suvero was pinned between the elevator and the shaft ceiling, crushed by thousands of

pounds of steel. That he survived was a miracle; that he ever walked again is no less miraculous.

The accident and its consequences radically altered di Suvero's way of working. Confined to a wheelchair, he could no longer perform the heavy physical labor of hauling and hammering mammoth pieces of wood. He was also forced to work with others as a result of his physical disability. His idealistic inclination toward cooperative effort was translated by fate into a necessity. One thing he could do alone, however, was weld. His first metal pieces were made sitting in a wheelchair, an asbestos apron in his lap. The urge to make everything himself, to leave the mark of his own hand, overcame the need to involve others in his work. This incident points up a certain contradiction in di Suvero's thought concerning communal efforts. For, while he is ideologically committed to the idea of collaboration, in fact, he feels impelled to make everything himself. In this, he differs from the "minimal" sculptors of his generation such as Judd and Morris, who send their work out to be industrially fabricated. Their art has a mechanical precision that is the opposite of the rough, irregular handmade look of a di Suvero; he seems intent on preserving all the marks of human error in his work.

The conceptual basis of minimal art is also antithetical to di Suvero's trial-and-error improvisational method. In his way of working as well as in his rebellious attitudes, romantic postures, and passionate idealism, di Suvero is much closer to abstract expressionism than to the art of his own generation. More interested in the actual execution of a piece, in progressive modifications that could take place *in situ* as a work organically developed, than in preconceived systems, theories, or concepts, he continued to preach traditional humanistic values at a time when these values were widely assaulted by American artists.

The use of the industrial technique of welding permitted the further development of di Suvero's work. Metal could be bent, twisted, and suspended in space in ways wood could not. Of the works of the early sixties still extant (a great deal of di Suvero's work has been lost or destroyed), *Prison Dream* occupies an important position in the artist's career. A disturbing, tortured work of mangled steel "limbs" and twisted reaching and grasping appendages, the work has a powerful psychological content that suggests analogies with the frustration of all who feel physically or mentally imprisoned. In this sense the work is a comprehensive analogue—a complete symbolic projection—of the artist's psychological and physical state. By the time *Prison Dream* was completed in 1962, di Suvero had renounced the obvious pathos of the expressionist

upward grasping *Hands* pierced with nails or of a menacing rod that he had modeled two years earlier. However, the twisted hands already contain di Suvero's essential form: the core or trunk (in this case the palm) from which upward spreading members grasp and grip space in a gesture of desperate aspiration. The fingers that claw the air, the upward spreading hand, are metaphors for a powerful resurrection.

By the time abstract expressionism faded from the scene around 1960, the rhetoric of "struggle" was worn thin. Artists were talking about struggling with their canvases and drinking champagne with their collectors. This did not often produce convincing work, and most of di Suvero's contemporaries reacted against the existential aesthetic of abstract expressionism as a result. Di Suvero, however, was engaged through this time with a real, concrete, literal struggle: the battle to walk. The evolution of his art documents his progress. *Prison Dream* is partially a horizontal piece; its clawlike appendages reach forward, like a reclining man trying to rise. Balancing the reclining horizontal element, however, is a striding, vertical form that beckons, which, if we wish to literally interpret it, may be the premonition of di Suvero's mobile, upright self. By 1963, di Suvero could walk again. That year he helped found the Park Place Gallery with fellow sculptors Forrest (Frostie) Myers, Chuck Ginnever, and Robert Grosvenor, and returned for a visit to California. In 1962, he had begun experimenting with moving elements in works like *Love Makes the World Go Round,* a miniature carousel with seats made of tires. The idea of kinetic elements, of the opposition of a static constant core to a swinging or fluctuating element, was explored in other works made with and for children. It was during this period that di Suvero began conceiving of sculpture in terms of giant toys, or rides that invited spectator participation.

In 1964, di Suvero was living in Los Angeles and working on the beach. The move to the West Coast meant an increase in scale. In California, di Suvero could work out of doors as he could not in New York, where he was frustrated by the limitations of loft and gallery space. From 1964 on, his major works have been over twenty feet high, and he has needed a crane to lift elements into place. These large-scale works combined wood and steel, and in some cases occasional found objects. Two works of this period, *A-Train* and *Nova Albion,* were especially important for his future development. When *A-Train* (honoring the jazz classic titled after a particularly disagreeable New York subway) was shown at the Park Place Gallery in 1965, it was in two parts. The top part, made of wood beams joined by steel rods, had a ladder suspended from it, and was hung like a "mobile" on a chain from the ceiling.

Reconstructed outdoors, the piece was substantially changed; the two segments were connected by a strict vertical interior pole, which acted as the fulcrum for a pivoting kinetic overhead structure. It is important to mention in this connection that di Suvero's works consist of interlocking parts; after they are dismantled, they may be changed when they are bolted or welded back into place. Sometimes di Suvero will use parts of one piece in another; sometimes he will leave fragments around until he has the proper structure in mind in which to combine them. This was the case of *Lover,* which existed as a fragment until di Suvero had the existing section transported from Duisberg, Germany, to Chalon, where the piece was completed.

A-Train was the first large-scale work with a kinetic element. *Nova Albion,* a work of the same period, the mid-sixties, also exists in two versions. Titled from a poem by William Blake, *Nova Albion* is significant because it is the first example of the tripod structure that characterizes many of di Suvero's recent pieces such as *La Petite Clé, Ave,* and *Etoile Polaire.* It is also the first work in which the balances are strictly engineered. In *Nova Albion,* appearance and reality coincide: the cables and chains that hold the piece together are necessary to the ability of the work to stand on the floor without a base. In earlier works such as the masterful, assembled construction of 1960, *Hankchampion* (named for di Suvero's brother Henry, nicknamed Hank), di Suvero had already successfully dispensed with the base, the pedestal that traditionally isolated art from the viewer and the space in which he moved by setting sculpture in the official space of "art" as opposed to the actual space of real objects.

The early constructions like *Hankchampion,* however, did not yet depend on the principle of mutual support or engineered balance to stand; they were nailed and bolted together, which gave the impression that the chains and ropes functioned decoratively as opposed to structurally. Compared with *Hankchampion, Nova Albion* has a formal simplicity and clarity. It emphasizes slender, linear elements rather than massive blocks of wood. The cables and chains function as a graphic subtheme. Based on a triangular module, this antiphonal form is played against the typee-tripod structure of the body of the work in the manner of theme and variation in a fugue.

Both the typee and the tripod are elementary structures. They provided a simple basic form that di Suvero could elaborate in many different ways, making possible both great vertical projection as well as considerable horizontal span. The structure of *Nova Albion,* among the prototypes of the tripod form in di Suvero's work, is once again an

analogue for the artist's physical projection of his own body image. (The extremities to which this empathic projection of the body image was taken in recent American art has been commented on by J.-P. Lebenstein in his study of Frank Stella, "L'Etoile," published in *Critique*, by Max Kozloff in his articles on Jasper Johns and Robert Morris, and by myself in my monograph on Claes Oldenburg.) I have suggested that di Suvero's stylistic development is tied to his own changing body imagery. Within this context, the two wooden "legs" and the steel rod that support *Nova Albion*, and the forward crouch position, may be seen as visual analogues of the stances of a man using a cane to support himself—as di Suvero indeed did until very recently.

The last phase of di Suvero's physical recovery coincides with the period spent in Chalon. He no longer needed the cane to walk, a fact reflected in the increasing uprightness and verticality of recent works. Planted in the earth, many of the new pieces reach explicitly toward the sky in a symbolic gesture of aspiration. Their uprightness and verticality are not strictly speaking anthropomorphic; rather they are metaphors for the erect dignity of man still capable of assuming an aggressive stance in a world in which the individual's will to action is constantly reduced to impotence.

Metaphors of defiance are an important part of di Suvero's content: the enormous horizontal elements suspended at great heights in *Ik Ook*, a kinetic work executed in Eindhoven, Holland, in 1972, as well as in *Ange des Orages* and *La Petite Clé*, executed in Chalon, challenge gravity. The ability to suspend tons of metal in the air took di Suvero some time to master. The visual drama created by the opposition of huge girders and beams swinging freely in the air is an essential part of the excitement of his recent works, and sets them apart from both kinetic and constructivist precedents. Both in their potential movement and in their splayed embrace, the V-shaped joined girders of *Ik Ook* and *La Petite Clé* suggest an erotic play element that asserts itself in opposition to the rigid industrial materials and geometric structures of the works. Like the gestures of defiance and aspiration, the erotic metaphor is implicit and suggested rather than explicit and illustrated. The intrusion of the erotic metaphor into the unlikely context of sculpture industrially fabricated and architecturally engineered is once again deliberate on di Suvero's part. Theoretically, it relates to neo-Freudian and neo-Marxist ideas of thinkers such as Norman O. Brown and Herbert Marcuse, both of whom have suggested the potential erotization of the contemporary environment and the importance of play as a means of humanizing industrial society.

In his insistence on sculpture, not only as a type of structure utilizing the process and materials of the machine age, but also as an expressive form and symbolic metaphor for a range of human values, di Suvero departs from his predecessors, the cubo-constructivists. Indeed, his work may be seen ultimately as a critique of that very constructivism from which it derives. The Italian futurists, the first to seek new forms equal to the spirit of the Machine Age, never realized the demands of their own manifestos. The Russian constructivists, on the other hand, less burdened by a great historical tradition of bronze and marble statuary, felt free to invent new techniques, using the materials and processes of industry itself. The failure of constructivism is one of the crucial intellectual defeats of the twentieth century, for the idealistic constructivists did not adequately consider two essential factors regarding the reception of their art. One was the role of esoteric content in abstract art, and the other—and perhaps more essential misunderstanding—was the failure to adequately deal with the enormous gap between the expectations of the public and the goals of the nonobjective artist. Despite the educational program undertaken by the constructivists, their art was never accepted by the Russian masses. Once divorced from its context of revolution, it quickly became museum art, an indication that it was, finally, not very radical. Few of the projects conceived for public spaces were ever executed; the most celebrated, Tatlin's architectural-kinetic *Monument to the III International,* is known to us only in a photograph of a maquette.

Di Suvero's work differs from that of the constructivists in its fundamentally humanistic orientation. Human gesture is expressed in its forms; human participation is emphasized in its environmental sprawl. The viewer finds himself included and embraced within, as opposed to outside of, the sculpture, which is no longer distanced object, but intimate experience. The shift from museum object to environmental experience is a central fact of ambitious sculpture of the sixties. It represents a realization on the part of sculptors like di Suvero that the public needs to be included within the work, to experience the kind of dramatic spectacle provided by looking up from under the Eiffel Tower, which looking upward through the massive baroque joint of *Etoile Polaire* also provides.

Although modern sculpture would hardly exist without the achievement of the constructivists, artists like Tatlin, Rodchenko, and Moholy-Nagy were so awed by the power of industry to change the world that they ended up idealizing the machine through making art in its image. Paradoxically, when the art of America, the world's most mechanized

country, came of age, it was violently opposed to machine imagery. Abstract expressionism, di Suvero's other direct source, emphasized the physical human gesture, and autobiographical improvisation in opposition to the nonobjective geometry of cubo-constructivism against which it rebelled. In many respects, di Suvero's art represents a synthesis of constructivist logic and utopian ideology and abstract expressionist humanistic existentialism. Despite his formal and structural innovations, his links remain with a historical tradition of sculpture, with the traditional expressive vocabulary of sculpture, including *contrapposto*, expressed as abstract torsion, as a means of activating three-dimensional space. However, di Suvero has extended the vocabulary of sculpture by expanding its scale through daring feats of engineered balance, and by developing a personal imagery tied to direct physical experience rather than to an intellectual concept like pure geometry.

During the sixties, it was mistakenly presumed that the greatest art was the most extreme, the most innovative. Today it seems obvious that the greatest art is that which represents the most complete synthesis and assimilation of all that has preceded it. To extend the past into the future means to preserve historical memory—apparently man's most difficult task in a period of rapid change. In this connection it is ironic, although perhaps inevitable, that the dream of Russian artists of a new art should be realized by an American on French soil.

II. DI SUVERO AND PARTICIPATION: SPINNERS, TUMBLERS, PUZZLES

Since his return to the United States in 1975, after an absence of five years, Mark di Suvero has lived and worked in Marin County, California, not far from where he spent his youth. Working alone with a crane, a cutting torch, and welding tools, he has continued to develop major themes that connect the wide variety of works in metal he has produced over the last two decades. In further refining these themes, di Suvero has clarified with greater focus the essential content of his work.

Writers have referred to the crippling accident that confined di Suvero to a wheelchair in 1960 as decisive. No one has noted the obvious: once di Suvero was immobilized, his works began to move. The accident seems to have forced di Suvero to concentrate on two preoccupations that have remained central to his work: mobility and participation. All the work he has done since his Whitney Museum retrospective in 1975 has parts that can either be moved, manipulated, or altered in configura-

tion by the spectator, who thus enters into a dialogue with the work of art far more intimate than our previous notions of the aesthetic response, which involved distance, both psychic and physical, as well as psychological remove.

Our contemporary consciousness demands a more intense encounter with the work of art for a variety of reasons. No longer remote, isolated from the viewer's space on a pedestal announcing its identity as an icon of one kind or another, the work of art now shares our own space, a reality more immediate than that of traditional sculpture, whose role as symbol meant that it referred to something other than itself, such as the glory of religion, the power of the state, or the prestige of an individual.

Di Suvero bears a lasting debt to constructivism, especially to Gonzalez and David Smith, who wrenched poetic statements from factory techniques and materials. A flamboyant romantic, his works express a drama and an overtly emotional intensity we associate not with the restrained geometry of constructivism, but with the operatic style of the baroque. Even in his earliest works, di Suvero created expansive forms that sprang away from a core, extending diagonally and reaching into space as baroque images break the frame in paintings and baroque drapery billows expansively in sculpture. In the new works, this baroque element has become even more important, and contributes significantly to the originality of di Suvero's synthesis of constructivism with elements of other traditional styles not confined to the angle and plane geometry of industrial forms.

The attraction to the baroque would seem natural for someone who is, like di Suvero, of Italian descent. One might even further conjecture that one reason northern romanticism held so little appeal for Italian artists is that the extravagance and excess of the baroque made the romantic ideal of emotional release seem tame by comparison, just as the legend of Michelangelo dwarfed any Nordic idea of the eccentricity of individual genius.

Baroque elements, at first in the form of simple curves and double curves, appear early in di Suvero's work. Confined to a wheelchair, di Suvero, who had been assembling large pieces by nailing together old wooden beams, timbers, and found objects, began welding—a process that permitted him to bend and curve metal into shapes that were at first merely primitive sections of a circle. Among the largest of these early pieces containing curved elements is the 1962 *Homage to Brancusi,* which ironically dedicated a construction based rather literally on the inside of a crane cab to the master of the carved monolith.

Brancusi was among di Suvero's many heroes and heroines to whom

the artist had dedicated pieces (others include Kandinsky, Giacometti, Stuart Davis, Marianne Moore, and Billie Holiday), but he was never his master. As soon as di Suvero was able to leave the wheelchair, he climbed up into a crane, which permitted him once again to work on a large scale. Working on a public scale—as indeed Brancusi had in his *Gate of the Kiss* and *Endless Column*—di Suvero concentrated in the late sixties and early seventies on bolting I-beams together in gigantic structures that projected the constructivist impetus of his wooden assemblages of 1959–60 onto a grand scale. However, the use of I-beams, standard construction modules, confined di Suvero to geometric forms. The acute angles and trianglar basis of the tetrahedron, which Buckminster Fuller had identified as the fundamental structural unit, dominate the large-scale works di Suvero executed in Europe between 1970 and 1975. They are also the basis for earlier works such as the 1966 *Praise for Elohim,* the largest spinning piece, and *Are Years What?* (for Marianne Moore) of 1967, the year in which di Suvero erected a hundred-foot Peace Tower in Los Angeles of interlocking tetrahedra of metal tubing.

At the same time that he was working with a crane on monumental constructions assembled from I-beams, however, di Suvero was torch-cutting more intimate works on a smaller scale. Some contained linked rearrangeable elements. Others, like the incredible intricate *Van Gogh's Ear, Shadowframe,* and *L'Amour des Escargots,* were each precariously balanced on a sharp-pointed fulcrum.

Some of these pieces alternate linear elements with elaborate filigree and forms ending in fanciful baroque loops defying the solidity of steel. They are rich in detail as well as textural effects, which are enhanced by emphasizing the rough, corrugated cross section of the crude steel. In some instances, found materials are included; in others, a hunk of steel is worked from scratch. Transparency and solidity are alternated in innovative conjunctions, altered by each action of the hand that feels irresistibly drawn to pushing the moving element around its core until every view of the 360-degree circuit has been explored.

BALANCE PIECES

Among the most complex and ambitious of the spinning or "balance" pieces is *La Tartouillant,* one of the last works di Suvero executed in Chalon-sur-Saône. A *bricolage* of materials left over from the giant steel plates that had been cut to form the base and "wings" of the *Ange des Orages,* the *Tartouillant* intimates the possibility of creating relation-

ships between mated pairs of shapes cut from the same metal sheet so that they echo each other as positive and negative oppositions.

If, as di Suvero maintains, the crane is his paintbrush, the torch has become his stylus. As the filigreelike tracery of *Van Gogh's Ear* prefigures the calligraphic element of the latest puzzle pieces, the cut-out shapes and baroque curves of the *Tartouillant* point to the relationships in *Timber Tongs* and *Magari*, two unrelated works done since di Suvero's return to California. *Timber Tongs* and *Magari* are, like the *Tartouillant*, life-size balance pieces that confront us on equal footing. We look through them from many views, choosing either to circle the pieces ourselves or to remain stationary while moving the piece. In either case, the effect is fully three-dimensional, the purist expression of the necessity for sculpture to function in the round. The smaller balance pieces are meant to be looked down on—the anthesis of the view up and into *Ange des Orages* and the other public sculptures which surround the viewer who walks through them.

It is significant that di Suvero works on all three scales: graspable, life-size, and larger-than-life. The varying scales afford different kinds of views as well as a wide range of expressive possibilities and kinesthetic responses, for walking through something is not the same as picking it up, standing on it, touching it, or moving it. Not surprisingly, the kinds of forms and degree of detail vary in relation to the scale of a work. The smaller pieces are more intricately worked; the intermediate life-size pieces involve larger units; and finally the monumental works have the most generalized and massive forms. So far *Ange* is the only public sculpture to be based on curvilinear cut-out shapes rather than on the straight edge of the I-beam. Like *Timber Tongs* its "arms" seem to suggest embrace. *Ange* is also unique because it is the first conjunction of the complex baroque forms drawn and cut out rather than assembled with a kinetic element on so large a scale. One of the last of the public works di Suvero executed in the Burgundian factory town of Chalon-sur-Saône, *Ange* was chosen by the people of Chalon to remain in their public square as a gift from the artist in exchange for their donations of factory and materials. The forward thrust of the prowlike motif, one of the many repeated naval metaphors in di Suvero's work, as well as the two "wings" of *Ange* recall the dramatic stance of the *Victory of Samothrace*, which was originally a ship's figurehead. The forward-bent prow and swept-back wing, with its double suggestion of movement through water and air, are recalled in new pieces like *Timber Tongs, Magari, Balance Piece II,* and *Balance Piece III,* which like the original *Ange* combine cut and bent elements.

Magari and the two smaller balance pieces further explore the possibility of cutting shapes out of steel sheet and using them elsewhere in the work as a formal repetition. In *Magari*, the disk cut out from the base is attached to the complex element that swivels around it in such a manner that one is constantly tempted to turn the piece to the position in which the solid disk is poised directly above the void in the base from which it has obviously been cut. In this position, one disk "eclipses" the other. Other astronomical associations, such as the idea of planetary rotation around a central core, as well as the literal use of gravity to balance the two major elements—stable base and spinning top—enrich the metaphorical content of *Magari*.

Such astronomical references reveal di Suvero's debt in his revolving kinetic works to Calder's late stabiles topped by rotating mobile elements. However, Calder treated steel like paper, cutting and folding thin sheets into flat planes, whereas di Suvero's work is intensely physical, stressing the weight of heavy steel, the pull of gravity rather than the play of wind. Calder's mobiles move easily with every passing breeze; but it virtually takes an approaching storm to get the wings of *Ange des Orages* (*Thunderstorm Angel*) into motion.

In the large-scale outdoor works with moving parts, di Suvero attempted to achieve both participation and motion. However, the truth is, direct physical contact is required to get the moving elements going, and few adults cared to climb to the top of a work like *Ik Ook* to set it rocking. Di Suvero was constantly concerned about possible accidents. Returning in recent works to life-size and small scale, he eliminates physical risk, which enables him to treat both participation and movement more successfully. Smaller scale also means greater possibility for intricacy of detail and the invention of new forms. In the indoor pieces, found and created forms are more easily and felicitously combined because the incorporated found objects—anchors, chains, bolts, screws, etc.—are more malleable than huge pieces; consequently they are more easily transformed from their identity as common objects into their new life as art components.

VARIABLE PIECES

This combination of found and formed is the basis of a series of mutable works di Suvero began in Chalon-sur-Saône. They are called "variables" because they can be constantly altered to suit the viewer's mood and pleasure. Occasionally di Suvero also refers to the "variable" pieces as "tumbling" pieces. Their interlocked forms seem to jump and

leap through each other, like tumblers, evoking a kinetic response related to the exhilaration of watching acrobats. So "tumblers" may be a more accurate description of these works that stimulate yet another kind of participation than the spinning or "balance" pieces, which are essentially based on the idea of the ride. The tumbling pieces are more toys than rides, inviting the audience to collaborate with the artist in rearranging the variety of preformed elements the artist has provided. By shaping the elements of his variables, di Suvero does not abdicate responsibility for creation in the manner of simple-minded works that simply display familiar materials or standard geometric units. However, by making it clear that many different satisfying arrangements are possible, he shares the creative process with his audience.

The idea of participation has taken on political connotations in recent years, more so as the direct participation of the individual in public life has declined. The essence of the democratic process, participation has a particular meaning to di Suvero, who, as a refugee from fascism, took the lessons of American history literally. His first "participation" pieces—as well as his first kinetic works—were rides and toys designed to amuse poor neighborhood children who came to visit when he was in a wheelchair. The earliest were based on the most primitive fulcrum balance, the seesaw, requiring two people to balance each other. Gradually the rides, as well as the small versions di Suvero referred to as toys because they could be played with, evolved into spinning sculptures. The most prophetic of these works was the 1963 *Love Makes the World Go Round*, a two-seater with a tripod base resting on a tire. The image of embracing arms here created by tubes occurs in many of di Suvero's works (including the recent *Timber Tongs*). Two tires function both as cushions and as repeated circular motifs tying together the doubly triangulated composition.

Although the relationship between gravity and balance became increasingly important to di Suvero in later large-scale outdoor works, until recently there were relatively few pieces of the spinning type in which a moving element is balanced precariously on a single point above a stable core. However, the exceptions—*Praise for Elohim* of 1966 and *Sparta* and *Homage to Stuart Davis* of 1968—are among di Suvero's most daring and successful pieces of the sixties.

Both "balance" and "variable" works successfully deal with motion. Participation, on the other hand, is most acutely focused in the "puzzle" pieces, the latest type of mutable sculpture. Because the puzzle pieces exist in a state that is closest to unformed, lying horizontally locked together in the steel block di Suvero has pierced with his torch, they

require the greatest amount of ingenuity and imagination from the viewer, who now becomes responsible for creating the balance element. Thus there is a natural progression from spinning or balance pieces, whose fixed and unalterable center of gravity is carefully calculated by the sculptor, to the tumbling or variable series, in which some elements are welded together, to the puzzle pieces, which exist as three-dimensional sculpture only through the direct intervention of the viewer, who has been made increasingly responsible for work and self-motivated effort.

In this progression, I cannot help but see a deliberate political metaphor, a demonstration of how gradually to educate people to take responsibility for their own actions, their own decisions, to share the power of imposing order and the excitement of creativity equally, rather than dictating taste in the form of any immutable ideal order. By reducing physical danger in reducing scale, admitting the limitations of man's present ability to resist self-destruction, di Suvero has used a moral autocritique to arrive at a new set of formal possibilities—a proof of the unique organicity of his art, which has constantly evolved in relation to environmental and social concerns.

PUZZLE PIECES

The "puzzle" pieces derive from the first multiple di Suvero designed for Gemini G.E.L. shortly before leaving the United States. Perhaps because the work was a multiple, di Suvero was especially concerned with the problem of involving many different people with the same work in a way that differed in relation to the receiver. The original Gemini multiple was a simple and relatively primitive puzzle in four parts cut out of the same thick chunk of steel. When horizontal and lying flat, the shapes locked into each other like the reverse curves of the yin-yang symbol. Assembled by the viewer in a vertical position, the piece had several possible arrangements, including one configuration that balanced three of the pieces from a central fulcrum in the manner of a scale or seesaw.

The evolution of the puzzle format into a highly sophisticated category of participation piece is perhaps the signal innovation of di Suvero's new work. Their elaborate forms recall both the volutes of the churches and the finials of the palazzos in Venice, the original home of the di Suvero family, where di Suvero taught architecture and worked on a solution to the problem of the canals flooding in the early seventies. During this period, he met his wife, a Venetian architect, and spent

most of his hours drawing because he could not find the money, materials, or equipment to make sculpture.

This enforced inactivity once again had positive effects. It brought di Suvero, a gifted draftsman, back into contact with his hands and with intimate scale, both of which are strongly reflected in the refined complexity of the rhythmic line he traces into steel to create the puzzle pieces. The elements thus traced cannot help but remind us of the Chinese picture-writing di Suvero has said he found so impressive as a boy in China, where he was born. However, di Suvero's solid "calligraphy" is no more specifically Chinese than it is Arabic, although in its complex weaving in and out across the solid sheet of steel—treated by the artist like a page on which he draws—the resultant script is also reminiscent of the arabesques of Kufic writing. Refined in form, they are also tough, as a result of the brutish material of untreated rusting steel. Paradox is the core of these works: they are solid when seen horizontally fitted together, but transparent and lacy, like moorish carving, when reassembled into the variety of configurations available to the viewer-participant. They are traditional in their intimacy and in their clear evidence of the artist's hand; but they are radical in their mutability and in their melding of intellectual and formal issues. For we cannot be unaware seeing the one possible configuration existing at any given moment that all the other potential configurations also exist simultaneously as mental permutations that, should the viewer wish, might be actualized.

Because physical contact is provoked by di Suvero, there is a childlike pleasure derived from spinning, creating one's own configurations or completing puzzles. This work thus has an enormous accessibility to all kinds of audiences of all ages. Permitting us all to regain the pleasure of play and of our own individual creativity, he restores the joy of childhood. Many artists have looked at the creativity of children's art for fresh forms, but only the greatest—the Picassos and the Mirós—have been able to resurrect the condition of innocent pleasure that we lose as we grow up and become "civilized." With the spinners, the tumblers, and the puzzle pieces, di Suvero has finally been able to realize an art that is neither hermetic nor arcane—as to a degree the abstract sculptures were sometimes perceived—but direct, accessible, and irresistibly playful. That this playfulness should be married to a powerful emotional expression operating on many levels, including that of complex formal relationships that are as satisfying to the eye as the interlocking and

repeated variations of a fugue are to the ear, is an achievement of the first order.

The organicity of di Suvero's thought appears a result of his unique ability to integrate complex factors and different types of meaning on a level that is so strictly intuitive it is not always apparent. Thus the power of his work resides in more than the daring of his constructions, the superhuman scale of the outdoor work, or the dramatic balance of a heavy mass on a single point, magically poised like the human figure *en pointe* in ballet, or even in the kinesthetic response evoked by tumbling, spinning, and moving steel. Not even the brute strength of his materials or the inventiveness of his forms accounts for the impact of di Suvero's work. Resisting all demands to make either a pure formal art or an illustrational representational art, di Suvero has remained in touch with the abstract expressionist call for an art of poetic content (with which even some abstract expressionists lost touch). For some years the formalist idea that form is content has seemed a weak argument, obscuring the obvious fact that content is metaphorical, whereas form is literal. The work of art that lacks metaphorical content cannot address us deeply or engage us psychologically as can the work of art that communicates universal themes.

The primitiveness and primacy of the erotic relationship is the principal metaphor of di Suvero's works, in which circles and stanchions recall the ancient Hindu lingam and yoni, and penetration and interlocking are metaphors for sexual union recalling the mystical union of yin and yang. In the puzzle pieces, the erotic relationship is conveyed in Platonic terms: the two halves that fit together echo each other eternally; however separated or displaced, each bears the imprint and negative contour of the destined mate. Thus, like the political metaphor, the erotic metaphor has progressed to a higher plane in di Suvero's recent works.

RICHARD SERRA: THE SITE IS SPECIFIC

Part of Richard Serra's success is the boldness of his conception. Other artists working in the same vein have chosen fragile materials. Their use of the fragile, however, tends toward sentimentality because the implicit decay of such materials illustrates ephemeralness, rather than focusing on the actual ephemeral nature of placement, order, and distribution. There is both an economy and a directness in Serra's work as well as a complexity, based, strangely enough, on his forcible insistence on relationships. This is somewhat ironic, since the "minimal" phase of sculpture attacked internal relationships of any kind. The types of relationships in Serra's work are mainly contrasts of material, as well as contrasting types of spatial relationships.

Serra's distinction lies in his ability to expunge pictorial qualities from his art. This is partially achieved through the choice of materials, which are assertively heavy, dense, and monochromatic or reduced in color or reflectiveness. Floor-distributed materials like rubber or latex neither create shapes nor give the impression they could as easily be arranged pictorially on the wall. Size, three-dimensionality, and physicality are aggressively stated. But his art is capable of generating memorable images. This is curious, because the main experience of the work is physical rather than emotive or cerebral. Metal is felt to be this or that weight, the precarious balance of tube against sheet is sensed as provisional yet not tentative, as it seems in more timid examples of this kind of work. Another big difference between Serra's work and that of lesser artists is that Serra's work is active: it acts upon space, controlling or defining a situation, clearly in command of the environment, rather than vice versa. So much of "post-minimalist" sculpture seems to me bad because it lies

around, passively and dismally, defensively retreating from engagement with the environment rather than actively and aggressively demanding confrontation.

Serra's art, on the other hand, is an art of overt materiality. The burden of expression is located in the ability of purely physical character-istics—the specific qualities of materials, the perception of weight and the force of gravity—to be sensed by the viewer. Chance is not exploited by Serra as an effect or a proposition.

The largest of a series of early outdoor environmental sculptures, Richard Serra's 1970 tripartite work occupies an open meadow on the Joseph Pulitzer estate in St. Louis, Missouri. It is an extension of Serra's concerns with the psychology of perception. It forces the viewer to become aware of his or her relationship to the environment and the visual data contained within that physical space. The entire piece con-sists of three triangles of untreated Cor-Ten steel. The work demands inspection from multiple points of view: only one part or at the most two parts of the work are visible from any given single vantage point. This fact reverses cubist notions of sculpture, still virtually the most prevalent sculptural ideas, despite a decade of reaction against cubism. To be more specific, cubist simultaneity involved the compression of many different points of view into a single moment of time. Serra makes such simulta-neous vision of all parts of the sculpture impossible by extending the piece over an area so large that in order to be understood or known, the work requires an experience of sequential viewing involving literal or "real" time. This represents an important development in his own work, which, although never object-oriented, could previously be read as an image in the sense that it could be seen at a glance.

This development in environmental sculpture came out of a newly awakened interest in the properties of sculpture in the round. In a series of standing steel-plate works buttressed against each other, Serra had become increasingly involved with forcing the viewer to explore the work. This demand for exploration in time was opposed to the im-mediacy of minimal sculpture, which confines itself to forms familiar in advance so that no reading in time is required. Serra's latest work can only be seen by walking around a piece that changes its configuration from each point of view. These freestanding sculptures originally evolved from experiments with raw steel at the Kaiser plant outside of Los Angeles in conjunction with the Los Angeles County Museum's Art and Technology program. Like the Pulitzer environmental piece, they took advantage of the painterly qualities of surface of the Cor-Ten material, which rusts irregularly and naturally, and they involved an exploration

of interior space, rather than of the sense of volume displaced by a monolith. They were not assembled like transparent cubist sculpture, which may be seen through but not entered. The cubist assembler welds metal plates, but Serra engineers balances—which create crucial differences both in tension and in expression.

The large freestanding Cor-Ten sculptures of 1970–71 are made of two-inch-thick steel plates. Sinking a similar rectangular plate diagonally into the ground gave Serra a way of balancing a sharp, finlike triangular wedge without needing to use a base as support. Acting as invisible support, the triangle underground is felt although unseen. This is important to our experience of the force of gravity and the understanding of the natural means by which the earth supports the work. Ridding sculpture of its base—which both separated it artificially from the viewer's space and tied it irrevocably to anthropomorphic imagery—has been one of the central concerns of American sculpture in the 1960s. But the absence of a base is the least radical element of Serra's work, which in many respects defines a new range of sculptural experience to be explored. The work alludes neither to landscape, the human body, architecture, nor object. Its experience is entirely abstract: its subject is perceptual knowledge itself. Avoiding any image or allusion, Serra has finally transcended what appeared to be definitive limitations of sculpture with regard to its relationship to a world of images exterior to itself by claiming an absolute autonomy from anthropomorphism and relating the work to its architectural or landscape context.

Sculpture, unlike painting, shares the viewer's space. Although it does not house like architecture, the relationship of sculpture to the human body is the essence of the sculptural experience. Without referring to body images, Serra insists on the central relevance of this experience. Through the character of the gradually rusting steel he emphasizes that our basic experience of the material is not of its materiality but of its *physicality*—of its heaviness and weight. The contradiction between that obvious weight and the invisible means of support are emphasized. Awareness of physical thrust and balance, of gravity and weight, override any considerations of aesthetic character of surfaces. There is "truth" to Serra's use of untreated, unpainted materials: he is not disguising any of its properties as metal with coats of paint to unify disparate parts. But the emphasis on the aesthetic qualities of pure materials, derived from Brancusi, that is central to such modern sculpture is not Serra's concern. Nor is our experience of Serra's work "optical," in the way that all sculpture whose conventions are derived from painting aspires to essentially an optical perception of form that ignores the concretely tactile.

In Serra's work, the emphasis is neither optical nor material, but purely perceptual. In the Pulitzer site work, attempts to orient oneself with regard to the surroundings demand organizing the visual data presented by the open arrangement of the three steel wedges, splayed out at angles from each other that change with each vantage point. The viewer becomes increasingly aware of the relationship of the irregular terrain to the piece, and of the changing relationships of the horizon line with regard to both ground line and sculpture. This increased awareness comes about because the laws of visual perception cause the viewer to see a flat wedge that is perpendicular to the ground in a variety of distorted perspectives from any position except a directly frontal one, from which only one side of a triangle known to have thickness is visible.

Thus, changes in the perception of form, size, and scale result from the natural rise and fall of the site as the viewer moves to gain fuller information. For example, from one point in the meadow, a given wedge may appear thick and foreshortened, from another distended and elongated, and from a third just a shining copper-colored line in the distance. Yet one is aware that from close-up views all three wedges are identical in one dimension: height, five feet—with length, from forty-five to fifty feet, depending on the degree of incline of the land. Five feet was arrived at as the height of the triangle because the incline of the site, fifteen feet, was allocated equally to three five-foot elevations. Each plate, moreover, had to be ten feet high, so that five feet could be sunk into the ground and five feet would be visible. The decision regarding the length of the hypotenuse of the triangle was determined, in equally pragmatic fashion, by the distance from apex to base, given the natural fall of the land. The three elements were located at the positions of sharpest landfall, as determined by a survey.

Decisions were made, in other words, to arrive at the simplest, most economical arrangement possible in terms of the specific, unique situation. The initial decision to plant the wedges at those spots of shortest drop was made because Serra decided that the experience of the most rapid fall of the land yielded the greatest amount of information regarding the topography of the site. The viewer's participatory act of organizing the data received from exploring the site and perceiving the sculpture in relation to its site creates the potential for a post-cubist environmental sculpture representing a unique and perhaps prophetic advance in the direction of an exclusively abstract conceptual experience. At the very least, it cuts sculpture entirely loose from painting, to which it has been tied throughout the modern period, raising the possibility that sculpture might once more become an exploratory and experimental art.

Serra's most impressive achievement is his independence of pictorial concerns and pictorial language. His site specific environments reveal no single, immediately perceivable image. To be perceived as a totality, they require surveys of the situation during a sequence of moments in time. In many ways, this experience of the duration of time is more closely tied to cinematic experience than to sculptural concerns. The viewer must identify his immediate experience because it is constantly changing. He notices the terrain changing around him with relation to the wedges that act as markers or instruments of measurement. Staking out space, they define the site; the viewer becomes a surveyor integrating comprehensive and comprehensible coordinates into abstract concepts that define a specific place. Because abstractness is consistently defined in terms of specific, concrete (even if constantly altering) experience, illusions created by the laws of visual perception are ironically utilized to subvert the certainty of experiential knowledge. The result is a subtle, remarkable, and difficult attitude of the work of art as internalized heuristic experience as opposed to distanced object.

SCULPTURE IN THE SEVENTIES

■

"Two dimensions is a stupid illusion . . . it's like running a foot race with only one leg," social satirist sculptor Ed Kienholz once said. He could have been speaking for the whole generation of artists who, bored or frustrated by the limits of painting, found that the three dimensions of real space were more potent visually than any artificially induced illusion on a flat surface. Looking back at the sixties, it seems now as if many of the various pop and minimal styles, which rolled off the canvas onto the floor, were born not so much from a love of sculpture as from a loathing of painting.

Cubist sculpture had roots in collage, but no sculptural expression was ever so closely allied with pictorial images as American sculpture of the sixties. Indeed, its peculiar originality seemed to lie in the rejection by younger sculptors of the history of their own medium in favor of the apparently more advanced single-image "wholistic" compositions and structures explored by painters like Barnett Newman. So strong was this attraction of sculptors to pictorial ideas that even an artist as central to a discussion of modern sculpture as David Smith felt the need, in his cut-out flat "zig" series, to emulate the flat, simplified geometric forms of his friend the painter Kenneth Noland. As pictorial thinking began increasingly to dominate the sculptural imagination, the requirement of a fully three-dimensional spatial experience of sculpture in the round began to suffer.

The goal of immediate instantaneous perception is common to the gestalt-oriented minimal artists of the sixties. Their objective was to deliver the totality of a three-dimensional work at one glance. This did not require walking around the work, and replaced the desire for an in-the-round experience. Donald Judd, Robert Morris, and Dan Flavin created in minimalism a radical break with sculptural tradition that

200

appears now as epiphenomenal when seen in the context of the current resurgence of physicality and the rediscovered importance of gravity. The sixties minimalist break with the history of sculpture was born of hostility to cubism. The insistence on an in-the-round reading distinguishes modern freestanding sculpture from the sculpture in the past that used to decorate monuments or buildings. The radicality of sixties sculpture was not without importance, however, for the future evolution of the medium. For the return to traditional sculptural concerns in the seventies is informed by the sophisticated experimentation with environmental possibilities as well as with the studies of the relationship of optical perception to physical and sensual stimuli carried out in the gestalt-oriented sixties.

Lessons learned in the sixties are being synthesized in the seventies with a new awareness of sculpture's own peculiar history—particularly that history more ancient than Western art itself. Ellsworth Kelly offers the most unexpected solution to a redefinition of sculpture. Inspired in certain respects by Richard Serra's site-specific pieces requiring complex mental integration of kinetic as well as optical information, Kelly's group of a series of ten-feet-tall Cor-Ten and aluminum vertical shapes is uncannily evocative. Like a group of abstract sentinels, they surround the viewer, who experiences them not by walking around any given piece (the backs are clearly designed not to be seen), but by pivoting around, until the totality of the relationship among the vertical shafts is ultimately perceived.

The art of the sixties sanctified the idea of literal "presence," but Kelly's curiously mysterious metal markers emanate far more inexplicably mystical overtones. Absorbed in their totemic atmosphere, I did not find the feeling of being surrounded either threatening or menacing. I felt in the presence of some transcendental and unnameable pure force—as if I had suddenly come upon a modern Stonehenge. An essential enigma, they raise immediate questions regarding the relationship of the subtle curves that indent or swell a given member to others in the series. Obviously these are sections of circles whose radii are in some manner mathematically related. Sensing these relationships, we come to have a picture of the work, not as a series of disparate parts, but as a whole whose essence, given the power of the response it provokes, must strike some eternal Pythagorean harmonic chord. A departure of considerable consequence from Kelly's earlier sculpture of brightly colored cut-out shapes, the new work adds to one's respect for Kelly as constantly pushing the limits of art, straining for new definitions. Today, this is no mean achievement.

ABOUT EVA HESSE

Out of the passing fads and fancies generated by the collapse of "minimal" art, Eva Hesse's work emerges as the real thing. The artist's career, from 1965 when she began making neosurrealist reliefs until her death in 1970 at the age of thirty-four, was brief but productive. Although Hesse's oeuvre was not extensive, it exhibits a coherent and unique poetic sensibility.

Eva Hesse's materials were odd and sometimes unpleasant mixtures of twine, rope, cloth, rubber hose, string, acrylic, and fiberglass. Her approach to both materials and forms was unconventional. It is easier to relate her quasi-organic forms to a surrealist tradition than it is to locate sources for her use of provocative and unusual materials. Certainly Claes Oldenburg's soft sculptures were a precedent for her casual arrangements of forms hanging loosely or suspended from the wall. Her glass cases of strangely shaped objects made of rubber and tubing recall Oldenburg's pastry cases as well. But Hesse's imagery is less specific than Oldenburg's, even if it is not entirely abstract either. She was also undoubtedly influenced by minimal art, with its repeated modular units. Ultimately, she was critical of its hard geometric volumes and predictable order. Her 1968 clear fiberglass cylinders and rods, although they are arranged by chance rather than preordained sequence, cannot help but bring to mind minimalist Robert Morris's clear fiberglass boxes. But Hesse crushes and "humanizes" them, making them appear fragile and injured.

A lot of work in the "postminimal" or "antiformal" vein was done in New York in the late sixties. But it will be Eva Hesse's reticent, poetic, precisely conceived informal arrangements that will be remembered, as the rest recedes from memory. There is an undeniable erotic metaphor in the rounded breastlike forms from which strings rather than nipples

protrude, as there is in the erect sausagelike accretions of the last and largest piece in the show, executed from the artist's model. Other hanging gnarled linear elements recall viscera, although there are also simpler, more abstract works like the flexible latex wall piece. It is difficult to characterize Eva Hesse's sensibility exactly, because her forms were both bold and delicate at the same time. But there is surely something unique, personal, and authentic in her work that points forward toward a sculpture based on a more intimate relationship to the human body, and a less alienated way of realizing forms that are free to express vulnerability as well as strength.

V

ON ART CRITICISM

ART CRITICISM IN AMERICA

Art criticism in America, denounced at every turn by its own practition-
ers, has, nonetheless, produced a substantial body of writing, some of it
durable, and some of it distinguished. Whether academic or progressive,
American critics have tended to share a shortcoming: they have taken
too literally Baudelaire's advice that a critic ought to be passionate and
partisan. The result has been that no matter what the stature of the
critic, he or she has been aligned closely with one group or artist, and
noticeably blind, antagonistic, or insensitive to other developments.
Consequently, American criticism has at times had depth, but seldom
breadth.

Art critics in America have tended to fall into four major categories:
moralist, social historian, formalist, or propagandist. Interpreted as a
branch of ethics, art history, sociology, aesthetics, or journalism, art
criticism has not been considered a profession. Many art critics earned
their living as academics; several of the most successful came to the field
from literature. Lesser reviewers have been recruited from the ranks of
artists and poets.

Internecine warfare has characterized dealings among artists, at least
since the Renaissance. But critics, too, have vehemently taken sides. In
America, they have done so with particular venom. Outspokenness,
brutal directness, and a general lack of delicacy are as characteristic of
American art writing as of American art. In 1916, Willard Huntington
Wright had this to say of his colleagues: "In America it is only too plainly
evident that the majority of our critics choose, with fatalistic invariabil-
ity, the inferior and decadent painters on which to spill their praise." To
Wright's mind, his colleagues (with two exceptions, Leo Stein and
Christian Brinton) were guilty of misleading the public. In order to

From the Introduction to READINGS IN AMERICAN ART, Barbara Rose, ed. (New
York: Holt, Rinehart and Winston), 1968

expose their irresponsibility, he gave a devastating analysis of the competition, a favorite game of American literary critics as well.

In "The Aesthetic Struggle in America," Wright indicted his contemporaries on a number of counts. Royal Cortissoz, "the *doyen* of our art reviewers," he considered most guilty of all. Characterizing him as "an industrious, sincere, well-informed, commonplace, unillumined writer, who possesses a marked antipathy to all that is new," Wright chastised Cortissoz's timidity and fear of the present. "He belongs," Wright concluded, "to the aesthetic and intellectual vintage of the sixties: he is, in fact, almost pre-Raphaelitic in attitude."

For Charles H. Caffin, he had equally unkind words: "He is a compiler, a historian, a chronicler, a disher-up of information—a kind of headmaster in the kindergarten on painting." Caffin's main fault, in Wright's opinion, was not his attitude toward modernism—Wright condescended to mention that "Mr. Alfred Stieglitz converted him to modern art, largely through hypnotism." It was to Caffin's lack of critical judgment and his willingness to tolerate all points of view that Wright objected.

Wright summed up Kenyon Cox's contribution as "his naive assertion that all progress in painting is an illusion." He reprimanded Cox for his aggressive and loud tone. Cox, according to Wright, was "apparently unconscious that the world is moving forward. He belongs to the academy of antiquity. Even modern academicism is unknown to him. . . . He believes that painting stopped with the Renaissance and sculpture with Phidias."

Pointing out that Frank Jewett Mather, Jr., was a professor of painting at Princeton, Wright denounced him as a "typical scholastic pedant." Mather's mind he found conventional, and his prejudices "of educational rather than emotional origin." As for what Mather chose to praise, Wright characterized it as "that which is inoffensive from the standpoint of puritan culture, provided it is thoroughly established and has the indelible imprint of traditional approval upon it."

Wright's judgments, though severe, were in many ways accurate. His basic criticism of art writing was the same as that leveled by Clement Greenberg nearly half a century later: that it lacked a firm grounding in aesthetics. As outspoken as Wright, Greenberg took his fellow critics to task in "How Art Writing Earns Its Bad Name." The subject remained the criticism of American painting, but many of the critics Greenberg named were European. Among the Americans, Harold Rosenberg was the major target. Of Rosenberg's interpretation of abstract expressionism, Greenberg wrote:

The very sound itself of the words "Action Painting" had something racy and demotic about it—like the name of a new dance—that befitted an altogether new and very American way of making art: a way that was all the newer, all the more avant-garde, and all the more American because the art in question was not actually art, or at least not art as the stuffy past had known it. At the same time, Mr. Rosenberg's ideas themselves sounded very profound, and most art critics have a special weakness for the profound.*

In general, Greenberg found appalling "the fundamental repetitiousness of most criticism of contemporary art, as well as . . . its rhetoric and logical solecisms."

When American critics have not been throwing brickbats at each other, they have faced a number of common problems. For the critic, as much as for the public, the question remained for much of this century whether America could produce a great artist. Forced to evangelize for American art, native critics had constantly to fight against an equation of European art with quality in art. They fought not only for the transcendence of their own personal point of view but also for the acceptance of American art in general, both at home and abroad. In 1917, Wright lamented that Robert Henri, "like all significant Americans . . . has been victimized by the public's snobbery. His nationality weighs heavily against him; for I cannot help believing that, were he a foreigner (why did he not pronounce his name Ong-ree?), he would be hailed as a great painter." The situation had obviously not changed much when, in 1952, Greenberg complained that had Pollock been a European instead of an American, he would already have been acknowledged as *maître*.

In America, art criticism has been published in newspapers, general periodicals, and specialized art reviews, which tended to expire as new magazines, in touch with current developments, appeared on the scene. Usually, the art magazines were limited by an editorial policy that strongly favored one or another of the art-world factions. Thus, their scope was narrow, and their claim to objectivity discredited. Criticism in newspapers, with a few important exceptions, such as the columns of Elizabeth McCausland in the *Springfield Union* and the recent reviews by Hilton Kramer in the *New York Times*, seldom transcends the journalistic level. It tends toward preserving the vested interests of conservative and academic viewpoints. From the first decade of the century, the

*Clement Greenberg, "How Art Writing Earns Its Bad Name," *Second Coming*, March 1962.

New York Sun was one of the few exceptions; it printed the criticism of Frederick James Gregg and James FitzGerald, which was favorable to The Eight, and later employed Henry McBride, a vocal partisan of modernism, as art critic.

In the first two decades of the century, important criticism was published in such general magazines as *The Century, Forum,* and *Harper's Weekly.* Several political journals, too, gave space to intelligent art writing. *The New Republic* employed Leo Stein from 1916 to 1926, and *The Nation,* beginning with Mather's tenure (1907–17) and continuing to the present, has enjoyed a distinguished line of critics, which included Clement Greenberg, Hilton Kramer, and Max Kozloff. Beginning in the late thirties, and continuing through the forties and fifties, *Partisan Review* published influential art criticism by, among others, George L. K. Morris and Clement Greenberg.

The art magazines, by and large, have passed in and out of vogue along with the artists they have supported. About the time of the Armory Show, the leading art magazines were *Arts and Decoration* and *The Craftsman.* Both were rather strongly oriented toward the Henri point of view, as was *The Touchstone,* edited by Henri's friend Mary Fanton Roberts. At the same time, the hyperreactionary *The Art World,* edited by F. Wellington Ruckstuhl, gave a fanatical interpretation of the academic position. Writing as Petronius Arbiter, Ruckstuhl denounced the "Bolsheviki" and "madmen" who were "foisting" modern art on an innocent public.

During the twenties, *The Arts,* intelligently edited by Forbes Watson, maintained a high level of discourse, printing the criticism of such informed critics as Virgil Barker, and alternating articles on contemporary European art with praise of the coteries of both Henri and Stieglitz. Since many avant-garde writers as well as artists gravitated toward Stieglitz, his protégés were particularly well received in the little magazines such as *Seven Arts, Broom,* and *The Little Review.* In their pages, writers like Paul Rosenfeld, Waldo Frank, and Lewis Mumford often defended Stieglitz's cause.

As art critic for *Dial* (1920–29), Henry McBride could be counted on to be sympathetic to the point of view of the moderns. Although his writing was enormously important in creating a climate of interest in modernism and as a bastion of defense for the American modernists, McBride's was not an incisive critical mind. He will be remembered for the excellence of his taste and eye, the balance of his judgment, and the courage of his convictions, rather than for the depth of

his criticism. As a member of the Arensberg circle, he favored Dada—a fellow critic once characterized McBride's writing as "Da," because he was only partially Dada—but he did not neglect to praise a wide range of modern art.

Important art journals of the late twenties and thirties included *Creative Art,* edited by Lee Simonson, and *American Magazine of Art,* later *Magazine of Art.* During the late thirties, European magazines such as *Cahiers d'Art* and *Plastique* were often scanned by American artists eager for more sophisticated material. In the forties and fifties, *Magazine of Art,* which ceased publication in 1953, and *Art Digest,* which became *Arts* in 1955, published criticism by art historians such as Robert Goldwater, Robert Rosenblum, and Leo Steinberg. Magazines published briefly by the surrealist artists in exile during the war, *Tiger's Eye* and *View,* printed statements by Americans as well. In the late forties and fifties, *ARTnews,* a relatively stodgy journal with a historical bias, which has been published since 1902, became, under the editorship of Thomas B. Hess, the champion of the new American painting. Although the mass of enthusiastic chauvinistic outpourings in its pages will be forgotten, essays by Hess, Rosenberg, Greenberg, and Meyer Schapiro in defense of abstract expressionism retain historical importance. In the late fifties, sculptor Philip Pavia published *It Is,* a magazine devoted exclusively to propagandizing for abstract expressionism and largely written by the artists themselves.

During the sixties, two new publications gained importance. *Art International,* published in Switzerland by James Fitzsimmons, and *Artforum,* first in Los Angeles, later in New York, have emphasized post-abstract-expressionist currents.

Besides artists, art historians, and assorted types of literati, collectors have also attempted art criticism. Since no credentials were needed, collectors often felt themselves to be—and in a few cases were—as well equipped as any to enter the field. Beginning with two of the original buyers from the Armory Show, Arthur Jerome Eddy, who wrote the first book on cubism to appear in English, and John Quinn, collectors have defended the points of view reflected in their collections. Duncan Phillips and Dr. Albert Barnes, the most sophisticated of the collector-critics, made substantial contributions to the literature on American art. Katherine Dreier and A. E. Gallatin effectively evangelized for the recognition of modern art in America. In recent years, B. H. Friedman and Ben Heller, collectors of New York School painting, have defended their taste in writing.

THE ISSUES

Although the battle lines were drawn even before the Armory Show made the issue of academic vs. modernist art topical, the Armory Show attracted participants into the conflict. Some critics, mainly the defenders of Henri and the realists, such as James FitzGerald, F. J. Gregg, and James Huneker, tended to steer a middle course, neither totally embracing nor categorically dismissing modernism. Others were to change their opinions during the debate, sometimes in an abrupt about-face. Duncan Phillips, for example, was a late convert to modernism, whereas Guy Pène du Bois and Leo Stein ended by abandoning its defense. In the seventies, Hilton Kramer became more receptive to the American avant-garde, but Clement Greenberg attacked pop and minimal art as inconsequential "novelty" art.

The battle of abstract vs. representational art, hard fought throughout the second and third decades of this century, became, in the thirties, identified with the issue of European vs. American art. By this time, abstract art had come to be largely identified with European paintings, whereas representational art was popularly considered the native mode of expression. Fostered by critics such as Thomas Craven, confusion between "modern" and "contemporary" helped to obstruct the development of modern American art, as it also protected regionalists and American scene painters from charges of academicism, to which they were certainly liable.

The leading apologist for abstraction in the thirties, George L. K. Morris, maintained that "during an epoch in history such as this, when everywhere the mind seeks some order for its broken cultural fragments, the abstract art-work takes on fresh significance. It has the 'look' of its time, the ability to hold its place among the mechanisms that characterize the new civilization we are just beginning to know." But Morris's position was compromised by the fact that he seldom if ever praised anything but abstract art. Critics of the forties, fifties, sixties, and seventies would be less exclusive, and less prone to attempt to objectify personal taste into prescriptive dogma.

Attempts to make aesthetics or criticism scientific were undoubtedly naive and mistaken. Nevertheless, there arose from this concern with finding objective criteria of evaluation a type of criticism that endures as one of the strongest traditions, perhaps *the* strongest tradition, of criticism in America. Although the roots of formalist criticism are usually traced to the English critics Clive Bell and Roger Fry, it is as much an

American as an English tradition. Bell and Fry, as members of the
Bloomsbury group, sought to put art criticism on an equal footing with
literary criticism. Toward this end, they introduced some of the concepts
of advanced literary criticism into art criticism, especially that which
held form to be the expression of content. This was in contrast with the
Americans who wished to eliminate the subjective factor entirely from
criticism in order to provide systems of analysis that, transcending cate-
gories, personalities, and historical epochs, would prove their universality
and general applicability.

Fry's attention was first focused on the problem of the analysis of form
in art when, early in the century, he served as a young curator in the
European-painting department of the Metropolitan Museum, where he
might have remained to illuminate the course of American art, had his
talents not gone entirely unrecognized. During these years, he became
acquainted with Denman Ross's *Theory of Pure Design*, which must
have influenced his thinking enormously, since it was the only work he
acknowledged in his 1909 "Essay in Aesthetics."

Fry's definition of art as the expression of emotion, and his separation
of aesthetic beauty from the beauty of "a woman, a sunset, or a horse,"
was immediately accepted by the American critics Walter Pach, Willard
Huntington Wright, and Christian Brinton. Clive Bell, as Fry pointed
out, supported this formulation in observing that "however much the
emotions of life might appear to play a part in the work of art, the artist
was really not concerned with them, but only with the expression of a
special and unique kind of emotion, the aesthetic emotion." The aes-
thetic emotion, for Bell, was communicated through "significant form."

Convinced of the rightness of Bell's and Fry's positions, Dr. Albert
Barnes spent many years and devoted several books to the definition of
"significant form." His search not only provided the basis for an exten-
sive method of formal analysis, it influenced the thinking of some of our
most important historians, critics, and aestheticians, including John
Dewey, whose *Art as Experience* is dedicated to Dr. Barnes. Published
in 1934, *Art as Experience* touched the thinking of a generation of
American critics, and continues to be an important step in the develop-
ment of American criticism.

During the thirties, under the rising tide of realism and illustrational
painting, formalist criticism underwent a relative setback. The most
telling case against formalist criticism, however, was made by Meyer
Schapiro, in a review of Alfred Barr's *Cubism and Abstract Art* ("Nature
of Abstract Art," *Marxist Quarterly*, January–March 1937). Schapiro
criticized Barr's book, which still stands as the most lucid and thorough

study of cubism, on the grounds that it was unhistorical and separated art from its historical context. Objecting to Barr's presentation of art history as a cyclical process of exhaustion of forms and styles and reactions to this exhaustion, Schapiro stated that "the theory of immanent exhaustion and reaction is inadequate not only because it reduces human activity to a simple mechanical movement, like a bouncing ball, but because in neglecting the sources of energy and the condition of the field, it does not even do justice to its own limited mechanical conception."

That art history undergoes periodic cyclical reversals was the view of the Swiss art historian Heinrich Wölfflin. Such an interpretation traces the evolution of forms in art independent of the personalities and conditions that generated them. To Schapiro, and other historians and critics opposed to this point of view, stylistic change is directly tied to social, cultural, and political change. In Schapiro's words: "The broad reaction against an existing art is possible only on the ground of its inadequacy to artists with new values and new ways of seeing. . . . the banal divisions of the great historical styles in literature and art correspond to the momentous divisions in the history of society."

The argument is that formalism ignores the question of social context or content in art by concentrating exclusively on formal relationships. Many critics, ranging from partisans of representational art to moralists and social philosophers, have maintained that content—ethical, emotional, social, or political—takes precedence over form as the primary criterion of value in art. Harold Rosenberg continued to take such a stand, insisting that the validity of abstract expressionism resides in its "crisis content," rather than in its sense of pictorial form.

As a rule, formalist critics have stopped short of discussion of content. Roger Fry, fearful such a discussion would plunge him into the "depths of mysticism," stopped "on the edge of that gulf." Greenberg is apparently equally wary of plumbing the ineffable. In neither case can the accusation of illogicality or muddled metaphysics be made as it can be of many critics of modern art. The issue becomes instead: if the aesthetic emotion and significant form are ineffable, how much can the critic tell us about art?

ONE-DIMENSIONAL CRITICISM

The act of criticism is the value judgment. The rest is art writing. The crucial issue for criticism is the definition of the criteria on which the critic bases his evaluation. We know that different periods have had different sets of aesthetic coordinates. Thus we must question what such objective criteria for evaluation, which would be equally applicable to the art of all times and all places, might be. Some general characteristics such as unity, harmony, balance, rhythm, and movement have been singled out as identifying the successful art work. But contrary evidence reveals that certain styles are marked by discontinuity, discordance, and asymmetry, whereas still others give primacy to equilibrium and stasis. All these qualities, in fact, can be found in avant-garde art today. Therefore we must conclude that formal analysis does not yield any universally applicable or verifiable standard of measure, however useful it may be in describing the mechanics of composition.

This is not surprising, since formal criticism was developed in response to a particular historical style, namely cubism. Hence it is admirably suited to the analysis and even the evaluation of cubist work, which depends for its success or failure on a balanced structure created by the relationship of analogous parts. Movements and countermovements, echoes and reechoes of *motifs* can be isolated, diagrammed, and graded for their sufficiency. But today we are faced with an art that more and more asks to be viewed as an integral gestalt. This art, whether it be Jules Olitski's spray paintings or Donald Judd's boxlike volumetric structures, cannot be seen as a series of parts relating to a whole, but only as that concrete, indivisible whole itself. Because artists are calling into question the notion of composition as it has traditionally been understood, attempting to deal with their works in terms of the dynamics of cubism is fruitless. As Malinowski's study of matriarchal societies revealed that

Freud's interpretations of familial relationships applied only to the patri-archal society of which Freud was a product, evidence points to the conclusion that formal criticism is best suited to dealing with cubism.

Formal criticism, an Anglo-American enterprise, was developed in order to place art criticism on a less impressionistic, more abstract plane of discussion. The English critics Clive Bell and Roger Fry sought to bring to art criticism the pure aesthetic attitudes of modern literary criticism. American critics such as Willard Huntington Wright and Dr. Albert Barnes (who is responsible for much of the complicated method of formal analysis) sought to provide art criticism with a scientific basis. In America, this search for objective, scientific, verifiable standards has led not only critics but artists into error. For art criticism is no science; very little that can be said about an art work is verifiable. Very little that is verifiable is relevant to a discussion of art.

By the same token, extended factual descriptions of art objects do not lend much to our understanding or appreciation of them. Such dry and pointless descriptions have become the sixties' answer to the purple passages of fifties art writing, which foolishly attempted to evoke the art object by creating a literary equivalent for it. There are no literary equivalents for visual experience, and this is the heart of our dilemma as art critics. Our main problem is one of language. We are in constant need of new terms to meet the new situations artists present. What I mean by finding new ways of communicating visual responses through language, however, is not to coagulate prose into opaque constructions nor to complicate terminology by finding fanciful jargon for saying the same old things. The job of the art critic is to clarify, not to obfuscate. Preciosity has no more place in criticism than it does in art.

Given the evidence of world art history, the critic cannot honestly maintain that there is a uniform formal test of excellence, a single set of aesthetic coordinates to which the valid art of all times and all places conforms. The critic can discriminate value, then, only by means of his own sense of quality, which he has developed by looking at a wide variety of works of art. His reaction is entirely subjective and intuitive. The goal is critical detachment, but one can hardly end by doing more than establishing personal preference as the standard of excellence. Some-times the critic experiences great difficulty when his own taste conflicts with his perception of quality. In this case he attempts to transcend the limitation of taste. The eye of the critic is as good as the critic's charac-ter, experience, and sensibility. The capacity to marshal evidence for his case is the proof of the degree of penetration into the art work. Although glib critics are capable of positing sophistic arguments, these arguments

soon lose their ability to convince as more information becomes available. In the final analysis we must agree with John Graham that "intuitive measurement is the only precise measurement. Scientific methods are neither exact enough nor fine enough for determining quality. Great minds agree and form cultural standards." It is the consensus of great minds that will validate critical judgments in retrospect and test the record of the critic.

Outside of making value judgments, the most important thing a critic of current art can do is to identify new concepts as they are generated by the artists. There is no point in judging something in terms that no longer apply.

The special problem of the critic in the sixties has been locating a tradition of criticism within which to operate. The rhetorical inanities of the large part of the criticism of the fifties, its inability to come to terms with any of the essential issues provided by the art of the period, made one even more desperate to find solid ground. In that situation, formal criticism was not one of many possible critical traditions, it was the *only* viable critical tradition. But the appropriateness of dealing with abstract expressionism in purely formal terms was already questionable, since the abstract expressionists themselves claimed that theirs was above all an art of content. It became increasingly clear that the less the art under discussion had in common with cubism, which was a hermetic art for art's sake, the less useful were the tools of formal criticism.

Today, if we wish to keep pace with the art being done, critics must be willing to discuss what is implicit in an art work: that is, its content and intention. These cannot be verified, but they can be discussed, keeping in mind that any statements about content and intention are merely assertions, hypotheses open to argument. In this case, we are responsible for challenging each other's assertions when these assertions about content or intention do not seem to correspond with what we see.

The responsible critic is hence a social critic. Today, in the face of the lack of any generally understood criteria for evaluation, collectors, dealers, and those artists who respond to the laws of supply and demand allow standards to be set by market pressures. The collector looks for the museum seal of approval to certify his taste and insure his investment. The dealer quietly disembarrasses himself of work museums will not show.

If we deal with intentions and content, we are once more thrown back on the question of value. Insofar as the critic has a system of values, he will find certain intentions and certain kinds of content superior to others. Whether an artist is capable of realizing his intentions is an

aesthetic question, but the evaluation of his intentions is a moral issue. The serious critic is finally pushed into this particularly excruciating area in which the serious artist works today. If art criticism is a profession or a discipline and not merely a tout sheet, a hobby, or a vehicle for the display of mental gymnastics, the responsible critic of contemporary art must be as concrete, straightforward, and committed as the best artists of the time.

Now that the New York art world has come of age, the critic is bombarded by an assortment of stimuli, some of which are valuable and some of which are fabricated false signals. An open-minded critic will be willing to consider the variety of stimuli offered, but a responsible critic will be selective, focusing on the essential and rejecting the rest as static. By refusing to broadcast static the critic performs a useful service. The questions become: what is essential and worth discussing and conserving, and what is peripheral or irrelevant. Clement Greenberg, quoting Matthew Arnold, saw the task of the critic as defining the mainstream tradition. Mr. Greenberg has done an admirable job of defining its course from cubism through abstract expressionism to post-painterly abstraction. But at any given time, the mainstream is only part of the total activity. In our time, it may even be the least part. To concentrate exclusively on the mainstream is to narrow one's range to the point where even tributaries to the mainstream, such as Dada, surrealism, and pop art, are not worthy of consideration. Yet these movements are surely part of the history of art, even if they are relatively minor chapters, as opposed to the history of taste.

Formal criticism, in a reaction against nineteenth-century deterministic criticism, ignores the historical context in which a work of art is created. The argument is that since modernist art emancipated itself from the demands of society, the history of forms has been self-referential, evolving independently of the history of events. I think that this argument is demonstrably false. It constitutes the single greatest limitation of formalist criticism. The art of the time is inextricably linked to the history, sensibility, and thought of the time, and it is our duty as critics to say how.

Beyond evaluating works of art and identifying those that belong to the mainstream, the critic may decide on a more or less generous kind of art writing that he wishes to pursue. Despite the degree of mere sensation seeking and vicarious living involved in most of the attention currently directed toward art and artists, there is a certain amount of genuine interest and commitment in the newly enlarged art public,

especially among the young. The generous critic will wish to provide such an interested public with the clues to experiencing and interpreting the messages of new work, to communicate his enthusiasm for specific works and evoke their special qualities, and to establish a context in which contemporary art will become more intelligible and less bewildering.

CRITICISM AS PROPAGANDA

What is
there in being able
to say that one has dominated the stream in an
attitude of self-defense;
in proving that one has had the experience
of carrying a stick:

—Marianne Moore,
"Critics and Connoisseurs"

In the late fifties, it was fashionable to speak of the crisis in art; in the late sixties, it would appear that art only has problems, but criticism is in a state of "crisis." To a large degree, current critical assumptions depend on the efforts of Clement Greenberg. His book of essays, *Art and Culture,* published in 1961, served as the point of departure for the views of my own generation of critics. In those days I can remember thinking *ARTnews* and *Journal of Aesthetics and Art Criticism* equally remote and hilariously beside the point. In this situation, Greenberg's voice was a unique and welcome call to clarity, logic, and meaning.

Recently, many have begun to probe the source and nature of Greenberg's growing authority. Such questioning ranges from the sporadic griping and sniping of the various factions of art-world malcontents, of the sort Greenberg has always attracted, to the measured intellectual attacks of some of the most sophisticated minds involved with contemporary art.

The reaction against Greenberg is part of the general reaction against the limitations of an exclusively remote formal criticism. Beyond this,

220 Unpublished, 1970

however, there is the additional problem of the "general falling off in quality"—to paraphrase his own recent verdict on Picasso's late work— of Greenberg's writing since the appearance of *Art and Culture*. Since my own views have been so indebted to Greenberg, I found the reviews and articles he has published since the appearance of the essay *Modernist Painting* in 1965 especially disappointing.

At this point Greenberg stopped questioning his own assumptions with a degree of complacency that obscures how questionable some of these are. The latest critical issues of a formal approach were generated almost exclusively by Michael Fried, whom Greenberg himself took to quoting. As art historians have begun to build up a literature on twentieth-century art, the situation changed considerably, to the point where a well-trained graduate student can analyze the compositional dynamics of any work for which there are already preestablished critical criteria. These criteria quickly become an academic set of rules of decorum. Greenberg has articulated many of these criteria, especially with regard to cubist and cubist-derived work, which he certainly has understood better than anybody else. If the job of the critic is the discovery of new critical criteria capable of evaluating fresh aesthetic developments as they occur, then Greenberg has more or less effectively retired from the field. Why then is his activity an issue any longer?

Clement Greenberg continues to remain the central focus of critical discussion not because of the relevance of his critical writing to current aesthetic problems, but because of his power, now on the wane, to dictate taste. For a time, discussions of Greenberg's ideas were replaced by a widespread questioning of his authority as a tastemaker. Indeed, Leo Steinberg has argued that Greenberg's effectiveness as a tastemaker depended on his ability to reduce art to a single standard of quality. According to Steinberg, the rating system that Greenberg's comparative judgments provided was easily appropriated by collectors as an investment guide to blue chips: Greenberg's reduction of all aesthetic values to a single value—that of quality—was immediately translatable into terms of real value, i.e., dollars and cents. A cause-and-effect relationship between Greenberg's insistence on the single measurable standard of quality and the marriage of, as Steinberg puts it, "big money and the avant-garde" was inevitable once it became clear that modern art had amazing and unpredictable investment potential.

As an example of Greenberg's later writing, let us consider the following passage from his review of the Irish "Poetry of Vision" exhibition (*Artforum*, April 1968):

One of the surprises was how good the three paintings by Alechinsky
looked; I had always before found Alechinsky too pat and set. Tapies, too,
looked good, but that was no surprise; and he did not look good enough
to be more than minor. Another good minor artist, Vasarely, could have
been better represented than he was.

Granted, this is a particularly unhappy sample of Greenberg's recent
criticism, but the laconic style and the arbitrary schoolmarmish grading
system—good, better, minor—is altogether typical. So terse and reduc-
tive has Greenberg's writing become, in fact, that it is often difficult to
distinguish late Clement Greenberg from early Donald Judd. (Not since
Judd stopped writing criticism has "plausible" been used as an adjective
to describe a work of art.)

If Greenberg's criticism has degenerated into a catalogue of unsup-
ported value judgments, why does anyone pay him any mind? Green-
berg's authority is based, like so many popular beliefs, at least partially
on legend. By this time a mystique, much like the mystique of Jackson
Pollock, surrounds Greenberg's legend. Because he is reputed to have
spotted Pollock, as well as Newman, Louis, and Noland, before they were
generally recognized, Greenberg's own fortunes became tied to theirs,
and their acceptance by collectors and museums meant his own as well.
In the uncertain world of avant-garde art and its increasing involvement
with gambling and racing, special credence was given to the opinion of
the man "who picked the winners."

America, it is depressing to observe, is a country that inspires men to
assume dramatic poses in order to stand out from the crowd, to fashion
an image that is larger than life and to throw a long shadow long enough
to be noticed. This requires a stylized identity to be projected onto the
big screen of public events. To be fully effective, the image should be
in some way suggestive of a popular American stereotype hero—for
example, the rugged individualist, or the lone sharpshooter in town on
the side of the angels, ready to confront the forces of evil. We had, for
example, Harold Rosenberg cast as Manolete, frantically twirling his
banderillas and executing ingenious linguistic veronicas in the arena of
his imagination, and Clement Greenberg appearing in some provincial
town—a truculent Gary Cooper, armed with only the fastest eye in the
East, tensely poised for a showdown with art history.

For it is, of course, art history that Greenberg challenges. As Hilton
Kramer astutely pointed out in his review of *Art and Culture*, Green-
berg's judgments, if they were to carry weight, *had* to be made in the

name of history. Greenberg has been extremely chary of ever offering either a theory of history or a system of aesthetics, relying instead on a very personal mélange of Kant, Hegel, and Marx, leavened by a dash of Croce. Implicit in his thinking is the foundation of a logical, linear progression from Manet to Cézanne to cubism to abstract expressionism to present-day stained-color abstraction, representing the "mainstream" of modern art. By developing the idea of a "mainstream," which one presumes he got from the literary criticism of Matthew Arnold, Greenberg was able to justify the exclusion of any material that did not contribute to its development. Thus far in the twentieth century, this has meant the exclusion of Dada, surrealism, and pop art or any representational styles, which Greenberg banished some years ago from the history of art to the never-never land of "the history of taste." This contradicts the facts.

The history of abstract expressionism is by this time a matter of documented record. Without the Dada use of chance as a means of art making, followed by the surrealist discovery of automatism as a means of liberating gesture and breaking the cubist "grid," abstract expressionism could never have evolved as a major style. As William Rubin has amply demonstrated in *Dada, Surrealism and Their Heritage,* the impact of surrealism on American art was crucial in terms of its space, technique, imagery, and "poetic" content.

Another instance of Greenberg's refusal to acknowledge the contribution of "minor" artists and movements, not part of the mainstream development as he sees it, is his desire to overlook the contribution of earlier American art to its subsequent evolution. Reading the accounts Greenberg gives of American art in his historic capsule history of the New York School, the essay on *American-type Painting,* as well as other more questionable recent reconstructions of art history, one has the impression that the birth of abstract expressionism was a feat of parthenogenesis, with the School of Paris its single parent. This is more than a gross simplification. It is a distortion of history.

Does it matter that a critic misrepresents history or gives a partial view of it, if he never passes himself off as a historian? It matters if this distortion of history has as its end the imposition of critical judgments that will only hold if they are made in the name of art history. In other words, if Greenberg is unable to come up with something better as a criterion for quality in art than that the work or artist in question belongs to a putative "mainstream," he is forced to rewrite history falsely. He must do this so that none of the crucial formal innovations are stumbled

on by mistake by minor artists, outside the strictly exclusive frame of reference he seeks to impose in order to turn his judgments into officially accepted standards.

In the name of history, Greenberg distorts and edits history: he has excluded, simplified, adumbrated, and flattened the complex developments in twentieth-century art until they conform to an easily diagrammed and hence easily assimilated progression. *This is something no critic in the past has ever done or sought to do.* It means that Greenberg has a very different view of the role of the critic than any held in the past, and that he is prepared to use techniques of communication which are disturbingly familiar in another context. Once again, that context is political.

The techniques Greenberg has used in order to convince, persuade, illuminate, and convert his public are precisely the techniques of opinion manipulation known collectively as propaganda. As Jacques Ellul points out in *Propaganda,* three of the principal techniques of opinion-making are repetition (conditioned reflex), simplification (inculcating ideas rather than explaining them), and exclusion by silence. The last technique, Ellul points out, is among the most effective. Propaganda, according to Ellul, "tried to convince, to bring about a decision, to create a firm adherence to some truth." It acts "no longer to lead to a choice, but to loosen the reflexes." Intellectuals, Ellul points out, are especially susceptible to propaganda because they feel they must have an opinion or a judgment on everything.

A pessimistic critic of the technological society such as Jacques Ellul would no doubt see the devolution of criticism from a method of discourse to a technique of manipulation as an inevitable development. The transformation of critical writing in support of art that addresses itself to no *existing* social class but to an imaginary elite into a form, not of inquiry but of sloganizing, is the most depressing development of the criticism of the sixties.

According to Ellul, in advanced technological societies, propaganda becomes a sociological phenomenon as much as a specifically political weapon. Beginning with politics, eventually it permeates every type of discourse. In *Propaganda,* his study of mass communications, Ellul points out that the primary function of propaganda is to quell doubt and uncertainty. It was not initially clear to me, but I have come to see that the nature of mass media determines absolutely the content of what can be communicated. This is as true and as damaging for art criticism as it is for anything else. At best, at its most neutral and least judgmental,

art writing in the media is reportage. At worst, it is inescapably manipulative sales-directed propaganda. The media require the simplification of language and concepts, the flattening out of irregularities and complexities, the masquerading of opinion as fact. This conforms entirely to classic definitions of propaganda. The repetition of the same names over and over contributes to this propagandizing function of recent criticism. The third time that one reads that Jasper Johns is a "genuine minor master," one does not necessarily believe it, but one begins to give it some thought. It is never explained *why* Jasper Johns is a genuine minor master, so the message is that much easier to grasp and assimilate. In such a situation, the presence of "quality" is an article of revealed faith for the multitude to whom the judge-critic addresses himself as pontifical absolute authority.

These are the premises of judgmental criticism, and they are extremely troubling premises. They are made yet more questionable when one realizes that they are being made in the name of the critic's superior *taste.* Superior taste, if it exists, has never been the proof of the quality or probity of criticism. In actuality, a given critic's taste may be the least of his or her virtues. The two most revered nineteenth-century critics, Ruskin and Baudelaire, praised second-rate artists in the main, yet this does not make their criticism any less valuable.

A full reading of a work of art, which includes its historical and human context, is too complex, ambiguous, and interrelated to other phenomena to allow a propaganda message to come through. Because judgmental art criticism may become very boring, another propagandistic technique, that of overstatement, has become prevalent. The media demand simplified propaganda or unprocessed reportage. Criticism that assumes to legislate judgment necessarily becomes the former. More alarming than the media's ability to diminish criticism to the level of reportage is their ability to formulate taste in an extended and proliferating system of art patronage. Changes in the institutional structure of the art world have created a situation in which judgmental criticism can only function in relation to a marketplace. In this case of instant market validation, it is perfectly absurd to maintain that value judgments do not have definite practical and material consequences.

When the avant-garde was divorced from the economic basis of society, such win-or-lose gambling games with art history were harmless diversions. However, Greenberg's contempt for art history, which requires the full work of art and a complete record of the circumstances and intentions of its making, may be seen as a necessary rejection of

complexity. He is forced to evolve a reductive criticism because a complete reading of a work is too complex, too ambiguous, and too interrelated to other phenomena to allow the propaganda message to come through with sufficient clarity to stimulate the public, not to reflection and further doubt and questioning, but to an exciting potentially profitable way of playing the art game.

The following examples may serve as illustrations of Greenberg's use of propaganda techniques:

1. Repetition: Rather than run a statistical analysis on the number of times the same names crop up in Greenberg's articles, it is easier to show how these names are consistently introduced even in contexts where the subject is ostensibly something quite different. Thus, in an article entitled "Recentness of Sculpture," Greenberg gratuitously informs us that "the best of Monet's lily-pad paintings—or the best of Louis's and Olitski's paintings—are not made any the less challenging and arduous, on the other hand, by their nominally sweet color." Why bring up Louis and Olitski here at all? Again, Ellul suggests an answer: in order to be effective, propaganda must address itself to some timely issue. The color in Louis and Olitski is certainly an issue, conceivably a more important issue than recent sculpture, but it's not as *timely* right now, so the message must in some way be introduced into alien contexts. Of course, all critics have their *leitmotifs* and concerns that seem so pressing they are introduced even into extraneous contexts. But Greenberg's reiterations go beyond this. The effect is to prepare the reader to accept notions he or she might once have held unthinkable. Thus, the first time I hear that Matthieu redeems recent French painting, I might not believe it; but by the fifth time I have received the same message, it begins to be credible, in the same sense that the idea that Excedrin really can do something for you ordinary aspirin can't begins to be believable.

2. Simplification: In the above-mentioned article, Greenberg writes: "Still another artist who anticipated the Minimalists is Anne Truitt. And she anticipated them more literally and therefore as it seems to be, more embarrassingly than Caro did." Again, no explanation of how Caro anticipates minimal art (which is a case I would like to see proved). Moreover, although I admire Miss Truitt's sculpture, too, one would have to be blind not to see that it is extrapolated from the paintings of Ad Reinhardt, whom Greenberg has just finished off in the preceding paragraph as a "trite" artist. It is equally hard to see how her 1963 pieces

anticipated Robert Morris's 1961 single-volume constructions, exhibited in New York in 1962, or Walter De Maria's boxy structures.

To find value in Truitt's work, Greenberg is forced to see it as setting some, in this case entirely spurious, historical precedent. In other words, it is not enough to make a case for the work giving pleasure in its own right; for it to have any consequence, it must make history. The extreme pressure being put on the notion of radicality or innovation as the single criterion for value in art leads to distortions of this nature. What is not taken into consideration is that at this point discoveries in art are close to the pattern of discoveries in science: as soon as the problem is exposed fully and clearly enough, someone is bound to arrive at a solution. Moreover, the chain of thought leading to the "breakthrough" will more likely than not pass through the work of more than one artist, setting up connections that cannot be acknowledged if the unique measure of quality is the "radicality" of the work of a given individual. This suggests that alternate criteria for quality in art in addition to innovation must be developed not to force the critic to indulge in a distortion or simplification of history.

3. Omission: I do not wish to catalogue who and what Mr. Greenberg has decided to exclude from the history of art by proclamation. Any critic is necessarily selective. Yet once again, Greenberg has begun to stretch this prerogative to limits no conscientious historian can endure. For example, in an account of American art since World War II, Greenberg writes of the importance of Kenneth Noland's 1958 paintings "with concentric bands and stripes of flat color." Left out of this account, however, is the fact that these paintings were home in Noland's studio in Washington, D.C. The paintings Noland *showed* in New York in that year at the Tibor de Nagy Gallery, on the other hand, were in an allover vein still largely indebted to Pollock and Frankenthaler. At the same time, the banded flags and concentric targets painted by Jasper Johns from 1955 to 1958 were widely discussed and reproduced (on the cover of *ARTnews*, for example). Johns, of course, has already been written off by Greenberg as a "genuine minor master," and as we know, minor masters do not make the major formal advances.

I have insisted on Greenberg's use of the techniques of propaganda not necessarily because I disagree with his ends, or even with many of his judgments, but because I feel his *means* are ultimately debasing to the practice of art criticism as a humanistic discipline. In many ways, Clement Greenberg's career is a paradigm of the fortunes of the Ameri-

can intellectual formed in the thirties. Like Harold Rosenberg, and others outside the field of art who came to art criticism, he has ended by conforming to the cultural stereotypes he once exposed. The question that might be posed now is whether "Alexandrianism," to use Greenberg's own phrase for a decadent pluralistic culture, constitutes a greater threat to the survival of high culture than the indiscriminate use of propaganda.

THE POLITICS OF ART

■

I. AESTHETICS AS REVOLUTION

I can imagine, in these days of global intercourse and indiscriminate CIA subsidy, a cultural summit meeting at a health spa outside of, say, Montevideo. Here South American revolutionaries, who might be underpaid intellectuals by day and guerrillas by night, could sunbathe with their *yanqui* opposition. Eventually, it might hit home that American culture, and in particular American art, lately found useful in selling the American way of life, is as unwanted and as unexportable as our economic system. For the cultural problems of an underdeveloped society on the brink of revolution are radically opposed to those of the postrevolutionary affluent society. Revolutionary societies traditionally think of art in the service of revolution. On the other hand, close reading of some recent American art writing will reveal that a disappointed political idealism, without hope for outlet in action, has been displaced to the sphere of aesthetics, with the result that for some, art has become the surrogate for the revolution.

The first clear indication of a displacement of political ideals into the area of aesthetics is Harold Rosenberg's notion of "action painting." Writing about art, Rosenberg still resorts on occasion to the vocabulary and polemical tone he used as a political writer in the thirties. But Rosenberg's confusion of art with politics and art writing with political writing is a typical confusion among American critics. I cannot explain the tone of polemical virulence that has characterized recent American art criticism (to which this writer has contributed on occasion) except on the grounds that the degree of intensity expressed these days in discussions of art might at other moments in history have found another kind of outlet, specifically a political expression.

To this tone of outrage, our most brilliant critic, Michael Fried, has added the vocabulary of Marxist pamphleteering. If we examine Fried's criticism, we find that not only the tone and vocabulary of Marxist polemics, but a certain amount of its actual content is to be found there. For example, Fried writes of a new type of disagreement among critics, "the disagreement that occurs when two or more critics agree, or say that the work of a particular artist or group of artists is good or valuable or important, but when the terms in which they try to characterize the work and its significance are fundamentally different."

Describing himself as angered and stunned when he reads what seems to him "bad or meretricious criticism" praising work he admires, he states: "Indeed, I am surprised to find that I feel more desperate about what seems to me bad or meretricious criticism written in praise and ostensibly in elucidation of art I admire than I do about bad or meretricious art." Certainly one must agree with Fried that what is at stake in any serious critical discussion is nothing less than the critic's view of history. What ought to be questioned, however, is why Fried should feel such anger, frustration, and desperation, or, as he himself put it, why it should matter that much to him.

It matters, of course, because he is such a deeply committed critic. But beyond that, Fried explains that his desperation depends on "the conviction that, in the criticism of which I'm speaking, the terms in which certain paintings are described and certain accomplishments held up for admiration are blind, misleading, and above all *irrelevant* to the work itself and to the difficult, particular enterprise by which it was created." He imputes to such blind critics an inability to see what qualifies the works in question as paintings and an inability to understand the identity of their creators. He goes on to characterize the "openness and tolerance and humaneness and distrust of extremism of all kinds" on the part of such critics as reflective of the "values of bourgeois liberalism," values which "amount instead to nothing more than promiscuity and irresponsibility verging on nihilism."

Fried is not content, in other words, to discredit his opposition. He feels called upon to annihilate it in a manner that is familiar to anyone who has read Marxist political writings. Such polemics charge the opponent with "ideology." They attempt to destroy opposition on the grounds that no discourse is possible because the opponent is not representing the same world, that in fact the entire edifice on which his thought rests is determined by class values. In other words, the bourgeoisie cannot understand the proletariat because the bourgeois thought

structure and worldview is rooted in an ideology determined by its economic position in the world.

By saying that certain critics are in the grip of a fundamentally divergent thought system, Fried is leveling at them a similar charge of "ideology." This is quite clear if we compare Fried's reasoning with Karl Mannheim's analysis of the concept of ideology (in *Ideology and Utopia*):

> . . . previously, one's adversary, as the representative of a certain political-social position, was accused of conscious or unconscious falsification. Now, however, the critique is more thoroughgoing in that, having discredited the total structure of his consciousness, we consider him no longer capable of thinking correctly. This simple observation means, in the light of a structural analysis of thought, that in earlier attempts to discover the sources of error, distortion was uncovered only on the psychological plane by pointing out the personal roots of intellectual bias. The annihilation is now more thoroughgoing since the attack is made on the noological level and the *validity of the adversary's theories is undermined by showing that they are merely a function of the generally prevailing social situation.* [Italics mine.]

For Fried, "the most important single characteristic of the new *modus vivendi* between the arts and bourgeois society gradually arrived at during the first decades of the present century has been the tendency of ambitious art to become more and more concerned with problems and issues intrinsic to itself." What this means for Fried is that art has become purged of all political content. More than that, it means that political content can actually work against aesthetic quality, so in fact it *must* be purged. Using Picasso's *Guernica* as an example, he writes that "in this century it often happens that those paintings that are most full of explicit human content can be faulted on formal grounds."

Paradoxically, the moment art is purged of political content coincides with the moment art criticism begins to focus on the issues of the "dialectic" of modernism and the "radicality" of specific painters. These clearly Marxist political terms gain respectability in a critical discussion because they have a certain art-historical pedigree: the art historian Heinrich Wölfflin had constructed a system of analysis on a Hegelian model that is the basis for Clement Greenberg's interpretation of modernism, on which Fried admittedly relies. That Wölfflin's cyclical progression was already superseded in the nineteenth century by a more

sophisticated evolutionary approach such as that of Alois Riegl seems to bother no one.

The periodic exhaustion and renewal of art through self-criticism that Fried, following Greenberg following Wölfflin, brings to contemporary art allows for an ideal of, as Fried describes it, "perpetual revolution." Politically, Trotsky's thesis of the permanent revolution, which a phrase like "perpetual revolution" echoes, split the socialist camp with which both Greenberg and Rosenberg were associated in the thirties. In the realm of art, however, particularly in the unfettered realm of pure abstraction, such an abstract idea can take on substance. Now it is possible to concentrate exclusively on the formal elements in a work, to the degree that Greenberg in a recent discussion of Picasso's *The Charnel House* did not feel called upon to mention, even in passing, that the subject was a death camp, or to consider the specific expressive qualities of the vocabulary of forms employed by Picasso in its representation.

The sublimation of political issues within an aesthetic context makes it possible to ignore (or even to begrudge) the political content of art. In Fried's case it even makes it possible to discuss critical issues with a sense of passion and outrage once reserved for questions of life and death. But art has never been a question of life and death, and to address to it the intensity and sense of urgency that should be reserved for questions of life and death is repugnant. It is true, of course, that art has already usurped religion as the refuge of the spiritual. Is it now to subsume ethics and politics as well? Even if that were possible, would it be desirable?

Fried's position is dangerous because it would extend the aesthetic to encompass systems of ethical and political *value*. Such a displacement of ethical and political values to the sphere of aesthetics has already produced inferior art. As a critical position, it threatens to deprive the aesthetic of its only real justification—the giving of pleasure, an aspect I do not remember Michael Fried referring to once. The exaltation of the life of the mind, in which political acts take place only in the imagination, and the "perpetual revolution," available only in art but never in life, permit precisely the accommodation with bourgeois liberalism to which Fried alludes in his condemnation of open-minded critics. His position here is based on a psychological projection: it makes it possible not for radical *art*, but for the radical *critic* to achieve a *modus vivendi* with bourgeois liberalism.

Art criticism dominated by an element of the disenchanted American left, led by Rosenberg and Greenberg, has managed to achieve a rap-

prochement with the society it once rejected. Traumatized by Stalinism, anesthetized by McCarthyism, and pacified by affluence, it has found a home, and a comfortable home at that, in art criticism. Although its excesses may be understandable as the excesses of a misplaced zeal, its transferal of the ideas of the active life to the context of the contemplative life constitutes a perversion of idealism.

II. PHOTOGRAPHY AND DEMOCRACY

Although their sources are identical up to a point—the paintings of the abstract expressionists in general and the work of Jackson Pollock in particular—two ideologically and aesthetically opposed currents are discernible in recent American art. One current, color abstraction, has been championed by Clement Greenberg as the "mainstream" style, the only legitimate heir of abstract expressionism, and by extension, of the School of Paris.

The common characteristics of post–abstract-expressionist color painting have been sufficiently evident to identify it as a coherent style. However, the common characteristics uniting "pop" and "minimal" art, which together make up the other polarity of American art in the sixties, remain to be distinguished.

I see pop and minimal as closely related in their connection with earlier twentieth-century American art and in their antagonism to "modernism" as a European or alien style. If we examine the statements and works of American artists, both past and present, we find that certain aesthetic prejudices consistently color American taste. The natural, the uncontrived, the immediate, the direct, the "honest," the physical, and the literal are not merely preferences of sixties artists. These are qualities constantly emphasized by American artists. In many respects, the "heroic" postures of the abstract expressionists went very much against the American grain. Pop and minimal attitudes toward the heroic—that it must be mocked or rejected—are far more characteristic of inbred American attitudes. The emergence in the sixties of native-born, largely non–East Coast, American artists signals not only a resurgence of these tastes and attitudes, but also an attempt to expunge any vestiges of the European tradition that might oppose or dilute their expression.

For the significance of Carl Andre's rock and brick accumulations or Robert Smithson's ironic epicene disquisitions on the beauties of Passaic, New Jersey, and the charm of airline terminals we must look back not

only to Dada and constructivism, but also to precisionism, a native art movement that has so much in common not only formally, but iconographically, with current tendencies.

While it is true that the forms of the precisionists were provincial simplifications of cubist volumes, their iconography had a very different source. Both Sheeler and Demuth frequented the home of Walter Arensberg, collector, bibliophile, and friend to itinerant Dadaists. Here they came into contact with Duchamp, who was a crucial influence on both—a fact Demuth at least publicly acknowledged. Duchamp's ironic acceptance of America in terms of the future as present, his own willingness literally to renounce the European past in order to live in that future—toward which he had a more than ambivalent attitude—provided an important example for the precisionists.

Formally, precisionism was vastly in advance of the other versions of American scene painting. Sheeler's and Demuth's determination to base art on what was authentic in the culture, rather than adopting forms and subjects inconsistent with their experience, took great courage in the face of the aesthetically impoverished quality of that experience. The precisionists were unlike other American scene painters in at least one important respect: they were determined to make art out of what was at hand, but they did not simply embrace the available. Instead they passed judgment on what they saw, isolating what was best about indigenous American forms—their cleanness, integrity, efficiency, and simplicity. These are qualities sought after by contemporary minimalists as well.

America, unlike Europe, is a country without real monuments, a country in which the historical consciousness developed late, too late to celebrate ideals that were no longer practiced. Precisionist attempts to convert the everyday into the monumental at best, or to locate the monumental in the everyday at least, also find echoes in pop art. Pop art responds to the tawdriness of American culture as it is reflected in films, newspapers, advertisements, and mass literature, making a fetish of the "secondhand" content-drained quality of these images. Minimal art responds to an equally important aspect of the environment: the American landscape, with its anonymous factories and water towers, and its painful absence of classical monuments. Minimal art is the last act in the drama of the conflict between the American landscape, itself heroic and monumental, and the demands of the absent monument, the man-made embodiment of these traditional classic ideals.

Faced with this disparity between glorious landscape and absent or

mediocre art tradition, many artists have made desperate attempts to reconcile the heroic with, on the one hand, the overwhelming grandeur of the American landscape, and on the other, the overwhelming banality of much of the democratic experience. Deprived of a classical tradition, American artists have often attempted to create something positive out of the local culture, without falsifying it with a European veneer.

The precisionists, following Duchamp's lead, were the first American artists to proclaim that *what* you looked at did not count as much as *how* you looked at it. The importance of photography to the precisionists is related to this search for the classic in the everyday. Only a photograph can make the inside of the Ford Motor plant the equal of Chartres cathedral. A photograph is the great equalizer: it can transform any subject, no matter how banal, into a classic formal arrangement. Moreover, it can do so without denying the significance or identity of the subject. In a photograph, formal and subject meanings can have equal value; and the abstract must remain indivisibly wed to the concrete.

The number of photographs—of earth projects, sites, parking lots, rubbish heaps, and other typical local "monuments"—currently being made by Americana artists does not indicate any burning interest in photography as such. Rather it reflects the stubborn determination to deal with basically unaesthetic material aesthetically, while simultaneously flaunting its unheroic true identity. These photographs represent "found monuments." They project Duchamp's object-matrixed aesthetic beyond the gallery and the museum into the total environment. Their double-edged attitude toward their subject is but another instance of the American regret that there is nothing to remember. Smithson with his camera in New Jersey is only illustrating the nostalgia of the pop refrain "Is it Granada I see or only Asbury Park?" Ed Ruscha's remarkable series of classic gas stations, archaic parking lots, and spartan Los Angeles apartment houses have some undeniable poetry, but they, too, reflect a similar cutting irony with regard to their subjects. These "found monument" photographs, earth sculptures, desert indentations, et al., are the literalist equivalent of the American scene.

Such a search for meaning within the American context was more intelligently pursued by the precisionists than by their opposite numbers, the regionalists. Thomas Hart Benton lost himself in a misunderstanding of the baroque, but Sheeler discovered the purity of Shaker furniture and utensils and was able to base his art on their integrity of design. Today, Robert Morris echoes Sheeler when he explains the preference for rec-

tangular forms in recent object art: ". . . it [the rectangle] stands as a self-sufficient whole shape rather than as a relational element. To achieve a cubic or rectangular form is to build in the simplest, most reasonable way, but it is also to build well." The "reasonableness of the well-built," as Morris terms it, becomes an end in itself—as the functional design of Shaker objects was for Sheeler an acceptable, in the sense of humble and unpretentious, classicism.

The notion that American art should be "self-sufficient," like the good pioneer individualist, and humble, like common objects, barns and factories, permeates American art on many levels. Early in the century Robert Henri described how he loved mechanical tools because "they are so beautiful, so simple and plain and straight to their meaning. There is not 'Art' about them, they have not been *made* beautiful, they are beautiful." Henri's fascination with the contents of hardware stores has been carried to its logical extreme in minimalist appropriations of standard manufactured units that travel the route from Canal Street to Fifty-seventh Street with astonishing rapidity.

Indeed, one might go so far as to interpret the current widespread use of standard units, "self-sufficient" nonrelational forms and nonhierarchical arrangements of equal members, as a metaphor for relationships in an ideally leveled, unstratified anti-elitist democratic society. Precisionism and New York Dada, like pop and minimal art, are a recapitulation of certain of their common attitudes, particularly toward heroic subjects and the complex, often misunderstood relationship of American art to the European tradition.

Extending art beyond the object, attempting to take an affirmative, if ironic, view of the American scene, presupposes that untransformed piles of dirt, rocks, and bricks are beautiful. Beauty is, in this case, literally in the eye of the beholder. The artist's intention is not necessarily to destroy art (although one ought not to write off that possibility) but to make art the property of Everyman. The gift of the artist to his audience in this case is no longer a unique object that can only be owned by the rich and powerful or buried in museums, but *a way of seeing*. The reduction of aesthetic means to standard industrial modules invites Everyman to become an artist as well, since the means are now equally at the disposal of all. If I like a Dan Flavin well enough, I can go downtown and buy my own fluorescent tubes. When art and work both finally concern decisions rather than skill or labor, the possibilities of the creative life are unlimited. The question of whether everyone should be educated may well be supplanted by the question of whether everyone should be an artist.

III. CHAOS AND ENTROPY

If the pragmatic method is, as William James describes it, "the attitude of looking away from first things, principles, 'categories,' supposed necessities; and of looking towards last things, fruits, consequence, fact," then a pragmatic criticism might begin by examining the consequences of current artistic activity. To begin with, we might list a number of current art objects, or more precisely nonobjects:

— arrangements of identical units that exist as an art object only when assembled as such in the proper context (Andre)
— a room full of dirt (De Maria)
— a pile of dirt, grease, and metal odds and ends (Morris)
— a grave-size ditch in Central Park (Oldenburg)
— written descriptions of nonsites (Smithson)
— projects for rearranging the surface of the earth (Morris, Heiser, Oppenheim, De Maria, et al.)
— proposals for the erection of nonexistent monuments (Oldenburg)
— piles of folded felt (Kaltenbach, Morris, Le Va)
— floors and walls of gallery covered with graphite chalkings and sweepings (Bollinger)
— Drawings penciled onto gallery walls (Lewitt)
— paintings stapled to gallery walls (Gourfain, Ryman)
— works for sale for the price of materials or labor (Morris, Andre, Lewitt)
— loose piles of chemicals (Saret, Heiser)
— blown-up statements regarding the nature of art (Kosuth, Baldessari)
— the gradual removal of strips of curved plastic from a vacant lot (Levine)
— a "sculpture" made of steam (Morris)
— photographs, documentation, description of nonexistent "work" (Barry, Heubler, Kosuth, Ruscha, Smithson, et al.)
— a standard Air Force dye marker thrown into the sea (Weiner)
— paint sprayed directly onto floor (Serra, Weiner)
— limp piles of materials, randomly distributed (Morris, Serra, Saret, Hesse, Le Va, et al.)
— trenches dug in the desert (De Maria; collection R. Scull)
— ditches dug in driveways (Weiner; collection Mr. and Mrs. Robert M. Topol)
— a series of ellipses scattered throughout the Whitney Museum (Artschwager)

— a label on a bench at the Whitney Museum identifying it as an art
work (anonymous)

We may best test the intention of art "works" such as the above
perhaps by considering their practical consequences. What is the out-
come, we may ask, of conceiving an "art" not dependent on the creation
of objects or discrete material entities? Denying that art is a trading
commodity with measurable intrinsic quality translatable into real value
erodes the very foundation of the art market. By making immaterial,
ephemeral, or extra-objective work, the artist eliminates intrinsic quality.
This challenges not only the market mechanism but also the authority
of the critic by rendering superfluous or irrelevant his role of connoisseur
of value or gourmet of quality.

If criticism is going to exist at all in relation to this art—and whether
it should is a real question—then it can no longer function as *gourman-
dise* or *Fingersputzengefühl,* but only as a form of heightened sensitivity
or perception. Perception, however, must precede evaluation, as opposed
to being pursuant to it, because to be a true measure it must proceed,
not from an idealist base of fixed absolutes and mechanical theories, but
from pragmatic considerations of intention, effect, and concrete conse-
quence in practice and experience. Criticism must reorient itself at this
time because younger artists are responding to a new worldview that
holds far more in common with pragmatism than with idealism. In place
of metaphysical absolutes, compartmentalized essences, and abstrac-
tions, the new art, like pragmatism, focuses on use, function, and behav-
ior, both perceptual and experiential.

The reaction of many young American artists against the rigidities and
proscriptions of an idealist aesthetic was anticipated by John Dewey's
own rejection of Kant. Before today's revolutionaries saw formal criti-
cism as the cornerstone of the market mechanism they despise (could
Marx have foreseen that art would be one of the commodity staples of
late capitalism?), Dewey was taking Kant apart, implying that Kantian
idealism was tied to a specific set of social, political, and economic
factors. In *Art as Experience,* Dewey wrote: "The compartmentalized
psychology that holds to an intrinsic separation between completeness
or perceptual experience is, then, itself a reflection of dominant social
institutions that have deeply affected both production and consumption
or use."

For today's pragmatists, as for Dewey, the aesthetic is differentiated
from ordinary experience in that the latter is typified by apathy, lassi-
tude, and stereotype, where art provokes attention, interest, and vari-

ance. We have seen that the pragmatic focus on art as a kind of human activity rather than an ideal category with norms of decorum provides a point of departure for new aesthetic attitudes. That such a view meshes perfectly with Duchamp's notion of art as defined by context and completed by the spectator's response makes pragmatist aesthetics that much more apposite today.

Dewey's original objections to Kant are equally relevant at this moment. "To define the emotional element of aesthetic perception merely as the pleasure taken in the act of contemplation independent of what is excited by the matter contemplated, results . . . in a thoroughly anemic conception of art," he wrote in an early attack on idealism. The bridge connecting Dewey and Duchamp, or more simply, pragmatism and Dada, is an odd one, but it is increasingly well traveled. Its keystones are Cage, McLuhan, Fuller, Norman O. Brown, and, most recently, Morse Peckham. In *Man's Rage for Chaos,* Peckham implies that the purpose of art in the technological society will be the same as that of art in earlier societies: to provide what life does not. Pursuing this argument, however, he concludes that what will be missing in life will not be control, order, and rationality, but release, disorder, variation, and spontaneity. For Peckham, art is a "rehearsal" for life situations, and an art based on disorientation, chance, randomness, innovation, and ingenuity is the best teacher of adaptive behavior. Such a conception assumes a primarily didactic, although not necessarily moralizing, function for art, placing us back again on the favorite terrain of American artists, who have felt so often that art must transcend the "merely" aesthetic to inform experience more directly.

Given this kind of definition, the primary role of art shifts from self-expression or decoration to disinterested imaginative play. Until recently, the notion of imaginative play in art was more or less linked to the play of images. The abstract expressionist use of automatism extended play to form. But the new art demands an even larger area for the free play of the imagination, one that extends beyond objects to a series of possibilities, alternatives or hypotheses which may remain mere speculation. Given this, the application of absolute, invariable, nonrelative criteria developed by formal critics from idealist aesthetics must inevitably fail to deal with quality differentiations in an art predicated on variability and discontinuity. The critical criteria for such an art obviously are not the adherence to categorical imperatives, but the variety of experiences and the range of imaginative play offered.

Dewey's rejection of Kant's "ivory tower" definition of Beauty as remote from all desire, action, and stir of emotion in favor of an aesthetic

response integrated into life, dealing with acts, decisions, and experience, is seeing its fulfillment today. The recrudescence of certain fundamentally American attitudes toward art would not in itself be remarkable were the context and form of their reappearance not unexpected, to say the least.

Once Harold Rosenberg established that art consists mainly in the *act*, the gesture, rather than in the completed object, an art that went beyond the object in the direction of pure gesture was but a step away. This step was taken by Rauschenberg, the first artist to create an art combining elements of painterly abstraction and pure gesture, an art that sought to present itself in terms not analyzable by means of the conventional criteria for quality. Rauschenberg initiated the aggressive assault against such criteria in the mid-fifties by erasing a de Kooning drawing, subtracting from the original "masterpiece" where Duchamp had added to a reproduction of one. His telegram to the Parisian dealer Iris Clert announcing that "this is a portrait of Iris Clert if I say so" was conceptual art *avant la lettre.* In 1957, he duplicated the "spontaneity" of an action painting in *Factum I* and its nearly identical twin replica *Factum II.* Rauschenberg questioned the status of the masterpiece, the uniqueness of the art object, or even the necessity for making objects. His "earthwork," a painting with a patch of sod on its surface, was the first New York statement about process. The notion of a mutable work of art had been posited earlier by Duchamp, but it was not tested by American artists until Rauschenberg became interested in such a possibility.

In the sixties, the principal artists involved with such extra-objective considerations have been Andre, Morris, and above all, Oldenburg, whose projects for monuments are the source for most of the recent examples of pure theoretical propositions. Andre's projects for earth sculptures for Philip Johnson and Betty Parsons, although unexecuted, were widely discussed in the art world in the mid-sixties. His public gesture of eating a five-dollar bill at the Cedar Bar had been a scandal of the late fifties. Robert Morris's documents changing the status of works of art by fiat were equally common currency. Walter De Maria also used documents and proposals at an early date.

Environments were explored first by Kaprow, Oldenburg, and Dine from 1958 to 1960 in an expressionist form. In the mid-sixties, Morris, Flavin, and Andre changed the inflection from expressionism to constructivism and created abstract environments. Andre stacked and piled beams in 1961. Oldenburg began making soft sculpture "composed" by

gravity in 1962. From these sources, the vast proliferation of environ-
mental art, antiformal art, earthworks, project art, and site and nonsite
proposals that are the latest wrinkle on the art scene developed.

That there is art that does not traffic in objects but in conceptions has
both economic and political consequences. If no object is produced,
there is nothing to be traded on the commercial market. This conse-
quence defines the intention of current antiformal tendencies. The artist
does not cooperate with the art market. Such noncooperation can be
seen as reflective of certain political attitudes. It is the aesthetic equiva-
lent of the wholesale refusal of the young to participate in compromised
situations (e.g., the Vietnam War). But work which cannot be absorbed
by the museum-gallery patronage situation still needs an audience to
exist.

The perfect audience for any kind of art aimed at creating a series of
novel encounters is, of course, the media. The intention of a good deal
of art being done now—to disrupt or frustrate expectations, to create
situations forcing new types of psychological or perceptual adaptation,
above all, *not to repeat itself*—is, however, inevitably distorted by the
media. For the single critical criterion of the media is *newsworthiness.*
Whether the news is good or bad, trivial or portentous, is irrelevant.

The relationship of the mass media to art today is the great differen-
tiating factor between the current situation and earlier Dada antiformal
manifestations. This relationship is compromised because the media
must distort as it transmits. To take specific examples, the original intent
of pop art was not an unqualified celebration of the American Dream,
yet interpretation and media presentation soon neutralized any kind of
critical or satirical charge pop may have intended. Now conceptual and
process art, originally motivated by moral revulsion against the baseness
of American society, has also been quickly assimilated into the existing
structure. Its original negative stance has become diffused. It is utterly
robbed of any critical sting.

The advanced state of permissiveness that now exists concerning art
is largely the result of media acceptance and coverage of radical art as
the latest high-rating novelty. Media approval of radical art rang down
the curtain on the social institution of the avant-garde as a coterie club.
Media coverage made art public once more, integrating it into the social
structure. But media participation in art creates a situation in which
would-be radical artists are left stranded: even if they can make art
sufficiently far out to exceed the museum-gallery context, they can't
come up with anything unacceptable to the media. The media as pri-

mary audience has its advantage, it allows the artist to speak directly to the mass public without recourse to the screening process of critics or cultural institutions. This situation corresponds to Buckminster Fuller's metapolitics, by means of which political change is seen as issuing inevitably from the interaction between the information media and technology, both of which are independent of political institutions, even if they are not independent of politics. Thus we arrive at a situation in which the artist may erode existing cultural institutions by overriding their authority and going straight to the media. This tactic was Andy Warhol's greatest success.

The futurists demanded the destruction of the museums. There is no need now to burn the museums. You can just ignore them, since they follow rather than lead the media. The media audience, unlike the museum audience, does not need objects. It can be fed with fantastic ideas, theoretical propositions, and unrealizable projects. Art of this nature could not exist in fact without the media audience, which presents the possibility of an entirely immaterial art, which seeks to subvert traditional art and its institutions. Undoubtedly the role of art in earlier cultures, the *ancien régime* for example, was equally compromised. However, the artist who worked within such cultures first of all shared its dominant values, no matter how frivolous and materialistic. The constant awareness of how art is being abused and manipulated by mass culture, however, haunts the contemporary artist, who simply cannot feign ignorance of the destiny of his work as a blue-chip investment.

It is obvious that the art I have described, constantly reactive to political, social, and environmental as well as aesthetic factors, defying absolutes and fixed definitions as well as traditional forms and standards, does not aspire to achieve transcendence. By definition, it cannot be timeless and immortal. The willingness to renounce aspirations of timelessness and immortality posits an entirely new worldview, one which shifts cultural values from a death-oriented, commemorative, past-enshrining culture to a life- and present-oriented civilization with a taste for the immediacy experienced in a temporary art consumed as it is created. In this sense, Oldenburg's monuments do represent, as he has contended, not the appearance of something, but its disappearance.

The tomb, the memorial, the shrine, the monument all belong to cultures that commemorate. There are no modernist examples of these forms worth mentioning. To make an art that is programmatically and not just incidentally of the moment indicates far more than a search for mere novelty. It signifies an attempt to create an art as fragile, as

unpredictable, as fugitive, as pulsating, and as responsive as life itself. This desire is better expressed in the performing arts, but that does not mean it will not continue to be expressed visually.

The current efflorescence of ephemeral art is the second stage in the secularization of art, of which Marcel Duchamp was the prophet. The initial secularization of art coincided with the beginning of modernism, itself an indication that religion could no longer compel conviction. The religious images of Manet, Cézanne, Gauguin, and van Gogh, to name the most prominent examples, are eloquent testimony to the acuteness of the crisis provided by the discovery that "God is dead."

One of the fundamental assumptions of modernism is that *art* can replace religion as the repository of the spiritual and the bearer of moral conviction. The origins of abstraction itself are shrouded in mystical speculation. Art becomes acutely conscious of the ineffable, the mysterious, and the transcendental—above all of its own need to compel conviction—at precisely the point when religion can no longer do so. Of the assaults we are currently witnessing—against critical authority, against existing institutions, against the notion of art as private property—the revolt against modernism as the religion of art is, I believe, the most significant, the most profound, and possibly the most enduring. We are witnessing the demythification of art and the desanctification of the artist, as art is brought down to earth and forced to approximate more and more closely the mundane world of nonart.

The artist who does not create, but who chooses from the preformed refuses to play God: he is no hero-creator, but a common man among men. The only difference between him and the man in the street is that he has found a self-proclaimed identity. Art is not a mystery but a fact. It may have content, but that content is not absolute, not transcendent, above all, *not spiritual.*

Both the complexity and the genuineness of the current crisis, which is above all a crisis of *belief,* are evidence of further cultural fragmentation. The present split between "revolutionary" function and "radical" form constitutes yet another step in the decomposition of modern culture. Chalked, sprayed, penciled, or stapled to gallery interiors, art is literally, figuratively, and symbolically up against the wall, like everything else in this society. The "revolution" challenges elite art, while the traditional forms themselves are petering out or at best desperately hanging on, poised between the easel convention and a full-scale decorative mural style demanding an architectural context. The agony of criticism is the necessity of maintaining full consciousness while not flinching at the

truth. And the truth is, we are not going to see the "return" of this or that or the other thing, nor possibly the survival of much of our own tradition. There are, in fact, many indications that art, or at least art of any spiritual depth, is, for the mass of humanity, if not for the surviving "happy few," about to follow religion as an illusion without a future.

THE MYTH OF POLLOCK AND THE FAILURE OF CRITICISM

As photographed by Hans Namuth in the heat of the moment of creation, Jackson Pollock projected superhuman energy, a kind of animal magnetism. These photographs of Pollock working do not conform to the style of the artist's portrait or the studio interior. They are related to the style of motion photography used in photographing wild animals unconscious they are being observed. For it was Namuth's brillance to make himself invisible and "stalk" his subject. Pollock, totally immersed in his own trancelike activity, was oblivious to the repeated click-click of the high-speed film that permitted Namuth to capture his spontaneity in images that freeze the artist's frenzied movement into a blur of urgency. In these remarkable and daring photographs, Pollock's rhythmic gesture finds a perfect analogue: the man could no more be physically pinned down by the machine than his paintings can be made to assume static patterns by vision whose normal tendency is to perceive legible shapes.

In picturing the artist in the grip of impulse, driven by inner forces, Namuth, following his own unconscious intuition, provided the material necessary for the creation of a cultural myth of the artist as an inspired shaman, entirely "other" than the pedestrian businessman who dominated American social life. Given the historical context within which they were made, these photographs were destined to have profound reverberations. Eisenhower had become President but he had ceased to be a hero, although the appetite for heroes had not died with the end of the war. In the immediate postwar period, the American people were understandably casting about for heroic figures to fill the shoes of those who risked their lives in combat. With no suitable political figure such

as de Gaulle to fill the void, the country was ready—for the first time—to acclaim a culture hero, with of course the ambivalence that marks the businessman's attitude to culture.

In this context, the publication and diffusion of Namuth's photographs of Pollock was especially propitious, for they provided an image of an artist so novel and remarkable that even an expert such as Steichen could not recognize them within the convention of artists' portraits. First published early in 1951 in *Portfolio,* a short-lived review edited by Franz Zachary and Alexei Brodovitch, art director of *Harper's Bazaar* and Namuth's teacher at the New School, Namuth's photographs of Pollock at work received broader circulation in May of that year when *ARTnews* published a series of black-and-white photographs illustrating "Pollock Paints a Picture" by Robert Goodnough. On June 14, 1951, the Museum of Modern Art screened the color film of Pollock painting. From that moment, the images of Pollock in action attached themselves as additional meanings to his works to a degree that they began to color the perception of his paintings, which remained for most people, including artists and critics who admired their obvious energy and daring, largely incomprehensible.

The initial response of the art world's reception of Pollock photographs was felt in an article published the following year in *ARTnews,* Harold Rosenberg's essay "The American Action Painters," which gained world fame as the manifesto of abstract expressionism. I recall being puzzled by the article when it was republished in a collection of Rosenberg's writing titled *The Tradition of the New* in 1959. Although it was obvious that Rosenberg was talking about something, I could not identify his subject as painting, and for good reason. According to Rosenberg: "At a certain moment the canvas began to appear to one American painter after another as an arena in which to act. . . . What was to go on the canvas was not a picture but an event. . . . A painting that is an act is inseparable from the biography of the artist. The painting itself is a 'moment' in the adulterated mixture of his life. . . . The act-painting is of the same metaphysical substance as the artist's existence. The new painting has broken down every distinction between art and life."

In retrospect, I realize Rosenberg was not talking about painting at all. He was describing Namuth's photographs of Pollock. All the metaphors were decipherable from the photographs: Pollock attacking his canvas spread out on the floor in front of him like a boxing ring or a bullfighting arena, with paintbrush extended aggressively, in the manner of banderillas—Pollock pictured alone, isolated from any frame of reference save his own creation, which obviously dwarfed and engulfed him—

what images could more poignantly conjure up a literary vision of the existential hero?

By the late fifties, Namuth's photographs had been sufficiently reproduced and circulated and the film screened widely enough to provide an alternative to dealing with the difficulty of Pollock's painting, in the face of which critics grew mute. Even Clement Greenberg, falsely credited with discovering Pollock—a distinction that belongs to John Graham— had little to say beyond asserting Pollock was great and radical. Greenberg's most penetrating discussion of Pollock in *Art and Culture*, his collected essays published in 1961, consists of a brief description of Pollock's relationship to cubism in "American-Type Painting." Although Greenberg was said to be working on a more extended study of Pollock, his only further publications on Pollock were two short articles, one dealing with the impact of Pollock's death on the art market, and an article in the April 1, 1967, issue of *Vogue* on the occasion of the Pollock retrospective at MOMA. Illustrated by the requisite Namuth photo, a close-up of Pollock clearly pouring as opposed to "dripping" paint, the article was Greenberg's last attempt to come to terms with the artist he considered "in a class by himself."

Greenberg was hardly the only critic to find it difficult to write about Pollock. Indeed, the state of Pollock criticism, as opposed to Pollock scholarship, which in the hands of William Rubin and Francis V. O'Connor has made substantial progress, has hardly altered since Donald Judd, dumbfounded by the grandeur of Pollock's accomplishment, complained: "It would take a big effort for me or anyone to think about Pollock's work in a way that would be intelligible." It was obviously an effort Judd was not willing to make. Judd's article, also published at the time of the 1967 MOMA retrospective, and illustrated by a full-page Namuth photo of Pollock working as well as a clip from the film, is an amazing document, as full of hostility to art critics as it is of monosyllabic admiration of Pollock's singular achievement. A final assault on criticism, the Pollock article was one of Judd's last sorties into that detestable activity. In it, Judd accurately summed up the state of Pollock criticism:

> Not much has been written on Pollock's work and most of that is mediocre or bad. . . . Bryan Robertson's book, published in 1960, is the only large one on Pollock; its text is useless. Whatever is accurate is factual and appeared earlier in Sam Hunter's short preface to the catalogue of the Museum of Modern Art's first show of Pollock's work in 1956–57 and in various reviews and general articles. There are only a couple of articles on Pollock, one in 1957 by Clement Greenberg. The rest of Robertson's

book is wrong in one way or another, usually just glibly wrong. Frank
O'Hara's small book, published in 1959 in the Braziller series, has the
same biographical and received information as Sam Hunter's preface,
some baloney and no real thought.

In this article, written as Judd was about to give up criticism for good
to devote himself to his career as an artist, he maintained that "art
criticism is very inferior to the work it discusses." Two years earlier, Judd
had written a widely circulated essay, "Specific Objects," that expressed
a disgust with the limits of painting as an illusion and a preference for
literal space, shapes, and materials that came to be characteristic of the
sixties. Here Judd asserted that "a work needs only to be interesting,"
a remark that announced the refusal to make distinctions in quality that
is the essence of art writing of the last decade.

Although he did not claim to speak for others, Judd's stance was
typical of the attitude of those artists who assumed that Pollock's paint-
ing could not be either critically assimilated or artistically superseded—
that it was the *ne plus ultra* of what could be made with paint on canvas.
Stained-color-field painters had sorted out an element in Pollock's tech-
nique that could be used to resolve the problem of how to keep different
colors from creating a spatial illusion related to cubism; but "minimal"
artists, who are really better termed literalist artists, took Pollock's use
of actual materials—glass, pebbles, wire, etc.—to suggest an art that was
completely literal and entirely anti-illusionistic. Again, Namuth's photo-
graphs of Pollock working were critical means of communicating infor-
mation. They showed the artist working on the floor, with canvas appear-
ing as unstretched fabric, suggesting to some artists that the stretcher
itself was unnecessary.

Judd was central to spreading a literalist interpretation of Pollock, but
the origin of the attitude that Pollock signaled the end of painting is
actually an essay by Allan Kaprow, "The Legacy of Jackson Pollock"
(*ARTnews*, October 1958). According to Kaprow, Pollock "created
some magnificent paintings, but he also destroyed painting. . . . With
Pollock the so-called dance of dripping, slashing, daubing and whatever
else went into a work, placed an almost absolute value on a kind of
diaristic gesture." Looking at photographs of an artist aggressively ges-
ticulating in a paint-splattered studio that was the total antithesis of the
tidy studio and disciplined activity of an easel painter like Masson,
Kaprow spoke for an entire generation of younger American artists to
whom surrealism meant little, but who yearned for revolution and spon-
taneity in a drab, repressed gray-flannel era. To Kaprow, Pollock was "the

embodiment of our ambition for absolute liberation and a secretly cherished wish to overturn old tables of crockery and flat champagne. We saw in his example a possibility of astounding freshness, a sort of ecstatic blindness." What Kaprow saw, in other words, and I suspect he saw it in Namuth's photographs and not in Pollock's deliberately controlled paintings, was the possibility of uninhibited acting out—catharsis through art. Later, in *Environments, Assemblages and Happenings,* published in 1966, Kaprow underlined the debt of the happening and environmental artists to Pollock. He included two Namuth photographs of Pollock, one of the artist surrounded by his gigantic canvases titled *Little Man in a Big Sea,* faced by a photograph of Kaprow himself lost in an environment of rubber tires, presumably a three-dimensional equivalent of the rubbery loops of paint in a Pollock.

In another photograph from that book of Oldenburg in an early happening, *Snapshots from the City,* the inspiration of Namuth's images of Pollock at work is equally obvious. More sophisticated and certainly more artistically gifted than his contemporaries, Oldenburg was the only "pop" artist to think seriously about Pollock and to derive his conception of his store reliefs as fragments ripped from a mural by Pollock rather than from Johns's *Flag,* the prototype for the rest of pop. Oldenburg's appropriation of randomness as a new element in sculpture was derived from an analysis of Pollock's technique, which is documented in notebook entries about Pollock, the only artist for whom Oldenburg has no critical words, as well as in several drawings done in imitation of Pollock's fluid style. Always sensitive to the moment, Oldenburg felt Pollock's paintings receding in a culture dominated increasingly by reproduction and secondhand experience. In the *Bedroom,* an environment of 1967, Oldenburg mocked the assimilation without comprehension or experience of Pollock's work by framing a piece of printed textile, a vulgar commercial adaptation of Pollock's image, as a motel decoration.

1967 was a turning point in art, as the minimal styles fell apart into distributional, antiformal, anti-illusionist, conceptual, process, or body art. All these subcategories I believe were inspired by the larger-than-life blowups of Namuth's Pollock photographs that accompanied the 1967 MOMA retrospective. In these impressive images, the artist merged with his art. Paint often looked like scattered objects on the floor. This stimulated Carl Andre, Barry Le Va, Robert Morris, et al., to conceive of environments in which materials were placed in random arrangements on the floor. Soon, a raft of performance and "process" artists could think of documenting the process of making as an end in itself that did not require the final act of producing an object that

could be judged. All that was required by the audience was an "interesting" experience. I thought of those acts made in the name of art that did not produce an object as expressions of contempt for the art market; more and more it seems to me they were and are an attempt to avoid critical judgment.

In refocusing the act of art on the artist as actor instead of maker, the art of the late sixties and seventies was indebted to Namuth's widely reproduced photographs of Pollock. The photographs, with their focus on the act of art, became a way of avoiding analyzing the consequences of Pollock's paintings as a culminating synthesis of the history of Western art. The actual paintings deliver little of themselves in reproduction. The photographs of the artist had a fullness of informational content that reproductions of the work lacked, and it was through reproduction that most people experienced Pollock. Available as the paintings themselves never were to every provincial and academic audience, Namuth's Pollock photographs and film affected a far larger audience than the paintings had. In reproduction, the relationship of work to personality becomes inverted: as the work loses its qualities of scale, color, surface, and facture through reduction and mechanical duplication, the personality of the artist begins to dominate, as conversely his own image is enlarged, blown up, or projected. The persona of the artist takes on a dimension greater than his works. This could not help but have a devastating effect on the generation of artists who matured in the late sixties and seventies, who, relieved of the burden of Pollock's art, have focused their energy on projecting a persona or self-image that could be as compelling as Pollock's media image.

More readily intelligible, more widely diffused, accessible, and available than Pollock's rare works, Namuth's photographs had a far greater consequence than anyone has understood in determining the course of recent art history. Only one other sequence of photographs is in any way comparable: Man Ray's portraits of Duchamp in various camp masquerades—as his drag alter egos *Belle Haleine* and *Rrose Selavy,* as the shaving-cream satyr on the phony Monte Carlo notes, as the wanted criminal on the ersatz police poster, and as the strategist in the mock war games of chess. If we study Man Ray's portraits of Duchamp, we note they have one thing in common: all are images of inauthenticity, of the artist as something other than himself, of the artist as an intellectual alienated from the physical processes of manual labor.

Both Man Ray's Duchamp and Namuth's Pollock are actors. Duchamp, however, appears in costume, disguised. His acts of art are committed in privacy, as if they were a covert crime or private perver-

sion. There is a distinct and deliberate disjunction, an almost paralyzing degree of self-consciousness regarding the artist's presentation of himself as something other than a worker. Duchamp's insistence that he never be pictured sweating or dirty relates to the initial Renaissance distinction between the liberal and the manual arts. It reflects Leonardo's assumption that painting was superior to sculpture because painting was a mental activity, whereas sculpture was messy and physical.

In Europe, the idea of the fine artist as a member of the professional class had taken root to such an extent that when Alexander Liberman photographed the leading members of the School of Paris for his classic book *The Artist in His Studio,* the bohemian beret and smock had given way entirely to the ascot, tie, and business clothes of the middle-class professional. In America, however, fine art was not recognized as a legitimate profession until the sixties, when art became an important element in the university curriculum and academic attitudes began to prevail among the artists. Art became more and more intellectual and conceptual, with the artist assuming more and more the role of industrial designer whose work is fabricated by machines or other laborers. In this climate of alienation, the photographs of Duchamp and Pollock gained even greater resonance as antithetical conceptions of the artist. For even as the artists took up Duchamp's cry for an intellectual art (unaware that Duchamp was secretly continuing his dirty habit of making art with his own hands), the images of Pollock, dressed in paint-spattered laborer's clothes, working in the oblivious absorption of primitive consciousness akin to the tribal artist creating his ritual objects, became articles of a haunting nostalgia for work as unalienated self-expression.

Man Ray's Duchamp impersonates roles rather than expressing an inner life. Namuth's portraits of Pollock as a tormented, agonized man, torn by self-doubt, the victim of an inner *Sturm und Drang* nakedly revealed in his contorted face, provided a necessary image of authentic feeling. The picture of the romantic genius, possessed by demonic *terribilità,* permitted an excited but naive public to turn to the myth of art to supplement the meagerness of its actual experience of an unfamiliar expression with no precedent in the tradition of American Judaic-Protestant iconoclasm.

However, although painting had no place as icon within the American tradition, photographs—specifically photographs of movie stars which served as domestic and public votive images—did. Namuth's pictures of Pollock were perfectly assimilable to this tradition because Jackson Pollock coincidentally looked the part the public needed him to play. George Segal's reaction to Namuth's photographs was typical:

I had an image of Marlon Brando's brooding pouting profile looking down while Stella ripped his tee-shirt from his sloping shoulders with gouging fingernails. But Pollock's creased forehead in his photographs intrigued me. He had the agonized look of a man wrestling with himself in a game of unnameable but very high stakes. I was reeling under a barrage of words when I first saw Pollock's paintings. The words said, You can't talk about me. You can't explain art.

As I reevaluate art of the recent past and the way it has accommodated Pollock's myth and image to avoid confronting his artistic achievement, my respect for those painters who did not lay down their brushes in a desperate attempt to make a photographic image literally more powerful than Pollock's paintings grows. To place Namuth's photographs back where they belong, in the history of photography where they have a significant position, is to return to the problems of painting Pollock left unresolved in 1956.

DOCUMENT OF AN AGE

■

Kunst ist überflüssig—"art is superfluous"—is the motto of the most important exhibition of the aesthetics of the seventies. Now attracting droves of cognoscenti to the remote West German town of Kassel, Documenta 5, fifth in a series of international art fairs held in Kassel museums every four years, has replaced the moribund Venice Biennale as the focus for summer art shenanigans. Perhaps the most striking feature of this year's Documenta is that it has almost nothing to do with works of art. Taking the exhibition's title literally, Harald Szeeman, the brilliant Swiss curator who organized the show, chose to ignore painting and sculpture almost entirely to produce a documentary survey of the current status of art as social activity. By so doing, Szeeman has become the greatest conceptual artist in the world, assimilating the activities of what purports to be today's avant-garde to his own ends. He and his associates have created the only great work of art in the show, a monstrous superdocument, the Documenta catalogue, in which every strategy and ploy of the contemporary artist to remain outside of society and critical of its institutions is proved useless, as these activities are categorized, indexed, and integrated into the existing social structure and its cultural institutions.

A masterpiece of Teutonic pedantry, the catalogue's format resembles the Yellow Pages. It weighs over ten pounds, and has to be carried by the handles of its plastic slipcase. On the cover, a swarm of insects calls to mind the putrescence indicative of the death of a culture. This sense of decay is implicit in page after page of evidence of the pathology and alienation of today's avant-garde. Every kind of abnormal behavior has its place at Documenta: narcissism, megalomania, sadomasochism, necrophilia, etc. In a section titled "Personal Mythologies," a number of artists exhibit themselves as works of art. Gilbert & George, the English

"living sculptures," sing deadpan popular ditties, looking like animated store-window dummies. Their alienation from spontaneity and feeling illustrates the spiritual vacuum of contemporary consciousness. In another room, Joseph Beuys, Germany's most original and serious artist, known for his disturbing performances and environments evoking concentration-camp imagery, harangues the public to join his political party for a participatory democracy. But the artist who best exemplifies the relationship of today's avant-garde to contemporary society is Frenchman Ben Vautier, who lies asleep on a platform with a sign reading, "I am ashamed to be here showing myself off for glory so I have taken sleeping pills. Do not wake me."

It is evident that these artists hate themselves for participating in a society which, they feel, thrives on bad faith, human exploitation, and cultural consumerism. In acting out this self-hatred by exhibiting their feces, masturbating in public, and mutilating themselves (all this happened in New York galleries last season, lest you think I'm talking about European perversions), artists demonstrate symptoms of severe pathology. But abnormal behavior on the part of the avant-garde is no news. The rupture between art and society precipitated by the coming of the industrial age, accompanied by loss of faith in conventional church/state authority, created a situation of open hostility between artist and society. To act with any conviction, the artist was forced into forms of behavior unacceptable to middle-class norms. That art must exist in opposition to bourgeois values was the accepted morality of the avant-garde until fairly recently. The effect of the media interest in cultural affairs completely transformed the relationship of art to society by applauding every effort of the artist to *épater le bourgeois* as "news." Because of media attention, a mass public became aware of art as sensation. The artist in return began to have delusions of grandeur regarding his capacity to affect society, and art was once more brought inside as opposed to outside a social context.

The question is, what kind of society is it inside of, and what function does it have within such a society? The conclusions one must draw from the immense supply of data accumulated at Kassel are depressing indeed. That Documenta is capable of assimilating the most outrageous and overtly deranged behavior dramatized the role of the museum as an instrument of cooptation. Nothing, it appears, can escape the murderous capacity of our cultural institutions to assimilate through acceptance any kind of protest—thus negating any critical thrust intended by the artist. The museum's role is spoofed at Documenta by Claes Oldenburg's Mouse Museum and Marcel Duchamp's *Boîte-en-Valise*. The Mouse

Museum occupies a room shaped like the head of Mickey Mouse, within which mass-produced popular objects, many of them toys and kitsch souvenirs, are displayed like precious objects in Cartier-type cases. Duchamp's "suitcase" is packed with miniatures of his works, including the celebrated *Fountain* by R. Mutt. The only dead artist represented, Duchamp haunts the exhibition as a kind of *éminence grise*, the originator of many of the attitudes expressed in the exhibition. Duchamp attempted to show *Fountain*, an ordinary urinal, in a 1917 exhibition to dramatize the point that we look at objects in a museum differently from the way we look at them in the world.

The seventies are haunted by Duchamp's aesthetic conundrums. He is hailed as the prophet of all the latest affronts on taste and values, from conceptual art, to body art, to earthworks, to ephemeral antiform. His point, radically condensed, is that modern society engages in the grossest hypocrisy by conferring the status of art on objects within museums, while ignoring the aesthetic impact of experiences, objects, and images *outside* the museum. Duchamp was far ahead of his time in realizing that the museum itself is an instrument of alienation conceivable only in a disintegrated culture where art does not serve a purpose as it did in every known human social organization except modern industrial society. He was, moreover, aware that mass culture and mechanical reproduction were radically altering the relationship of art to society.

Documenta picks up all these threads of Duchampian prophecy and knits them together into a thematic investigation of the relationship of Art to Reality. After seeing this Art-less exhibition, which is a kind of Disneyland as designed by Hieronymus Bosch, we have a better picture of the critical situation we find ourselves in. Ours is not the usual age of transition: it is the turning point between art and anti-art. From here, art can go in any of the following directions: (1) if everything we do is creative, then "art" *may* be superfluous; (2) if every man is an artist, a democratizing leveling will necessarily eliminate quality and excellence; (3) art will be robbed of any antagonistic critical dimension by assimilation through the media into the technological and post-technological information culture. In the best of all possible brave new worlds, there will be room for both the individual genius *and* participatory activity. Duchamp first suggested the possibility that art might be superfluous by posing the question: Is a urinal inside a museum a work of art? Documenta 5 indicates we may finally have an answer and that answer is: NO.

PROTEST IN ART

PUERILISM WE SHALL CALL THE ATTITUDE OF A COMMUNITY WHOSE
BEHAVIOR IS MORE IMMATURE THAN THE STATE OF ITS INTELLECTUAL
AND CRITICAL FACULTIES WOULD WARRANT, WHICH INSTEAD OF MAKING
THE BOY INTO THE MAN ADAPTS ITS CONDUCT TO THAT OF THE ADOLES-
CENT AGE.

J. Huizinga, *Salmagundi*, 1972

Because Dada reacted against bourgeois society and its culture in the
period just preceding, during, and after World War I, various anti-
authoritarian styles of behavior in America in the late fifties and sixties
have been variously labeled neo-Dada. Undoubtedly, direct connections
between happenings, environments, ephemeral art, and the like—cha-
racteristics of the American avant-garde—and Dada manifestations
exist. There are, however, crucial dissimilarities, especially with regard
to the role of antiauthoritarian behavior as an act of protest.

Beginning in the sixties the existence of an audience created a whole
set of new problems. Even initially, it was obvious that the permissive
attitude of this audience was evidence of bad faith. Thus by the time
the American avant-garde was forced into direct commerce, so to speak,
with an audience that was not itself, the original Dada impulse to *épater
le bourgeois* was no longer viable as a strategy of protest. For one thing,
the notion of shock is predicated on an idea of what normative behavior
might be, and even that standard was lacking in America. Something is
shocking only in relation to an accepted system of values. Here a system
of decorum had never been firmly enough established to create a code
of behavior with regard to which certain kinds of activities could be
considered shocking. There was, of course, one notable exception, and

that was the vestiges of sexual prudery left over even as late as 1960 from American puritanism. Whether American art helped inspire the sexual revolution, or whether it simply ran alongside it is a difficult question to answer. At any rate, we do see suddenly around 1960 a preponderance of taboo themes in American art. Lucas Samaras's plaster dolls (recently seen at the Whitney Museum) miming the positions of the Kama Sutra, George Segal's plaster copulating couple, Ed Kienholz's bordello, Oldenburg's overt sexual imagery, Wesselman's mammary fantasies (with their clear juxtaposition of female genitalia, breasts, and food) generated a certain excitement when they were originally exhibited. Today they seem almost prudish, reticent in comparison with ordinary popular entertainment. Porno movies, massage parlors, topless clubs, and the rest have forced the artists to look for categories other than the erotic for forbidden themes that might challenge conventional norms.

Inevitably the nature of the relationship of the avant-garde to its audience defines the types of protest available at any given time. When the audience has become as excessively permissive as the current American audience, there is no longer any act of aggression the artist can direct toward it, since these actions will not be interpreted as aggression but as mere diversion. The system of signaling has therefore broken down, largely as a result of the communications revolution, which neutralizes information and deprives both art and criticism of a role antagonistic to established culture. Through the media, aggression is transformed into harmless entertainment.

On one level, every stylistic change in the history of art may be viewed as an Oedipal confrontation. However, as the ruptures between generations become greater, and entire systems of values are at variance, the generational confrontation takes on a more and more violent character. All forms of rebellion are revolts against authority; but the degree to which this authority is held to be illegitimate becomes critical. The initial rebellion of the avant-garde in the nineteenth century took place within the context of a specific and generally understood discipline. How much classical academicism reflected the values of an entire social structure, its investment in ideals or hierarchical order, is revealed by the violence with which the questioners of these values were attacked by the public. They were jeered at, mocked, deprived of honors and status, deliberately impoverished, and forced to live as classless bohemians. When we read Manet's and Degas's letters, we realize how ill prepared the artist was for such rejection, and how much he continued to crave society's acceptance. For no mere stylistic change in the past had ever evoked such hostility from society at large. Therefore something greater

than stylistic change must have been at stake in these first manifestations of the modern spirit.

The equation of a disruption of the social order with a disruption of the cultural order was not the intention of the artists who originally caused these disruptions. Once cast out from society, however, they had no choice but to play the role of pariah which society had assigned them. Yet they never ceased suffering from rejection, for their goals were highly idealistic. It is at this stage of rejection, for example, that we get figures like van Gogh and Gauguin, tortured by guilt because of the discrepancy between the idealism of their intentions and the reception of their art by society.

Van Gogh's career as a missionary and evangelist testifies to the extreme idealism of his personality; as does Gauguin's religious iconography. Yet both ended as martyrs—van Gogh a suicide, Gauguin an exile. Both were haunted by masochistic guilt feelings expressing the conflict between their own conception of the good and society's values. Gauguin's self-portrait in the National Gallery in Washington, D.C., for example, illustrates this conflict, for he shows himself with both angelic and diabolic attributes—a celestial halo as well as the devil's pronged tail.

The artist's self-identification with martyrs provides a fascinating art-historical category. At first he paints himself as martyred religious figures—Dürer sees himself as Christ, Rembrandt as the apostle Paul. Beginning in the late nineteenth century, however, the theme of the artist as society's martyr goes beyond his identification with religious figures or saviors. In one of his best known essays, the playwright, poet, and essayist Artaud writes of van Gogh as "the man suicided by society." Society's rejection of the artist forces him to accept the role of martyr as opposed to his intended role of savior. A work by Claes Oldenburg illustrates the contemporary artist's feeling that the public is eating him alive: it is a Jell-O mold in the image of the artist. Andy Warhol finally attracted so much violence to himself that it was inevitable that he should be shot—martyred by a society that literally endangers any artist that dares come into direct contact with its chaos.

By the late sixties, the artist's feelings of rejection, self-hatred, and guilt have crystallized to new dimensions in a form called Body Art. The success of Body Art depends on the degree to which the artist can mutilate his own body. We have had many examples, all exhibited in galleries and museums to a public no longer shocked but titillated into a sadomasochistic identification with the act of self-mutilation. One may cite as examples Dennis Oppenheim methodically ripping off a toenail, Vito Acconci rubbing cockroaches into his bare chest, and Chris Bur-

den's suspending himself between buckets of water and live electric currents that presumably could electrocute him if one of the buckets were tipped over.

The *ne plus ultra* of Body Art, however, was the self-castration of Rudolph Schwarzkogler, a German artist who cut off slices of his penis until he finally bled to death. The photographs recording this process were exhibited at Documenta 5 last summer in Kassel, West Germany. The examples of self-mutilation and masochistic practices among artists today are so numerous that it becomes simply repetitious to catalogue them. What is significant is that protest is no longer directed outward as an aggression toward society—as in Dada—but turned in against the self. As the potential for protest is gradually eradicated by the ability of technological culture to co-opt any form of criticism toward its own ends, the artist turns against himself.

Although conceptual art presumably sought to destroy the status of the art object as a medium of exchange, its strategies too were proved pointless as the artists began exhibiting "documents"—photographs, videotapes, prints, etc., of their works in commercial galleries and museums. The permissiveness of dealers, curators, and the public seemingly had no end. Dada's testing of limits was demonstrated as ridiculous in the present context, which admits of no limits. The result is that in its current confusion, society has abdicated the parental authoritarian role vis-à-vis the rebellious artist adopted in the formative years of the avant-garde. In other words, society in general no longer wishes to perpetuate the traditional relationship between itself and the avant-garde: society appropriates to itself the artist's license to remain a child, perpetually at play, knowing no limits.

Dada seems to us now a delightful episode, its despair a combination of adolescent weltschmerz and romantic self-pity, in contrast to the present moment of harsh truths and dead ends. Adolescence is the period of preparing for something else, preparing for a future without precisely knowing what the future might be. It is a period of testing, experimentation. Above all, it is a period of fantasies.

In discussing Dada psychology, I do not use the term adolescent in a pejorative but in a descriptive sense to distinguish Dada modes of rebellion from current forms of antiauthoritarian behavior. The Dada artist had the good fortune to be permitted to act as an adolescent with regard to his relationship to a society that still conceived of itself as paternalistic and authoritarian, a society in which there were still boundaries and standards of behavior. In such a society, the hope of growing up, of finally replacing the old order, was not yet dead. In the face of

so many additional defeats of the idealistic utopian spirit subsequent to Dada, that hope is all but extinguished in the current generation of artists. Present forms of antiauthoritarian behavior can no longer conform to the model of adolescence, nor even in most instances to any classical generational conflicts, which presuppose the possibility of vanquishing the father.

The attitude is not of protest but of infantile passivity, and even those acts of protest that continue are couched in infantile terms. Thus the late Italian neo-Dadaist Manzoni exhibits his own canned feces in the gallery. Blood and filth are smeared over performers in ritualistic happenings. Galleries are filled with heaps of junk, garbage, and dirt as the artist resorts to more and more infantile strategies to attract the attention of the unloving, uninterested parent. Infantile feelings of omnipotence are expressed in earthworks—grandiose projects to change the world—giant sandpiles financed by a bored public. Eventually every kind of pathology is hailed as art: Exhibitionism (Vito Acconci masturbating in public); Autism (the "living sculpture" of Gilbert and George impersonating singing automatons); Necrophilia (Paul Thek's life-size replica of himself entombed); all are common fare. Alienation becomes a favored subject. The body itself is conceived of as a foreign object. Bruce Nauman paints his testicles black and Wolfgang Stoerkle animates his penis in rhythmic patterns on videotape. Images of castration and dismemberment are everywhere, from Jim Dine's headless bathrobes (one with ax attached) to Jasper Johns's scattered parts of the human anatomy to Robert Morris's brain covered with dollar bills to Ed Kienholz's recent tableau *5 Car Stud*, depicting castration of a black by four whites. The images of masochism, self-mutilation, and self-destruction multiply as the artist, deprived of his capacity to protest, or sensing the inadequacy of protest, turns against himself.

Part of the artist's sense of impotence derives from his recognition that society affords him no possibilities for responsible action. All decisions regarding the artist's life and work are made by others—bureaucrats, government functionaries, trustees, dealers, collectors, institutions, etc. Artists are rarely if ever consulted in a decision-making capacity because society sees them as irresponsible infants—whose antics are considered cute or bad, depending on how much mess they make. Given this situation, the type of personality who chooses to be an artist at this juncture in history is frequently dysfunctional to the point of pathology, infantile and desperate.

Conceptual art aims to deprive the public of art as commodity. Depriving the parent of the desired object is the typical infantile strategy;

and the infantilism of conceptual art should be evident. It is also a strategy doomed to failure, because it presumes that society is still acting *in loco parentis* with regard to its wayward artists, that it feels the absence of the art object as a deprivation. Yet there is no evidence to cause us to believe art is missed: what is missed is the amusement provided by art.

We are confronted now with artistic attitudes formulated not in terms of the disgust of Brecht but the disgust of Beckett. In the world of Dada and Brecht, the world is garbage. But garbage for an artist like Schwitters is imbued with charming nostalgia—the past is in pieces, but nevertheless we may still reconstruct the fragments. In the world of Beckett, the garbage cans of *Endgame* are filled not with the Merz scraps of dead civilizations but with empty human beings. Humanity, not merely its cultural artifacts, has become garbage. This is the deepest pessimism, an eschatological view no longer relieved by the possibilities of millenarian fantasies of redemption. In these circumstances art is conceived not as a form of protest but as a form of pathology.

In this case, the emphasis on the play element, on the ephemeral as opposed to the experimental, leads to a redefinition of art not as a specific kind of object but as non-goal-oriented behavior. In these terms, art is no longer involved with any fixed objective but with acting out various antiauthoritarian strategies. New categories of the forbidden must be located, not in protest against institutions or value systems but in terms of overtly pathological behavior. The following description of a performance of the Viennese artist Hermann Nitch's Orgies-Mysteries Theatre at The Kitchen last December advertises the worth of Mr. Nitch's work on the basis that "his abreaction theatre was cause for trial and prison sentences for offending the public and for blasphemy." Mr. Nitch, according to his publicist, "is working with very essential materials, like flesh, and blood and brains. In his theatre he wants to sublimate the excessive, sado-masochistic 'abreaction' [lacerating of meat, disembowelment of slaughtered animals, trampling on the entrails] . . . The means of this theatre to achieve its goal are the sado-masochistic dispute with meat and 'abreactive' events which lead to a cathartic climax."

Such a description indicates that increasing permissiveness has created a state of desperation in the minds of artists whose principal tactic for engagement has been shock. Moreover, when all activities— war, art, and human relations included—begin to be interpreted as games, as forms of behavior not tied to value systems, pathological activity more obviously attracts attention. One of the most alarming aspects of neo-Dada theory is its embrace of the play ethic, if one may

use this for a call to destroy art–life boundaries, which is implied in the view that all events are theater and all art is an extension of the real world to the exclusion of boundaries previously separating the two. In the essay on puerilism quoted, J. Huizinga, the Dutch historian noted for his study of play (*Homo Ludens*), comments: "The most fundamental characteristic of true play, whether it be a cult, a performance, a contest or a festivity, is that at a certain moment it is *over*. The spectators go home, the players take off their masks, the performance has ended. And here the evil of our time shows itself. For nowadays play in many cases never ends and hence is not true play. A far-reaching contamination of play and serious activity has taken place. The two spheres are getting mixed." Here exactly is the danger of a kind of moral confusion beyond any aesthetic confusions that current strategies of antiauthoritarian behavior imply.

TWILIGHT OF THE SUPERSTARS

THERE ISN'T ANYTHING THAT DOESN'T GO NOW. THE ARTIST COMMU-
NITY IS COMPLETELY DISSOLVED AND ARTISTS AREN'T EVEN TALKING TO
EACH OTHER. THEY'RE ALL GEARED TO THE PUBLIC, AT LEAST INTELLEC-
TUALLY. THE POP ARTISTS EXPLODED THE THING. . . . POLLOCK WANTED
TO BECOME A CELEBRITY AND HE DID. HE GOT KICKED OUT OF THE 21
CLUB MANY TIMES AND DE KOONING IS LIVING LIKE ELIZABETH TAY-
LOR. EVERYBODY WANTS TO KNOW WHO HE'S SLEEPING WITH, ABOUT
THE HOUSE HE'S BUILDING AND EVERYTHING. HE HAS NO PRIVATE LIFE.
BUT FINALLY IT WAS ANDY WARHOL. HE HAS BECOME THE MOST
FAMOUS. HE'S A HOUSEHOLD WORD. HE RAN TOGETHER ALL THE
DESIRES OF ARTISTS TO BECOME CELEBRITIES, TO MAKE MONEY, TO HAVE
A GOOD TIME, ALL THE SURREALIST IDEAS. ANDY WARHOL HAS MADE
IT EASY.

> —Ad Reinhardt, unpublished
> monologue

IN THE FUTURE, EVERYONE WILL BE FAMOUS FOR FIFTEEN MINUTES.

> —Andy Warhol

"Eight Contemporary Artists"* is an exhibition of new works by concep-
tualists, three American, four European, and one Australian. Their com-
mon premise appears to be that art should provide minimal visual stimu-
lation, a lack presumably compensated for by the professed profundity
of its cerebral content. Normally one would easily overlook such a show,

*"Eight Contemporary Artists," an exhibition of work by Vito Acconci, Alighiero
Boetti, Daniel Buren, Hanne Darboven, Jan Dibbets, Robert Hunter, Brice Marden,
Dorothea Rockburne, at the Museum of Modern Art, October 9, 1974–January 5, 1975

which is as bland and tepid as its deliberately noncommittal title. "Eight Contemporary Artists" is the most extensive exhibition of contemporary art held by the Museum of Modern Art since 1970. As the widely acknowledged arbiter of current taste, the Museum of Modern Art continues to serve as a telling barometer of prevailing standards and attitudes. That a show of this nature should take place within its exclusive precincts represents the degree to which the MOMA has modified its relatively conservative position. Until now, the museum has not acknowledged the feverish flowering and fading of seasonal styles by singling out any particular group of presently modish artists from the many contending stances and styles that have splintered the art community into so many antagonistic factions (e.g., Photo-Realists, neorealists, minimalists, land artists, pop artists, media environmentalists, and abstract painters and sculptors, themselves individually polarized toward varying degrees of liberalism, lyricism, hard, soft, and no edges).

Other than a general lack of interest in what Marcel Duchamp ironically categorized as "retinal art" (that which appeals to the eye), the eight artists share two other rather telling characteristics: short careers and long bibliographies. The successor to a series of exhibitions sporadically organized by retired MOMA curator Dorothy Miller featuring heterogeneous groups of American artists, "Eight Contemporary Artists" differs from Miss Miller's "Americans" in that it seems less the expression of an idiosyncratic and fallible personal taste than a carefully computed scorecard, a kind of All-Star team based on Gallup Poll ratings taken from the current art press. There is an uncanny correlation between the artists exhibited and the number of pages devoted to their works in *Art International, Arts, Studio International,* and especially *Artforum,* which has had full-scale articles on a majority of the artists in the show, including cover stories on two, Dorothea Rockburne and Brice Marden, who are, one should in all fairness say, by far the most interesting of the lackluster lot. There are several possible explanations for this connection. Attacked from many quarters for not keeping up with the avant-garde, MOMA may have felt intimidated by the audience and editors of *Artforum,* which lately has been hammering away at various aspects of MOMA's operations, from the political implications of its international exhibitions to the fortunes of its trustees to its troubled staff relations.

To be as arbitrary as Dorothy Miller, one would have to feel a kind of confidence in one's own taste few curators today have the courage to display, given the aggressiveness with which the art press is ready to criticize the exclusion of their favorites. Which brings us to the point

of why it is necessary for an influential magazine such as *Artforum* to have a stable of favorites, whose careers seem not just advanced but invented by reviewers, critics, interviewers, documenters, or, if need be, by the artist him- or herself in various autopromotions. To understand the current state of affairs, one must recapitulate for a moment the history of the contemporary art press. During the fifties, *ARTnews* alone polemicized for the acceptance of abstract expressionism, which was largely ignored by museums and attacked by everyone else. *ARTnews* was an insider's magazine, the house organ of action painting. Its contents usually came straight from conversations at the Cedar Bar, translated for the outsider public by editor Thomas B. Hess or critics Harold Rosenberg and Clement Greenberg. A coterie magazine committed to the New York School, *ARTnews* nevertheless ran hundreds of reviews in every issue, thereby deflecting some of the spotlight to cover the whole of the art community.

The art community in those days was considerably smaller than it is today. In a filmed interview, Robert Motherwell commented that there were "perhaps fifty modern artists in New York" in the late forties, and that for the most part, they all knew each other, visited each other's studios, and gave each other the courage to survive. Today, by contrast, there are tens if not hundreds of thousands of artists in greater New York, not to mention the rest of the country. They do not generally know each other, nor do they frequent the same restaurants and bars, exhibit together in mutual recognition of common ground, or give each other solace. Instead they compete for the attention of critics and curators who may raise them to prominence above the burgeoning crowd of their peers. While personal communication has broken down, the network of information provided by the widely disseminated art press has grown in importance. In addition to the regular art journals, *Art in America, Art International, Arts, ARTnews,* and *Artforum,* there is a raft of new internationally distributed tabloid magazines such as *Art Press, Artetudes, Avalanche, Flash Art,* etc., that document earthworks, conceptual art, performance and ephemeral art, video—in short, all those activities that reject the context of the museum. Functioning as a substitute frame of reference for the museum, the total art press now represents a media alternative to exhibitions. As a result, art concepts, if not art works, can be disseminated via documentary photographs, artists' journals, and critical commentary on ephemeral events. Because of the transient, topical quality of media, which appear in a timed sequence, but can be stored indefinitely, as opposed to the stable context of museum exhibitions, which have an afterlife only as catalogues, artists today can have careers

that are as insubstantial as the Paris air bottled by Marcel Duchamp, who anticipated this whole phenomenon in his portable *Boîte-en-Valise*, containing printed reproductions of his works.

It is no exaggeration to say that all the latest developments (with the possible exception of "land art," or earthworks, which uses landscape as a canvas) were already quite thoroughly explored by Duchamp. The minions of artists crowding the field of his lengthening penumbra are involved in little more than illustrated exegeses of his work. Yet no one seems capable of dealing with the complexity of Duchamp's last work, the immensely provocative *Etant Donnés* in the Philadelphia Museum of Art. His pose of indifference and idleness to the contrary, Duchamp spent the last decades of his life neither playing games nor producing literary commentary, but in the actual labor of creating a material work that strikes an absolute balance between the cerebral and the sensual-experiential.

Neither an exhibition based on its own extensive reserves nor a show of older modernists, or even of younger artists working in the traditional media would have had the same predictable news value nor the same insured reception by the art press that created the reputations of "Eight Contemporary Artists." Rather than taking any risks, the show was the surest bet for the art world's approval or at least attention. In the past, art journals were content to report on exhibitions, reviewing the initiative of curatorial taste. Now the situation appears reversed and museums feel compelled to feature the "stars" created by the media. This is a peculiar inversion, indicating perhaps a new relationship of the communications media to cultural institutions.

I am using the term "star" to describe artists catapulted to eminence through the pages and images of the media. The word "star" appropriately characterizes the growth of a cult of personality. This promotional approach is rapidly replacing earlier criticism that established reputations on the basis of comparative quality, or even on the shakier grounds of significant innovation, the questionable criterion used to justify the elevation of some reputations in the sixties. As the art world has extended more and more into the world of business and entertainment, art is noticeable to a public clearly not interested in aesthetic values, but hungry for art gossip. Symptomatic of this curiosity is the *National Enquirer*–style treatment given by *New York* magazine to Jackson Pollock's personal life and the unbelievably vulgar article—with illustrations—on Rothko's suicide in *Esquire*. That these names mean anything at all to a mass public is the result of the immense publicity attendant to the sale of Pollock's *Blue Poles* for an unprecedented sum and to the

daily reporting of the trial concerning the disposition of Rothko's estate. The artist's personality is transformed into an available cultural commodity, yet a curious numen of respect continues to surround artists' visionary works, suggesting that even if money can't buy love, it could conceivably, in today's world, buy God.

It is just as well that the appetite of this enlarged public is not for new art, but for new personalities. Finally, there is little to differentiate one conceptual artist's work from another. One pale grid on the wall is pretty much like any other; one page of compulsive calligraphy is hardly distinguishable from another. The shift in focus from art work to the persona of the artist is necessary in a greatly expanded art world. In an overcrowded and undercapitalized milieu, only media attention can single out the happy few from the madding crowd. Because communications media are by definition fickle, there is little loyalty to these overnight sensations. New personalities must constantly be created to satisfy not only the artist's ego, but also the critic's equivalent need to distinguish him- or herself through the discovery of a definitive new talent or movement of spurious "style."

Parallel to the substitution of "stardom," the instant prominence as opposed to a steadily growing reputation evolving over a long period, is the redefinition of the critic, not as the judge of quality, but as the artist's impresario. The disbelief that art has any intrinsic quality leads to the conclusion that all an artist needs to succeed is a press agent who can write Artforumese. This cynicism is supported by attitudes toward success inculcated in art schools and promulgated by a new type of literature devoted to advising artists how to market their careers, manage their images, find galleries, collectors, etc. Along with books by accountants and lawyers about art, this is the largest new category of art literature.

Bending to the artist's demand to be considered *sui generis,* critics are now reluctant either to compare or to link artists. This contributes to the thoroughly fragmented and unfocused quality of recent art criticism, which can in no way be considered dialogue. "Criticism" no longer confronts any general issues nor evaluates the artist; it assuages and aggrandizes his ever-expanding ego. The rhetorical and hortatory tone of what has become critical apology rather than critical evaluation accounts for the reader's sense that these accounts, replete with minichronology and other appurtenances of a pseudo-art-historical approach, represent commercial promotion brochures rather than the conventional value judgments of past criticism.

The rejection of "judgmental" criticism by the critics of the seventies is part of the general rejection of authoritarian attitudes that character-

ized the collapse of leadership in all areas at the end of the sixties. The relativity of aesthetic judgments is an obvious analogue to the relativity of moral judgments. That the leaders have clay feet decimates the ranks of followers. For example, the documented revelation that Clement Greenberg willfully changed the color of David Smith's sculptures after the artist's death has diverted focus from the contribution of Greenberg's evaluative criticism to his shortcomings as an authoritarian personality, adding to the skepticism regarding any criticism based on distinctions of quality. Without Greenberg as a figurehead, the circle of critics who unquestioningly accepted his premises has been eclipsed, to be replaced by another group of critics whose point of departure seems to be that no further distinctions can be made between good art and bad art and that, as Donald Judd put it, a work need only be "interesting."

To an extent, I must agree that at present it is extremely difficult to qualify art. There is a general level of competence among younger artists who continue to practice the traditional arts, and an even higher level of technique, especially in terms of drawing, currently emerging as an important medium. Yet there are no towering personalities that cry to be singled out. It is even more difficult to make distinctions among artists using new media, who specifically disavow any interest in quality. There are two ways of looking at this situation: either it takes artists longer to mature than we have been willing to admit, and the present moment is one of fertile if slow incubation, or else we are experiencing a decline from the Golden Age of the School of Paris, to the Bronze Age of the New York School, to the present Iron Age, and are destined to sink back into the primitivism of a new Dark Age, in which the traditional artistic skills will be lost along with literacy, as they were at the end of the ancient world.

Since we do not know the outcome of our current process of cultural upheaval, statements regarding the future of art by responsible people tend to be hesitant and moderated. Museums are, as William Rubin points out in an interview in *Artforum*, nineteenth-century institutions, compromises between private and public patronage invented by the bourgeois democracies. The publication of this extended two-part interview underscores the intimacy of *Artforum*'s curious love–hate relationship with the Museum of Modern Art. Insofar as the museum shows itself responsive to art-media comment, to either its antagonism or its approval, it exhibits the shift in the power balance between media and cultural institutions in which the media dominate.

In his interview, Professor Rubin, Director of the MOMA Department of Painting and Sculpture, posits the eventuality that modernism

is a closed or closing issue. He says, "Perhaps the dividing line will be seen as between those works which essentially continue an easel painting concept that grew up associated with bourgeois democratic life and was involved with the development of private collections as well as the museum concept—between this and, let us say, earthworks, conceptual works, and related endeavors, which want another environment (or should want it) and, perhaps, another public." Rubin makes it clear that the museum is not, by definition, an ambience hospitable to many of the latest art tendencies. In an article titled "The Function of the Museum" published earlier by *Artforum,* Daniel Buren, one of the Eight Contemporary Artists, articulates in a fairly intelligent manner his hostility to the concept of the museum. "The Museum/Gallery instantly promotes to 'Art' status whatever it exhibits with conviction," he writes, with gratifying probity. Buren goes on to attach the concept of the timeless masterpiece as a fetish of museum culture and to further explore the (to him) repulsive tendencies of museums to conserve the art of the past.

Artists' attacks on museums are no news. The question is, if both Professor Rubin and Mr. Buren concur that Buren's work, which at MOMA consists of decorative striped panels pasted to the gallery wall, equal in size and shape to the windows they face in a corridor, does not belong in a museum, what is it doing there?

Buren's nondescript and deliberately ephemeral, nonqualifiable pieces, vaguely resembling travesties of Stella's stripe paintings, are displayed at the Museum of Modern Art, one begins to suspect, because Buren has been particularly clever at keeping his name and images in print. In the world of the blind, the one-eyed is king. Given the present critical vacuum, Daniel Buren is a Superstar. To be admired and presented to an unwary museum public, his works need be neither good nor bad: they need only generate print and photographs.

A word should be said about the evolution of the concept of the "Superstar." The term was invented by Andy Warhol, who learned how to manipulate the media for his purposes from the original Great Impostor, Duchamp himself. A Superstar is anybody Warhol happens to notice, whose image and/or voice is recorded by his indiscriminate camera or cassette. The gag originally was that Superstars were just ordinary people, with no particular attributes of distinction. In fact, I recall once taking two insatiably curious Queens College students to Warhol's old Factory. By the time they left, he had made them Superstars in one of his lesser vehicles. Now *Interview,* Warhol's parody of *Modern Screen,* publishes interviews of real celebrities that reveal the banality and ordinary drabness of the celebrated. Fame is exposed for

what it is: a pure fabrication of media, independent of any intrinsic value or achievement.

There is an unconscious similarity between the inane *Interview* conversations with rock stars, models, actresses, and socialites and *Artforum*'s new informal interview style, which Warhol in his infinite wisdom probably enjoys. For, having introduced the ideas that art has no quality and that the artist needs no special technical skill or training, so anyone can make art, Warhol has seen his worldview triumphant, not among the masses, whom in fact he might be seeking to liberate from the oppression of bourgeois culture, but among the priests of high culture itself. In his devastating equation of Liz Taylor and the *Mona Lisa* in similar silk-screen replicas, Warhol exposed the leveling process of the media. Reduced to photographic reproduction, Liz is a star, and the *Mona Lisa* is a star, too. This confusion has by now infiltrated museology and criticism sufficiently to produce an atmosphere of chaotic insecurity and uncertainty.

The creation of such an atmosphere of confusion was undoubtedly Warhol's intention. It seems clear now his goal was nothing less radical than the obliteration of traditional culture, not through direct attacks, but through the guerrilla tactics of subversion and infiltration—the gradual erosion of values through the equation of diverse images once categorically antithetical. No head-on confrontation, no aggressive assaults, just a progressive takeover of the apparatus of culture by Smiling Andy, the Exploding Plastic Inevitable.

Warhol is the only genuinely revolutionary figure in the sixties. But I am not confused about the goals of his revolution: the demolition of bourgeois cultural leadership through an appeal directly to the masses by way of common channels of information: the mass media. Warhol has succeeded by appealing to base curiosity, the mass taste for sensationalism, novelty, and entertainment. And his success in creating a cult of personality has impressed a younger generation of artists, some of whom, more interested in careers as artists than in making art, have imitated his tactics with a shameless lack of originality.

Why are artists styling themselves after movie stars? Suffice it to say that the impotence and irrelevance of seriousness of any kind in a democratic mass culture every day demonstrated by the election of movie stars to public office is demoralizing generally. The latest and most blatant bid for attention by an artist determined to promote a Superstar career is Lynda Benglis's double-page advertisement for herself in the November 1974 *Artforum*, in which the artist is seen nude, oiled, and masturbating an oversize penis, apparently extending from her own

body, that is convincingly flesh-colored but rather unconvincingly enlarged. Shades of Linda Lovelace and Alice Cooper.

In the same issue of *Artforum* is an article on Benglis by Robert Pincus-Witten, a senior editor of the magazine. Commenting on Benglis's last exhibition poster, a rear view of the artist bending over, blue jeans dropped to her ankles, coyly peering over one shoulder, Pincus-Witten writes, "The cheesecake shot—in part homage to Betty Grable pinups—recalls for me a late version of Odilon Redon's *Birth of Venus.* Though this work can hardly have been in her mind, Benglis is strongly interested in Classical myth. Among her most recent works are pornographic Polaroids rendered ambiguous by their cultural context—they are parodies of Mannerist and Hellenistic postures. Il Rosso Fiorentino and ithyphallic kraters, a Leda without a swan." Dr. Pincus-Witten's erudition notwithstanding, the Benglis poster is less reminiscent of Redon than it is a virtual duplication of the October cover of a Times Square porno magazine ironically called *Gallery.*

I quote the passage above as typical of current art writing. Superstardom is accomplished by means of establishing greatness by association. This requires the development of a pseudo-art-historical approach to self-serving trivia once reserved for the iconography of the great masters. In an article on Brice Marden, Jeremy Gilbert-Rolfe creates a ludicrously exalted pedigree for Marden's competent if innocuous wax panel paintings, which in fact are hardly more than serial variations on the theme of Jasper Johns's encaustic *Painting with Two Balls* (without the balls): "Like the thickness of Mallarmé's book, the space of a Marden is a physical volume that one recognizes as able to conceal and, therefore, to reveal anew. One remembers that Zurbaran lived in a country economically enmeshed with Northern Europe and ideologically centered on Rome. As if to invite comparison with *Gravity's Rainbow,* which discovers America in its—primarily nineteenth century—European past, the *Grove Group* was painted after a trip to Greece, where the Ideal clarity of the Adriatic is a naturalistic fact of life." With a few deft associations, Gilbert-Rolfe constructs a new Pantheon: Mallarmé, Zurbaran, Pynchon, and Marden.

Paradoxically, the age of the artist-Superstar coincides with the actual waning of artistic originality and individualism. The visible similarities of one work with another accompany a leveling of quality. For years, artists found it possible to conceive of themselves privately as individuals working within their own community of outsiders, in relative anonymity. Now the rewards of art seem insufficiently gratifying. The artist competes with the porno star or the sadomasochistic rock entertainer for

attention. Warhol initiated this direction, but his actions and words are still commentaries on a situation, not merely extensions of it. Sex, as Duchamp once again was the first to notice, will inevitably excite a public, any public. Warhol maintained his distance from his subject matter, managing to make pornography boring, through the alienation effect. The new art pornography of Photo-Realism or the promotional advertisements of would-be Superstars no longer have any distancing mechanisms. They have become what they presume to be about: pornography and sadomasochism.

If there is a conscious aim in such publicly degraded behavior, then it must be the degradation of art. For some time I have felt that the radicalism of minimal and conceptual art is fundamentally Dada politics. Its implicit aim is to discredit thoroughly the forms and institutions of dominant bourgeois culture: to demoralize the public, preparing it to renounce the official culture, which is shown to be meaningless and consequently not worth perpetuating. This is certainly revolutionary strategy—a kind of abstract Warholism—although one cannot see how it prepares the way for the triumph of proletarian culture. On the other hand, weakening public trust in art may as easily pave the way for fascist counterrevolution, for a mass culture in the service of totalitarian ideals. Whatever the outcome of this strategy, one thing is certain. When an institution as prestigious as the Museum of Modern Art invites sabotage, it becomes party, not to the promulgation of experimental art, but to the passive acceptance of disenchanted, demoralized artists' aggression against art greater than their own. Once the canon, the standard of excellence, MOMA joins those who have decided cultural standards are no longer worth defending. This is a suicide pact of collaboration with forces that would annihilate excellence, replacing the criteria of sustained achievement with the transient overnight flash of meteoric Superstars.

AMERICAN PAINTING: THE EIGHTIES

I became an art historian and a critic over twenty years ago because I loved painting. When I was a student, the paintings of the New York School were widely visible at the Museum of Modern Art, and at galleries like Sidney Janis, Betty Parsons, and Sam Kootz. The artists of my generation whom I respected were those who admired abstract expressionism too much to imitate it. But in their wish to be original at any cost, to create an American art totally freed of European conventions like drawing, illusionism, brushwork, scale, metaphor, and compositional relationships, they finally arrived at styles that I ultimately found lacking the qualities that had drawn me to the study of art in the first place.

And so, with very few exceptions, I stopped writing about contemporary art. Nothing in object art, conceptual art, performance, video, or even photography and film, which could have a claim to more than narcissistic exhibitionism, moved me as painting had. I shared the disgust of painters who rejected abstract art in favor of realism for the cynicism, nihilism, demoralization, and contempt toward both the public and their craft that so-called artists, lacking faith in the future, displayed in ephemeral art and works made of materials destined to disintegrate. Yet I could not believe in a *retardataire* "return to realism" that jettisoned those fundamentals of modernism that artists since Cézanne had fought to establish. In good conscience, I could not pretend that the last seventy years of the evolution of a self-awareness and an awareness of the properties of art and art making never happened.

Thus I found myself isolated, revolted by the excesses and extremes to which the idea of art as tradition-smashing revolution had been taken, but unable to identify with the other extreme of a wholesale conversion to the exhausted conventions of the art of the last century. Once I had looked for community to an art world that had disintegrated into a petty,

Exhibition Catalogue, AMERICAN PAINTING: THE EIGHTIES, Grey Art Gallery, Sept 5–Oct 13, 1979 273

squabbling armed camp of internecine quarrels, power-mongering, self-promotion, materialism, and egos inflated by premature adulation. In the galleries I saw eccentric sensational ploys to gain attention. SoHo made me nostalgic for Tenth Street, where the art was bad enough, but at least it was art and not some social, political, or promotional statement made in its name. I returned to the study of the Old Masters, the modern masters, and earlier American modernists who had not felt it necessary to reject all that had gone before them to make important new art. Although I continued to visit galleries and modern-art museums, it was obvious that the dealers were playing follow the leader, and the curators were for their part following the lead of the dealers. Since those of my colleagues whom I had once learned from had ceased writing for the art magazines, with little regret, I gave up reading the art press.

Sometimes in the Metropolitan or the Frick, I would run into a young artist. We would talk about El Greco or Velázquez or Ingres, or about Leo Steinberg's *Other Criteria*, his essays emphasizing the similarities between the Old Masters and the modern masters, as opposed to their differences. Many young painters took heart from Steinberg's opposition to the idea that formalist criteria were the only means for judging content, and his challenge to the reductivist simplifications of recent art criticism. A few times a week I talked to Tom Hess, who loved painting as I did; after Tom died, I mainly talked to myself.

Last year, I began to see a lot of painters again. There was no club, no forum, no bar, no school, no magazine they congregated around, but there were four critical exhibitions that took place in 1978–79, where painters gathered: "Cézanne: The Late Works," "Monet at Giverny," the Jasper Johns retrospective, and "Abstract Expressionism: The Formative Years." The cumulative effect of these exhibitions was a giant shot in the arm of painting. Both the Monet and the Cézanne shows concentrated on the old age of the artist, emphasizing synthesis rather than innovation. The Johns retrospective showed the work of a painter who rejected the facile iconography of pop art to paint (with oil and brushes on a rectangular stretched canvas!) a personal subjective vision, a world of psychologically charged images and painterly surfaces. In reality as alone as Cézanne at Aix, Johns's media persona contrasts sharply with the difficult, hermetic images he has produced since 1960, when his art began to turn around in conscious opposition to all that was winning critical praise. For Johns maintained a commitment to hand painting, fine craft, visible brushwork, subjective imagery, representation, and painterly tactile surfaces for the two decades when automatic tech-

niques, stained-color-field abstraction, and optical art were claimed to be the only hope for high art. His refusal either to become a creature of the media or to capitulate to the one-note aesthetics of those who damned him as a "minor master" indebted to a dead European tradition was interpreted by many younger painters as exemplary negation. They saw his retrospective as the record of an artist who had continued to evolve, slowly, painstakingly, resisting the temptation to join any group—standing his solitary ground.

For younger American painters, however, struggling for over a decade to forge individual styles, the greatest revelation was exposure to the early work of the abstract expressionists. These extraordinary paintings, out of sight, for the most part, for thirty years, revealed the distinctively European roots of the New York School, as well as its connection to earlier American abstraction of the Stieglitz school, which later criticism and chauvinistic packaging—sometimes by the artists themselves—conspired to obscure. Seeing what Still, Pollock, and de Kooning were doing at their age encouraged a generation of painters now mainly in their thirties to make their own mistakes, to risk failure with bold moves. Further revelations were the painterly early works of Tomlin, Krasner, Reinhardt, and Pousette-Dart, and the extent to which Motherwell, Newman, Gottlieb, Baziotes, and Rothko were indebted to surrealism. The emergence of Gorky as the great figure of the early forties contributed to a reappraisal of nature as the inspiration of lyrical painting. The refinement, nuance, and technical skill of Gorky's exquisite works reaffirmed a commitment to painting as a sensual, tactile experience involving hand as well as eye and brain.

Although I stopped writing about contemporary art, I continued to find provocative, if not yet fully mature, work in studios, and even occasionally in galleries run by adventurous young dealers like Paula Cooper, Klaus Kertess, Michael Walls, Miani Johnson, and Patricia Hamilton. After many years of watching with interest the development of this work, I suddenly began to see in 1979, in studio after studio, bold and affirmative images executed with a new degree of complexity, density, assurance, and ambition. Dozens of artists had begun simultaneously to "break through"—not to some radical technique or bizarre material, but to their own personal images. I found these artists not through galleries, museums, or art magazines, but through the artists' grapevine, the underground signaling system that has proved an infallibly accurate barometer of a change in the weather. What I saw is obviously not all there is to see of quality and originality, but to find so

much of a high caliber was enough to give me the courage and the
incentive to write again about contemporary art.

THE NEW IMAGISTS

Ten years ago, the question "Is painting dead?" was seriously being
raised as artist after artist deserted the illusory world of the canvas for
the "real" world of three-dimensional objects, performances in actual
time and space, or the secondhand duplication of reality in mechanically
reproduced images of video, film, and photography. The traditional
activity of painting, especially hand painting with brush on canvas, as
it had been practiced in the West since oil painting replaced manuscript
illumination and frescoed murals, seemed to offer no possibility for
innovation, no potential for novelty so startling it could compete with
the popular culture for attention, with the capacity of the factory for
mass production, or the power of political movements to make history
and change men's minds. In the context of the psychedelic sixties and
the post-Vietnam seventies, painting seemed dwarfed and diminished
compared with what was going on outside the studio. In the past, the
painter would never have compared his activity with the practical side
of life. By the time Senator Javits presented President Kennedy with an
American flag painted by Jasper Johns, the idea that art was an activity
parallel in some way with politics, business, technology, and entertain-
ment was on the way to becoming a mass delusion.

Once Andy Warhol not only painted the headlines but appeared in
them as well, the potential parity of the artist with the pop star or the
sports hero was stimulating the drive to compete instilled in every Ameri-
can by our educational system. In the past, a painter might compete with
the best of his peers, or in the case of the really ambitious and gifted,
with the Old Masters themselves; but now, the celebrated dissolution of
the boundary between art and life compelled the artist to compete with
the politician for power, with the factory for productivity, and with pop
culture for sensation and novelty.

Perhaps most pernicious, the drive toward novelty, which began to
seem impossible to attain within the strictly delimitative conventions of
easel painting, was further encouraged by the two dominant critical
concepts of the sixties and seventies. The first was the idea that quality
was in some way inextricably linked to or even a by-product of innova-
tion. The second was that since quality was not definable, art only

needed to be interesting instead of good. These two crudely positivistic formulations of critical criteria did more to discourage serious art and its appreciation than any amount of indifference in the preceding decades. The definition of quality as something that required verification to give criticism its authority contributed to the identification of quality with innovation rather than mature synthesis. For quality judgments to claim objectivity, they had to be based on the idea that an artist did something *first*—a historical fact that could be verified. The further erosion of critical authority was accomplished in other quarters by the denial that quality was in any way a transcendent characteristic of the art work; for if a work validated its existence primarily by being "interesting" (i.e., novel), then qualitative distinctions were no longer necessary. Far more aligned than they might appear at first, these two crudely materialist critical positions conspired to make painting less than it had ever been, to narrow its horizons to the vanishing point.

In the sixties and seventies, criticism militated on two fronts against styles that were based on continuity instead of rupture with an existing tradition. The term "radical" vied with "advanced" as the greatest accolade in the critic's vocabulary. Slow-moving, painstaking tortoises were outdistanced by swift hares, hopping over one another to reach the finish line where painting disappeared into nothingness. Such an eschatological interpretation of art history was the inevitable result of the pressure to make one's mark through innovation. For those who could not be first, at least there was the possibility of being the first to be last.

REDUCING RECIPES

This drive toward reductivism, encouraged and supported by a rigorously positivist criticism that outlawed any discussions of content and metaphor as belonging to the unspeakable realm of the ineffable, was a surprising finale to abstract expressionism, which had begun with an idealistic utopian program for preserving not only the Western tradition of painting, but also the entire Greco-Roman system of moral and cultural values. Of course this was to ask of art more than art could deliver. The revulsion against such rhetoric was a primary reason for the rejection of abstract expressionist aesthetics by pop and minimal artists beginning around 1960.

To be accurate, however, one must recall that the subversion of abstract expressionism began within the ranks of the movement itself.

A popular art-world joke described the demise of "action painting" as follows: Newman closed the window, Rothko pulled down the shade, and Reinhardt turned out the lights—a gross oversimplification of the critique of gestural styles by these three absolutist artists. This superficial gloss of Newman, Rothko, and Reinhardt was interpreted literally by art students throughout America, anxious to take their places in the limelight and the art market, without traveling the full distance of the arduous route that transformed late abstract expressionism into simplified styles subsuming elements from earlier modern movements into a synthesis that, while reductive, was still a synthesis. What lay behind abstract expressionism was forgotten ancient history in the art schools, where recipes for instant styles (two tablespoons Reinhardt, one half-cup Newman, a dash of Rothko, with Jasper Johns frosting was a favorite) pressed immature artists into claiming superficial trademarks. These styles in turn were authenticated by art historians trained only in modern art history, and quickly exported to Europe, where World War II and its aftermath had created an actual historical rupture and an anxiety to catch up and overtake American art by starting out with the *dernier cri.* Soon the minimal, monochromatic styles that imitated Newman, Rothko, and Reinhardt in a way no less shameless than the manner in which de Kooning's Tenth Street admirers copied the look of his works gave a bad name to good painting on both sides of the Atlantic.

This is not to say that all the artists of the sixties and seventies who interpreted abstract expressionism literally—seizing on those aspects of the works of the New York School that seemed most unlike European art—were cynical or meretricious. But they were hopelessly provincial. And it is as provincial that most of the art of the last two decades is likely to be viewed when the twentieth century is seen in historical perspective. By provincial, I mean art that is determined predominantly by topical references in reaction to local concerns, to the degree that it lacks the capacity to transcend inbred national habits of mind to express a universal truth. In the sixties and seventies, a specifically American content became an objective to be pursued instead of avoided.

The abstract expressionists by and large had European or immigrant backgrounds. They rejected the strictly "American" expression as an impediment to universality. Beginning around 1960, however, the pursuit of a distinctively American art by native-born artists provided the rationale for the variety of puritanically precise and literalist styles that have dominated American art since abstract expressionism. A reductive literalism became the aesthetic credo. The characteristics of painting as mute object were elevated over those of painting as illusion or allusion.

TECHNIQUE AS CONTENT

Even those artists who maintained closer contact with the European tradition, like Bannard and Olitski, avoiding the provincial American look, were unable to find more in painting than leftovers from the last banquet of the School of Paris, *art informel.* However, *tachiste* art, with its emphasis on materials, was nearly as literal as the local American styles. The absence of imagery in Yves Klein's monochrome "blue" paintings, the ultimate *informel* works, identifies content not with imagery or pictorial structure, but with technique and materials. In identifying image and content with materials, *informel* styles coincided with the objective literalist direction of American painting after abstract expressionism.

The identification of content with technique and materials rather than image, however, also had its roots in abstract expressionism. In seeking an alternative to cubism, the abstract expressionists, influenced by the surrealists, came to believe that formal invention was primarily to be achieved through technical innovation. To some extent, this was true. Automatic procedures contributed to freeing the New York School from cubist structure, space, and facture. But once these automatic processes were divorced from their image-creating function, in styles that disavowed drawing as a remnant of the dead European past to be purged, the absence of imagery threw the entire burden of pictorial expression on the intrinsic properties of materials. The result was an imageless, or virtually imageless, abstract painting as fundamentally materially oriented as the literal "object art" it purported to oppose.

The radicality of object art consisted of converting the plastic elements of illusion in painting—i.e., light, space, and scale—into actual properties lacking any imaginative, subjective, or transcendental dimension. No intercession by the imagination was required to infer them as realities because they were *a priori* "real." This conversion of what was illusory in painting into literal realities corresponds specifically to the process of reification. As the fundamental characteristic of recent American art, anti-illusionism reveals the extent to which art, in the service of proclaiming its "reality," has ironically been further alienated from the life of the imagination. The *reductio ad absurdum* of this tendency to make actual what in the past had been a function of the imagination was "process art," which illustrated the procedure of gestural painting, without committing itself to creating images of any permanence that would permit future judgment. In conceptual art, the further reification of

criticism was undertaken by minds too impotent to create art, too ter-
rified to be judged, and too ambitious to settle for less than the status
of the artist.

Thus it was in the course of the past two decades that first the
criticism and then the art that reduced it to formula and impotent theory
became so detached from sensuous experience that the work of art itself
could ultimately be conceived as superfluous to the art activity—which
by now epitomized precisely that alienation and reification it nominally
criticized. Such were the possibilities of historical contradiction in the
"revolutionary" climate of the sixties and seventies. In painting, or what
remained of it, a similar process of reification of the illusory was under-
taken. Edge had to be literal and not drawn so as to suggest illusion;
shape and structure had to coincide with one another to proclaim them-
selves as sufficiently "real" for painting to satisfy the requirements of
radicality. In reducing painting to nothing other or more than its mate-
rial components, rejecting all forms of illusionism as *retardataire* and
European, radical art was forced to renounce any kind of illusive or
allusive imagery simply to remain radical. And it was as *radical* that the
ambitious artist felt compelled to identify himself. In its own terms, the
pursuit of radicality was a triumph of positivism; the rectangular colored
surface inevitably became an object as literal as the box in the room.
Even vestigial allusions of landscape in the loaded surface style that
evolved from stained painting in gelled, cracked, or coagulated pig-
ment—reminiscent of Ernst's experiments with decalcomania—express
a nostalgia for meaning, rather than any convincing metaphor. For
radicality demanded that imagery, presumably dependent on the out-
moded conventions of representational art, was to be avoided at all costs.
The result of such a wholesale rejection of imagery, which cut across the
lines from minimal to color-field painting in recent years, was to create
a great hunger for images. This appetite was gratified by the art market
with photography and Photo-Realism.

Photography and the slick painting styles related to it answered the
appetite for images; but they did so at the enormous price of sacrificing
all the sensuous, tactile qualities of surface, as well as the metaphorical
and metphysical aspects of imagery that it is the unique capacity of
painting to deliver. Pop art, which is based on reproduced images, had
self-consciously mimicked the impersonal surfaces of photography, but
Photo-realism rejected this ironic distance and aped the documentary
image without embarrassment. In a brilliant analysis of the limitations
of photography ("What's All This About Photography?" *Artforum*, May

1979) painter Richard Hennessy defines the crucial difference between photographic and pictorial imagery. A devastating argument against photography ever being other than a minor art because of its intrinsic inability to transcend reality, no matter what its degree of abstraction, the article makes a compelling case for the necessity of painting, not only as an expressive human activity, but also as our only present hope for preserving major art, since the subjugation of sculpture and architecture to economic concerns leaves only painting genuinely "liberal" in the sense of free.

According to Hennessy, photography, and by inference, painting styles derived from it, lacks surface qualities, alienating it from sensuous experience. More than any of the so-called optical painting styles, photography truly addresses itself to eyesight alone. Upon close inspection, the detail of photography breaks down into a uniform chemical film— that is, into something other than the image it records—in a way that painterly detail, whether an autonomous abstract stroke, or a particle of legible representation as in the Old Masters, does not. Thus it is the visible record of the activity of the human hand, as it builds surfaces experienced as tactile, that differentiates painting from the mechanically reproduced imagery. (Conversely, the call for styles that are exclusively *optical* may indicate a critical taste unconsciously influenced in its preference by daily commerce with the opticality of reproduced images.)

The absence of the marks of the human hand that characterizes the detached automatic techniques of paint application with spraygun, sponge, spilling, mopping, and screening typical of recent American painting, relates it to graphic arts as well as to mechanical reproductions that are stamped and printed.

EXAMPLE OF HOFMANN

Among the first painters to insist on a "maximal" art that is sensuous, tactile, imagistic, metaphorical, and subjective, Richard Hennessy himself painted in a variety of styles, examining the means and methods of the artists he most admired—Picasso, Matisse, Klee, Miró, and above all Hans Hofmann. The last has come to symbolize for many younger painters the courage to experiment with different styles, to mature late, after a long career of assimilating elements from the modern movements in a synthesis that is inclusive and not reductive. Indeed, Hofmann's commitment to preserving all that remained alive in the Western tradi-

tion of painting, while rejecting all that was worn out by convention or superseded by more complex formulation, has become the goal of the courageous and ambitious painters today.

Who could have predicted in 1966, when Hofmann, teacher of the abstract expressionists, who brought Matisse's and Kandinsky's principles to New York, died in his eighties, that the late-blooming artist would become the model for those ready to stake their lives on the idea that painting had not died with him? Hofmann's example was important in many ways, for he had remained throughout his life an easel painter, untempted by the architectural aspirations of the "big picture" that dwarfed the viewer in its awesome environmental expanse. Conscious of allover design, Hofmann nevertheless chose to orient his paintings in one direction, almost always vertically, the position that parallels that of the viewer. The vertical orientation, which implies confrontation, rather than the domination of the viewer by the painting, is also typical of many of the artists working now, who accept the conventions of easel painting as a discipline worthy of preservation. Moreover, Hofmann had also turned his back on pure automatism, after early experiments with dripping. Like Hofmann, with few exceptions, the artists who follow his example maintain that painting is a matter of an image that is frontal and based on human scale relationships. They paint on the wall, on stretched canvases that are roughly life-size, working often from preliminary drawings, using brushes or palette knives that record the marks of personal involvement and handcraft, balancing out spatial tensions by carefully revising, as Hofmann did.

Of course, not all the artists I am speaking of have a specific debt to Hofmann. In fact, the serious painters of the eighties are an extremely heterogeneous group—some abstract, some representational. But they are united on a sufficient number of critical issues that it is possible to isolate them as a group. They are, in the first place, dedicated to the preservation of painting as a transcendental high art, a major art, and an art of universal as opposed to local or topical significance. Their aesthetic, which synthesizes tactile with optical qualities, defines itself in conscious opposition to photography and all forms of mechanical reproduction that seek to deprive the art work of its unique "aura." It is, in fact, the enhancement of this aura, through a variety of means, that painting now self-consciously intends—either by emphasizing the involvement of the artist's hand, or by creating highly individual visionary images that cannot be confused either with reality itself or with one another. Such a commitment to unique images necessarily rejects seriality as well.

THE PAINTER AS IMAGEMAKER

These painters will probably find it odd, and perhaps even disagreeable, since they are individualists of the first order, to be spoken of as a group, especially since for the most part they are unknown to one another. However, all are equally committed to a distinctively humanistic art that defines itself in opposition to the *a priori* and the mechanical: a machine cannot do it, a computer cannot reproduce it, another artist cannot execute it. Nor does their painting in any way resemble prints, graphic art, advertising, billboards, etc. Highly and consciously structured in its final evolution (often after a long process of being refined in preliminary drawings and paper studies), these paintings are clearly the works of rational adult humans, not a monkey, a child, or a lunatic. Here it should be said that although there is a considerable amount of painting that continues pop art's mockery of reproduced images—some of it extremely well done—there is a level of cynicism, sarcasm, and parody in such work that puts it outside the realm of high art, placing it more properly in the context of caricature and social satire.

The imagery of painters committed exclusively to a tradition of painting, an inner world of stored images ranging from Altamira to Pollock, is entirely invented; it is the product exclusively of the individual imagination rather than a mirror of the ephemeral external world of objective reality. The rejection of symmetry and of literal interpretations of "allover" design, such as the repeated motifs of pattern painting, defines this art as exclusively *pictorial.* It is as unrelated to the repetitious motifs of the decorative arts and the static centeredness of ornament as it is to graphics and photography. This rejection of the encroachments made on painting by the minor arts is another of the defining characteristics of the serious painting of the eighties.

Although these artists refuse to literalize any of the elements of painting, including that of "allover" design, some, like Howard Buchwald, Joan Thorne, Nancy Graves, and Mark Schlesinger, are taking up the challenge of Pollock's allover paintings in a variety of ways without imitating Pollock's image. Buchwald, for example, builds up a strong rhythmic counterpoint of curved strokes punctuated by linear slices and ovoid sections cut through the canvas at angles and points determined by a system of perspective projections referring to space in front of, rather than behind, the picture plane. Thorne and Graves superimpose several different imagery systems, corresponding to the layers of Pollock's interwoven skeins of paint, upon one another. Schlesinger, on the other

hand, refers to Pollock's antecedents in the allover stippling of neoim-
pressionism, which he converts into images of jagged-edged spiraling
comets suggesting a plunge into deep space while remaining clearly on
the surface by eschewing any references to value contrasts or sculptural
modeling. These original and individual interpretations of "allover"
structure point to the wide number of choices still available within
pictorial as opposed to decorative art. For in submitting itself to the
supporting role that decorative styles inevitably play in relationship to
architecture, painting renounces its claims to autonomy.

THE LEGACY OF POLLOCK

To a large number of these artists, Pollock's heroism was not taking the
big risk of allowing much to chance, but his success in depicting a
life-affirming image in an apparent state of emergence, evolution, and
flux—a flickering, dancing image that never permits the eye to come to
rest on a single focus. Like Pollock's inspired art, some of these paintings
emphasize images that seem to be in a state of evolution. Images of birth
and growth like Lois Lane's bulbs, buds, and hands and Susan Rothen-
berg's desperate animals and figures that seem about to burst the mem-
brane of the canvas to be born before us, or Robert Moskowitz's boldly
hieratic windmill that stands erect in firm but unaggressive confronta-
tion—a profound metaphor of a man holding his ground—are powerful
metaphors. In the works of Lenny Contino and Dennis Ashbaugh, as
well as in Carol Engelson's processional panels, a kind of surface dazzle
and optical excitement recall the energy and sheer physical exhilaration
that proclaimed the underlying image of Pollock's work as the life force
itself. Because he was able to create an image resonant with meaning and
rich with emotional association without resorting to the conventions of
representational art, Pollock remains the primary touchstone. The bal-
ance he achieved between abstract form and allusive content now ap-
pears as a renewed goal more than twenty years after his death.

As rich in its potential as cubism, abstract expressionism is only now
beginning to be understood in a profound instead of a superficial way.
What is emerging from careful scrutiny of its achievements is that the
major areas of breakthrough of the New York School were not the "big
picture," automatism, action painting, flatness, etc., but the synthesis of
painting and drawing, and a new conception of figuration that discon-
nected the image from its roots in representational art. For cubism, while
fracturing, distorting, and in other ways splintering the image (some-

thing neither abstract expressionism nor the wholistic art that came from it did), could never free itself of the conventions of representational art to become fully abstract.

Drawing on discoveries that came after Pollock regarding the role of figuration in post-cubist painting, painters are at ease with a variety of representational possibilities that derive, not from cubist figuration, but from the continuity of image with surface established by Still, Rothko, Newman, and Reinhardt, who imbedded, so to speak, the figure in the carpet, in such a way as to make figure and field covalent and coextensive.

Post-cubist representation is not based on an abstraction from the external objective world, but on autonomously self-generated images. It is a mental construct as conceptual in origin as the loftiest nonobjective painting. Lacking any horizon line, Susan Rothenberg's white-on-white horse, Lois Lane's black-on-black tulips, and Robert Moskowitz's red-on-red windmill, or Gary Stephan's brown-on-brown torso have more in common with Malevich's *White on White* or Reinhardt's black crosses in black fields than with any realist painting. Like Dubuffet's *Cows*— perhaps the first example of post-cubist representation—and Johns's targets and numbers, these images are visually embedded in their fields, whose surface they continue. This contiguity between image and field, enhanced by an equivalence of facture in both, identifies image and field with the surface plane in a manner that is convincingly modernist.

The possibility of depicting an image without resorting to cubist figure–ground relationships greatly enlarges the potential of modernist painting for the future. No longer does the painter who wishes to employ the full range of pictorial possibilities have to choose between a suicidal minimalism or a retrenchment back to realism. By incorporating discoveries regarding the potential for figuration with an abstract space implicit in Monet, Matisse, and Miró, as this potential was refined by Pollock and the color-field painters, an artist may create a representational style that is not realist.

Today, it is primarily in their pursuit of legible, stable, imagistic styles—both abstract and representational—structured as indivisible wholes, a legacy of color-field painting, rather than composed in the traditional cubist manner of adding on parts that rhyme and echo one another, that the latest modernist painters are united. The representation of an image never invokes naive illusionism. To remain valid as a modernist concept, figuration is rendered compatible with flatness. This may mean nothing more radical than Clive Bell's assumption that a painting must proclaim itself as such, before it is a woman, a horse, or a sunrise.

However, it does necessitate conveying the information that the depicted image is incontrovertibly two-dimensional, that it lies on the plane, and not behind it. The contiguity of image with ground is established often as the impressionists did, by an allover rhythmic stroking. All that in cubism remained as vestigial references to the representational past of painting—value contrast, modeling, perspective, overlapping, receding planes, etc.—is eliminated so that the space of painting cannot be confused with real space. Once the truth that *illusion, not flatness, is the essence of painting* is established, the artist is free to manipulate and transform imagery into all manner of illusions belonging exclusively to the realm of the pictorial, i.e., the realm of the imagination. Depicted illusions belong to the imagination. They are registered by the brain as well as the eye. Surface, perceived as constituted of pigment on canvas, can be manipulated to evoke a tactile response that has nothing to do with the experience of a third dimension, but is entirely a matter of texture.

The difference between a painting that is composed, a process of addition and subtraction, and one that is constructed, through a structuring process that takes into consideration the architecture of the frame, continues to be a primary consideration. These artists take a responsibility to structure for granted, just as they reject the random, the chance, and the automatic as categories of the irresponsible. In this sense, decision-making, the process of deliberation, becomes a moral as well as an aesthetic imperative.

THE FUNCTION OF THE IMAGINATION

Today, the essence of painting is being redefined not as a narrow, arid, and reductive anti-illusionism, but as a rich, varied capacity to birth new images into an old world. The new generation of painters who have matured slowly, skeptically, privately, and with great difficulty have had to struggle to maintain conviction in an art that the media and the museums said was dying. Not the literal material properties of painting as pigment on cloth, but its capacity to materialize an image, not behind the picture plane, which self-awareness proclaims inviolate, but behind the proverbial looking-glass of consciousness, where the depth of the imagination knows no limits. If an illusion of space is evoked, it is simultaneously rescinded. In one way or another, either in terms of Hofmann's "push-pull" balancing out of pictorial tensions, or by calling attention to the actual location of the plane by emphasizing the physical

buildup of pigment on top of it, or by imbedding the figure in its contiguous field, serious painting today does not ignore the fundamental assumptions of modernism, which precludes any regression to the conventions of realist representation.

Not innovation, but originality, individuality, and synthesis are the marks of quality in art today, as they have always been. Not material flatness—in itself a contradiction, since even thin canvas has a third dimension and any mark on it creates space—but the capacity of painting to evoke, imply, and conjure up magical illusions that exist in an imaginative mental space, which like the atmospheric space of a Miró, a Rothko, or a Newman, or the cosmic space of a Kandinsky or a Pollock, cannot be confused with the tangible space outside the canvas, is that which differentiates painting from the other arts and from the everyday visual experiences of life itself.

The idea that painting is a visionary and not a material art and that the locus of its inspiration is in the artist's subjective unconscious was the crucial idea that surrealism passed on to abstract expressionism. After two decades of the rejection of imaginative poetic fantasy for the purportedly greater "reality" of an objective art based exclusively on verifiable fact, the current rehabilitation of the metaphorical and metaphysical implications of imagery is a validation of a basic surrealist insight. The liberating potential of art is not as literal reportage, but as a catharsis of the imagination.

The surrealists believed, and no one has yet proven them wrong, that psychic liberation is the prerequisite of political liberation, and not vice versa. For most of the twentieth century, the relationship between art and politics has been an absurd confusion, sometimes comic, sometimes tragic. The idea that to be valid or important, art must be "radical," is at the heart of this confusion. By aspiring to power, specifically political power, art imitates the compromises of politics and renounces its essential role as moral example. By turning away from power and protest, by making of their art a moral example of mature responsibility and judicious reflection, a small group of painters "taking a stand within the self," as Ortega y Gasset described Goethe's morality, is redeeming for art a high place in culture that recent years have seen it voluntarily abdicate for the cheap thrill of instant impact.

Because the creation of individual, subjective images, ungoverned and ungovernable by any system of public thought or political exigency, is *ipso facto* revolutionary and subversive of the status quo, it is tautology that art must strive to be radical. On the contrary, that art which commits itself self-consciously to radicality—which usually means the

technically and materially radical, since only technique and not the content of the mind advances—is a mirror of the world as it is and not a critique of it.

Even Herbert Marcuse was forced to revise the Marxist assumption that in the perfect Utopian society, art would disappear. In his last book, *The Aesthetic Dimension,* he concludes that even an unrepressed, unalienated world "would not signal the end of art, the overcoming of tragedy, the reconciliation of the Dionysian and the Apollonian. . . . In all its ideality, art bears witness to the truth of dialectical materialism— the permanent non-identity between subject and object, individual and individual." Marcuse identifies the only truly revolutionary art as the expression of subjectivity, the private vision: "The 'flight into inwardness' and the insistence on a private sphere may well serve as bulwarks against a society which administers all dimensions of human existence. Inwardness and subjectivity may well become the inner and outer space for the subversion of experience, for the emergence of another universe."

For art, the patricidal act of severing itself from tradition and convention is equally suicidal, the self-hatred of the artist expressed in eliminating the hand, typical of the art of the last two decades, can only lead to the death of painting. Such a powerful wish to annihilate personal expression implies that the artist does not love his creation. And it is obvious that an activity practiced not out of love, but out of competition, hatred, protest, the need to dominate materials, institutions or other people, or simply to gain social status in a world that canonizes as well as cannibalizes the artist, is not only alienated but doomed. For art is labor, physical human labor, the labor of birth, reflected in the many images that appear as in a process of emergence, as if taking form before us.

The renewed conviction in the future of painting on the part of a happy few signals a shift in values. Instead of trying to escape from history, there is a new generation of artists ready to confront the past without succumbing to nostalgia, ready to learn without imitating, courageous enough to create works for a future no one can be sure will come, ready to take their place, as Gorky put it, in the chain of continuity of "the great group dance."

This is a generation of hold-outs, a generation of survivors of catastrophes, both personal and historical, which are pointless to enumerate, since their art depends on transcending the petty personal soap opera in the service of the grand, universal statement. They have survived a drug culture that consumed many of the best talents of their time; they have lived through a crisis of disintegrating morality, social demoraliza-

tion and lack of conviction in all authority and tradition destroyed by cultural relativism and individual cynicism. And they have stood their ground, maintaining a conviction in quality and values, a belief in art as a mode of transcendence, a worldly incarnation of the ideal. Perhaps they, more than the generations who interpreted his lessons as license, have truly understood why Duchamp was obsessed by alchemy. Alchemy is the science of trans-substantiation. The tragedy of Duchamp's life was that he could only study alchemy because he could not practice it. To transform matter into some higher form, one must believe in transcendence. As a rationalist, a materialist, and a positivist, Duchamp could not practice an art based on the transformation of physical matter into intangible energy and light. Those who perpetuate an art that filled him with ennui are the last of the true believers; their conviction in the future of painting is a courageous and constructive act of faith.

ART IN DISCOLAND

Today's art—good, bad, and indifferent—has the significance of ephemeral fashion to many who flock to the latest performance and cram SoHo and the East Village in hot pursuit of cheap thrills and masterpieces for investment. A side effect of overselling art to the American public through such commercial devices as advertising, direct mail, and press agents is that "art" is now virtually a meaningless word that can be applied to anything to give it a touch of class. "Art" has become ubiquitous decor, visual Muzak. In this context, no self-respecting Hollywood producer fails to provide artistic background to indicate ultimate stylishness. Mass-market films like *Beverly Hills Cop* have art galleries as sets. Art awareness has penetrated Los Angeles, heart of the pop-music, television, and film industries, to the point that art is more than merely a status symbol: it is an absolute prerequisite for any TV or film biggie with cultural pretensions. In the present situation a large segment of the art market consists of newly rich collectors investing money made quickly in mass media. Their taste has been formed by media, but so has that of many of today's most popular artists, like David Salle, whose prepackaged, recycled images are ideal fare for culturally impoverished, art-hungry, busy media moguls.

Salle, a product of the school financed with Walt Disney money, the California Institute of Arts, has translated the media mentality into a perfect cocktail: one part sensational sex and violence, one part pretentious art-world "in" jokes about structuralism and enigma, one part eclectic imagery, all mishmashed together in a punk symphony of dissonance with immediate impact. Taking up where Warhol left off, David Salle pushes pop one step further, using projected rather than printed images as his point of departure. The result is a translation of the film-editing concept of montage, which associates various images

290

through juxtaposition, into painting. Crossing the once sacred boundary between fine art and mass media has given Salle celebrity status, since the expanded art public is mainly gratified by the familiar. We can thank Andy Warhol for introducing the radical concept that art should be easy, not difficult. Easy art, of course, is dumb art, which is also the point. You no longer need to be intelligent, sensitive, or cultivated to participate in the happy art-world carnival of fun, fun, fun. Looking right and having the cash are sufficient to get you a ticket to the best rides.

This new definition of art as a kind of Disneyland for the upper middle class is totally compatible with art decorating discos. There is, of course, the possibility that we will soon arrive at that point where it is no longer possible to distinguish fine art from cartooning, public relations, and fashion. At that moment, the utopian dream of every radical avant-garde from the Russian suprematists to the French Dadaists will be realized. Fine art, that hideously elite and class-conscious category of snobbery, will disappear.

Museums like the Whitney are actively aiding the coming of this millennium of cultural democracy by exhibiting Walt Disney cartoons, further confusing an already confused public. Artists like David Salle and Julian Schnabel, also in the vanguard of this revolution in consciousness, make incoherent art, whose content is incoherence, thus disorienting an already dazed public. By sanitizing the East Village scene and moving it to the Upper East Side, virtually intact, in a recent Biennial, the Whitney Museum provided an important service to the poor in spirit but heavy in pocketbook, simulating the ambience of danger and adventure without the risk of real dirt or violence. In this way, the function of the museum becomes indistinguishable from that of Disney World with its endless possibilities for passionless rides through historical periods and cultures.

At the Whitney Biennial in 1985, for example, one could simultaneously experience Minimal World, Pop World, Social Protest World, Performance World, Kitsch World, Postmodernist World, Conceptual World, Graffiti World, and even, in the works of Jasper Johns, Elizabeth Murray, John Duff, and Susan Rothenberg, which seemed weirdly out of place, Fine Art World. Naturally, with such vivid competition, Fine Art World is bound to look miserably dull. Why concentrate on a brushstroke by Johns or decipher his hermetic imagery, which is a *coherent* statement about incoherence, decadence, death, and dissolution, when one can relax with a big-screen high-power jolt from David Salle? In the brave new world of art as fashion, subtlety, nuance, precision,

talent, and difficulty are Out. Overt sex, violence, commercialism, bright textile patterning, primitivism, and instant visual overload are In.

As art descends into the streets, life gets lonelier and lonelier in the ivory tower, not to mention colder, because there is no heat there. So what is the poor artist, who, after all, wants a piece of the action, to do? Since we have lost the concept of an afterlife along with a lot of other ideas that used to be considered valuable, nobody wants to wait to be dead to be discovered. Ergo, it is necessary to compete with the overcharged, overstimulated world of mass media, indeed to use media to fight media. This has led a group of bright young artists, including Robert Longo, Barbara Kruger, Jenny Holzer, Laurie Anderson, Cindy Sherman, Judy Rifka, and Hannah Wilke (the last three not yet to be seen in discos), to arrive at a kind of Trojan Horse strategy. They draw imagery and techniques from billboards, TV, and advertising. Once inside the enemy's gates, however, they attack rather than collaborate with mass culture. Their art is cerebral and gives little in the way of sensual pleasure. It is overtly and intentionally theatrical and sensationalistic. Then again, how else can you attract attention these days?

Attracting attention from a public normally uninterested in or ignorant of art was one of the socially democratic intentions of pop art, which succeeded in expanding the art world to include anybody who could pay to get in. The nihilism one senses in much new art is only a reaction to the intensification of materialism as mass culture bottoms out to the lowest common denominator. TV teaches that life has no meaning, hence it follows that art, like life, is also meaningless. Artists, however, are stubborn. Some are still trying to hold out by criticizing instead of collaborating in the gradual destruction through assimilation of Fine Art World into the ersatz culture of Disneyland. Robert Longo's series of "corporate war" images and his scenes of urban violence are hard to ignore. Longo is out to challenge Robert Wilson as a producer of extravaganzas. "I got bored with words," Longo says, explaining his interest in visual theater. "The movie *Network* had a big effect on me. There was no nature, no people, just TV. It makes me think a lot about all those frustrated people waiting in line outside the clubs. The question is, what are they waiting in line for?" Certainly, this is the question that runs through one's mind on seeing hordes of desperate, would-be-in groupies, so uncertain of their own identities that they arrive in costume, praying to be anointed for entry by the goon squads who guard the portals of Discoland.

The ultimate irony is that the democratization of art has resulted in

the most undemocratic situation: how you look determines who you are, and cash determines caste. In this situation, it is no surprise that art has turned into fashion. When people line up at discotheques and restaurants not to dance or to eat but to look at the decor, you know that life, not art, has become the spectator sport.

ABOUT THE AUTHOR

▬

Barbara Rose was born in Washington, D.C., and was educated at Smith College, Barnard College, and the Sorbonne. She received a doctorate in art history from Columbia University. Recipient of a Fulbright Fellowship to Spain, she was twice awarded the College Art Association Mather Award for distinguished art criticism.

Dr. Rose has served as contributing editor of *Art International, Art in America, Arts,* and the *Partisan Review.* She has taught at Sarah Lawrence College, the University of California, Irvine, Yale University, and Hunter College.

As curator, Dr. Rose organized many major museum exhibitions, including the controversial *American Painting: The Eighties.* With William C. Agee, she prepared the *catalogue raisonné* and retrospective of American cubist Patrick Henry Bruce. She also organized *Miró in America* and *Lee Krasner: A Retrospective.* She currently serves on the visual arts committee of the Spanish Institute. Barbara Rose is the author of many books, articles, and films on American art.